The Nature of Craft and the Penland Experience

The Nature of Craft and the Penland Experience

Published on the occasion of the exhibition at
the **Mint Museum of Craft + Design**,
Charlotte, NC, *celebrating the*

75TH ANNIVERSARY OF PENLAND SCHOOL OF CRAFTS

EDITOR: Jean W. McLaughlin
CURATORS: Ellen Paul Denker, Dana Moore
ASSOCIATE EDITORS: Robin Dreyer, Ronni Lundy, Dana Moore
EDITORIAL BOARD: Ellen Paul Denker, Robin Dreyer, Nicholas Joerling, Dana Moore
ART DIRECTOR: Kristi Pfeffer
ASSOCIATE ART DIRECTOR: Leslie Noell
COVER DESIGNER: Kristi Pfeffer
ILLUSTRATOR: Leslie Noell
PRINCIPAL ART PHOTOGRAPHER: David Ramsey
EDITORIAL ASSISTANCE: Donna Jean Dreyer, Delores Gosnell,
 Nathalie Mornu, Sarah Warner
PROJECT MANAGER: Robin Dreyer

Library of Congress Cataloging-in-Publication Data

The nature of craft and the Penland experience / edited by Jean W. McLaughlin.
 p. cm.
 "Published on the occasion of the exhibition at the Mint Museum of
Craft + Design, Charlotte, NC, celebrating the 75th anniversary of
Penland School of Crafts."
 ISBN 1-57990-575-7
 1. Handicraft. I. McLaughlin, Jean W. II. Penland School of Crafts
(Penland, N.C.)
TT157.N326 2004
680'.71'0756865--dc22

 2004000387

10 9 8 7 6 5 4 3 2 1

First Edition

Published by Lark Books, a division of
Sterling Publishing Co., Inc.
387 Park Avenue South, New York, N.Y. 10016

Distributed in Canada by Sterling Publishing,
c/o Canadian Manda Group, One Atlantic Ave., Suite 105
Toronto, Ontario, Canada M6K 3E7

Distributed in the U.K. by Guild of Master Craftsman Publications Ltd.,
Castle Place, 166 High Street, Lewes, East Sussex, England
BN7 1XU
Tel: (+ 44) 1273 477374, Fax: (+ 44) 1273 478606,
Email: pubs@thegmcgroup.com, Web: www.gmcpublications.com

Distributed in Australia by Capricorn Link (Australia) Pty Ltd.,
P.O. Box 704, Windsor, NSW 2756 Australia

ISBN: 1-57990-575-7

FRONT COVER
Iron Studio Gate, 2000
Iron Class Project (see page 180)
Photograph: David Ramsey

BACK COVER
Pitcher, circa 1930–1938
Attributed to Penland Weavers and Potters (see page 159)
Photograph: David Ramsey

Sound Suit, 2002
Nick Cave (see page 150)
Photograph: Stephen Hamilton

This project received funding from the National Endowment for the Arts and the North Carolina Humanities Council. Penland School of Crafts receives funding for its programs from the North Carolina Arts Council, and agency funded by the State of North Carolina and the National Endowment for the Arts.

Photos: top, Dana Moore; others, Robin Dreyer

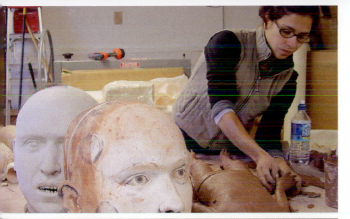

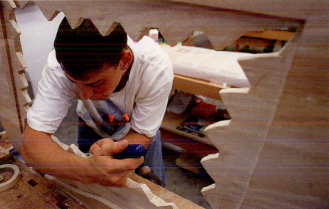

TABLE OF CONTENTS

Penland School of Crafts has, throughout its long history, been a pioneering force in craft education. Equally compelling, the school has been an extraordinary haven for an international cadre of established and emerging craft artists. Penland has served as a hotbed of creativity and innovation, a place where artists have honed their skills and transformed their creative visions into extraordinary works of art. *The Nature of Craft and the Penland Experience* illustrates in vivid detail the ascendancy and evolution of the school. It portrays the depth of the school's involvement in stewarding craft heritage while influencing generations of talented makers. Such artists, through their unique and varied approaches, have fueled the growth of the craft field as we know it today. As technology and its numerous applications are rapidly challenging the primacy of making by hand, the notion of physically manipulating materials into forms of great beauty and use can inspire us to consider equally the value of such an enterprise.

Since opening in January 1999, the Mint Museum of Craft + Design has continually sought out institutional partners who, together with the museum's resources, can leverage greater educational results to benefit the broadest possible audience. Thus, it is in the spirit of cooperation and learning that the museum is proud to be an organizing partner with Penland School of Crafts in the development of the exhibition *The Nature of Craft and the Penland Experience*.

The Mint Museum of Craft + Design's goal, as it relates to the craft sector of our mission, is to foster an understanding and appreciation for the handmade form, its heritage, and its place in today's global society. In order to accomplish this goal, we are committed to developing an international collection of studio craft and functional utensils that exemplify the highest achievements in design, technique, and aesthetics. We also place a high premium on original research that becomes the foundation for fresh, innovative exhibitions and scholarly publications. Through the use of technology and the World Wide Web, we seek to eliminate geographical barriers and promote public learning at all levels and across craft's various disciplines.

Together, Penland School of Crafts and the Mint Museum of Craft + Design are committed to promoting the singular and beneficial dividends that accrue from the timeless human instinct to transform materials by hand into useful, visually enticing and durable forms.

Mark Richard Leach
Deputy Director, The Mint Museums

Dan Bailey
Penland Target, 1983
(Detail)

INTRODUCTION

For seventy-five years, Penland School of Crafts has helped people reach across continents and time to connect with each other and with the material cultures of the world. Craft stands as a common denominator among peoples, as an act of invention, embellishment, and communication. To honor craft is to recognize the value inherent in the human spirit. To pay attention to craft is to learn from materials and processes, to find joy in the utilitarian and the commonplace, and to realize that powerful ideas are made manifest through the work of the hands.

One of our goals for celebrating Penland's long history was to create a book which takes a fresh and inclusive look at craft—a book which reaches further than simply telling the story of Penland School and speaks to the phenomenon of craft itself. Our goal was to create a body of new writing which will resonate in the field for years to come, and to present a selection of outstanding work which shows craft defined as broadly as it is in our educational programs.

One of the defining characteristics of Penland School is that it is a place where students and instructors are encouraged to take chances in their work. In choosing writers for this book, we decided to honor this tradition by finding interesting thinkers who were not necessarily experts in craft, and giving them an opportunity to observe and comment on our field. We wanted to test the idea that craft speaks with an interdisciplinary voice. We wanted to bring new ideas into the study of craft. We hoped that writers from other realms would reflect back to us impressions that would be stimulating or even startling. We wanted to explore ways of understanding craft through the perspective of fields such as anthropology, science, folklore, sociology, poetry, and cultural history and criticism.

Eight writers were invited to spend time at Penland observing classes, talking to students and instructors, trying their hand at whatever interested them, and generally immersing themselves in Penland's world. In their turn, they made presentations to the Penland community about their own work. They were then invited to write from the perspective of their own areas of study, without any restrictions or specific instructions from us. In fact, we did not to attempt to shape their personal observations and reflections.

Some of the invited writers incorporated their experiences at Penland directly into their essays. Some brought to their pieces broader observations of craft while others wrote specifically from their own areas of study. Each of them succeeds in bringing the essayist's special perspective to bear on fundamental matters such as craftsmanship, love of materials, aesthetic expression, and the creative impulse.

The book also contains images of the 137 works of art included in an exhibition, also titled *The Nature of Craft and the Penland Experience,* held at the Mint Museum of Craft + Design—another component of Penland's anniversary celebration. All of the work selected by curators Ellen Paul Denker and Dana Moore was made by artists affiliated with Penland School as instructors or resident artists. Craft is a large umbrella at Penland, so this book includes photographs, prints, and paintings along with media more traditionally described as craft. Some of the pieces date back to the earliest years of the school; others were made after we started planning this project. The work is not, however, an attempt to show a chronology of craft throughout Penland's history. The images are grouped according to concepts which cut across media, style, and time. Each section of work begins with co-curator Ellen Paul Denker's explanation of that section's theme. The essays are interspersed to reflect some of the connections we found between the writers' observations and the works of art themselves. Our hope is that these images and essays will help readers penetrate the very nature of craft.

As we are celebrating an anniversary, we open the book with an essay on Penland's history written by Penland staff member Robin Dreyer. He traces the school's roots and explores its contributions to craft education. This piece is paired with an essay by exhibition co-curator and material culture historian Ellen Paul Denker. Her essay is also historical in nature, and argues that the Arts and Crafts movement was not simply a stylistic period in decorative arts history, but rather a set of ideals that continues to flourish in contemporary studio craft. This essay provides additional context for the story of Penland School of Crafts.

The first of the guest essays is by chemist and poet Roald Hoffmann, who managed to do a little work in almost every Penland studio during his visit. He also gave a memorable poetry reading and several mini-lectures on the chemistry of various craft materials and processes. He used his visit to Penland as a springboard for observations on the connection between the work of scientists and the work of craftspeople. Interdisciplinary scholar Ellen Dissanayake has spent more than two decades developing a body of research incorporating behaviorism, Darwinism, and other fields into an ongoing investigation of the biological origins of art. Her essay considers why creative activity may be a necessary component of a healthy human psychology, growing out of the very first activities of life. Cultural anthropologist Norris Brock Johnson chose a single visual motif—the spiral—to represent his view of craft as a carrier of fundamental cultural information that cuts across time and space.

Michael Owen Jones is a folklorist whose broad definition of his field has taken him from the shops of Appalachian chairmakers to the storefront churches of Los Angeles. He was fascinated by the creative expression of people who work at Penland School and incorporates these observations into an essay on aesthetics in everyday life. This interest in everyday expression is also pursued by architectural sociologist Galen Cranz, who takes the reader into personal living spaces to reconsider the idea of taste.

Poet Eileen Myles first came to Penland as a visiting artist for a quiltmaking class and then returned as part of the anniversary project. She presents a highly personal, almost cinematic, account of the rhythms of Penland School and talks about the way certain activities alter our sense of time. Writer Lewis Hyde, who has been responsible for some of the most provocative contemporary thinking on art and society, was attracted to Penland because of his interest in a list of sixty senses created by potter Paulus Berensohn, a long-time neighbor of the school. Hyde's essay is a journal which records his movement through Penland, his conversations with Berensohn, the shadow of impending war, and his powerful observations on what motivates people to engage with craft materials.

The book begins with a look at the past and so it ends with a glimpse into the future, as critic Patricia C. Phillips presents a layered and challenging assessment of craft's relationship to fine art, public art, design, and critical theory. Some of the important questions she raises remain unanswered, opening the conversation to future commentators and observers.

In addition to the essays, the book contains a number of short quotations on craft, creativity, teaching, and the Penland experience. These quotes serve to bring the voices of artists into the book and to expand the spectrum of our inquiry into craft. We have also included a timeline of Penland's history and a list of the people who are the true foundation of Penland's story and accomplishments: the instructors, resident artists, and core students.

Taken as a whole, the words and images in this book succeed in exploring many of the ideas we believe are central to craft: that learning, creativity, and play are integrally linked; that craft is informed by ritual, celebration, and function; that the hand and physicality are key influences in the making of craft; that the natural environment, community expression, and the oral transmission of information are of great importance to craft traditions; that craft has a relationship to the body, to beauty, and to spirituality; and that craft, a universal language, is used cross-culturally by artists as a means of inspiration and communication.

The diversity of style and content in both the writings and works of art presented here is such that it would be unreasonable to expect every reader to respond to all of it. It is my expectation, however, that anyone with an interest in craft, materials, education, or human creativity will discover ideas and images that are surprising, provocative, and inspiring. It is with great pride that I present *The Nature of Craft and the Penland Experience* as an anniversary gift from Penland School of Crafts.

Jean W. McLaughlin
Director, Penland School of Crafts

THE JOY OF HANDS AT WORK

Penland School and the Evolution of Craft Education

Robin Dreyer

I was taking a jewelry class with Gary Noffke who has done some blacksmithing himself. He had us making stakes—jewelry tools. I had such a big time doing it that I thought I'd like to make a hammer. So I went up to the iron studio and asked Doug Wilson if I could make a hammer and he said, sure, and handed me a big chunk of steel.

I had no idea what I was doing, and after I had worked on the thing for about ten hours I had the worst headache of my life. I went back to the dorm and I sat down on the bed. I took a couple of aspirin and I told myself, well, this was something that you wanted to do but you've found that you're just not capable of doing it, so just forget it, go back to jewelry. Then I decided I'd take a shower and get all that crud off of me. While I was in the shower I thought of about ten more things I wanted to make in the iron studio, so I went right back up there the next morning and I've been going back ever since.

Blacksmith and sculptor **Elizabeth Brim**, who lives near Penland School of Crafts and has been a Penland student, core student, instructor, and iron studio coordinator, from an interview in 1990

Although she was a woman of great vision, Lucy Morgan was probably not imagining Elizabeth Brim and her chunk of steel when she arrived in the North Carolina mountain community of Penland in 1920. She had come to accept a teaching position at the Appalachian School, an Episcopal mission school which had been run for a time by her brother Rufus, who was a priest. She had no definite plan for how long she would stay.

During the forty-two years Morgan lived and worked at Penland she established an educational experiment which continues to this day. Over a seventy-five year history, Penland School of Crafts has nurtured the personal and creative lives of thousands of individuals; it has helped establish an alternative model of education; it has contributed to the growth and development of a major area of aesthetic expression; and it has established a distinctive niche for itself in the cultural life of our society.

These accomplishments have been led by the vision of a few key people and supported by the creative and financial contributions of many more. Guiding the school through its remarkable history has been a persistent adherence to a few basic ideas: the value of lifelong education, the power of aligning mind and body in the execution of challenging and creative tasks, a love of handmade objects, the importance of community, and the significance of place.

Elizabeth Brim's discovery of steel, its effect on her life, and her intricate relationship with the school are a good story, but not a rare one. Hundreds and hundreds of similar stories make up the fabric of Penland's history.

Photo: Robin Dreyer

There were two things I very much wanted to do. The first was to help bring about a revival of hand-weaving, which in our country—I'm speaking of the nation now—had become all but a dead artThe other thing I wanted to do was provide our neighbor mothers with a means of adding to their generally meager incomes without having to leave their homes.

Lucy Morgan in *Gift From the Hills*

The prehistory of Penland School is a complex story which twines together strands of church philanthropy, progressive-era educational and social philosophy, and an amorphous phenomenon known as the Appalachian craft revival. The school's early history is also intermingled with that of two other institutions: the Appalachian School and the Penland Weavers and Potters. The story is driven by the relentless energy and adaptable vision of the school's founder.

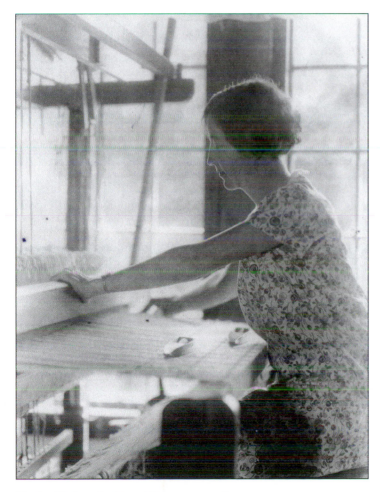

Penland's founder Lucy Morgan, weaving, 1920s.

Lucy Morgan (who was referred to as "Miss Lucy" most of her adult life) was born in Macon County, North Carolina, in the far western end of the state. The daughter of socially active Episcopalians, Morgan was educated, through connections made by her brother Rufus, at Central State Normal School (now Central Michigan University) in Mt. Pleasant, Michigan. After graduating in 1915, she taught public school in Michigan, Montana, and suburban Chicago. During several years in Illinois, she attended summer school at the University of Chicago, and in 1919 she worked at the U.S. Children's Bureau, a social welfare agency.

Chicago in that era was a seedbed for the development of progressive education and social work in the United States. John Dewey, the philosopher and advocate of experiential education, was a major influence at the University of Chicago. Hull House, founded by Jane Addams and Ellen Gates Starr, was a pioneer in providing broad-based social services to the poor. Hull House had philosophical connections with the Arts and Crafts movement and included craft activities in its programs. The Children's Bureau, where Morgan worked, was run by Julia Lathrop, who had worked at Hull House and was involved in the development of early child labor laws. It was from this social climate that Morgan went to Penland in 1920.

Lucy Morgan and her brother Rufus had discussed for some years the possibility of her teaching at the Appalachian School. He had also talked to her of his dream that the school's vocational program could be expanded to include handcrafts, particularly weaving. Rufus Morgan had sought out the very few women in the vicinity of the school who still practiced this craft and had expressed his interest in reintroducing it through the Appalachian School.

By the time Lucy Morgan came to join the school, her brother had moved on and the school was headed by their mutual friend Amy Burt. Burt was also on the faculty of Central State Normal School and was present at the Appalachian School only in the summers (it was a year-round boarding and day school). For a few years Morgan taught primary school and also served as acting principal in Burt's absence.

In the winter of 1923, Morgan was asked to accompany a local girl named Bonnie Willis who was traveling to Berea, Kentucky, to continue her education at the Berea Academy (and then at Berea College). They were joined by Howard "Toni" Ford, a young Appalachian School teacher also enrolling at Berea. The college offered weaving classes, and

Morgan had decided to spend her nine-week vacation studying the craft. The teacher was Anna Ernberg, a weaver from Sweden. Ernberg directed a program in which students produced woven items for resale as part of the school's work-exchange program. She had developed an efficient and light-weight counterbalance loom which was much easier to operate than the looms used by Appalachian weavers of earlier generations. In addition to learning the basics of weaving, Morgan also met Edith Matheny who was running a program which placed looms in the homes of local women and purchased and marketed their woven goods. Morgan returned to Penland with new skills, several looms, and an idea for a weaving program aimed not at her students, but at the surrounding community.

Back at Penland, Morgan set up looms and invited local women to try them out. As her intent was to reintroduce a craft which some women might have seen practiced by their mothers or grandmothers, she wanted potential weavers to experience first-hand the improved technology she found at Berea. "Everybody who came in to see these little looms marveled at how much smaller and lighter they were than the cumbersome old ones they remembered seeing their grandmothers use," Morgan wrote in her memoir, *Gift from the Hills.*

As her proposed program would operate as part of the Appalachian School, she needed approval from the bishop, Junius Horner, before proceeding. Although the women of the community were involved with farming, gardening, livestock, and household work, Horner worried that weaving might be too strenuous for them. He also protested that there was no money for such a program. Morgan, exhibiting the commitment and persistence which would characterize her entire career, offered her savings of $615 to underwrite the project and accepted the bishop's challenge to weave continuously for eight hours as proof that the work could be done by women. Soon after this, Morgan gave up teaching at the Appalachian School and put her energy into crafts.

The first person interested in weaving was Bonnie Willis's mother, Adeline. She took a loom into her home and, with Morgan's help and instruction, began to weave rugs in the Log Cabin pattern. When the first rugs were delivered, Morgan wrote her a check for twenty-three dollars, an impressive amount of cash for a woman in that time and place to earn. Word spread and soon Morgan had to send to Berea for more looms, and many more were made by local woodworkers. These were placed in homes, and Morgan spent her time going from house to house, instructing the

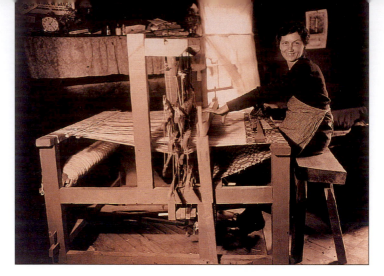

Weaver Mary Lee Murdock working in her home, 1920s.

new weavers in the basics of the craft. Paying for the goods quickly depleted Morgan's savings as the weavers produced scarves, bags, rugs, and other items. She had initiated the project with no plan for marketing, and when she was finally $2000 in arrears, she turned to the church for help. Bishop Horner agreed to place the project under the sponsorship of the Appalachian School. The school paid Morgan a salary and the church provided a Ford pickup truck for transporting and marketing the goods.

She began selling woven items at mountain resorts, at agricultural fairs, through church gift shops, and eventually at the general conventions of the Episcopal Church. A successful marketing trip to the North Carolina State Fair in Raleigh put Morgan in contact with George Coggin, the administrator of the state's vocational education program. He found that Morgan's weaving program qualified for support under the Smith-Hughes Act, a federal program which subsidized vocational training.

This government money provided half of Morgan's salary (and would later subsidize instructor pay at Penland School for a number of years). The terms of the act required the weavers to meet regularly in a central location, so Morgan established Wednesdays as "Weaving Day," and the women gathered at one of the Appalachian School buildings for instruction, socializing, to pick up materials, and to deliver finished work. In 1926, with seventeen weavers producing, a dedicated building, called the Weaving Cabin, was built on church property by the families of the weavers.

The next significant evolution of Morgan's project revolved around a man named Edward F. Worst, who was considered the country's leading expert on hand weaving. The director of manual education in the Chicago public

schools, Worst was a proponent of the theories of John Dewey and had profound connections to the ideals of the Arts and Crafts movement. He had studied weaving in Sweden and at the Lowell Textile Institute; he had authored several manuals on weaving and established a cottage industry based on handweaving. He was an early proponent of occupational therapy and believed in handwork as an intrinsically worthy component of basic education.

Morgan had used one of Worst's books when she was at Berea and later was able to secure an invitation to study with Worst himself. She spent nine weeks working with him in Chicago and then persuaded him to visit Penland in the summer of 1928. In addition to setting up and demonstrating a ten-harness loom, Worst met some of the weavers and suggested to Morgan that pottery be added as a production item. Worst sent an associate to help set up a ceramics shop and pots were made for sale, but shipping and quality control proved to be a problem and the ceramics never succeeded as a market item. What did stick, however, was a new name for the project: The Penland Weavers and Potters.

According to *Gift from the Hills,* an account of Worst's 1928 visit in a small publication called *The Handicrafter* produced letters of interest from other parts of the country. When Worst returned in 1929 to work with the Penland weavers for a week, a few guest students joined the local women for instruction. Morgan would later date this workshop in the summer of 1929 as the birth of Penland School. In 1930, the Penland Weavers and Potters formally announced a Weaving Institute under the direction of Edward Worst and again a number of students traveled to Penland to join the local weavers.[1]

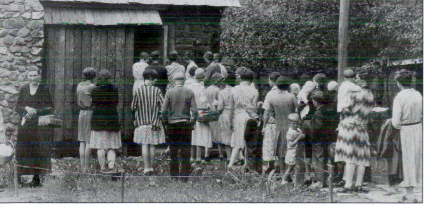

Penland weavers gathering at the Weaving Cabin for Weaving Day, 1920s.

The production weaving program grew in size until the late 1920s, when it peaked with about sixty women weaving. Although the addition of pottery was a failure, Morgan picked up the rudiments of hammered pewter while on a trip to New York and introduced it alongside the weaving. The production program continued for several decades, even as Morgan's attention was increasingly occupied by the school she was developing. (She did make a colorful sales trip to the Chicago World's Fair in 1933, with a tiny log cabin on the back of a pickup truck.)

Edward F. Worst teaching weaving at Penland, 1930s.

The management of the production program was taken over by others and eventually the numbers of weavers and metalworkers began to decline. The Episcopal Church ended its subsidies in the early 1930s. Jessie McKinney, who ran the program during its final days, reported in a 1993 interview that as factory work and other cash-producing jobs became available, it was difficult to persuade the next generation of women to take up weaving. In 1967, the Penland Weavers and Potters came to an end.

With no documented accounts from the weavers themselves, it's difficult to assess the impact weaving had on the lives of women like Adeline Willis, Mary Lee Murdock, and Sally Sparks. There's no question that weaving is hard work and that these women were already working hard. It's also clear that sales of handcrafted goods were bringing much-needed cash into these families: there are still Mitchell County residents who talk about things their grandmothers paid for with "weaving money." What is absolutely certain is that Morgan viewed the program in more than simply economic terms. She had helped reintroduce a craft which had almost faded away, and like her friend Edward Worst, she

believed in the personal and spiritual benefits of making things by hand. In *Gift from the Hills,* Morgan describes some of the other benefits of weaving this way:

> Not only were our weavers producing goods for sale, but there was hardly a weaver who hadn't created things with which to beautify and make more comfortable her own home. They were weaving curtains, towels, table linens, dresses. One weaver had woven her husband a suit. They had revived a cultural heritage.

The Penland weaving program did not, however, exist in a vacuum. Morgan had seen a similar program at Berea; in Asheville was Allenstand Cottage Industries, founded by Frances Louisa Goodrich; the Crossnore School, twenty miles north of Penland, had developed a weaving program under the guidance of Mary Sloop; Morgan's friend Clementine Douglas operated The Spinning Wheel in Asheville, which marketed goods woven locally under her guidance; Clay County's John C. Campbell Folk School founded by Olive Dame Campbell taught and marketed traditional handicrafts.

Most of these programs were established with stated ideals almost identical to Morgan's. Sloop, Douglas, Morgan, and Campbell were integral to the founding of the Southern Highland Handicraft Guild, a pivotal craft marketing group which had its organizing meeting at Penland in 1928. These organizations and other similar efforts were key components of what is referred to as the Appalachian Craft Revival. It's worth noting that while a tradition of handcraft may have been revived through these efforts, the products themselves (which were frequently presented to the public as pure mountain craft) were shaped by the market and were often based on skills, designs, and technology (such as the Ernberg loom) imported by the likes of Lucy Morgan, Anna Ernberg, and Edward Worst. This merging of new information into craft traditions would become a consistent feature of Penland's educational programs.[2]

I knew as soon as I came up the hill that the beauty and history of the place would facilitate creation.

Elizabeth Dorbad, former Penland core student, speaking in 2002

Nineteen thirty-one was a significant year for Lucy Morgan and her fledgling school. The one-week Weaving Institute was attended that year by forty Penland weavers and seventeen other students, representing nine states and including housewives, teachers, students, weavers, one lawyer, and one businessman. It was also the year that Bonnie and Toni Ford returned to Penland.

Bonnie Willis Ford was the same Bonnie Willis who had traveled to Berea in 1923 accompanied by Lucy Morgan and Toni Ford. Willis and Ford had completed their studies and married. Toni Ford would teach in the art department at Oklahoma A&M University and would later spend years working for various agencies as a design, production, and marketing advisor to craftspeople throughout the world. For many of the years that Morgan ran Penland School he was also a lively and integral part of the summer programs, teaching a variety of crafts, writing a daily newsletter for students, helping with promotional materials, and generally making himself useful.

Bonnie Ford quickly became the *de facto* manager of both the production and educational programs at Penland; she continued working at the school until her death in 1976. She was steady, levelheaded, and a good writer. Morgan described her as "Penland School's Rock of Gibraltar." The school's second director, Bill Brown, called her, "my ace in the hole." Ford's daughter Martha recalls people saying, "Miss Lucy dreamed the dreams and Bonnie tied the shoestrings together."

In 1932, the weaving institute was expanded to include pottery (taught by Toni Ford), basketry, leather tooling, and wood carving. In 1935, students were offered the option of one or two weeks of preliminary weaving classes before Worst arrived, and instruction in carding, spinning, dyeing, bookbinding, pottery, basketry, block printing, leather work, soap making, jewelry making, and hickory chair bottoming. That year the classes attracted twenty local students and sixty-two others, representing nineteen states.

That was also the year when Morgan embarked on the first of several ambitious building projects. The summer programs had become large enough to conflict with the Appalachian School's use of its buildings, and the students in the 1934 Weaving Institute put together a pool of money for the construction of a building devoted to craft classes.

In May of 1935, with a small amount of donated money (a $2.50 donation paid for one log), whatever funds Morgan could borrow against her life insurance, and materials given to the project against the promise of future payment, the logs were raised for a fifty- by eighty-four-foot structure on land Morgan owned adjacent to the Appalachian School. It was

named the Edward F. Worst Craft House. The community log raising was documented by Morgan's cousin, the photographer Bayard Wootten, who had been photographing periodically at Penland.

It would be several years before the building was finished, but it was used that same summer, with no water, no windows, no chinking, cracks in the subfloor, and bedrooms divided by hanging blankets. The project was typical of Morgan's ambitious enthusiasm and idealism: she had paid women to weave goods before she had a market for them; a workshop for local weavers turned into a Weaving Institute the moment there was outside interest; throughout her career she began buildings without funds to complete them; she never hesitated to put all of her own resources into her projects; and when she retired, the school was $17,000 in her debt.

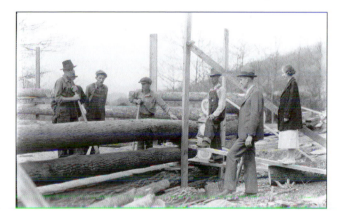

Lucy Morgan with some of the men who raised the logs for the Edward F. Worst Craft House, May 1935. This building, one of the largest log structures in the Southeast, is still in use today.

The completion of the Craft House set the tone for Morgan's relentless and creative fundraising. She sought help wherever she could find it, in the form of cash, materials, or labor. A friend secured donations of plumbing fixtures from three major manufacturers. Morgan asked students, community members, and other interested parties to pay for a window, a door, a bedroom, or a workspace, and she asked Episcopal women's groups to raise money. Worst brought his family and friends to hang sheetrock. A new bathtub was paid for by raffling off the first bath, which was then covered as a news item by the local papers. Morgan's ability to involve anyone at any level was the hallmark of her fundraising.

It was also in 1935 that Morgan convened the school's first board of trustees. She had been advised not to incorporate nor to deed her property over to a self-perpetuating board as this might impact her ability to make independent decisions,

and for several years her board functioned as an advisory committee. In 1938, she decided to go ahead with incorporation; Penland School of Handicrafts was registered as a nonprofit corporation, and in 1940 the property and buildings were transferred to this new entity. This new organization also included the Penland Weavers and Potters, which had ceased to function as a part of the Appalachian School.

Penland School's articles of incorporation have as much to say about service to the local community as they do about craft education. Morgan's commitment to that community continued throughout her life, but as the educational program grew, it increasingly served a national and even international audience.

By 1947 the brochure described the school this way:

> The Penland School of Handicrafts is a small but well known school with an excellent staff, adequate equipment, and a desire to serve. It is a nonprofit educational corporation directed by a Board of Trustees, and is operated for one purpose only—to instruct all who wish to come in the craft skills of their choice. Its students are a cross section of America, with mountain folk, college presidents, home makers, teachers, and occupational therapists learning together. They come from nearly all of the states, from Canada, Alaska, and even from farther lands—China, Peru, Cuba, and England. There are no entrance requirements excepting the desire to learn.

At this point, the summer was divided into four three-week sessions. The main areas of instruction were weaving (with a long list of loom types and different styles of weaving, including tapestry), metal crafts (forming, decoration, jewelry making, and lapidary), and pottery (wheelthrowing, handbuilding, slip casting, and sculpture). Along with these areas were "related crafts," which in various years included spinning, carding, dyeing, silkscreen, block printing, leathercrafts, candle making, doll making, bookbinding, shoemaking, plastics, chair seating, felt crafts, wood carving, drawing, basketry, stenciling, lampshade making, corn schuckery, and the making and playing of shepherd's pipes. There were also classes in color and design (often taught by Toni Ford). The flyer asked students to indicate their major area of interest, but said, "you may take any crafts you wish or all of them." Students were also cautioned against working too intently and were encouraged to take advantage of field trips and other recreation.

The instructors included a few well-known experts (Edward Worst continued teaching at Penland until his death in 1949), particularly in weaving, where the school was able

to attract prominent European craftspeople. It also included a number of industrial arts, vocational education, and home economics teachers who summered at Penland. And the faculty continued to include craftspeople from the local community, such as dyer Emma Conley, who wrote a small book on vegetable dyeing, chairmaker Arthur Woody, whose descendants still have a chair shop in Spruce Pine, and Bonnie Ford's sister Floss Perisho, who taught a number of crafts and was a member of the Southern Highland Handicraft Guild. Several key faculty members, including weavers Rupert Peters and John Fishback, had received most of their training at Penland.

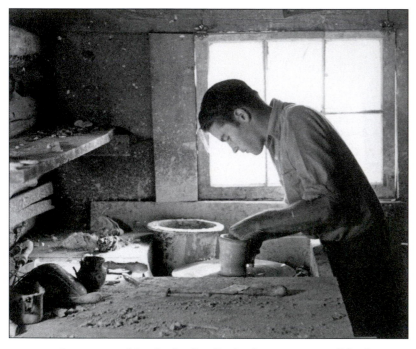

A potter working in the first Penland pottery, a small log barn now known as the Dye Shed.

The school was so popular by the late 1940s that Morgan complained she was unable to limit sessions to eighty students and was turning people away. She proposed a long-range plan in 1947 that included a winterized, year-round teaching facility, sending craft teachers into the public schools, monthly training sessions for county extension agents, and other expanded activities. These plans were not realized (although some of these things happened years later), but Morgan moved with the times and was always on the lookout for new ways to attract students and special groups who might be interested in Penland's programs and facilities. Penland organized workshops for blind students, for home demonstration agents, and for groups of college students on field trips. Special efforts were made to serve occupational therapists. For a number of years there were sessions for members of the Southern Highland Handicraft Guild. Beginning in 1954, the school hosted an annual photography workshop in the fall. The G.I. Bill, passed at the end of World War II, brought new students and money into educational institutions of all sorts. Morgan was quick to get Penland approved for G.I. Bill students which had a significant impact on enrollment. She also arranged, beginning in 1961, for students to be able to receive college credit for Penland classes, an option which has been available ever since.

Penland attracted a number of foreign students and hosted groups of foreign visitors who were sent to Penland by various government agencies. The school also received occasional visits from foreign officials and educators interested in replicating some aspect of the school's program. Morgan was especially proud of these international connections and speaks in *Gift from the Hills* of Penland's "loving concern for human beings of all races, nationalities, religions."

This largesse, unfortunately, did not extend to African-Americans—this was, after all, North Carolina in the Jim Crow era. A report to the board written by Bonnie Ford in 1959, while Morgan was on sabbatical, contains a heartbreaking description of the difficulties she had hosting a black student that summer. The young woman was, by Ford's account, a model student, but the social discomfort caused by her presence led Ford to begin asking students to state their race on the application form. This practice was quickly abandoned by Morgan's successor who made it immediately clear to all that Penland School would not be a segregated institution.[3]

Penland's promotional materials during the 1940s and 1950s were charming, quaint, and folksy, promoting not only craft classes but a mountain experience which included scenic field trips and visits with local characters. They also convey principles which remain important to this day. Admission was on a first-come, first-served basis and classes were open to all levels of skill.[4] There was no set curriculum and no grades: teaching revolved around the transmission of skills and ideas to people who were interested in them. A noncompetitive, community feeling, along with the spectacular physical setting, were essential components of the experience. And, most importantly, learning to make things carried a value to the individual apart from that of the objects produced. Morgan's own writing in *Gift from the Hills* and the school's newsletter, *Mountain Milestones,* stresses this final point over and again.

While Penland in this era was primarily a center for traditional and folk craft it was not without connections to the studio craft movement which began in the 1950s. In 1946, ceramic artist Robert Turner, who would later teach at Alfred University in New York, went to Penland as a student to try working with clay for the first time. Lenore Tawney, one of the most influential figures in contemporary fiber art, described six weeks of study at Penland with Danish tapestry weaver Martta Taipaile in 1954 as a turning point in her career.

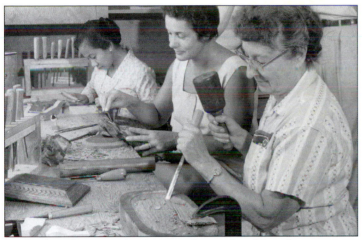

Penland students carving in an early woodworking class, 1950s.

By the mid-1950s, however, the school had gradually begun to decline. Enrollments were down sharply, subsidy from the Smith-Hughes Act ended in 1954, and board meetings were dominated by discussions of increased expenses, indebtedness, tactics for attracting students, problems with the physical plant, and Morgan's desire for retirement. At the 1961 board meeting a search committee was appointed to find a new director for the school. With a recommendation from Robert Gray of the Southern Highland Handicraft Guild, the committee found William J. Brown. Committee chair John Benz reported that he was "convinced that no better person could be found." Morgan was enthusiastic about Brown and offered him the job. His requested salary was modest, but it represented a new expense, as Morgan was paid only when there was enough money to do so. The board's faith in Brown and its commitment to the school's future was such that they undertook a special fundraising campaign (including 1200 appeal letters) to raise the money for his first year's salary.

Lucy Morgan retired in 1962 and moved to Webster, North Carolina where she lived until her death in 1981. She never gave up weaving, which she had continued to practice during her years running the school. She received two honorary doctorates, from Central Michigan College of Education and Women's College, University of North Carolina at Greensboro. In 1993 the Women and the Craft Arts Conference at the National Museum of Women in the Arts gave her a posthumous lifetime achievement award.

As Morgan's successor, Bill Brown was a spectacular choice. Plain spoken, witty, and charismatic, he is remembered by many as a person reluctant to judge or criticize—a man whose special genius was empowering others to follow their passion. "There is no way to educate anyone," he once said, "they have to do it on their own." He had an MFA from Cranbrook Academy of Art, the innovative Michigan school which counted prominent European craftspeople among its faculty. A practicing sculptor, he had taught design at the University of Delaware and at the New York State Teachers College at Oswego. After becoming disillusioned with university education, he had left to teach at the Worcester Center for Crafts in Massachusetts. But most importantly, from 1951 to 1962 he had spent summers teaching and assisting the director at the Haystack Mountain School of Crafts in Maine.

Haystack was founded by philanthropist Mary Bishop, whose specific intent was to create a school similar to Penland, where she had taken classes. She invited printmaker and Flint (Michigan) Museum of Art Director Francis Merritt to run the school. The stated philosophy of Haystack, while more contemporary in its language, echoed Penland's traditional combination of artistic and social goals: "It is a friendly, informal place, gathering its aims from the best ideals of socially useful living and from the highest standards of design and production in the crafts." Haystack's program, however, evolved quickly toward single-subject, total immersion workshops, taught by a rotating group of guest instructors, and this was the model Brown brought with him to Penland.

A quality that characterizes craft workshops is that you have a group of people who are showing up with their arms wide open. There's an openness—to a new place, new techniques, new people. So you're likely to have people opening up to re-evaluating where they live, what they do, their lives. The time frame is long enough—and all your needs are taken care of—that you can leave your daily life, which has a momentum, a busyness that fills it up. When you leave it, there's room for new thoughts, new perspectives.

Along with that is the shedding of our categories. I've helped load cars at the end of a two-week workshop and only then found out what the person was going back to—a student, a rabbi, a lawyer. Because of that lack of slotting you get to have different conversations. It's a setting that has people from eighteen to eighty interacting with one another in meaningful ways, something that's rare in this culture. We all gather around a material and lay out our own challenges. The playing field is level because we're not playing against anyone. Getting from here to there, at whatever level, is the reward. We're all in it together.

Nick Joerling, potter, Penland instructor, student, trustee, and neighbor, writing in 2003

In a 1979 interview, Bill Brown remembered his first day at Penland. It was September, 1962, and summer classes were just ending. "The first breakfast we had here," he said, "there was only one person who was under fifty years old. Everyone had to sit at the same table, at the same place. It was quite quiet.... It was a very nice place, but it needed some kind of a jolt. The problem was that the school had a background of years and years of doing wonderful things and it had gotten tired, that's all. So in trying to do anything you had to be careful not to hurt anybody that had worked so hard." Brown invited all of the regular faculty to return the next summer.

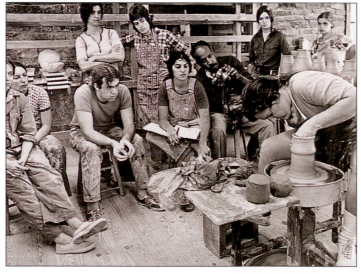

Penland resident artist, instructor, and neighbor Cynthia Bringle demonstrating in a Penland class, 1960s.

The Penland catalogues of 1961 and 1962 had departed from the old-fashioned look of earlier catalogues and reflected more contemporary graphic design. Brown's first catalogue in 1963 followed suit, replacing the old logo that was a silhouette of a female weaver with one constructed from stylized type. The word "handicrafts" was no longer in evidence; the school was now called Penland School of Crafts.[5]

The 1963 catalogue contained completely different information. Gone were the folksy descriptions of life at Penland, the long lists of what might be taught, and the tone poems about the beauty of the mountains (along with the recommendations about sensible shoes). Information about program content had been scaled back to a few sentences, including language like this: "Weaving is taught as a structural problem with emphasis on technical excellence through which the student may gain a freedom of expression." Within a few years, even these brief descriptions were gone. The dozens of minor crafts were gone as well. The program still included the principle areas of ceramics, metals, and textiles, to which were added graphics (primarily printmaking) and wood, which was taught by Brown's former student C.R. "Skip" Johnson.

Brown's initial changes at Penland were subtle but significant. Most important was increasing studio access. At Haystack, studios were available twenty-four hours a day. At Penland, the shops opened at nine A.M., were closed during mealtime, and the lights went out at nine or ten in the evening. A studio monitor was always present to keep track of materials sold to students. Brown unlocked the studios and put sales on an honor system. He saw this as the beginning of the jolt the school needed. "Now the lights were on all over the place," he said, "all night long, nobody went to bed."

Although he did not want to forcibly replace the teachers who had been with the school for years, Brown brought with him a formidable network of contacts in the emerging studio craft movement. By rotating instructors each session, Haystack was giving students access to prominent studio artists and university teachers, and Brown adopted this practice at Penland. He began by inviting a number of his colleagues to come as "visiting scholars," to simply be present, doing their own work. The 1964 catalogue lists seven of these visitors along with a half-dozen new instructors.

By 1969, the program was completely transformed. Almost all of Lucy Morgan's instructors were gone. Summer had been extended to seven sessions, two or three weeks in length, with a total of sixty-three individual classes listed.

Most instructors taught a single session. The topics were ceramics, glass, wood, weaving, plastics, enameling, metals, lapidary, photography, graphics, sculpture, tapestry, and dyeing. Rotating special classes in this time period included workshops in soft sculpture, banner making, and guitar building. Students enrolled in a single class for the duration of the session, which, combined with unlimited studio access, made it possible to cover a seemingly impossible amount of territory in a few weeks.

The G.I. Bill, which had influenced Penland's program in the 1950s, had driven an expansion of university art departments, many of which began to incorporate areas traditionally designated as craft, such as ceramics, metals, fiber, and wood. The American Craft Council, through its sponsorship of conferences, a national magazine, and a New York museum had brought new attention to these media. The postwar optimism of the 1950s and the counterculture of the 1960s were attracting people to all sorts of alternative possibilities. Among these was the idea of building a life around making and teaching pottery, jewelry, or tapestry. The Penland catalogue for 1967 lists instructors who were graduates or faculty members from Parsons School of Design, University of Wisconsin, Cranbrook Academy, The School for American Craftsmen (R.I.T.), Cleveland Institute of Art, Kansas City Art Institute, and Alfred University. The faculty was a mix of university teachers and full-time studio craftspeople.

While the basic media areas had not expanded much since 1963, photography, which had been taught informally in the 1950s, became a regular program in 1968, and the addition of glass to the lineup was especially significant. Glass did not emerge as a craft which could be practiced in small studios until 1962 when Harvey Littleton and Dominick Labino demonstrated a small scale glass furnace at the Toledo (OH) Museum of Art. In 1965, Brown arranged for Bill Boysen, one of Littleton's students, to set up a glass studio at Penland. According to a 1984 interview, Brown gave Boysen a ten- by twenty-foot shed along with "$150 and a license to steal." Within a week Penland students were making glass. This early embrace of the craft led to Penland being the site of the founding of the Glass Art Society in the early 1970s, and the school has remained strongly identified with the development of contemporary glass.

Another significant addition to the program was blacksmithing, which was added in 1981 with help from Brown's son, Bill Jr. Blacksmithing eventually took over the school's sculpture studio and eclipsed that program. Penland's first iron

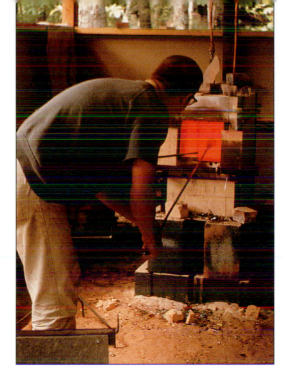

A glassblower working in the first Penland glass studio, 1960s.

class was taught by Brent Kington, a sculptor who started the first university program in ironwork, and the Penland program has been largely shaped by instructors influential in the development of iron as an expressive and sculptural medium.

The Penland board gave Brown complete autonomy in running the school, and he gave this same freedom to his faculty. He did not publish class descriptions, and after 1968 he didn't even publish biographical information. When instructors asked him what they should teach, he told them to teach whatever was important to them. Potter Paulus Berensohn offered a colorful example of his experience with Brown's extraordinarily open attitude: "It was the first time I came, in 1968. He walked into the studio the first morning and I had everyone on the floor blindfolded, with clay on their chests, and he got purple in the face. But at the end he said, 'I don't know what you are up to, but the students liked it, so come back next summer.' That was Bill."

Despite his art school training, Brown had no use for formal critique, which he saw as destructive, and he thought competition only made sense in sports. He saw the close proximity of different media and the potential for friendly cross-fertilization as essential components of Penland's structure. The collaborative, community learning atmosphere promoted by Lucy Morgan was extended and solidified during Brown's tenure.

Brown's management of the school benefited from the experience and good sense of Morgan's stalwart assistant Bonnie Ford, who served as business manager, bookkeeper,

and registrar. His wife, Jane Brown, supervised housing and the kitchen and managed the school's work-study scholarship program. Also important to Brown's management were the uncountable personal relationships he and Jane Brown developed with students and faculty.

There is very little information about scholarships during Morgan's era, although the 1946 brochure describes a work scholarship arrangement similar to the one that exists today. During Brown's time, work-study became integral to the school's operation, with fifteen or more students working three or four hours a day under Jane Brown's direction. Scholarship students paid a small fee to cover part of their room and board, and this program made Penland financially possible for hundreds of students who might not have attended otherwise.

Enrollment at Penland increased throughout the 1960s, slowly at first and then in quantum jumps. Brown reported to the board in 1969 that the school was running at maximum capacity with about 100 students per session. The school began receiving support from new sources, primarily the Hanes and Reynolds families of Winston-Salem (the Mary Reynolds Babcock Foundation had made grants to Penland as far back as 1954). Instructors were paid equally and received, more or less as in Morgan's time, room, board, travel money, and a tiny honorarium. Penland, however, had become a crossroads for craft information, and despite this minimal compensation Brown had no trouble attracting first-rate instructors.

While the caliber of the faculty and the nature of the classes had changed dramatically, Penland's open door had not. In 1975 Brown wrote,

> Thousands of people from North Carolina, from every state in the Union, and from over sixty foreign countries have come to this mountain community to learn to weave, to make pottery, and to work with wood, metal, glass, and stone. Some of these students have become professional craftsmen; many hundreds of others have developed an avocation that has been meaningful to them and their families. . . . We have college and art school students, grandmothers, doctors, lawyers, teachers (and they come in all colors)—anyone who wants to learn.

Brown did not limit himself, however, to transplanting the educational model he and Francis Merritt had developed at Haystack.[6] Other programs established during the first decade of his tenure would give Penland a singular character all its own.

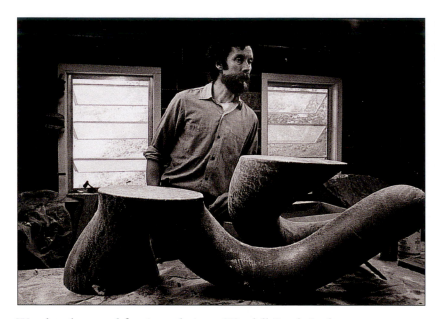
Wood sculptor and furniture designer Wendell Castle in the Penland woodshop, 1969

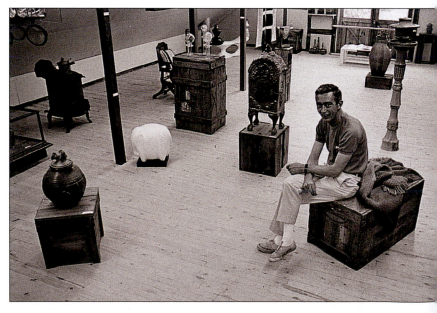
Bill Brown, Penland's second director, with a display of work by Penland resident artists in the renovated barn which is still used as studio space, 1969

A doctor or a lawyer, when they get out of school, they can get a job in a law office as a junior partner or they can go to a clinic and be a doctor until they build up their clientele and then they have their own office. Well, a craftsman needs space and he needs a lot of tools or equipment, a woodshop or a weaving studio, you got to have all this stuff.

Here it was dormant during the winter time. And I thought, well we should use the equipment and facilities and bring people who are trained—most of them have a masters degree or equivalent—and have them learn to produce and market their work. And hopefully if they did it here they would like the area and like the people and the climate and they might choose to stay around after they had been here as a resident, and that's worked out pretty much so."

Bill Brown, speaking in 1979

At the first board meeting Brown attended as director, in June 1963, he talked about his ideas for using the facility when classes were not in session. Chief among these was his plan for a residency program, an opportunity he saw missing in the crafts. Ed Brinkman and Skip Johnson came in 1963, and by the fall of 1965, there were four artists living at Penland School and using the studios in the off-season to produce their work. Then in the spring of 1965, Penland was presented with an opportunity that would shape not only the resident program but the entire future of the school. The Appalachian School had decided to close its doors, and its 220 acres of land and all of its buildings were being offered for sale for $100,000. Brown knew the school couldn't afford this price, but he was convinced that buying the property was the right thing for the school to do. "I wanted the place to hold onto itself and have enough room around it," he said years later, "because we're noisy and boisterous and we don't need that heat."

Industrialist Philip Hanes committed himself to raising $25,000 and Brown sent a letter to everyone on the school's mailing list asking for help. Eventually, he was able to persuade the Episcopal Diocese to reduce the price to $40,000 and, with support coming from all directions, Penland School was able to buy the land. Horner Hall, which had been a dormitory and chapel, gave Penland space for more students and new studios. Brown's eye, however, was on a couple of live-

stock barns that had been used by the Appalachian School's farming program.[7] In 1968, with a grant from the James G. Hanes Memorial Fund, the barns were renovated to make studios and apartments for the resident artists, which meant they no longer had to vacate their workspaces when classes began in May. The new facility allowed Penland to give residents year-round studio and housing for a modest fee. Brown selected the residents (often consulting with artists he trusted) and there was no fixed length for their stay.

In 1967 Ed Brinkman bought property in the area, potter Cynthia Bringle built a house at Penland in 1969, and by the late 1970s the school was surrounded by craftspeople, many of whom had first come as resident artists. The presence of the resident artists and the complex and lively relationship between the school and the craft community that has grown up around it would become distinguishing features of Penland's program.

In 2004, there are well over one hundred working studios within fifteen miles of the school; fifty of them are operated by former resident artists. One hundred and fourteen people have participated in the resident program and more than ninety percent of them are still producing craft. Throughout its history, the program has had few, if any, specific requirements of the resident artists. Nevertheless, they have contributed in countless ways to the school's growth and well-being. Today, the program has a formal application process and the length of stay has been standardized at three years, making it one of the longest artist residencies in the country.

These eight-week sessions afford an unusual opportunity for sustained and focused attention on the studios, on the materials, on ourselves, and on each other. And they are attended by those poised for growth—whether in preparation for the beginning of a career or as something long awaited and finally received...There is time to focus, concentrate, learn, and produce.

From Penland's Concentration flyer, fall 1995

With the resident program moved to the renovated barns, Penland's teaching studios were again vacant for eight months each year, and this opened the way for several more educational innovations. In the fall of 1970, Penland began a program called Concentration, with potter Cynthia Bringle and her sister, the weaver Edwina Bringle, as the first two

instructors. These were eight-week classes built on the same workshop model as the summer: a group of students taking a single class on a single subject with a single instructor and round-the-clock access to tools and materials. There was, and is, no other program quite like it in crafts—almost as long as a college semester but with the focused attention of a workshop.

The original structure of Concentration had the instructors teaching in the fall and again the following spring; they were given housing and studio space through the winter to do their own work. The first year, only ceramics and weaving were offered; by 1972 the program stabilized with classes in ceramics, glass, metals, photography, and textiles. Brown's minimalist approach to information reached its zenith in the Concentration flyers which, until 1982, didn't even name the instructors. The Concentration extended Penland's class schedule from March through November, which opened the way for another Penland program which has never been duplicated elsewhere.

The Browns were working with a small staff, and Jane Brown's workload included cooking on weekends along with supervising housing and the work of the scholarship students. With the newly extended season, it became possible to offer a few students a year-round scholarship in exchange for their taking over some of the ongoing responsibilities at the school—in effect becoming part-time members of the staff. This evolved into the Core Student Program, providing several years of room, board, and tuition and an opportunity for students to focus on one medium with a succession of instructors, or to explore the entire range that Penland offers. Many core students go on to graduate school, and the university faculty who teach at Penland are an invaluable source of information about graduate programs. Most former core students are still working in craft and many have returned to Penland as resident artists and instructors.

Another important component of the Penland program also emerged in the late 1960s. In 1966 Brown invited poet and potter M.C. Richards to lead a cross-disciplinary workshop at Penland with a group of instructors from different fields, including several dancers. While this sort of class was never repeated, one of the dancers, Carolyn Bilderback, returned many times as a visiting scholar. Bilderback's friendship with Jane Brown and Jane Brown's later study of the Alexander Technique, a system of movement and body awareness, led to supplementary movement classes becoming a permanent and valued feature of Penland's instruction.

Bill knew what were the hottest things happening and he brought them to Penland. His indulgence led to the third floor of the Lily Loom House being the site of some early, exciting dye experiments. We moved away from the kettles of marigolds to stretching warps and painting on them. Bill would look the other way when we were making a horrible mess. He'd let us do things that didn't make sense.

Weaver **Ruth Kelly Gaynes**, speaking in 1994

Bill Brown was a man for his time. His management style might accurately be called familial, and much of the school's development in this time period was built on the personal loyalty of dozens of brilliant craftspeople. Brown visited the studios every day. He invited the instructors to his house every afternoon and again after evening slide shows. Once each session, he and Jane Brown hosted a party at their house for faculty, students, and visitors. They both worked with the scholarship students in preparing the housing for each session. Brown depended on a cadre of close friends who, unpaid, helped manage the studios and line up each summer's instructors. The instructors themselves were paid almost nothing, a fact which Brown referred to with some pride; he often called them Penland's most important annual donors. He selected the resident artists, and they stayed as long as he felt they were benefiting. Although Brown, with help from the novelist John Ehle and others, successfully secured funding from foundations and government agencies including the National Endowment for the Arts, much of his fundraising

In celebration of Penland's fiftieth anniversary, resident artists and others enacted an elaborate pageant titled *A Quest* each session during the summer of 1979.

was done by letting wealthy supporters know of his needs and trusting they would come through. In addition to guiding the school's program, he made decisions about finances, the physical plant, and matters of policy with little input from his board, which met once a year to endorse his leadership. In researching his time at Penland, it was impossible to overlook the number of people close to Brown who referred to him affectionately as a benevolent dictator.

These same qualities, which had done so much to raise Penland School to new levels, would contribute to Brown's conflicts with his board in the early 1980s. In 1979, a fiftieth anniversary campaign raised over $600,000 for much-needed building renovations and to create a scholarship endowment. Some of the funds were restricted and also required substantial matching money, and this brought a new level of fiscal scrutiny from the board. The board recruited several successful businessmen and the first craftspeople to serve, and the minutes from this period show a marked increase in activity and involvement. The board began to meet twice a year; it set up a committee structure around finance, fundraising, buildings and grounds, and long-range planning; and it began to assert its prerogative to set policy for the school. Brown expressed reservations about all of this. A study commissioned by the board to assess the feasibility of a capital campaign made a number of specific management recommendations which Brown adamantly disagreed with. Penland School had, throughout its history, operated without a budget or an endowment, and some board members felt it was important to the future of the school to change this.

None of this seems extraordinary by today's standards for nonprofit governance, but it was unprecedented at Penland. Brown felt that his achievements were directly related to his ability to make unencumbered decisions, and he chafed under this unaccustomed level of supervision and organization. "I have had some success as the skipper of a P.T. boat," he wrote to the board. "I may not have the qualifications nor the desire to be in charge of a battleship." His relationship with the board deteriorated and, in October, 1983, he was asked, at age sixty, to take early retirement. This move sent a shock wave through the Penland community, both the school's artist neighbors and the much wider community of students and instructors whose lives had been touched by the Browns. Letters of inquiry, complaint, bewilderment, and protest came from all over the country. Brown was given a modest pension, and he lived the rest of his life in a house he and Jane had built near the school. [8]

Brown was made an honorary fellow of the American Craft Council in 1979, and in 1991 he received the North Carolina Award in recognition of his work at Penland. He died in 1992. His grave is marked by an uncut boulder with this inscription: "He gave us the strength to believe in ourselves." Jane Brown teaches the Alexander Technique at Appalachian State University and tutors dyslexic children.

Brown's lasting influence is such that, with a few significant additions, Penland's program in 2003 is essentially the one which he established between 1963 and 1972. The philosophical underpinnings of the educational program developed by Morgan and Brown continue to guide the school.

Schools like Penland and Haystack would have died if there hadn't been a need for them. The need continues to exist despite the small amount of income they bring in and how expensive it is to run a small center. These schools continue to be important because their small scale and flexible structure allow them to experiment and develop programs in a way that can't be done within the more formalized structure of the universities and art schools.

The changing faculty of distinguished artists is an incredible attraction. The small community environment and the beautiful compound of these schools fosters an exchange between people which is quite different from a university. In bigger schools you go to your class; people in the fibers department aren't walking into the ceramics department. At Penland you learn by watching others and that's very important. That community of exchange and sharing is hard to document but it's part of why Penland exists.

Paul J. Smith, curator emeritus of the American Craft Museum and former Penland trustee, speaking in 2003

Bill Brown's immediate successors were Verne Stanford (1984–1989), Hunter Kariher (1989–1992), and Ken Botnick (1993–1997). These relatively short tenures following two directors who had served the school for thirty-three and twenty-one years, respectively, may reflect a society in which mobility is the norm and long, linear careers are less common. It is also typical of the difficulties many organizations have in finding stable leadership in the wake of charismatic,

visionary founders (Penland had two of these). [9]

This third era of Penland's history has been one in which directors, staff, trustees, contributors, students, and instructors have worked in various ways to create a sustainable future for Penland's educational and social ideals. During this time the school has moved away from an intense identification with the personality of the director. Penland's current director, Jean McLaughlin, made this statement in 1998 shortly after she joined the school: "I think that Penland is larger than any of us—certainly larger than me. There are so many people who care passionately about Penland, and I want to make sure we move forward together with a collective vision."

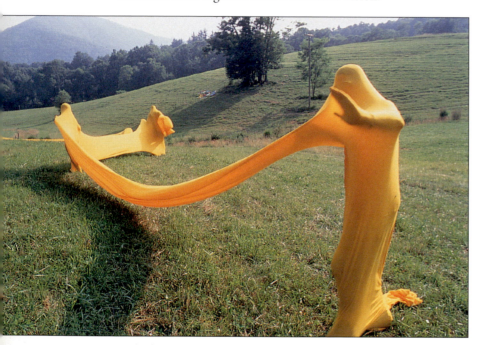

A performance by students in a 1995 workshop taught by textile artist Nick Cave

It has been a time period characterized by a general opening up—of the program, the instructor group, and the school's base of support. And the school has cautiously opened up to a larger public. It has also been a time when the world has moved a little closer to the circle of hills that surround Penland School.

Between 1985 and 1993, under the leadership of Verne Stanford and Hunter Kariher, there was a significant expansion in the media offered. Books, paper, painting, and drawing all became regular programs. A second clay studio added more classes in handbuilding and sculpture. Flameworking took a place beside hot glass. Graphics was redefined as printmaking. This expansion of the program culminated with the construction of a new studio complex—for books, paper,

photography, printmaking, painting, and drawing—and a new kitchen, which allowed the maximum number of students to rise from 100 to 167. The current summer pattern of fourteen studios and seven sessions for a total of ninety-eight classes was set in the early 1990s. The longer Concentration sessions endured constant tinkering with the length and number of classes offered before settling back, in the mid-1990s, to six or seven classes at the original length of eight weeks.

During this period, Penland began offering considerably more information about what was being taught and who was teaching. Class content is still primarily determined by the instructors, but course descriptions and instructor bios are published for each class. For a few years, the school's summer catalogues were dubbed *The Penland Journal* and included thoughtful essays about craft, education, and expression. These publications were too expensive to continue, but they still make surprisingly good reading. *The Penland Line* began in the 1980s as a neighborhood newsheet and then evolved into a periodic newsletter that promotes Penland's programs and also publishes content similar to the *Penland Journal* catalogues.

The expansion of the 1980s, which allowed the school to serve the field of craft more broadly, didn't come without a price. Despite more organized fundraising and the develop-

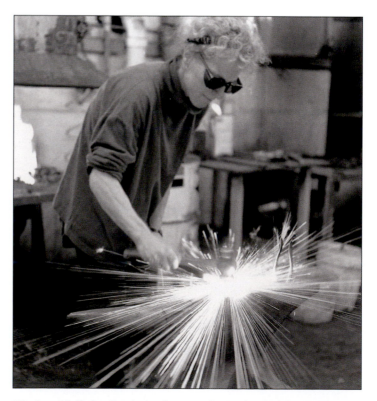

Blacksmith Paige Davis working in the Penland iron studio, 1995.

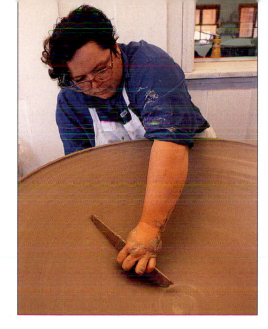

Penland resident artist and instructor Mary Roehm, throwing a very large piece at the Penland clay studio, 1990.

ment of operating budgets, the school carried varying levels of debt during this time period. This situation was not remedied until Penland managed to create, with help from the National Endowment for the Arts and a large bequest first promised to Bill Brown in 1969, an endowment of over two million dollars, and then only with tight fiscal controls enforced by director Hunter Kariher.

The flexibility of the workshop format and a succession of creative program directors have resulted in consistently innovative classes. Special workshops in the past two decades have included stone carving, kite making, casting—in glass, bronze, iron, paper, concrete, and other materials—performance, site-specific sculpture, classes based on gathered materials and found objects, classes that incorporate writing and text with traditional materials, and classes that straddle several media. A recent summer included both the deeply traditional techniques of Windsor chairmaking and a class which explored ephemeral imagery made by manipulating light and shadow. Theme sessions, cutting across all media areas, have been offered in site-specific work, figurative art, and public art.

A series of experimental neon classes, combining traditional tube bending with scientific flameworking and hot glass, has brought new information into the world of electrified gases. Four workshops co-taught by Danish textile engineer Joy Boutrup introduced techniques and materials which have had a noticeable impact on studio fiber art throughout the country. Teacher training workshops have supported the development of classroom-friendly art and craft activities. Iron symposia hosted by Penland in 1989 and 1995 are still viewed as watershed moments in that field. According to Jim Wallace, director of the National Ornamental Metals

Museum, the 1989 event was the first time people working in iron and steel came together to discuss content and motivation rather than technique.

Several programs added in the past twenty years have expanded the school's reach beyond craft workshops and residencies. Penland now provides supplemental art classes to the Mitchell County school system. The content of these classes is developed so that it dovetails with the school curriculum in other areas—students learning about Japanese culture, for instance, are taught to write haiku and paint with sumi-e inks. This program hearkens back to Lucy Morgan's 1947 wish list which expressed her desire to place craft teachers in the local schools.

The school had a gift shop at various points in its history, but no way to accommodate a large number of visitors curious about craft. A small gallery and visitors center was opened in the mid-1980s and has grown into an impressive showcase for contemporary craft which attracts about 14,000 visitors each year. Along with this growth in size has been the development of a clear educational mission for the gallery. While it brings revenue into the school, it functions as a real information center and a gateway to the surrounding craft community.

The facility has also received considerable attention in the past decade. Director Ken Botnick had a background in landscape design and worked with several gardeners to give the

An exhibition at the Penland Gallery, 1999

school's landscaping the same care and attention students were bringing to their studio work. Botnick also supervised the design and construction of a new glass studio. His successor, Jean McLaughlin, expanded this concern by creating a comprehensive plan for the buildings and grounds which emphasizes renovation, preservation of the school's existing aesthetic, and limited construction to meet program needs. This plan guided the location and design of an award-winning new iron studio, built in 2000. It also sets a direction for dealing with the thorny problem of improving accessibility at a campus built over a seventy-year period on the side of a hill.

Support for Penland has expanded considerably during this time. The number of annual contributors is now over a thousand. Penland receives general operating funds from the North Carolina Arts Council, as it has since 1979. Hundreds of artists donate work to fundraising auctions, and the school receives regular support from foundations and corporations. Even with many sources of support, however, adequately funding the school's programs and the needs of its aging facility continues to be a struggle. Instructors are paid quite a bit more than they were in the past (they are still, however, paid equally), staff positions have been created to do jobs that used to be done by volunteers, and the requirements of running a public facility are more complex and demanding than they once were. The school is also beginning to address decades of deferred maintenance.

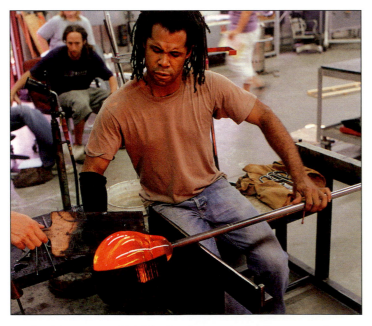

Penland instructor Ché Rhodes demonstrating in a 2002 glass workshop.

Today's Penland board of trustees includes a number of working artists and people with financial, legal, business, and fundraising skills. Many board members take classes at Penland and in addition to contributing financially, donate countless hours of work to the school. While there have been difficulties, dating all the way back to Bill Brown's retirement, in establishing a clear relationship between the board and the staff, their respective roles are now well defined and the two groups work together harmoniously.

Ensuring a future for Penland School has required an increased level of organization and accountability and new kinds of expertise. While this has meant the loss of some of the extraordinary looseness of the school's earlier years, Penland remains a small, flexible, and creative organization dedicated to personal and artistic growth.[10] Metalsmith Mary Ann Scherr, who has been teaching at Penland since 1968, made this very personal comment about the school's continued vitality. "For more than thirty years," she said, "Penland has remained positively important in my life. As the world moves, so does Penland in its own way, and it offers me an opportunity to grow with it. Each time I go back, I find whole new ways of thinking."

> *I think material has its own intelligence. Individuals will seek out the technique they need to accomplish what they want to do, but what I have to teach is how to go back to your own studio and work out of your own impulses and know that you don't have to know how to do something before you start. The material will talk to you and tell you what to do and lead you. You do something, it does something.*
>
> the late **Betty Oliver**, papermaker, sculptor, poet, and Penland instructor, in the *Penland Line*, 2000

A survey of current dictionaries finds that the word "craft" is generally defined as "skill in the making or doing of something." Despite fifty years of craft shows, craft magazines, craft councils, and craft museums, lexicographers have stubbornly refused to define craft as an area of creative expression. Constructing such a definition is outside the scope of this essay, but this does seem like an appropriate place to attempt a definition of craft education, at least as it is practiced at Penland. For this effort, the dictionary turns out to be a useful starting point.

Ceramist Ah Leon began each day of his class in traditional Chinese teapot making by serving tea.

Craft education at Penland is very much a matter of skills and making things. Almost every course description in a Penland catalogue talks about skills which will be taught and things which will be made. Another equally important component, however, is not addressed by the dictionary. Penland's classes are universally rooted in a relationship with materials. The school's studios are named after their predominant material or process: clay, glass, printmaking, textiles. Penland's classes, with a very few exceptions, are based in the assumption that the material itself—its physical properties, its personality—is of great interest and that the processes involved in working with that material are as important, and as interesting, as the objects created. Of equal importance with materials and processes are ideas and content. One of the beauties of Penland's open atmosphere is how comfortably ideas and techniques coexist—in the same way that utilitarian, sculptural, and conceptual work are embraced along a continuum rather than a hierarchy.

The Penland workshop proves to be a vessel capable of holding a broad array of teaching styles and approaches to subject matter. For example, recent workshops by ceramist Ah Leon focused on the traditional teapot-making techniques practiced in Yixing, China. Students in this class were given an astonishing level of information about the exact design parameters demanded by each portion of the pot—handle, bowl, spout, lid. The class material, however, was cultural

and aesthetic as well as technical. Each day began with students sitting at a long table drinking tea. The instructor sat at one end brewing and serving tea which was consumed according to traditional Chinese etiquette. While this was going on, he gave informal lectures on some aspect of teapot construction, on the various qualities of fine tea, on the role of tea drinking in Chinese life, or on his system of packing ceramics for shipment. Craft education is an extraordinarily oral tradition; Ah Leon's workshop exemplifies a quality of information often contained in these classes that's simply not available in any other form.

Jerry Spagnoli is the world's foremost practitioner of the daguerreotype, the earliest practical form of photography, introduced in 1839. This process produces a brilliant image on the surface of a silver-coated sheet of copper with characteristics unattainable through any contemporary process. Spagnoli is one of a tiny handful of artists producing daguerreotypes today and the only person regularly teaching the technique. Producing a daguerreotype is a labor intensive and unforgiving activity with a very high failure rate; Spagnoli's most successful students managed to produce three or four good images during a one-week workshop. Nevertheless, under his methodical and patient teaching, the studio was a beehive of enthusiastic activity. Halfway through the session, students began to realize that in addition to his daguerreotype work, Spagnoli has had a varied career including work in advertising, studio photography, and as a master printer. They all began soliciting his advice about other projects they were working on, about photographic careers, and about other educational possibilities. While the advertised content of this workshop was both challenging and fascinating, the instructor's broad experience and his generosity with information created an added layer of value for his students.

In the spring of 2001, Peter Ivy was teaching a hot glass class. Ivy's technical approach was based on a strong grasp of basic shapes and fundamental techniques. One Saturday morning he scheduled an exercise called *factory day*. He presented a simple design for a glass pitcher and then divided the group so that each person or team was responsible for one element of the pitcher; they turned them out at a rate of one every few minutes, occasionally rotating stations so people could work on different elements. Penland resident artist Susie Ganch was teaching an introductory metals class that spring. She heard about the exercise and decided that a day of assembly line work would be good for her students as well. Their production line turned out a series of decorative silver

It is a long-standing tradition that Penland photography classes leave a group self-portrait in the photo studio. These often exemplify the content of the class. This portrait was created by Dan Estabrook's 2001 workshop which explored the use of toners, negative manipulation, collage, and other means of altering photographs.

tea infusers complete with hinges and hooks. This migration of ideas and techniques from studio to studio is commonplace in a Penland session.

These three stories are presented not as extraordinary events, but as evidence of the diversity and invention that exist within the format of the hands-on craft workshop. The course descriptions in the Penland catalogues are concise statements of the instructor's intent, which then become the most consistent record of Penland's programs. It is difficult, however, for these brief descriptions to adequately convey the depth of experience these classes actually represent.

An installation of student work from a 1998 metals workshop that explored the design and fabrication of oil lamps

Visitors to Penland School occasionally comment that its most lasting legacy must surely be in the works of craft made by artists the school has nurtured. As a long-time observer of Penland, I have always taken exception to this point of view. In June, 2003, as I was finishing this essay, I met Bill Jackson, a fifty-one-year-old chemical company technician from Fort Mill, South Carolina. He had come to Penland as a beginner in hot glass four years earlier and was taking his third glass class. With no studio at home, all the glassblowing he's ever done has been at Penland. Bill made a comment about his class which summed up much of what is essential about Penland School of Crafts: "I was working on a group project with four other people in the glass studio," he said, "and it occurred to me that corporations spend thousands of dollars on consultants and trainers who try to foster communication, trust, and cooperation, and it doesn't always work. Here was this group that had gotten together at Penland to learn about a material and talk about art and we had these things almost instantaneously."

Lucy Morgan put it this way: "I am quite convinced that we cannot hold in our hands, we cannot run sensitive fingers over, we cannot study with discriminating eyes the textures or forms or colorings of our most beautiful and most useful Penland productions. I say these are the Penland intangibles, the wondrous handicrafts of the spirit, things impossible to feel in your fingers or examine under a magnifying glass but real, nevertheless, and tremendously important and of value inestimable. These are the things not made, but won, earned—received, at any rate—in the making of things."

Photo: Robin Dreyer

Author's Note

Although I have tried to approach this subject as objectively as possible, the reader should know that since 1995 I have managed Penland's publicity and publications. My association with Penland School has had a profound effect on my professional and personal life. I have tried to be scrupulously accurate, but every writer has a bias and this is mine: I love the place. I must leave to someone else the task of writing this story as a dispassionate outsider—I will never be qualified to do so.

The title of this essay comes from a bit of sentimental poetry written by Toni Ford which was published in *Mountain Milestones* and again in *Gift from the Hills*. It ends with the lines *"Remember friends and mountain neighbors | And the joy of hands at work | Remember mountain days."*

Notes

1. Beside *Gift from the Hills,* I was unable to find any accounts of what actually took place in 1929. Two accounts of the Penland Weavers written by Bonnie Ford make no mention of the 1929 event, but talk quite a bit about the first Weaving Institute in 1930.

2. Lynn Ennis's paper, "Penland and the 'Revival' of Craft 'Traditions': A Study in the Making of American Identities," contains an extensive socio-economic analysis of the Appalachian Craft Revival.

3. During the 1960s and 1970s Penland had a few African-American and other non-white instructors, and there were occasional African-American students. In recent years the board and staff have worked to increase diversity at Penland, both racial and otherwise. Today, about fifteen percent of Penland's instructors are non-white, and there are increasing numbers of non-white students.

4. This policy has continued with a few modifications. Penland now offers some classes which require a basic level of skill, but most are open to all levels; it's not uncommon to have beginning and advanced students in the same class. Classes that are oversubscribed during the first wave of registration are handled through a lottery, and an application process is used for the school's extensive scholarship programs, but the bulk of registration still follows the first come, first served principle.

5. The school's name was not changed legally until 1984.

6. My research did not extend to establishing the origins of this educational method, but it would make a wonderful topic. Residential craft workshops are now offered by a number of excellent schools, notably Anderson Ranch Arts Center (CO), Arrowmont School of Arts and Crafts (TN), John C. Campbell Folk School (NC), Peters Valley Craft Center (NJ), and Pilchuck Glass School (WA). Countless other institutions offer similar programs in music, dance, theater, personal growth, and other subjects. The total-immersion workshop is used worldwide as a method for teaching languages.

7. Penland continued to acquire small pieces of property, often with houses, over the next two decades. Today, the school has about 400 acres and 45 structures.

8. My account of this controversial moment in the school's history is based primarily on the records of the Penland board of trustees and the personal papers of John Ehle. I am also grateful for conversations with Cynthia Bringle, Jane Brown, Susan Larson, Mike Page, and Doug Sigler. (Bringle, Larson, and Page were on the board in 1983).

9. Verne Stanford is currently working as an arts consultant; Hunter Kariher is a studio woodworker; Ken Botnick is on the faculty of the Washington University School of Art (St. Louis).

10. This is the expanded mission statement of Penland School of Crafts as found in the school's current strategic plan: **The mission of Penland School of Crafts is individual and artistic growth in crafts.** *Penland enriches the lives of individuals through teaching skills, ideas, and the value of craft in the world. Everyone is welcomed and served, from avocational and vocational craft practitioners to the general public. Penland is a beautiful, stimulating, transformative, and egalitarian place where people love to work, feel free to experiment, and often exceed their own expectations. Penland's programs encompass traditional and contemporary craft, firmly acknowledging the human spirit expressed through the world in craft.*

Bibliography

Alvic, Philis. *Weavers of the Southern Highlands*. Lexington: University Press of Kentucky, 2003.

Brown, Charlotte V. "Penland Now," catalogue of the 2000 New York Sculpture, Objects, and Functional Art (SOFA) Exposition. I am grateful to Dr. Brown for several key insights into the Penland program contained in this article and in her accompanying lecture.

Byrd, Joan Falconer. *The Bill and Jane Brown Glass Collection,* exhibition catalogue, Chelsea Gallery, A.K. Hinds University Center, Western Carolina University, 1984.

Coyne, John, ed. *The Penland School of Crafts Book of Pottery.* New York: A Rutledge Book, Bobbs-Merrill, 1975.

Eaton, Allen H. *Handicrafts of the Southern Highlands.* New York: Russell Sage Foundation, 1937. This seminal work, with photographs by Doris Ulmann, is a basic reference on Appalachian craft of the early twentieth century.

Ennis, Lynn. "Penland and the 'Revival' of Craft 'Traditions': A Study in the Making of American Identities." Ph.D. diss., Union Institute, 1995. This exhaustively researched dissertation contains detailed information about Lucy Morgan, the Penland Weavers and Potters, and the early days of Penland School of Crafts. Dr. Ennis's research was important to my account of this time period.

Ford, Bonnie Willis. *The Story of the Penland Weavers.* Third Printing, Penland: Penland School of Handicrafts, 1941.

Herman, Lloyd. *Art That Works: The Decorative Arts of the Eighties, Crafted in America.* Seattle: University of Washington Press, 1990. This book contains a concise history of American craft in the twentieth century.

Mahoney, Olivia. *Edward F. Worst: Craftsman and Educator.* Chicago: Chicago Historical Society, 1985.

Mangan, Kathleen Nugent, ed. *Lenore Tawney: A Retrospective.* New York: American Craft Museum, Rizzoli, 1990.

Morgan, Lucy with LeGette Blythe. *Gift from the Hills.* Second edition. Chapel Hill: University of North Carolina Press, 1971. This book, written in the first person, was drafted by journalist LeGette Blythe from his interviews with Lucy Morgan. It was originally published in 1958; the 1971 edition includes an epilogue. The book is written in a romantic and folksy style which differs somewhat from Morgan's other writing. Lynn Ennis includes a detailed discussion of this discrepancy of voice in her dissertation.

Video

Bill and Jane Brown interview with Chris Felver, 1989, raw footage, collection of Jane Brown.

Bill Brown North Carolina Award tribute, WUNC, Chapel Hill, NC, 1991.

"Penland Summer, 1969," WBTV, Charlotte, NC, 1969.

"Penland Summer, 1979," WTVI, Charlotte, NC 1979.

Archival material

The Jane Kessler Memorial Archive at Penland School of Crafts was an invaluable source of primary material for this essay, notably Penland catalogues, board minutes, correspondence, newsletters, and grant applications.

The archive of Haystack Mountain School of Crafts provided early Haystack catalogues.

The University of North Carolina at Chapel Hill Southern Historical Collection provided documents from the papers of John Ehle.

Oral sources

Critical to this account were interviews and conversations with the following: Paulus Berensohn, Cynthia Bringle, Jane Brown, Kat Conley, Linda Darty, Ellen Denker, Donna Jean Dreyer, Michelle Francis, Bill Ford, Martha Ford, Ruth Kelly Gaynes, Kathryn Gremley, Jim Henkel, Nicholas Joerling, Stuart Kestenbaum, Susan Larson, Jean McLaughlin, Jessie McKinney, Dana Moore, Mike Page, Mary Ann Scherr, Doug Sigler, Robert Turner, Paul Smith, Verne Stanford, Janet Taylor, and Jim Wallace. Also these interviews taped by others for a 1999 oral history project: Bill Brown Jr., Jane Hatcher, Mark Peiser. The opening quote from Elizabeth Brim is from the tape script of a 1990 Penland School slide show.

Special thanks to Jane Brown for the loan of material from her collection and to Penland archivist Michelle Francis for tireless assistance and thoughtful conversations.

DEFINING CRAFT AS PROCESS

Continuity of the Arts and Crafts Movement in America Ellen Paul Denker

All of us yearn to be creative.

Lucy Morgan, 1958

The Arts and Crafts movement in America, in art historical texts, begins about 1880 and ends by 1920. Because art historians judge the movement largely on the basis of style (the appearance of things), this approach can be useful for museum galleries and art texts that seek to establish chronology. However, these dates define the movement both too broadly and too specifically. The expansiveness of the date range admits many manufacturers who were clever at adapting style but had little interest in preserving craft practices. Manufacturers, such as Gustav Stickley for example, may have contributed primarily to design history, rather than craft history. Stickley's products embraced the aesthetic ideas of their time, but the way these objects were made reflected common industrial practices. Defining membership in the movement only on the basis of style is also too specific because it ignores the contributions of later proponents and the continuity that transcends form and surface ornament. The Arts and Crafts movement has been growing continuously in America since the late 1800s. The face of it may have changed, but its heart is constant.

This essay explores an alternative view of the Arts and Crafts movement by defining it as the desire to make objects by hand in a relatively small workshop. The virtue of this approach—using process as the basis of definition rather than style—is to see continuity in the past 125 years of the history of craft and to understand that the principles of the Arts and Crafts movement have thrived for more than a century. In a definition of the movement as process, studio potter Mary Roehm (b. 1951) has more in common with art potter Susan Frackelton (1848–1932) of Milwaukee than with the famous Rookwood Pottery of Cincinnati, Ohio (1880–1960), that employed a large staff of painters trained in the local art academy. Furniture maker Wendell Castle (b. 1932) has more

in common with Charles Rohlfs' Workshop of eight to twelve furniture makers in upstate New York (1898–1928), than with furniture manufacturer Gustav Stickley (active 1899–1916), whose Craftsman Workshops supported two hundred cabinetmakers. Contemporary silversmith John Cogswell (b. 1948) has more in common with Massachusetts silversmith Arthur J. Stone (1847–1938) than with the Gorham Manufacturing Company of Providence, Rhode Island (1831 to present), perhaps most famous for its exclusive *Martelé* line of the early 1900s. Under the commonly accepted definition of the Arts and Crafts movement as style, each of these manufacturers—Rookwood, Stickley, and Gorham—is included and held in the same reverence as the historical studio artists—Frackelton, Rohlfs, and Stone. But, in fact, the similarity and continuity between these three artists and Roehm, Castle, and Cogswell is much stronger in terms of lifestyle and relationship to product than between any of the six artists and the manufacturers working in the same material. When the Arts and Crafts movement is defined in terms of process rather than style there is no room for "art industries," the oxymoronic term that Oscar Lovell Triggs used to describe companies like Rookwood, Stickley, and Gorham, which appropriated the style of craft but took short-cuts with the process.[1] When the Arts and Crafts movement is defined as process, its members emerge as those artists practicing their art alone or with a small workshop of apprentices and journeymen who are intimately involved with the creation of each object from design to completion. These artists have spent many years learning and developing their skills, and their wares speak eloquently to issues of making, using, and communicating with craft objects. This essay begins by tracing briefly the history of the Arts and Crafts movement as the search for meaning implicit in craft skills.

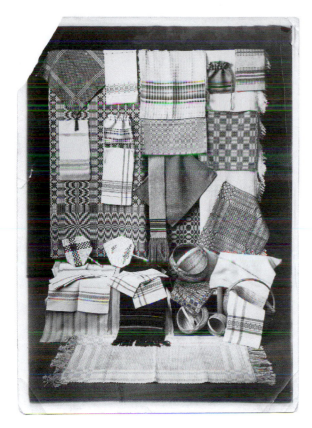

Handwoven textiles and basketry made by Edward Worst and his students, photographed about 1920

ANTIMODERNISM, INTENSITY OF EXPERIENCE, AND THE SURVIVAL OF CRAFT

The lectures of English art and social critic John Ruskin (1819–1900) at Oxford in the 1870s converted many followers to the socialism of craft. This was the anticapitalist movement of a managerial class sickened by the environmental pollution of modern cities and the spiritual degradation of industrial manufacturing. Many of them, like Englishman Ralph Radcliffe Whitehead (1854–1929), who founded the Byrdcliffe Colony near Woodstock, New York, in 1903, were the children of early industrialists.[2] They benefited financially from the first generations of industrialization, but wallowed spiritually in the moral perplexities of an age of plenty built on the mechanical labors of many. The antimodernism that swept this ideological class ushered in an era of reformers— art reformers who found spiritual solace in historic crafts and styles, education reformers who espoused intensity of experience through craft education for children and adults, and social reformers who developed craft programs for settlement houses and sanatoriums.[3]

Reform-minded writers in England and the United States dwelled on two main topics: sincerity and simplicity. English potter Charles F. Binns (1857–1934), who was founding director of the New York School of Clay-working and Ceramics at Alfred, New York, summarized the issues in a 1907 article entitled "The Mission of the Crafts."

> The halcyon days of the crafts were in the time when every workman was an artist and every artist a workman, when gain was of less importance than quality, and things were made to endure. The spirit of commercialism changed this and resulted in large production at low cost. This placed low priced wares at the command of the multitude, and luxury, in the sense of the ownership of many things, rapidly increased. Consequently the value of workmanship was lowered and the purchaser was satisfied with machine-made ornament. Naturally, then, excessive adornment became the rule, and art was divorced from industry.

In the American context, Binns identified this impulse as *insincerity* or the "common practice of living beyond one's means, the lavish use of veneer and imitation in the industrial arts, the general desire to be accepted as a fictitious valuation. . . ." Taking this theme into commercial fields, he noted that "stock is watered, false reports are spread and the market manipulated without regard to truth. This is an absence of sincerity and to crown all a fortune made by falsehood is distributed in benevolence." The answer to such degradation of labor was to pursue sincerity in one's work by embracing the "joy of working" with a conscience clear of rebuke for poor methods. "As this joy takes possession of the heart of a man," wrote Binns, "he becomes jealous of his reputation. . . . Thus does the dignity of labor acquire power."

For Binns, and countless other commentators, the second and vitally related issue was *simplicity*.

> Human happiness is compassed not by the maximum of possessions but by the minimum of desires. . . . The need is simplicity both in home and life and it is the mission of the crafts to promote this. In the home . . . the simplification of surroundings does not necessarily mean a lessening of cost. . . . A few things, yes, but each one of the best, each one a masterpiece bringing and ever repeating the message of a master. These are the works of which one does not tire. They become life-long friends and are so fashioned that they mellow but do not decay with age. In this way also the daily life is affected. . . . The mission of the crafts is to teach these things.[4]

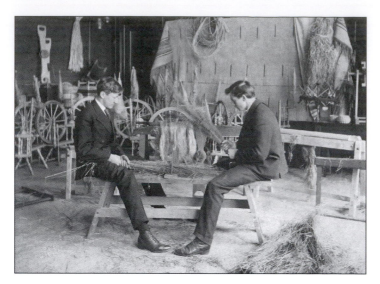

Students clean flax fibers at Chicago Normal School, about 1907, as part of a textile class developed by Edward Worst in which students learned the complete process of making linen from planting flax to weaving cloth on a loom.

At the same time that critics and artists such as Binns were trying to reform aesthetics and craft practices, educators were hoping to instill new vigor in urban public school systems through craft education. John Dewey (1859–1952), philosopher and educator, espoused the integration of mind and body as learning by doing through manual arts education. From his Lab School at the University of Chicago, Dewey promoted hands-on activities in school because they benefited society as a whole.[5] Educator Edward F. Worst (1866–1949), who helped Lucy Morgan start the Penland School of Handicrafts in 1929, was a follower of Dewey and educational reformer Francis W. Parker (1837–1902).[6]

Worst practiced their theories through his job as a teacher and director of manual training programs for the Chicago public schools and shared his experiences with, and his enthusiasm for, manual arts training in the elementary grades through his widely read classroom guides. In addition to his treatise on *Foot-Power Loom Weaving*, which attracted Morgan and which was reprinted many times beginning in 1918, Worst also penned *Constructive Work, Its Relation to Number, Literature, History and Nature Work* (several editions beginning in 1900), *Industrial Work for the Middle Grades* (1919), and *Construction Work for the Primary Grades* (1920).[7] Throughout these volumes, Worst stressed the belief that training the eye and hand led to greater abstract intelligence. Arithmetic, for example, was more easily grasped through construction projects than in its theoretical form. Having to

read instructions or follow verbal directions for the purpose of carrying out a project gave impetus to acquisition of language and communication skills. Free expression was encouraged by experience. Through construction projects—carpentry, basketry, clay modeling, bookbinding, and so forth—students also learned to apply principles of taste, exercise appreciation for the well-made object, and develop their powers of invention. These theories and practices permeated public education through the first quarter of the twentieth century. Teachers learned to use them through their own educational instruction in teachers colleges throughout the country and brought them into their classrooms.

Settlement houses and sanitoriums also embraced the crafts as part of their reform agenda. The craft program at Hull House in Chicago, founded in 1899 by social reformers Jane Addams and Ellen Gates Starr, is frequently cited as illustrative of this movement. At Hull House, Addams (1860–1935) maintained a Labor Museum that preserved immigrant arts and crafts and encouraged recent immigrants from these pre-industrial societies to apply their skills to industrial settings, and Starr (1859–1940), who later became a bookbinder, taught classes in art and literature. Hull House

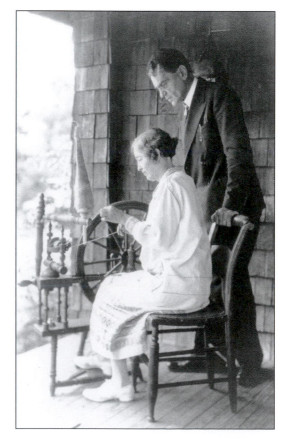

Edward Worst and Lucy Morgan with a spinning wheel at Penland, about 1930

A ROOM OF HIGHLAND HANDICRAFTS
WALL HANGING, LAMP, CANDLESTICK, COPPER PLATE, WOOD BASKET, BELLOWS, TOASTING
FORK, RUG, AND POTTERY FROM NORTH CAROLINA; CANDLE, WOODCARVING, COVERLET,
AND SCARF ON CHAIR FROM TENNESSEE; CHAIRS, BROOM, PILLOW, AND POPPETS FROM
KENTUCKY; BEAR FROM VIRGINIA; TABLE FROM WEST VIRGINIA; YARN FROM GEORGIA

The Frontispiece from Allen Eaton's *Handicrafts of the Southern Highlands*, published in 1937 by the Russell Sage Foundation, illustrates how crafted objects could be used to decorate a bedroom completely, from the floor and bed coverings to the mantle ornaments and fireplace tools.

Lucy Morgan, photographed on the porch of the Pines with visitors in the 1950s. After World War II, many students and visitors ventured to Penland from foreign lands and many Americans, like Lucy Morgan and Aileen Webb, believed craft would help unite people with political differences. "Penland is coming to be known as a little United Nations," Morgan wrote in 1958.

was only one of many settlement houses in cities across America that embraced similar activities at the end of the nineteenth century.

As the settlement movement grew in the early years of the twentieth century, it also spread outside cities and included reform agendas beyond issues of immigrant assimilation and worker emancipation. For Lucy Morgan, who established her settlement program among the mountain people of western North Carolina, the issues revolved around economic reform of the local cashless agrarian market. By encouraging local women to use and improve their weaving skills to make salable commodities beginning in 1923, Morgan hoped to bring money into the local economy from city folk intent on developing a moral domestic environment by using traditional crafts in their homes. Even in North Carolina, this movement predated Morgan's efforts.[8] In 1892, Presbyterian missionaries Frances Goodrich and Evangeline Gorbold established weaving as a small cottage industry in Brittan's Cove, near Asheville. In 1895, Goodrich (1856–1944) created Allanstand Cottage Industries in northern Madison County and developed school and related social programs in the area to support her program of developing the market for mountain crafts. Episcopal missionaries Eleanor Vance (1869–1954) and Charlotte Yale founded Biltmore Industries in Asheville in 1901 and the Tryon Toymakers and Wood Carvers at Tryon in 1915. Their efforts and others throughout the southeastern U.S. were documented in Allen Eaton's *Handicrafts of the Southern Highlands*, a study commissioned by the Russell Sage Foundation and published in 1937.

By the time Eaton's book was published, Morgan's Penland School of Handicrafts was already well established. The summer institute for weaving, which grew out of Worst's first visit to Penland in 1928, was opened to students outside the local community in 1929. For many years, the students who attended the institute and later the school, were teachers, social workers, and occupational therapists who used craft in their regular programs and sought advanced instruction to improve their skills and learn new ones. In the 1910s, occupational therapists represented a new breed of professional health care worker who took a holistic approach to treatment, believing that healing required the engagement of mind, body and spirit.[9] Many physicians felt that the objective approach of scientific medicine, while it had made great gains against infectious disease, lacked humanism. Occupational therapy, on the other hand, made quick work of convalescence by restoring physical function, improving mental attitude, and mitigating suffering.

In the original expression of the Arts and Crafts movement, craft was readily related to reform in almost any field. Reformers in the early 1900s, whether they sought to improve material goods, education, society, or health care, turned again and again to craft as a significant physical manifestation of their transformational activities. For all reformers, craft—the process of making things—was basic to life.

Schools for Craft

Schools such as Cooper-Union for the Advancement of Science and Art in New York City (1857) or Pratt Institute in Brooklyn, New York (1887), were founded in the late 1800s often by wealthy self-made industrialists to serve industry by training artisans and designers in the manual and liberal arts. University-based programs for applied arts followed in the early 1900s and promoted new relationships between craft and intellect that allowed craft to flourish as a way of life. Supported by university salaries, these artists were encouraged to preserve and promote the use of the hand to express the ideas of the mind.

At the same time, continuing education programs in the guise of summer schools of art and craft flourished by the late 1800s. Many of the earliest were media specific, such as the ceramics workshops initiated by Binns at Alfred and attended by many china painters turned ceramists like Adelaide Robineau (1865–1929), who later distinguished herself as the most significant female potter working in the early twentieth century. Other summer workshops were more general in nature, covering a variety of fine and applied arts. Elementary and secondary school teachers were frequently the students enrolled in these programs. Arthur Wesley Dow's Ipswich Summer School, established in 1891 in Massachusetts by Dow (1857–1922) and Minnie Pearson (later his wife) and operated until 1920, is just one of many that could be cited here. Dow changed the face of art education through his book *Composition*, which was first published in 1899 and continued to be used in teaching programs for forty years. Following his own philosophy that there was no distinction between fine and applied arts, the painter and art educator included in his summer programs a wide range of crafts—such as basketry, pottery, printmaking, photography, and even candle making—and de-emphasized painting in regular classroom instruction at Pratt Institute and Columbia University Teachers College, focusing instead on batik, stenciling, textile design, and photography.[10]

As the twentieth century plodded forward through wars, recessions, and depressions, the summer school phenomenon expanded to include many handcrafts. Those fleeting programs, like Dow's, tied to certain individuals gave way to formal organizations. Arrowmont School of Arts and Crafts in Gatlinburg, Tennessee, founded as a settlement school for local crafts by the Pi Beta Phi sorority in 1912, was opened to the public in 1945. The Penland Weaving Institute was first organized in 1928 as a workshop for local weavers, but quickly grew, through the reputation of Edward Worst, into the Penland School of Handicrafts, a summer school program embracing many crafts.

The Craft Movement Following the Wars

During the twentieth century, the ideas and ideals of the Arts and Crafts movement were applied to a growing body of material. In its earliest era, the Arts and Crafts movement was largely urban and upper class. It spawned artists who thrived on creating magnificent examples of furniture, jewelry, book bindings, and table silver for a wealthy clientele made up largely of urban industrialists. As the movement matured, reformers looked at American craft heritage still practiced in rural areas as a new resource to develop. Ellen Axson Wilson (1860–1914), first wife of President Woodrow Wilson (1856–1924), may be among the first who offered official sanction to rural arts. During her redecoration of the White House in 1913 for her husband's first term, she created the Blue Mountain Room for his personal use as a bedroom, including bedcovering, upholstery and a rug made in the Blue Ridge Mountains. Mrs. Wilson promoted interest in the Blue Mountain Room among Washington's elite, which opened new markets for traditional crafts and suggested new sources for craft design. Government interest in developing the rural craft economy expanded greatly during the next twenty-five years. The Smith-Hughes Act, passed in 1917 and signed by

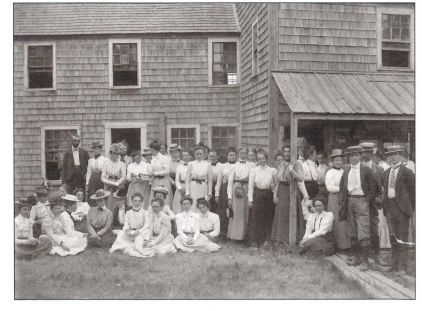

Arthur Dow and his Ipswich Summer School students

Fannie McLellan demonstrating vegetable dyeing at the 1954 Craftsman's Fair in Asheville.

Craft education became an important method of rehabilitating wounded soldiers during and after World War I, and occupational therapists were numerous among the early students at Penland School. In this photograph, a reconstruction aide teaches weaving at U.S. Army General Hospital No. 36 in Detroit, Michigan, about 1920. Craft activity was expected to help the soldier recover from wounds and give him vocational skills that would help him achieve independence after discharge from military service.

Wilson, provided about seven million dollars a year for vocational education. This money, administered through state boards, provided funds for training in agriculture, trades, home economics, and industry. The George-Deen Act, signed by Franklin D. Roosevelt in 1936, added more money for vocational education programs in rural areas. It joined a myriad of federal programs and agencies concerned with handcraft and housed in diverse federal departments including Interior, Labor, Commerce, and Agriculture. The Works Progress Administration alone supported more than 3,000 craft programs during the 1930s.

Handwork as therapy, one of the founding reform ideas of the Arts and Crafts movement discussed earlier in this essay, continued throughout this era and was especially embraced by the U.S. government. Following World War II, for example, the G.I. Bill of Rights provided money for manual arts training as therapy and occupational development. The Museum of Modern Art, one of many art institutions that took advantage of the public interest in programs of this type, developed the exhibition "The Arts in Therapy" (1943), which was "designed to encourage and broaden the use of the various arts and crafts in therapeutic work among disabled and convalescent members of the armed forces," by enlisting the help of American artists and craftsmen in developing a supply of designs and objects gathered through the auspices of the American Occupational Therapy Association and the New York chapter of the Junior League.[11] Lucy Morgan's Penland

Aileen Osborn Webb working in the pottery studio at the Garrison Art Center near her home in Garrison, New York, 1977.

School, born as a mission to mountain folk, benefited from the umbrella of government programs like the Smith-Hughes Act and the G.I. Bill of Rights. Money from programs such as these bolstered the school's operating budget for many years and affected its programs and instruction.[12]

While some proponents sought to develop appreciation for traditional crafts, others looked on them as ripe for reform. Aileen Osborn Webb (1892–1979) began her craft ministry much like Lucy Morgan had, as a way to help poor rural women in upstate New York gain access to cash; but Webb quickly decided to improve marketability by teaching artisans how to break away from traditional design and use their traditional skills to make new work. Through her American Craftsman's Cooperative Council (now American Craft Council), founded in 1939, Webb organized individual craft workers and craft organizations for their economic benefit through America House, the New York store she established in 1940, and also sought to improve American craft as an expressive medium by creating a magazine in 1941 (*Craft Horizons*, now *American Craft*), initiating a school in 1943 (School for American Craftsmen, now housed at Rochester Institute of Technology), and founding a museum in 1956 (formerly American Craft Museum, now Museum of Arts and Design, New York) to showcase and reward new work. Webb's final triumph in broadening the market for craft was creating the World Crafts Council in 1964. Like Lucy Morgan's embrace of foreign artists as students and instructors after World War II, Webb's vision looked beyond U.S. borders. Craft became an important agent for breaking America's isolationism.[13]

During the same years, from the 1930s to the 1960s, European artists arrived in the United States to infuse new energy into the craft movement. Many could be cited here, including Gertrud and Otto Natzler (1908–1991 and b. 1908, respectively), potters who emigrated from Vienna to Southern California in 1938; Finnish potter Maija Grotell (1899–1973), who immigrated to New York City in 1927 and taught in the Henry Street Settlement's crafts program; or Danish woodworker Tage Frid (b. 1915), who came to America in 1943 to teach woodworking in the new School for American Craftsmen. Through academic programs, these artists provided much of the new vigor that propelled the Arts and Crafts movement forward during a period of economic and political turbulence. Cranbrook Academy of Art is a good example of how this energy was harnessed by American educational institutions.[14] George (1864–1949) and

Potters Cynthia Bringle and Toshiko Takaezu chatting outside the clay studio at Penland, mid-1970s.

Ellen Scripps Booth (1863–1948), philanthropists who created the school, provided both a built environment that promoted artistic, cultural, intellectual, and spiritual ideals, and filled it with the artists and teachers to develop them. The Booths met Finnish architect Eliel Saarinen (1873–1950) in the early 1920s, when he was a visiting professor of architectural design at the University of Michigan. Eventually Saarinen headed the architectural activity that commenced under the Cranbrook Foundation beginning in 1927. In 1932, he became head of the new Cranbrook Academy of Art. Swedish sculptor Carl Milles (1875–1955), Hungarian painter Zoltan Sepeshy (1898–1974), and English silversmith Arthur N. Kirk (1881–1958) along with Saarinen were the first instructors. Booth's philosophy was rooted in his early experience with the Detroit Society of Arts and Crafts, where he spoke of spreading "the gospel of good work" and developing higher standards for the crafts. Cranbrook was his way of creating a community that integrated the making of things with daily life and social values, a unity that had been destroyed by industrialization, technology, and urbanization. Programs such as this continued to uphold the tenets of the Arts and Crafts movement during the difficulties of the 1930s and 1940s and provided the groundwork for rapid developments in the craft movement in the post-war period.

In many ways, Asian influences on American craft were even more profound than European during this era. Visiting artists such as Japanese potter Shoji Hamada (1894–1978), who toured the U.S. in 1932 and 1952, were critical in developing the contemporary demonstration of this appreciation which had been evolving for two centuries in American decorative and fine arts. American-born artists of Asian descent,

such as furniture maker George Nakashima (1905–1990) or potter Toshiko Takaezu (b. 1922), embraced their heritage in search of pathways to connect their Asian ancestries with contemporary American expressions.

THE ARTS AND CRAFTS MOVEMENT TODAY

By the early 1960s, the Arts and Crafts movement was poised for significant growth, freeing crafts from the constraints of the university education system and providing artists with real opportunities to make craft a way of life. The institutions that developed during the first half of the century—academic programs and summer schools to educate artists; marketing agencies, publications, and museums to promote sales—actually began to operate in unison and produce positive results. The life dedicated to craft that William Morris envisioned more than a century earlier had now become a reality.

Finnish silversmith Heikki Seppä remembered the situation in the early 1960s as one of rapid growth. After a youth in intensive manual training in Helsinki, Seppä had spent a decade in Canada before choosing in 1961 to study at Cranbrook Academy of Art as his entry into the U.S. craft scene. Once he arrived in Michigan, he encouraged his wife to sell everything in Canada and plan on a new life in the U.S. It was a period, he remembered in a recent interview, "when all the schools, all the institutions, all the craft offerings were so strong...there was a lot of work. And a lot of schools were really hard put to find instructors."[15]

Jeweler Phillip Fike, one of the many brilliant studio artists who helped build the summer craft programs, working with a student in the metals studio at Penland School, 1990.

This era marks a major transition point for Penland School as well. Lucy Morgan had run the gamut of traditional craft and worked federal and state government programs to support it for many years. As the prospect for craft brightened, the school needed a vision for the new era. William J. Brown seemed the perfect choice; he started as the school's second director in 1963. The product of a university art education, Brown had been assisting Fran Merritt in the summer school program at Haystack Mountain School, founded in 1950 in Maine. Brown understood that the Arts and Crafts movement was about to come into its own. Penland's summer school experience enlarged standard classroom education and fostered awareness that craft could be a way of life. "Penland's aim," he wrote in the first course catalogue of his era, "is to give people of all ages, who are serious students, the opportunity to learn that creativity, directed by knowledge and executed with fine craftsmanship, will give them the firm base which is needed to help the individual continue to grow and produce works which are worthy of respect." Systematically, Brown expanded the operation at Penland School to cover more months of the year, added a resident artist program, and encouraged the development of a local craft community that prospers today.

Popular consumption of handmade objects has been rising steadily during the last three decades in the United States. Greater leisure time, more galleries and collective organizations to promote sales, Internet accessibility to artists and galleries, and aggressive marketing through the American Craft Council expositions have all contributed to this increase.

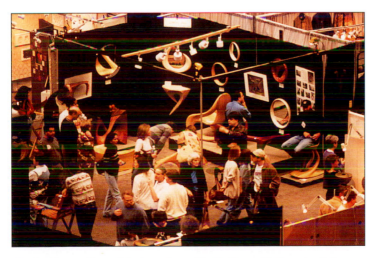

Craft fairs such as this American Craft Council show in Atlanta, Georgia, attract large crowds of people interested in contemporary craft.

While one measure of this rise is in dollars and cents, another clear indication of the growing interest in the material is the rapid increase in museum gallery space devoted to contemporary craft exhibitions. Several galleries associated with major art museums have been established in the last five years. The Mint Museum of Craft + Design in Charlotte, North Carolina (opened 1999), and the Houston Center for Contemporary Craft in Texas (opened 2001) are good examples of this trend. In addition, several established museums near major urban areas, such as the Racine Art Museum in Wisconsin (opened in 2003 with the collection of the Charles A. Wustum Museum of Fine Arts), near Chicago, and the Fuller Museum of Art in Brockton, Massachusetts, near Boston, have recently chosen contemporary craft as the focus of their exhibitions and collections. These changes suggest that major art museums are unable to satisfy the growing public desire for exhibitions of craft because gallery space is limited.

While the Arts and Crafts style is long gone, the Arts and Crafts movement as a phenomenon is still very much with us. Manufacturers may imitate an artist's work, but they can't duplicate the processes of the hand in concert with the mind that created the original. Like their predecessors, modern followers of the movement understand that making things by hand is one of life's necessities, both as an expression of ancient life forces and an antidote to the increasing mechanization that surrounds us. The popular awareness of craft is greater than it has ever been and promises to continue growing. Places like Penland School foster this awareness and help hundreds of thousands of craft enthusiasts realize their desire to make things with their hands. Clearly, this is the continuing fulfillment of the Arts and Crafts movement begun so long ago.

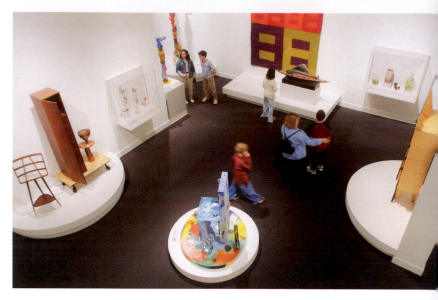

Craft today enjoys good visibility in museums such as the Mint Museum of Craft + Design, Charlotte, North Carolina.

NOTES

1. For a good example of the style approach to defining the Arts and Crafts movement, see the exhibition catalogue by Wendy Kaplan, *"The Art That Is Life": The Arts & Crafts Movement in America, 1875–1920* (Boston: Museum of Fine Arts, 1987). Examples of the work of all the historic artists and manufacturers mentioned here are included in Kaplan's catalogue. Work by the contemporary artists cited here is included in this book.

2. Nancy E. Green, et al, *Byrdcliffe: An American Arts and Crafts Colony* (Ithaca, NY: Herbert F. Johnson Museum of Art, Cornell University, to be published in 2004).

3. For further exploration of these issues, see Eileen Boris, "Dreams of Brotherhood and Beauty: The Social Ideas of the Arts and Crafts Movement" in Kaplan, *"The Art That Is Life,"* pp. 208–222.

4. Charles Fergus Binns, "The Mission of the Crafts," *Keramic Studio 9* (no. 3, July 1907): 64–66.

5. John Dewey, *The School and Society.* New York: McClure, Phillips & Co., 1900.

6. For more information on Worst's life and career, see Olivia Mahoney, *Edward F. Worst, Craftsman and Educator* (Chicago: Chicago Historical Society, 1985).

7. Edward F. Worst, *Foot-Power Loom Weaving* (Milwaukee: The Bruce Publishing Company, 1918), *Constructive Work, Its Relation to Number, Literature, History and Nature Work,* (Chicago: A. W. Mumford, 1900); *Industrial Work for the Middle Grades* (Milwaukee: The Bruce Publishing Company, 1919); and *Construction Work for the Primary Grades* (Milwaukee: The Bruce Publishing Company, 1920).

8. For more information on these schools and projects in the South, see *Southern Arts and Crafts, 1890–1940* (Charlotte, NC: Mint Museum of Art, 1996).

9. For more information on the emergence of this new movement, see Virginia Quiroga, *Occupational Therapy: The First 30 Years, 1900 to 1930* (Bethesda, MD: The American Occupational Therapy Association, Inc., 1995).

10. Dow's most famous student was painter Georgia O'Keefe; see Nancy E. Green, "Arthur Wesley Dow: His Art and His Influence," in *Arthur Wesley Dow (1857–1922), His Art and His Influence* (New York: Spanierman Gallery, 1999: 8–37).

11. "The Arts in Therapy," *Bulletin of the Museum of Modern Art* 10 (February 1943): 3.

12. Ennis, Lynn, "Penland and the 'Revival' of Craft 'Traditions': A Study in the Making of American Identities" (Ph.D. diss., Union Institute, 1995).

13. For more information on Webb and her activities, see Rose Slivka, "Our Aileen Osborn Webb," *Craft Horizons* (June 1977): 10–13.

14. For more information on Cranbrook Academy's history and influence, see Robert Judson Clark, *Design in America: The Cranbrook Vision* (New York: Harry N. Abrams and Detroit Institute of Arts, 1983).

15. Heikki Seppä interview with Lloyd Herman, Archives of American Art, 2001.

My first impression of Penland was asking the gas station attendant in Spruce Pine, six miles away, "Where is Penland School?" and he wasn't sure. I had driven eighteen hours to get there and was six miles from the place and he hadn't heard of it. I finally got there and it was Sunday morning at this sleepy little school with no one around. I thought to myself, "Boy, this was a wrong decision." At 6:00 P.M., a hundred people showed up from around the country and the next three weeks changed my entire life.

Woodworker **Doug Sigler,** oral history, 2002

Coming to Penland for the first time was the experience of arriving at a place you've never been and knowing you belong.

Weaver **Kathryn Gremley,** oral history, 2002

Wednesday was weaving day when weavers from up to ten miles away would come to the weaving cabin and spend the day to receive instruction. Here is a social gathering where ideas upon better ways of housekeeping and the care of children are exchanged. Matters ethical, moral, and religious, with all difference of church affiliation forgotten, are considered. Hymns are sung. Each weaver is ready to help her neighbor either at the community cabin or going to her own home, even though it be a matter of considerable time and labor. They are generous of themselves and of what is theirs in any good cause that presents itself.

Penland Director **Lucy Morgan,** 1932

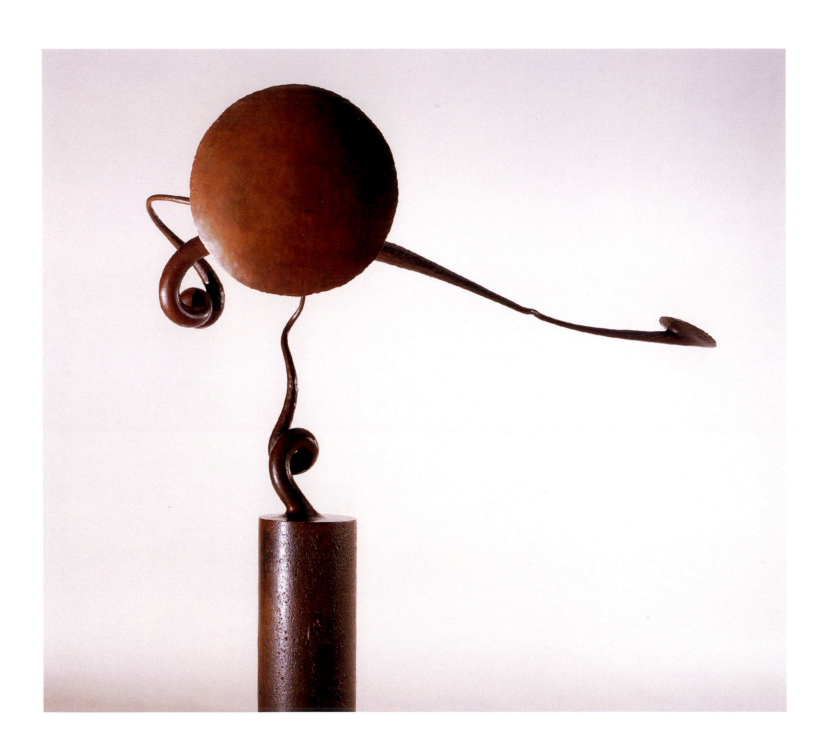

SKILL: MASTERY AND TRANSMISSION

Skill is a special ability, a competence learned and practiced. In craft, skill is expressed as the facility to transform elemental materials—wood, clay, sand, metal, fiber—into objects that inspire reflection and admiration. An artist's skill is acquired by mastering the ancient choreography that controls a particular material—carving, turning, blowing, hammering, weaving.

In the past, knowledge of craft skills was harbored by guilds of artisans who passed the secrets among themselves. Today, many artists readily share their knowledge by demonstrating and explaining the skills they have learned. Through craft education, the oral traditions developed over centuries of making things are passed to new generations.

BRENT KINGTON
Weathervane, 1978
Bronze, steel, paint; forged, cast
42 x 40 ½ x 13 in.
Collection of Museum of Arts & Design, New York, NY

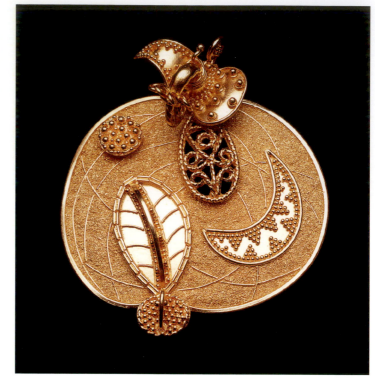

DOUGLAS HARLING
Golden Peach, 2001
Gold
3 x 3 x 1 in.
Collection of the artist

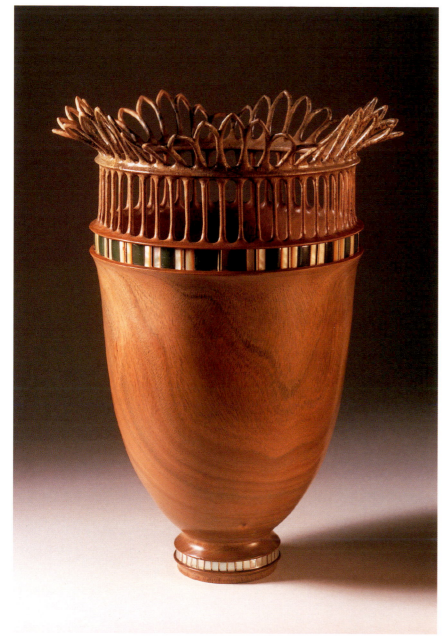

FRANK CUMMINGS III
Vessel, circa 1990
Lignum vitae, jade, gold, mother of pearl
9 x 7 in.
Collection of Los Angeles County Museum of Art, CA
Gift of Dr. Irving and Mari Lipton
Photo: © 2004, Museum Associates/LACMA

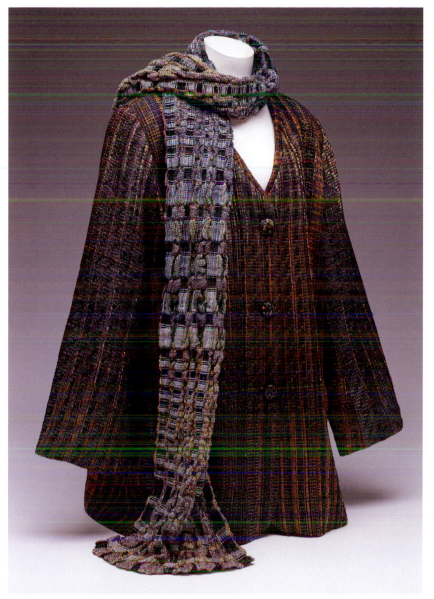

RANDALL DARWALL
Jacket and Scarf, 2002
Silk, hand dyed, complex weave
32 x 24 in. jacket, 11 x 70 in. scarf
Collection of the artist
and Leslie Gould

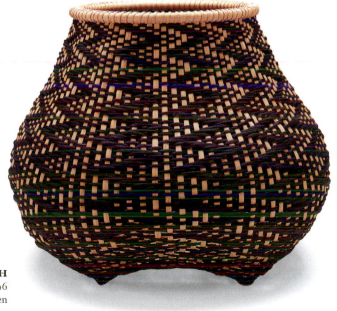

BILLIE RUTH SUDDUTH
Fibonacci 21, 1996
Reed, dyed and woven
16 x 21 in.
Anonymous collection

Don Reitz
She Broke Her Leg, Not Her Heart, 1985
Stoneware, colored slip
41 ¼ x 21 ½ x ¾ in.
Collection of the Arkansas Arts Center Foundation:
Gift from the Diane and Sandy Besser Collection.
86.058.001

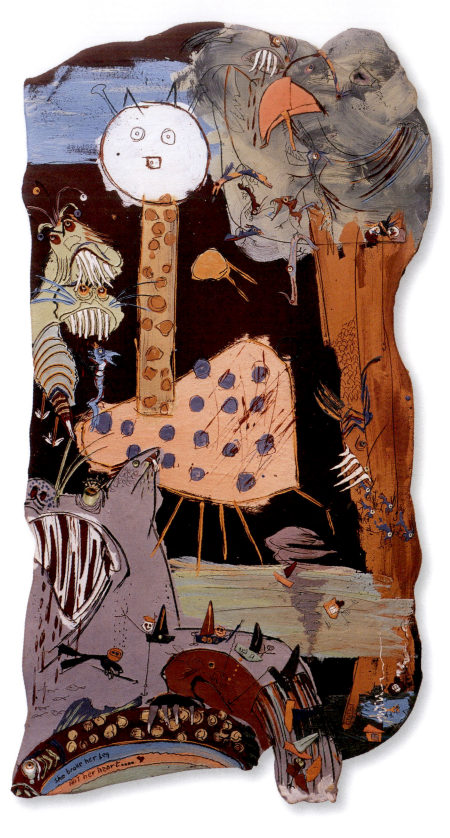

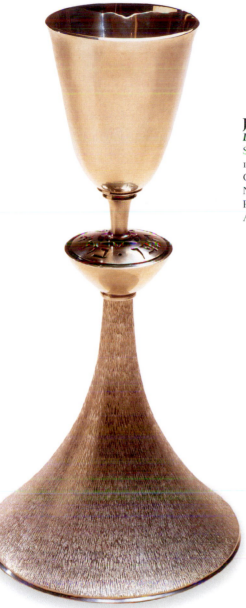

JOHN COGSWELL
Elijah's Cup (Kiddush cup), 1994
Silver
12 x 5 ¾ in.
Collection of The Jewish Museum,
New York, NY
Photo: The Jewish Museum, NY/
Art Resource, NY

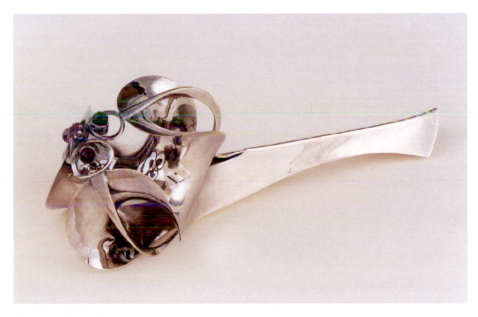

HEIKKI SEPPÄ
Top Branch of Kalevala's Big Oak, 1982
Silver, amethyst
4 ¾ x 11 x 5 ¼ in.
Collection of The Saint Louis Art Museum
Gift of Mrs. John Peters MacCarthy

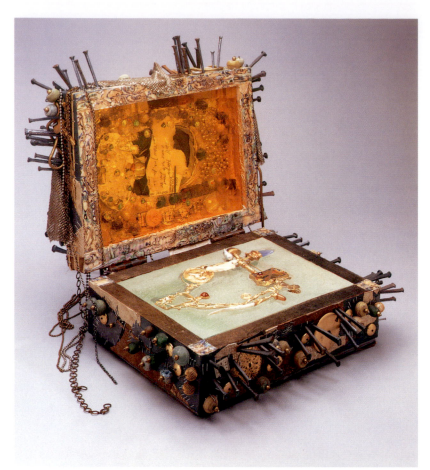

WILLIAM HARPER
Grand Barbarian's Trapeze with Cask, 1998
Gold, cloisonné enamel, opal, pearl, coral, shell,
carapace, Tiffany glass tile, nails, plastic, paper, beads
9 ¾ x 7 in. brooch.; 7 ¾ x 16 ½ x 13 in. casket (closed)
Collection of The Newark Museum
Purchase 2000 The Membership Endowment Fund

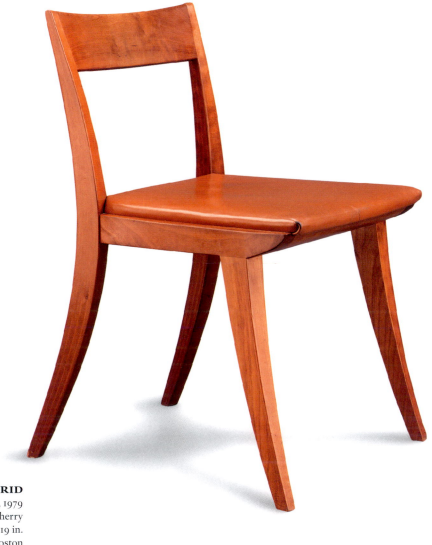

TAGE FRID
Side Chair (one of four), 1979
Cherry
31 ¼ x 19 ⅝ x 19 in.
Collection of Museum of Fine Arts, Boston
Museum purchase with funds donated by the
National Endowment for the Arts and the
Deborah M. Noonan Foundation, 1979.278

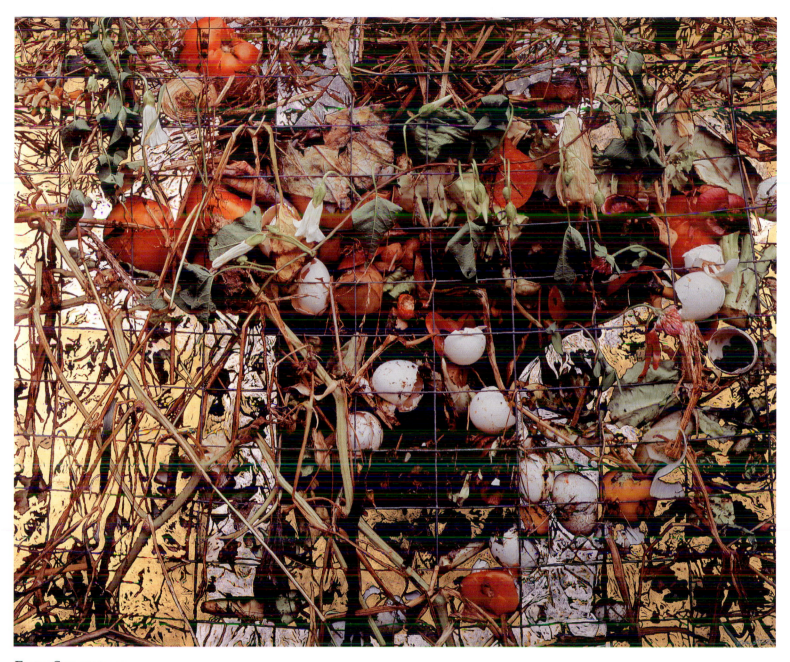

EVON STREETMAN
Gilded Landscape: Penland School Compost Cage, 1995
Cibachrome, enhanced with gold and silver leaf
24 x 36 in.
Collection of Martha Strawn

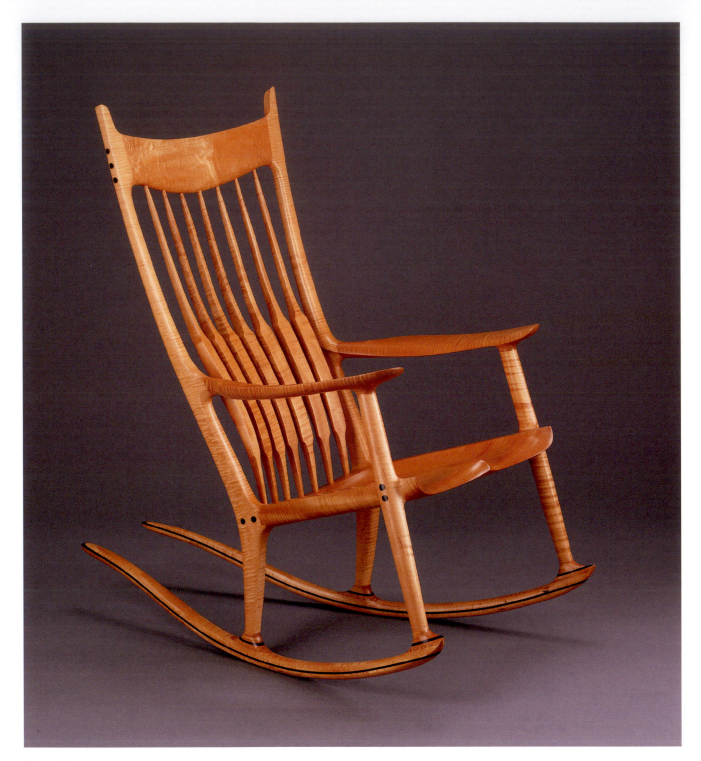

Sam Maloof
Rocking Chair, 1989
Maple, ebony
45 ½ x 25 x 44 in.
Collection of Museum of Fine Arts, Boston
Gift of the Nathaniel T. Dexter Fine Arts Trust
2000.693

JAMIE BENNETT
Email Fleur, 2002
Gold and enamel
3 x 2 ½ in.
Collection of the artist

WARREN MACKENZIE
Drop Rim Bowl, 2002
Stoneware, yellow matte glaze
4 ¼ x 10 in.
Collection of the artist

MARY ROEHM
Bowl, 1999
Wheel-thrown, wood-fired porcelain
with natural ash glaze
7 ¾ x 27 in.
Collection of the artist

MARVIN JENSEN
Mokume Vessel, 1989
Copper, kurimido, shibuichi, shakudo
5 x 8 in.
Collection of Museum of Art,
Rhode Island School of Design
Museum purchase with funds from the National
Endowment for the Arts and the Museum Associates
Photo: Erik Gould

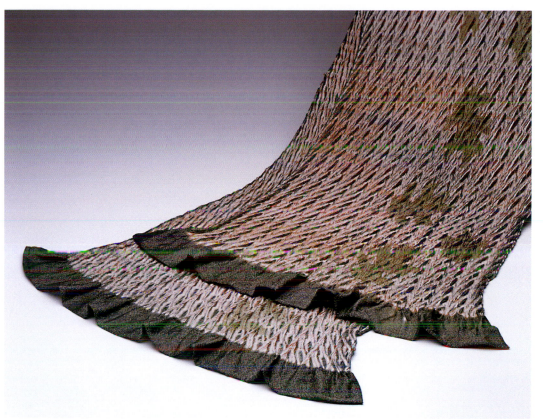

CATHARINE ELLIS
Wrinkled as a Leaf, 2000
Cotton and polyester, woven,
dyed and pleated
35 x 140 in.
Collection of the artist

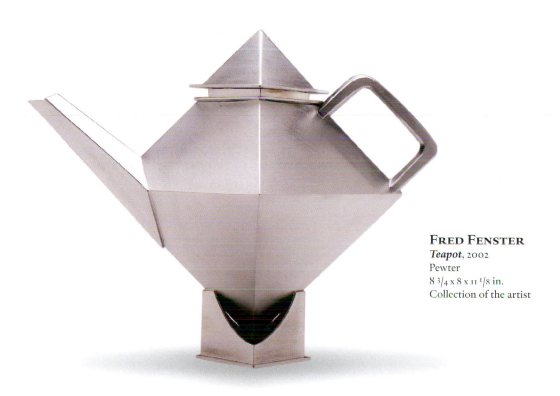

FRED FENSTER
Teapot, 2002
Pewter
8 3/4 x 8 x 11 1/8 in.
Collection of the artist

CYNTHIA BRINGLE
Vessel, 2002
Wood-fired, salt-glazed stoneware
31 x 14 x 10 in.
Collection of the artist

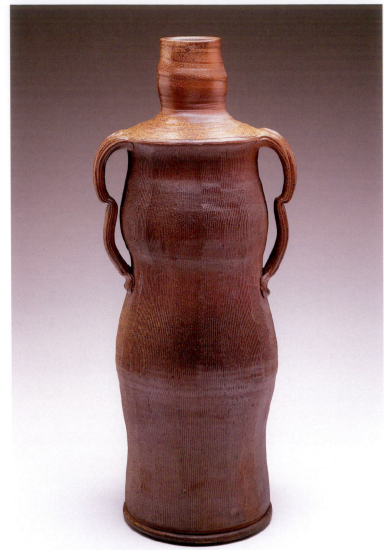

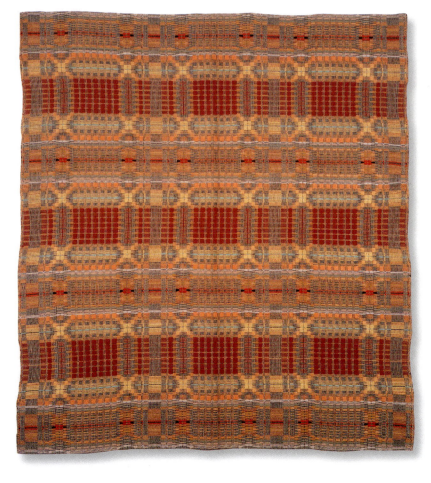

EDWARD F. WORST
Table Cover,
Indian War Pattern Variation, circa 1915–1940
Cotton and wool, overshot weave
45 x 40 ½ in.
Collection of The Illinois State Museum
Gift of William and Dorothy Worst
Photo: Gary Andrashko

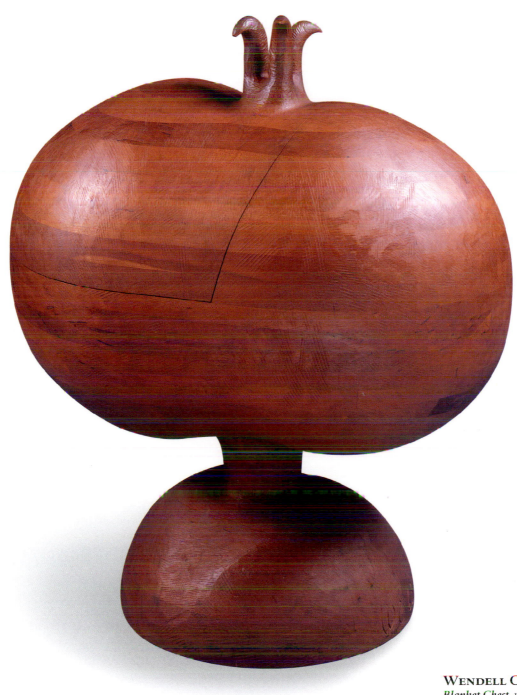

WENDELL CASTLE
Blanket Chest, 1963
Cherry
36 ½ x 34 x 13 in.
Collection of Memorial Art Gallery
of the University of Rochester
Gift of Mr. and Mrs. Michael L. Watson
in memory of Mr. Watson's grandparents

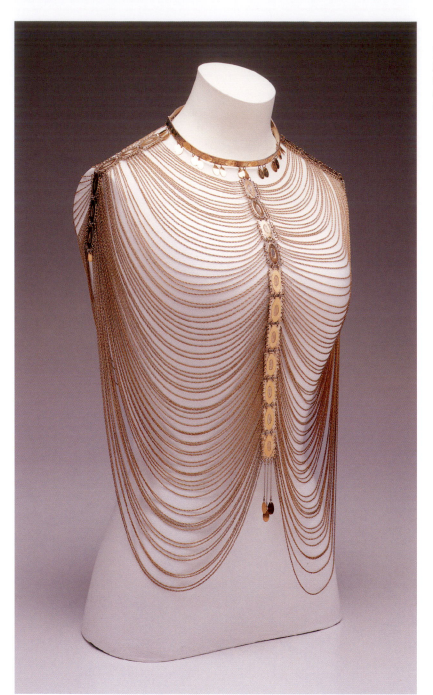

MARY ANN SCHERR
Dinka, 1997
Gold, silver, emerald
18 x 15 in.
Collection of the artist

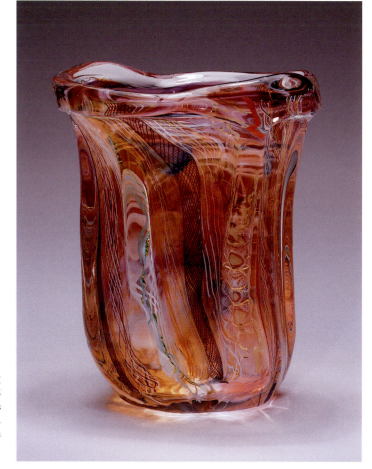

FRITZ DREISBACH
Vase, 1986
Blown glass
9 ½ x 7 ¾ in.
Collection of Mike and Annie Belkin

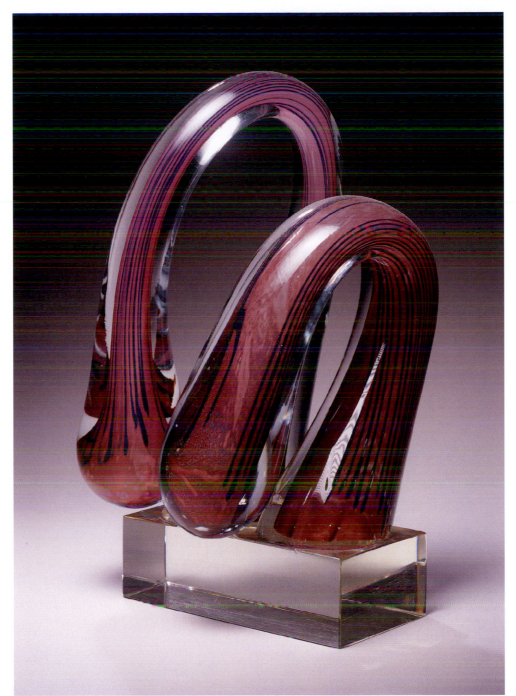

HARVEY K. LITTLETON
Sympathy, 1978
Barium/potash glass with cased double
overlay of Kugler colors drawn and cut
on a lead optic base
16 x 10 x 8 ½ in.
Collection of High Museum of Art,
Atlanta, Georgia
Gift of the artist
1984.36

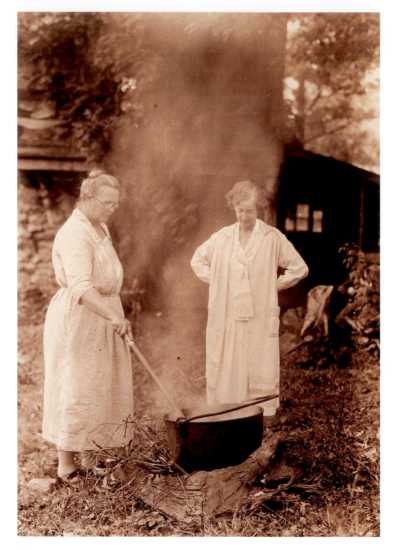

ANONYMOUS PHOTOGRAPHER
Emma Conley and Lucy Morgan with Dye Pot, circa 1945
Black and white photograph
7 x 5 in.
Collection of Penland School of Crafts

Exceptional craft is not always realized directly in an object. Much knowledge and skill may be lavished on processes that come before something is made. Emma Conley's ability to turn the natural fibers of plants and animals and the inherent colors of plant materials into the vivid filaments strung on a weaver's loom were well known around Penland. Mrs. Conley wrote down her recipes shortly before her death, resulting in one of Penland School's earliest craft publications.

EMMA CONLEY
Vegetable Dying by Mrs. Emma Conley,
Pamphlet, first edition, 1957
8 x 6 in.
Collection of Penland School of Crafts

What is it that one gets from a session at a craft school? Technical information surely. But even more than that, a sense of expanded personal possibility. Basic needs are taken care of. Food happens. There is a place to sleep and minimal contact with telephones and automobiles. There is nature. Unessentials are pared away. For a few weeks one can part the waters of everyday reality and stand on the dry land of a dream. It is a powerful and empowering experience.

Sculptor **Bob Trotman,** *Penland Line,* Spring 1997

Penland has a way of making the teacher and the student more alike than not, whereas in academia the lines are much more clearly drawn; it's just set up that way. Here we eat together, relationships are relaxed, and I can learn from them more easily. Here it's maker meets maker.

Painter **Clarence Morgan**, *Penland Line,* Winter 1995

Some days it's very difficult to distinguish between what you learn and what you teach.

Potter **Jack Troy,** oral history, 2002

SCIENCE AND CRAFTS

ROALD HOFFMANN

I came to Penland to write. The crafts were dear to me; first textiles, especially bobbin lace, which my wife made and collected, and taught me to look at. Then the Japanese ceramics to which Kenichi Fukui and Fred Baekeland introduced me, followed by the protochemistry of dyeing with indigo from snail and plant sources, to me still the ideal bridge between science and culture. The tribute is to be seen around my house—my children's inheritance consumed as much by crafts as "high" art.

So it was easy to accept an invitation to come to Penland and write. Who knew what would come? I wanted to write poems, perhaps an essay. For the poems I've needed nature—not so much to write about as to shake me loose from the everyday worries of the daily life I had in Ithaca. Nature was a path to concentration; I expected to find a different nature in the foothills of the Blue Ridge Mountains. I would watch the crafts process. Maybe someone would even let me try something. Or ask me to tell them of the chemistry of their craft. I, in turn, would craft my poems out of the green hills.

But this is not what happened. Here's what happened: I walk into Billie Ruth Sudduth's basketry class, and there's the whole group dyeing their canes—steaming pots of synthetic dye. I ask someone what they are doing, and she says, "Well, I'm getting ready for the upsetting," and then seeing the puzzled look on my face, patiently explains this old, wonderfully direct basketry term for bending the canes forming the base of a basket over themselves, so that they stand up.

I walk uphill to the iron shop, clearly more of a macho place, watch an intense young man, lawyer become sculptor as it turns out, hammer out a hand on a swage block. Ben tells me that it's possible to burn away the carbon in the steel, and the iron would "burn" too—oxidize, in too hot a flame.

In a studio downhill, a young student carefully carves out the wax sprues (yes, I have to be told what these are—and I thought science was full of jargon!) that will eventually help him form silver leaves. His instructor, thinking I might be the useful sort of chemist, asks me about gases emitted when the "investment" hardens. Alas, I'm a theoretician, as impractical

as they come within this profession.

There is no time to write, poetry suffers. The only nature I encounter are the ubiquitous fireflies as I walk back to my cottage late at night. I think of their wonderful luciferase chemistry, their rhythms and deceits—one carnivorous firefly species imitating another's flashing rhythm to lure a male to death.

My heart is open. I am in thrall to these intent older and younger people, and the transformations they perform. I am not even discouraged that my own attempts at pots, under the tutelage of a great teacher, Paula Winokur, or my try at blowing glass, or forging iron, fall short. I need practice. And I reflect on the kinship I have, as a scientist (and writer, too), with the creators of crafts. The magic of Penland opens people to each other and their hands' work. But there are deeper ties.

NATURAL/UNNATURAL

In the context of environmentalist and ecological disputes, scientists and technologists are often branded as the makers of the unnatural. Aware of the shades of meaning, progressively negative, which accompany the words crafted, man- or woman-made, artificial, synthetic, unnatural, I use unnatural as a provocative extreme. Because that's how people see it. Sure, you could say everything people do is natural because they/we, the makers, are. And we certainly deconstruct the natural/unnatural distinction every moment of our creative, transformative lives. Taking the natural, changing it. Making naturalistic shapes out of the most synthetic of materials. But I think it makes sense to distinguish the actions of human beings from those of the rest of nature, if we are to have a sensible debate on the environment.

My personal way to overcome this facile categorization into natural/unnatural is to ask people to think what's natural about a John Donne poem, Orson Welles at his most evil in *The Third Man*, a Bach cantata, a desegregation law. These are acts of human creation, they enliven (and may hurt—a romantic affectation of artists is that all art is inherently positive). We have been put on earth to create. And as human

beings, the act of creation of molecules or poems must be coupled with an ethical assessment—will this hurt, will this heal?

At Penland, everyone, absolutely everyone, was into making the artifactual, into transforming, changing, modifying nature. From the wonderful sculpture of a ballerina's tutu made from birch bark, to the shibori dyed cloth, to the shaved stakes worked into a basket, people were taking one thing (natural or synthetic) and transforming it into another. Yes, they did care about natural or synthetic dyes—maybe they'd use, for class purposes, synthetic dyes to color cloth or basket cane. At home they'd think again—some would stick with natural dyes; most I suspect would not.

The natural/synthetic story is fascinating in detail, and in the way it has provided an ethical dimension for crafts. People who make things for use (or beauty; could we live without it?) will go with any technical advance. No commercial fisherman will return to cotton nets after using nylon. Within three years of aniline dyes coming on the market in Germany, they were used in Persian villages, to the detriment of the rugs, initially—some of the first dyes were corrosive to the wool. Navajo weavers unraveled Spanish red cloth, bayeta, to reweave it into their blankets.

Bright color has a way into the soul. And since synthetic dyes often are more intense in hue than natural ones, they

Measuring a vessel

have always tempted the craftsperson. I like the idea that the question of what dye to use now has an ethical dimension for the craftsperson. And, to complicate matters, I like also that we have an inversion of the old class/color correlation—no longer are the rich more colorful.

In the company of craftspeople, I did not need my prefatory plea to recognize that we are all in the business of transformation. And we could move on—perhaps to the associated ethics, perhaps to the aesthetics.

CHEMISTRY

Not only were the craftspeople at Penland transforming the natural, but they were just plain doing a lot of chemistry. I've mentioned the dyes for textiles and baskets. In the magic of clay fired to a ceramic there was chemistry, also in the colors of the glazes. Higher up the hill was the land of perfervid metallurgy—people were not winning metals from their ores, but they were pouring bronze, burning out plastic or wax, annealing, tempering, etching, grinding, welding. I loved the sounds of the work. There were chemicals in the print shop, and the developer and hypo in photography.

There was concern about the health effects and safety of these processes—as there should be. The concern was amplified by the fact that people sometimes didn't know what they were working with; the ingredients were not specified (as little descriptive as "red earth" or "stabilizer"). Some people used the hazardous material data sheets provided by the school, others did not. All were torn by the tension of wanting to use materials that expanded the range of what they could do, and not being sure of the biological effects of the new materials. Chemistry is the art, craft, business, and now science of substances and their transformation. It was fun to see so many cryptochemists! Good, practical chemistry was being done left and right. In the usual way people have of thinking they are insufficient, and not having gone through a chemical apprenticeship, crafters were hesitant, and thus a little afraid of me, a professional chemist. Little did they know that I, a theoretical chemist, was much more of a klutz in practical chemistry than they were!

The craftspeople I met also weren't quite aware of how much they, in fact, were like professional chemists. What I mean here is that both scientists and crafters alternate doing things carefully (measuring out that bevel, controlling the kiln temperature), and tinkering, trying things, trying them again to get a process to work.

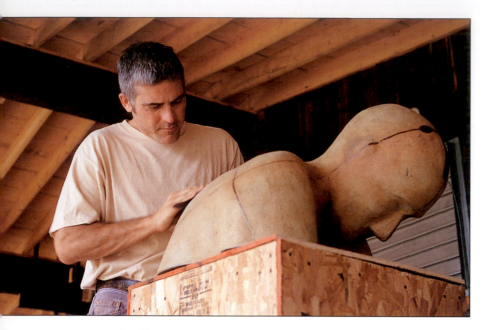

Sanding concrete

Chemists also pursue matter in all its rich variety on the microscopic scale—they think of chemistry as being the transformation of persistent groupings of atoms we call molecules. What happens downscale, to the molecules and their constituent atoms, determines, as one moves upscale, what form macroscopic substances take on and how they transform. Their colors, crystalline shapes, their biological effects, their chemical reactions—all these have a molecular basis.

The creative people I met were moving on the macroscopic plane. Would it help them to know more about the small structures inside?

How Much Does One Need to Know?

Not much. A lot. Just enough to create. I am speaking of the knowledge of the materials we work with, both as they "rest," and as we transform them. Is it important to know that steel is an alloy of iron and carbon, and that the carbon is there in several ways—part a solid solution in the interstices of metallic iron, part in discrete Fe_3C and Fe_5C_2 compounds? Should one care that the chemical structure of indigo is the one shown here, and that to have it bind better to wool and linen one has to "reduce" the molecule to a colorless form, which, once absorbed into the biopolymers, is oxidized back to a molecule colored "like unto the sea and the sea is like unto the sky and the sky is like unto the sapphire, and the sapphire is like unto the Throne of Glory" as Rabbi Meir said of the wondrous dye?

The art is wonderful, the overall change possessed of sufficient mystery to make the spirit soar when the blue of the dye reappears as the oxygen of the air hits the wool. Need we care about what happens on the molecular level?

Curiously, the question "Should I know?" or rather "Should I learn deeper?" is there in science as well. The special context there is reductionism—a world-view (unrealistic and unworkable in my opinion) that science bought into early on. By reductionism I mean the description of a hierarchy of sciences, and a definition of understanding in terms of a reduction from one science to another. So behavior is to be understood in terms of biology, biology is to be understood in terms of chemistry, chemistry in terms of physics. Given the premium on understanding, in this hierarchy there is no question that there is more value in going deeper. And deeper is defined in terms of reduction.

Actually, this kind of reasoning is often used as a rhetorical avoidance strategy for those unwilling to broach the real world—how matter might behave upscale.

In that real world, now of the practicing chemist, things operate very much as they do for the craftsperson. Chemists analyze, to be sure. But much of their activity is creative, the uniquely chemical matter of synthesis. A few hundred thousand new compounds are made each year. Why? For all kinds of reasons. For example, to make an anti-tumor agent, isolated from the bark of a yew tree in the lab, so one wouldn't kill yew trees by stripping their bark. Thus for a specific use. Also to "sell" these molecules. And for fun. There's no utility in a molecule shaped like an icosahedron, made all out of boron and hydrogen. When carbon wants to have four bonds going out toward the vertices of a tetrahedron, what would it take to induce those bonds to align themselves in the four directions of a square? The syntheses of chemists here are driven by beauty. And, incidentally, not only the facile beauty of Platonic polyhedra, but that beauty much harder to learn to love, in crafts or science: that of rococo intricacy.

Diagram of an indigo molecule

The mix of utility and beauty as motivation pervades science, as it does the crafts. And, in both fields, utility and beauty may be uneasy partners.

In making a molecule, the synthetic chemist often uses processes that he or she does not fully understand (to a reductionist's satisfaction). So there's a catalyst, a metal powder primed by another chemical, and that catalyst adds two hydrogens to a molecule just there, and not here. And while we don't know exactly how it does that, it does it so efficiently and reproducibly. The practical chemist often says, "I'll take that, let someone else find out how it works." My métier is actually calculating how it does work, on the atomic level.

Model of an icosahedral $B_{12}H_{12}^{2-}$ molecule

Here's a practical argument for trying to understand, at every level, in crafts or science: The synthesis, or carving a pattern of grooves into iron, is going great. But one day the catalyst fails to do its expected magic. And the next batch of steel just fails to give those temper colors. What does one do? Throws away that catalyst, that block of steel. Tries another. And then that fails, too. There must be a reason, which will not be revealed by prayer or anger—there is an argument here for trying to comprehend, at least piecewise, enough to fix something when it goes wrong. As it will.

But I think the primary argument for understanding is ultimately psychological and aesthetic, rather than practical. Potter Paulus Berensohn writes:

> The molecules of clay are flat and thin. When they are wet they become sticky with plasticity and hold together as in a chain. A connecting chain. I like picturing that connection in my head.
>
> I am making my connection with clay. Clay turns me on and in. It seems clearer and clearer that I was drawn to clay by

its plasticity. For it is plasticity that I seek in my life. To be able to move into new and deeper forms as well as make them. Making the connection and being plastic.

Knowing that in the fibers that will form paper is cellulose, gleaning from the arrangement of atoms in that molecule its kinship to rayon and to sugar or starch—that knowledge may be of little direct use to the craftsperson. But I think it makes all of us feel better—for understanding pleasures the mind.

Knowledge not only satisfies, but it also bolsters the mind when things don't work—when the flux pulls away from the metal, or the paper cracks. The intuition to try something else comes from knowledge subconsciously assimilated. One can go on, there are reserves of intuition to take a new tack. Knowledge also counters alienation—that of art from science, that of us from our materials and tools. These molecules are similar, they are different. They share some things, differ elsewhere. We see the world as connected. As making at least a little sense. And go on to make the next thing, as we are driven to do.

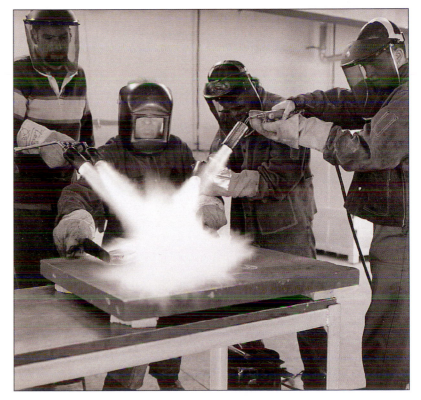

Keeping cast glass hot

You must go with the material, of course. The clay needs to be dried before it is fired, the glass and metal annealed. I watched Greg Fidler at Penland shape a glass bulb he had blown on a rounded wood form, flatten it a little, extend the thick neck separating it from another, connected bulb, soften the neck, and wait patiently for the moment when he would swing the blowpipe with the glass attached in a near circle. The neck stretched and the round bulb bent over as the steady swing was completed, in that moment nestling gently into the space the other flattened yet slightly curved shape made for it. There was suspense in that swing. And Greg knew when he could do it.

In his New York studio I watched a master sculptor, Daniel Brush, re-create Etruscan granulation, a way of attaching thousands of tiny gold spheres to a flat or curved gold sheet. The spheres loosely glued in place, he sprinkled the surface of the spheres with a copper salt, and heated it. As the object approached the softening temperature of gold, Daniel had all of about one second in which the alloyed copper metal formed on the sphere surfaces, melted, a tad before the gold, ran down the outer surface of the sphere, and formed a perfect weld at the juncture with the flat. Had he stopped heating a second earlier, there would be no bond. A second later the spheres would just melt.

"Going with" comes from observation, while working. Which builds into competence and is ultimately transformed into intuition, body, and mind intertwined.

But the will must be there to make out of the natural both the useful and the transcendent. I think of Antonio Gaudi's dragon in the gate to the Finca Güell in Barcelona. What iron ever wanted to be such a fierce segment of our imagination? I think of Egin Quirim and Cosmos Damian Asam, concocting a stucco angel on a fat cloud, just soaring out of a wall toward us in their Bavarian rococo church.

In science, as in craft, the master just knows what filter will effect the separation, intuits the flux to be used to make a solid state reaction run. And the apprentice learns. Intuition begins in trial and error, respecting the richness of matter and its changes. Homage is paid to chance, serendipity can be courted when invention stagnates.

But ultimately one tries to make matter do what it had not done before. This, incidentally, is what distinguishes chemistry from other sciences, and puts it close both to engineering and the arts. Maybe that's where crafts are, too! We

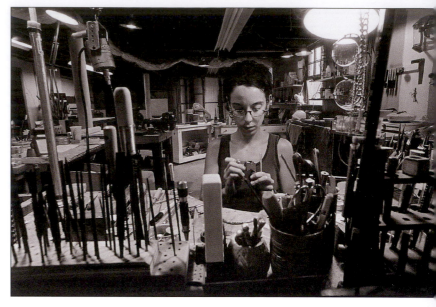

Metalsmith's studio

chemists make new molecules, a few hundred thousand of them every year. With the intention to do no harm, if not to heal. And yet some of them, like the chlorofluorocarbons that damage the ozone layer, hurt. But then creation has always been a risky business, and I'm not just talking about procreation. In the *Popol Vuh,* the book of the Quiché Maya of present day highland Guatemala, are told stories of several creations that went astray.

I saw a paper recently in which a German chemist reported the making of a line of six carbon atoms, bound to a line of three osmiums, each bearing several carbon monoxides. An unnatural assembly itself, it could be traced back to the naturally occurring element osmium, carbon from petroleum sources, and natural/synthetic (and poisonous) carbon monoxide. I saw that one line of atoms was tensed and curved, more than the other. Hard to know who to blame—carbon or osmium? One of my graduate students, Pradeep Gutta, said, "Hey, how about making a big circle out of it?" He had thought of the tension of an arc, of allowing it to play out that tension by completing a circle. Off he went to the computer, to build a model of the electron motions in that circular ribbon of osmium, carbon, and CO. Pradeep is most certainly going with what the molecule "wants" to do. And he is transforming it (on paper in our case, for we are theoreticians; but we have such great faith in our experimental colleagues—it will be done!) into something new and beautiful. And who knows, maybe useful.

A master smith

said: comply, but
contend—make

hard soft, hard
again, beat blade

and girder into
rabbit's ear and

morel. Love, oh
love for steel too,

is built sweet out
of strict desire,

for the you, that
is not you. You.

LIKE A HORSE AND CARRIAGE

For one aspect of craft there is an easy scientific counterpart—it is the experience of experimental work, using tools. Take DNA. One had to be able to separate biomolecules, and build X-ray diffractometers, before the structure of DNA could be deduced theoretically by two young helixeers fifty years ago.

But what is art in science? Is it theory, viewed in the general sense as the building of frameworks of understanding? It can't just be theory. I think the analogue of art is the imaginative faculty, which makes scientists creative. It does not come to the fore in deductive thinking, or applications of that easy idol of science, Occam's razor. Art is in the formulation of far-out hypotheses, in seeing connections between the seemingly unconnected, in designing instruments and experiments.

Science, a European invention, is a system for gaining reliable knowledge by the interaction of curious yet fallible human beings, who are obliged to tell others what they have done. Science also mandates a continuous dipping back and forth between reality (gauged by our senses and instruments) and flights of theoretical fancy.

So the system of science enforces links between the art of hypotheses and the craft of the instruments. You just can't have one without the other—a theory not tested will not be accepted, and reports of experience without trying to understand it (without a theoretical framework) are unreadable. It sure looks like you can't have the art of science without its craftsmanship.

Another interesting intersection is around the idea of utility, a subject not without dispute in the crafts. When is a teapot not a teapot? Does it matter whether a shape sells? The crafts were always of commercial value, they were a profession. And there were middlemen, even way back then. Half the students at Penland when I was there were making a living, or trying to do so, from their crafts.

Utility at first sight poses a problem. For many thoughtful theories of art conclude that the concentration, intensity, and unity in an art object can only be appreciated if one is disinterested in its value, whether monetary or utilitarian. I hear snickering on how this applies to the objects consecrated in our temples of high art. That aside, and admitting the corruptive power of money and familial (or political) relationship, I think it is too harsh to deny the beauty/crafting personal bond between object and human that daily use creates. Of a teapot, or my Harris tweed jacket.

There is an interesting utility/knowledge for knowledge's sake (substitute "art" for "knowledge") tension underlying all of modern science. We need support—once it was called

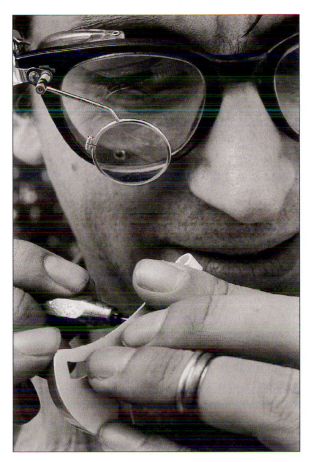

Precision jewelry making

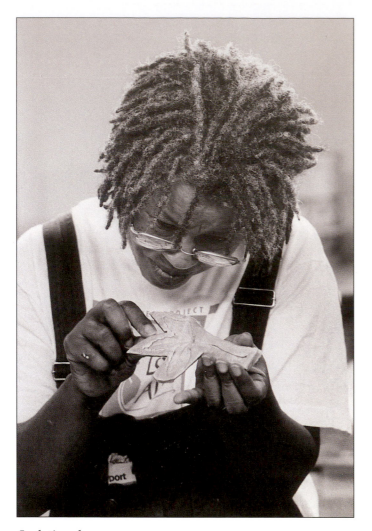

Sculpting clay

From time to time, we in chemistry are put under pressure to teach an introductory course without a laboratory. Couldn't you just talk about the logic of chemistry; wouldn't some molecular models and good stories suffice? At one such meeting, there rose to our defense a printmaker. He said, "There's a difference between talking about lithographs and making one," and sat down.

There is no question that the crafts are about hands and the senses, especially vision and touch. And sounds too—at Penland I loved the unexpected roar of the iron furnace, scissors snipping through paper, even the buzzsaw (at a distance). With a guiding mind, and yes, with tools and chemicals, a photograph is developed, printed, pasted into a book.

And science is about tools, and handwork too. Though the heroic figures of physics are by and large theoreticians (Fermi and Rutherford are the exceptions), the practice even of this quite mathematical science is largely experimental. The tools may be fancier, all those laser spectroscopes. But on the "optical bench" are carefully mounted mirrors, machined vacuum chambers, and yes, even now, blown glass containers—all designed and made artifacts.

For the crafts and for science, this—that both thinking and doing are engaged and cooperating—is our finest link. The world is disintegrated—separating mind and body. We cater to the mind through a novel or a Bach cello suite on a CD. And to the body through the long sanding of the walls before painting, or those Nautilus machines. Craft and science, both, integrate mind and body.

Could one imagine making a bracelet, linked silver triangles with an inlaid braid, without planning it out, making a mold for the triangles (all different), hammering in the decoration? The synthesis of a molecule shaped like a necklace—yes, there is such—begins with a plan. Which has to be changed a few times as one moves along, for things *do* go wrong. But the molecule is also a macroscopic substance, a solid, crystalline, each crystal the blue of aquamarines in a real necklace. And being something real and substantive, this necklace-shaped molecule must be made. It happens, in a wondrous ballet of all the glass vessels you can conjure up, the sequences of heating and stirring, of bubblings, filterings, stinky solutions, and mother liquors. It's a long day's night to make it, bracelet or molecule.

At the end, there's craftsmanship, the proud, cunning work of human hands and mind, joined in the service of creation.

patronage. Yet we resent it when the government, the modern patron, tries to direct our work with a dollared carrot—come work on "star wars" and you'll get support! At the same time we forget a little about the meliorative aspect, the desire to help people, to leave the world a little bit better place than it was before. In general, applied scientists don't get much prestige in academia. And yet one out of two assistant professors in molecular biology and materials science is running after that new start-up company.

I look at a mask on my wall by Alaskan native Evans Apatiki—carved whalebone, polar bear fur around it. It evokes its animal construction, its ritual use. And the mask is as expressive and constructed as an Ernst Barlach sculpture; or as the synthesis of vitamin B12 by R.B. Woodward and Albert Eschemoser with ninety-nine friends—each step necessary, executed with improvisational aplomb, a thing of beauty.

Working with craft materials really helps people to learn to think. It's a very strong force in cognition when you express ideas through elemental or primary materials. It's problem solving, but it's also problem inventing: thinking of things that need to be done.

Ceramist **William Daley,** *Penland Line,* Fall 1996

Part of the dilemma we're in right now is that we're trying to make people one-dimensional; you have to be a specialist, even in the arts. I would like to remove the limitations. For instance, chemistry is related to printmaking because you can't have inks without chemistry, and you can't have paper without some kind of chemical bonding. I'm trying to get the people I teach to think on that level, that it's all connected.

Printmaker and sculptor **John T. Scott,**
Penland Line, Spring 1996

THE ART OF RITUAL AND THE RITUAL OF ART

Ellen Dissanayake

All artists and writers know that inspiration may come suddenly and from a surprising source. My work was given an unexpected and powerful new direction in the autumn of 1983 when I taught a class called "Ritual, Play, and Art" at the New School for Social Research in New York. At the time, I was formulating my hypothesis that what artists do in all times and places is to "make special." The class was a way of exploring other behaviors—play and ritual—which also make special, to see what else art, ritual, and play had in common.

A colleague at the New School told me about the playful ritual between mothers and their infants described in a book called *The First Relationship*, by Daniel Stern.[1] As I read about the affectionate sounds, gestures, and facial expressions that adults (not only mothers) use when they talk to babies, I realized that "play" and "ritual" were not the only way to describe what was happening. Stern's descriptions reminded me so much of what *artists* do. I began to wonder: Could it be that artistic making and aesthetic responsiveness originate at the very beginning of life?

At first, this was only an indefinite question, one that I wasn't really sure how to approach. But, as with the germ of any fruitful idea, my rudimentary insight gradually unfolded, inspiring further ideas which themselves have become intriguing paths to explore. During the twenty years between my first exposure to Stern's book and today, I have continued to find truths about art and life in this "first relationship."

Eventually I would be led to learn about such unexpected subjects as hominid evolution, the anatomy and function of the brain, and "ritualized" displays in birds. I would study the behavior of humans in other cultures with their young and of primates with theirs. Such subjects do not noticeably seem to have anything to do with art, or for that matter much to do with ritual or play. But like the unpromising and recalcitrant mud or metal, planks or fibers with which artists make their creations, my findings from biology, anthropology, and psychology have become, after careful consideration and handling, something worth working with, something to share with others, and something to enrich our understanding.

The elements of the mother-infant playful ritual really *are*, I believe, the origin of later aesthetic behavior—though not in the simple, nurturant way ("good mothering produces artists") that might be expected. What I will describe in this essay is the importance of the innate psychobiological mechanisms that create emotional intersubjectivity (that is, the ways in which emotions between two or more people are coordinated and exchanged) which is at the core of making and experiencing art. My studies show that the techniques of making special as manifested in art and ritual turn out to be elaborations of the standard human equipment for creating and maintaining intimate and affiliative relationships.[2]

What does this mean for us as makers and experiencers of the arts?

Today, ritual is often dismissed as empty and conventional, while art may be thought of as a self-indulgent pastime or a sham. However, describing the components and commonalities between ritual and art makes clear how important they are to our species and, by extension, to us as individuals. In their origin, ritual performance and artistic making were like two overlapped lenses trained on the same needs, arising and developing as ways to achieve and demonstrate emotional concord and to publicly manifest matters of vital concern. The psychobiological vestiges of these origins remain and remind us of the continuing importance of art as ritual and ritual as art to full human lives today. It is in rare communities such as Penland that these values flourish and persist, even though they may not be explicitly articulated.

THE ART OF RITUAL

My studies reveal that mother-infant play can be justifiably described as a dyadic (that is, two-person) ritual in which innate aesthetic or protoaesthetic elements first appear and are developed. Although the following description may seem at first to be far removed from the making (or the "ritual") of art, it is good, I think, to be aware of the deep-rootedness of our aesthetic nature as it appears even in infants.

Photos: Robin Dreyer

MOTHER-INFANT PLAYFUL RITUAL

Babies come into the world prepared and eager for human company. They prefer human faces to any other sight (be it sharply contrasting or brightly colored shapes or cute stuffed animals) and human voices to any other sound (be it tinkling bells, soft music, or the Chipmunks). They can estimate and anticipate intervals of time—that is, form expectations of when the next beat will come, based on a pulse or rhythm that has been set up, say, by gently patting, rocking, or singing rhythmically to them.

These inborn abilities allow normal infants to interact with the people around them, and unobtrusively to persuade these people to talk, make funny faces, and move their heads in ways they would never do with anyone except a baby. It is a mistake to think that we speak in high-pitched voices to babies, or make abrupt head-bobs, nods, and open mouths just to attract their immature attention. On the contrary, babies train *us* to do these things because such sounds and expressions are what they most like and need; they are born wanting others to act like this. For our efforts, they reward us with their smiles and kicks and reachings-out, persuading us to do it even more. For them and for us, this is *play*.

Adult behavior to babies seems natural, because it is. People in cultures everywhere spontaneously (i.e., without deliberate practice or intention) talk to babies in short rhythmic, repetitive utterances, at a high pitch and with exaggerated vocal contours. They exaggerate and sustain certain facial expressions: wide eyes, open mouth, or pursed lips; they move their head forward toward the baby's face and back again; they look deeply and intimately into its eyes. They pat or stroke or rub babies steadily and rhythmically.

Although these behaviors are "natural," they are nevertheless quite unusual. At least they would be noteworthy—or even alarming—if we adults did them to each other. What is unusual is that these vocal, facial, and gestural expressions are extreme or "special" forms of the ordinary, daily ways we show friendliness to, interest in, and accord with other people. When used with infants, our everyday and unremarkable smiles of pleasure and affection, nods of agreement, looks of interest, or sounds and pats of support or sympathy become stereotyped or simplified (formalized), exaggerated in time and space, and elaborated through repetition (sometimes with variation). What is more, these vocalizations, facial expressions, and body movements are temporally coordinated, with adult and infant responding to the other as if in reference to a common pulse. It is possible to accelerate or decelerate gradually, but a sudden change of tempo disrupts the smooth flow. The behavioral coordination echoes or reinforces emotional conjoinment, where both partners are feeling and acting not alone, but with reference to each other.

Until films revealed the intricacies and exquisite attunement of these interactions, no one suspected that infants of only six weeks of age—before they can even hold their heads up reliably, or reach for and grasp an object—could be so receptive to these special signals and their presentation in time. Although the adult leads the performance, the baby is essential to it, for with its own sounds, facial expressions, and body movements it influences the pace, intensity, and variety of signals that are improvised. Indeed, one can think of adult-infant interaction as an impromptu multimedia duet, in which each partner responds with supreme sensitivity to the others' moods and actions.

Film analyses of this interaction show that it is also a multi*modal* duet. Each partner will respond pretty much the same to a signal whether it is aural, visual, or gestural. That is, a baby's sudden arm movement might be answered with the mother's voice becoming suddenly, sharply loud; as her remarks become faster, the baby might kick faster. A blind baby in a film I saw raised her arm and spread her fingers as her mother's singing swelled.

In a later book,[3] Stern introduced the concept of "vitality affects" to describe the emotional valence of qualities of such multimodal behaviors and responses—qualities related to intensity, shape, contour, direction, duration, and movement.

"What artists do in all times and places is to 'make special.'"

In *Art and Intimacy*, I called these qualities "rhythms and modes." They are not exactly emotions, but kinds of abstract "forms of feeling" that are common to many sensory experiences, whether from sight, hearing, touch, or movement. Although difficult to describe, the words used to try to describe these are often drawn from music or movement—such as "accelerando," "crescendo," "steady," or "jerky." But these and other descriptive words—such as fleeting, surging, fading-away, tentative, smooth—also apply to vision and touch. Visual artists who read this will easily think of lines, shapes, forms, and colors with these and other "multimodal" qualities.

Most parents are unconcerned about the "purpose" (or the silliness) of their interactive play—like babies, the important thing is to have fun together. But a biologist or psychologist has to wonder about what is accomplished by such a complex, closely attuned behavior. A number of intellectual, emotional, and social benefits have been identified. For example, mother and baby can adjust to each other's individual tempo or personality, gradually coming into "sync," as the level of arousal is mutually modulated up or down. The baby discovers that its behavior has effects on others—an important social lesson. The interaction contributes to eventual learning of language, both words and grammar, and the nonverbal indications of a partner's age, sex, mood, and intention. The interaction helps a baby "self-regulate" its feelings, that is, to become familiar with them, calibrate them with those of another, and eventually deal with them.

A scientist might also wonder how such an interaction came about. It is possible to infer that as humans evolved over several million years, the mother-infant ritual arose as a behavioral adaptation that contributed to the ancestral baby's very survival. Because of upright posture, the birth canal in humans is smaller than in a four-legged creature. Obviously, as brain size was increasing over evolutionary time, childbirth became a serious predicament for both mother and baby. A number of anatomical changes are known to have taken place to permit easier births of large-brained infants: their skulls can be compressed at birth, much brain growth takes place outside the womb, the female's pelvic symphysis can separate slightly at parturition. But in addition to these changes, it is clear that mothers of babies who were born at a less-developed, smaller stage had a better chance of a successful birth, and those smaller, less-developed babies would themselves later tend to produce smaller, less-developed babies. (For a human infant to be as mature at birth as a newborn chim-

"In their origin, ritual performance and artistic making were like two overlapped lenses trained on the same need, arising and developing as ways to achieve and demonstrate emotional concord and to publicly manifest matters of vital concern."

panzee would require a twenty-one month gestation period and the baby would weigh twenty-five pounds).

By simplifying, repeating, exaggerating, and elaborating the already existent signals that communicate good will to other adults, an ancestral mother expressed intense love and abiding interest to her baby. Additionally, she unwittingly reinforced affiliative neural circuits in her own brain, thereby helping to ensure that she felt such positive emotion toward her infant that she would be willing to devote the necessary effort and time required to care for such a helpless and demanding being. Infants who called forth these sorts of behaviors by coordinating with maternal rhythms and showing other appealing responses (like smiling) helped to assure that their mothers felt this way. Gradually, over generations, infants and mothers who became affectively attuned survived and reproduced better than those who did not.

ADULT RITUAL

The word "ritual" typically refers to prescribed performances required by a religious or other solemn occasion, such as an inauguration, graduation, baptism, wedding, or funeral. Although the term can be broadened to refer to almost any activity that has a conventional kind of progression—a meal, sports event, class, church service, even the pattern of an ordinary working day—typical usage presumes that a ritual is

Photo: Dana Moore

characterized not only by repeatability or conventionality but by unusual behavior that sets it off from the ordinary or everyday. Time, space, activity, dress, paraphernalia are made special or extraordinary, and so we can speak of ritual time, ritual space, ritual activity, ritual dress, ritual paraphernalia, and so forth.

What is the purpose of unusual, special, *extra*ordinary behavior? In our remote past, tens of thousands of years ago, our ancestors, at some point and for some reason, began to invent the multimedia packages that we today recognize as ceremonial rituals. These exist in every society that has ever been known, and enormous amounts of time, physical effort, and material resources often are devoted to them. Ceremonies obviously contribute something important to the people who perform them.

My suggestion is that ceremonies began as the behavioral expression of people's feelings about what they desired and needed most. They were a society's way of exhibiting in the most vivid, compelling ways how much they cared about the vital subject of the ceremony, whether it be procuring food, protecting from harm, ensuring prosperity, or healing the sick. At first, perhaps people simply moved and moaned together at a time of anxiety. Finding that it made them feel better, they were inclined to do it again at a later anxious

time. Perhaps they imitated for each other the animal they wished to kill, were successful in the hunt, and decided to imitate again. Over time the movements and sounds became more elaborated to what we recognize as dance and song, with visual decor added to attract even greater attention to what was done and said. When dress, implements, and surroundings were made more considered, sumptuous, and dramatic, they became more expressive of the underlying need or wish.

Because these early humans had of course all been babies, they had an innate susceptibility to emphasis and extravagance in visual, vocal, and kinesic modalities; they already were responsive to the emotional effects of formalization, repetition, exaggeration, and elaboration. Without consciously setting out to build upon these protoaesthetic sensitivities, they discovered that it was exactly these "operations" on sounds, words, movements, sites, objects, and bodies that gave form and expression to their deepest concerns and made them feel emotionally united with each other. As in maternal messages to babies, these operations communicated "Look at [pay attention to] this message [matter, outcome]!" or "I care about this, and I care that you know that I care. I want you to care too."

In this way, components of "the first relationship"—between mother and infant—became transmuted into the first arts, developed in ritual ceremonies as what we now call dance, song, poetic language, dramatic performance, and visual display. As with mothers and infants, ceremonial arts generally occur all together as "multimedia," and they have multimodal, interpenetrating effects.

In adopting the protoaesthetic operations of formalization, repetition, exaggeration, and elaboration, ritual ceremonies, then, became the cradle of the arts. The "art of ritual" is not only a metaphor, but an accurate description of what makes ceremonies emotionally affecting. They are troves of arts.

THE RITUAL OF ART

In a similar way, the "ritual of art" is not only a metaphor for, say, the way an individual artist sets to work every day, or for the customary routines of an institutionalized art world. In this section, I want to make the case that the arts today still contain important components from their origin in ritual—deriving from both the playful ritual of mother-infant interaction and ritual ceremony itself.

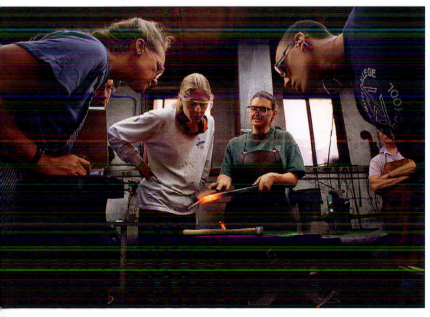

"Craft practitioners generally work within the communal, guild-like process or tradition, transmitted from master to pupil. This can be a powerful source of meaning."

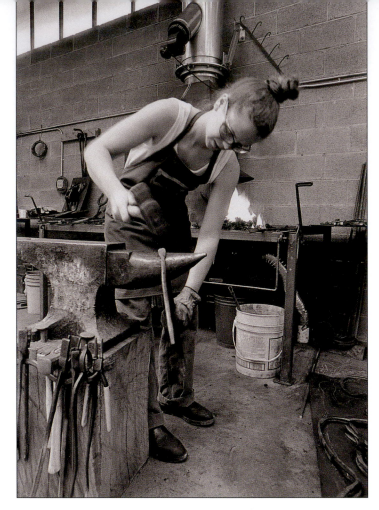

"Craft is ineluctably grounded in the life of the body, the physicality of material and material objects—their feel, their weight, their resistance, their fragility or durability."

It may sound simplistic to say that fundamentally what artists do with their materials, images, and ideas is—like mothers (as well as practitioners of ancestral rituals) with their sounds and facial-bodily movements—to shape or formalize, repeat, exaggerate, and elaborate them. Yet to realize this is also to realize how the arts are embedded in our biology. These aesthetic operations attract and hold attention, and make us recognize that the material or image or theme has been made special and that someone wants us to notice and heed. Drawing a frame around something, making it or a part of it larger or smaller than one might expect, emphasizing one place rather than another, adding color or a repeated design—these are the sorts of practices and decisions that artists deal with, unlike, say, makers of ordinary tools or dwellings, hunters or fishers, and food preparers or herb gatherers in early societies or the industrial designers, engineers, cooks, and pharmacists who do such work today. Insofar as these occupations do emphasize or elaborate (and

so forth), they are adding ritual or art, but in the simplest sense, aesthetic operations are not strictly necessary to achieving the practical goal. This use of aesthetic operations is what I described in the previous section as the "art" of ritual, and these same operations are used, and further elaborated, in the arts today. If ceremonies are troves of arts, the arts are suffused with the physical and emotional components of ritual behavior.

CRAFT AND RITUAL

So far in this essay, I have used the word "art" pretty much as a generic category that refers as much to "craft" as to "art." That is, I have not tried to distinguish between craft and art in my examination of what makers or practitioners do when they make their behavior, materials, or ideas special. In this concluding section, however, I am going to be more direct and claim that it is in craft, and craft communities like Penland, that the "ritual of art" (or the ritual in art) is most evident and contiguous with ancestral forms.

In a recent essay,[4] Bruce Metcalf, a metalsmith and craft historian, points out that the ideas comprised by today's term "craft" are, like those of "art," of relatively recent origin— even though, of course, the roots of craft are in pre-industrial technology. Both are post-Enlightenment concepts that come out of a cultural world that is heavily influenced by the marketplace, with its concomitants of buying, selling, advertising, and competition. In this recent usage, craft has typically been considered the stepsibling of art—although, as Metcalf notes, there are degrees of both and they may meet in the middle (e.g, the "artist-craftsperson").

Metcalf, however, chooses to consider the two categories separately. Among his criteria for craft are (1) handwork, (2) knowledge and use of traditional craft media, techniques, formats, and history, and (3) a sense of the primacy of the object and its function. Although he recognizes that contemporary craft includes "hybrids," many of which may be interesting and worthwhile, his notion of craft generally would exclude activities like installations or performances, techniques like computerization or electroforming, materials like plastic, and useless or found objects or the "anything at all" that has come to characterize visual art of the past several decades.

I like Metcalf's analysis of craft history and his insistence on the differences between craft and art today, based on historical knowledge and acquaintance with the contemporary art scene. The view that I have presented in this essay—which

might be called prehistorical—supports Metcalf's criteria of craft, although I speak here of craft and art when they were the same activity, when all art (including music and dance) was craft, in Metcalf's sense. That is, in its origins and in subsistence societies, "art" was—and had to be—functional, material, and communal.

1. Function.

As I have described, the aesthetic elements (or artful "operations") of mother-infant playful interaction arose to aid the survival of helpless babies; in ritual ceremonies, they were co-opted and developed in order to make the ceremony work—to better achieve its purpose. Presumably an ailment could be healed simply by applying a poultice or drinking a potion. But in healing rituals around the world, these remedies alone are usually perceived as insufficient. Special (that is, formalized, repeated, exaggerated, elaborated) words, movements, designs, costumes, behavior are required, not optional. They demonstrate that their makers have taken trouble to show how much they care.

This notion of function allied with specialness or artfulness remains inherent in craft. Although any hollowed out piece of wood can serve as a container, or a cured animal skin be worn as clothing, craftworkers of today, like their predecessors, include artfulness as necessary to function. In this they are aware that humans evolved to care about their lives, and to show this care by making special what is most important to them.

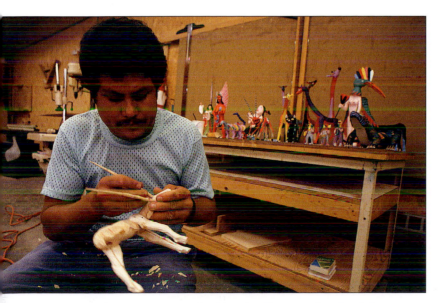

"For the perceiver, a made object implies not only a hand, but a person with hands—someone mortal like ourselves who fashioned this object, brought it into being."

2. Materiality.

Our ancestors evolved in a material, physical world to which they had to adapt. Their bodily attributes and abilities, their psychological needs and desires were developed with reference to that world in which they had to make a living. Craft is ineluctably grounded in the life of the body, the physicality of material and material objects their feel, their weight, their resistance, their fragility or durability. Humans are familiar with the products of craft in a way that they may not be with "works of art" that are meant to fool the eye or mind, that disguise the marks of the hand that made them, and which suggest a transhuman world. We focus not only on the subject or theme of a craft work, if there is one, but on its *thereness,* its substantiality, its *madeness.*

Madeness implies a hand or hands. Hands are one of our most distinctive human characteristics, one of the bodily attributes that evolved so that we could make tools and construct from natural materials the necessities of our lives. Humans possess j*oie de faire,* the pleasure of making things with their hands.[5]

Apart from appreciating how it is to make things, we have other associations with hands. We know how things feel to the hand and we know the varied touches of others' hands. The sense of touch and being touched (like the senses of vision, hearing, and movement, which also evolved in relation to materiality) provides us with rich, interpenetrating, multimodal associations—the "vitality affects" described earlier—with the natural world and the products made from it, as well as with our earliest interactive experiences with other persons.

If hands communicate directly by touch, they do so indirectly, too, with gestures. (Even infants make hand gestures that are communicative, different from their attempts to grasp and manipulate). And in what we make, our gestures take on permanent form so that, whether intended or not, making is a sort of presentation. Something made implies the age-old, open-handed gesture—"here, take this from my hands"— which offers not only a handmade object but evidence, as in one's handwriting, from which other humans can sense what underlies the maker's action and experience.

For the perceiver, a made object implies not only a hand, but a *person* with hands—someone mortal like ourselves who fashioned this object, brought it to being. The knowledge that "someone made this" can become an integral part of our experience of the object. In some cases of strong emotional connection, it can even lead to something very like "affect

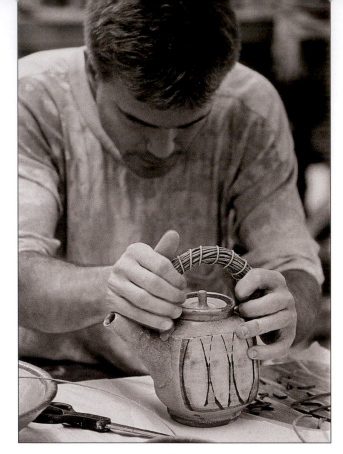

"Although any hollowed out piece of wood can serve as a container or a cured animal skin be worn as clothing, craftworkers of today, like their predecessors, include artfulness as necessary to function."

attunement" with the work/maker, an ardent, moving certainty of shared human feeling and the quality of that feeling.

3. *Communality.*

At the core of ritual and art as I have described them is the emotional intersubjectivity developed and practiced in mother-infant interaction. Making and making special are inseparable from the innate human impulse to share feelings and from the need and ability to express ourselves in relationship with others. And as just described in the preceding paragraph, we experience the works of others intersubjectively also. The gestural traces in handmade objects, like the bodily signatures in dance and song, contribute directly to another's reception or appreciation of them.

Yet in contemporary art theory and practice, works, their makers, and their perceivers are typically treated as lone individuals. Works are decontextualized and displayed as isolated, unique entities. Makers are said to be exploring their unique subjectivity and its preoccupations. Perceivers typically view works silently and alone, from a unique personal sensibility.

Although contemporary craft partakes of the modern art world's insistence on museum-like display and its requirement of originality—these being necessities of the marketplace—I believe that insofar as hand and material presence are maintained the transaction between maker/work and audience remains insistent and inescapable. Additionally and importantly, human relationship is manifested in craft not only horizontally, in the immediacy of close association, but vertically through time.

Craft practitioners generally work within the communal, guild-like process of tradition transmitted from master to pupil. This can be a powerful source of meaning. I remember feeling solemnly touched when my piano teacher told me that he had studied with Karl Schnabel, who had studied with his father, Artur Schnabel, who had studied with…back to Carl Czerny, who had studied with Beethoven. A poet friend, David Evans, tells me that he writes "for or towards those writers whose works I can't get enough of—artists who have given me great pleasure and understanding of myself as well as other human beings and the physical world. I've always had a great driving need to be a part of what they do and are."

At Penland, the vertical and horizontal of communality intersect. Members of the immediate community live and work together, but even when working alone after leaving Penland, the community is implicit. Creative artists sometimes feel that they are conduits for messages from something or somewhere else. Such a feeling takes on a natural, as opposed to supernatural, relevance when one becomes aware that at Penland, one belongs not only to the accidental community of everyone who happens to be there at the time, but additionally of all who have been there over the past seventy-five years, and the company of handworkers from the Pleistocene to today.

NOTES

1. Daniel Stern, *The First Relationship: Infant and Mother* (Cambridge: Harvard University Press, 1977).

2. Ellen Dissanayake, *Art and Intimacy: How the Arts Began* (Seattle: University of Washington Press, 2000).

3. Daniel Stern, *The Interpersonal World of the Infant* (New York: Basic Books, 1985).

4. Bruce Metcalf, "Contemporary Craft: A Brief Overview," in *Exploring Contemporary Craft: History, Theory, and Critical Writing* edited by Jean Johnson (Toronto: Coach House Books with The Craft Studio at Harbourfront Centre, 2003): 13-23.

5. Ellen Dissanayake, "The Pleasure and Meaning of Making," *American Craft* 55(2), (1995): 40–45.

Art is a state of grace which things
that succeed sometimes reach.

Sculptor **Martin Puryear,**
speaking at Penland School, 1997

Craft is simply "perfected attention,"
as the poet Robert Kelly keeps
reminding us.

Poet **Jonathan Williams,** in a catalog essay for an
exhibition of work by Penland instructors, 1969

THE SPIRAL DESIGNS OF NATURE AND CRAFT

Norris Brock Johnson

Fall.

A child consigned to rake leaves by now has fashioned several tall mounds of kaleidoscopic color. With a deep sigh, the child rests for a moment by slowly falling backwards, arms outstretched, to collapse into a waiting mountain of varicolored leaves.

Plussssh!

The child, all smiles at the squishy sound of falling into the mound, drifts into and is surrounded by the delicious smell and wonderful feel of the leaves. Above, the bare branches of maple trees lace a seemingly infinite expanse of sky. The child listens to its heart, beating excitedly.

A timeless moment, an epiphany, to be remembered throughout the life of the child.

Languidly gazing up into the sky, the child is mesmerized by the swirling descent of myriad leaves. The leaves twirl down onto the child, spread-eagled now, windmilling angel wings in the mound. The leaves pirouette in the air, glistening flakes of color. Innumerable hues of red and brown and yellow-gold dance in the soft afternoon light, twirling about each other while spiraling through patches of endless blue down onto the laughing face of the child, open-mouthed in wonderment.

Nature often takes life, moves, and grows both within and without as spiral formations and patterns of design. Consider the spiral form of begonia and honeysuckle stems, pine cones, or the dance of warm and cold air we call a tornado. People are nature, as well, and spirals are the form of vital parts of our bodies: the interlaced muscles of our heart; our inner ear; the whorls on the tips of our fingers.

SPIRALS, CORRESPONDENCE, AND CONSCIOUSNESS

In *Art as Experience,* John Dewey asks, "What, then, are those formal conditions of artistic form that are rooted deep in the world itself?" One response is that the spiral is an archetypal image embedded deeply not only in the world itself, within nature, but also embedded deeply within our human collective unconsciousness and expressed through artistic forms such as crafts. The works of art presented in this essay, seven pieces in various media, both intentionally as well as unintentionally, correspond in their spiral forms and patterns of design to spiral forms and designs of nature, vital aspects of the human body, as well as to the spiral design of crafts from cultures and times other than our own.

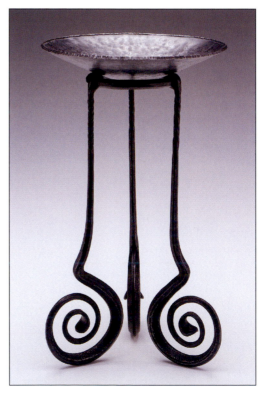

Figure 1: Paige Davis, *Bowl on Stand*

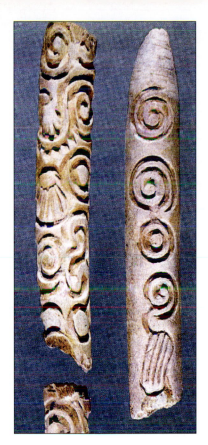

Figure 2

Correspondence is the ancient, widespread idea that things observed to be congruent in physical form in fact are linked, subtly, and metaphysically. According to Ananda Coomaraswamy, in *The Transformation of Nature in Art*, correspondence, observable congruencies of physical form, is a readily accessible way to experience "that single and undivided principle which reveals itself in every form of life whenever the light of the mind so shines on anything that the secret of its inner life is realized, both as an end in itself unrelated to any human purpose, and as no other than the secret of one's own innermost being." Spirals are that single, undivided principle, manifest as the underlying similarity of forms of life, of which we can become aware simply through our conscious awareness of them. In *Art and Beauty in the Middle Ages*, Umberto Eco notes that in many cultures, the primary function of intelligence has been perception of correspondences and "to decipher them [correspondences] was to experience them aesthetically." Life was enchanted, beautiful, and awe-inspiring, as one became aware of the underlying similarities of otherwise "different" forms of life. Eco concludes that through the lens of correspondence, "everything [experienced through physical form] answers to everything else." Pine cones and the stems of honeysuckle and begonia, through correspondence of form, thus participate in the spiraling dances of cold and warm air. Correspondence conditions awareness of fundamental similarities underlying apparent difference—pine cones and fingerprints and a galaxy perhaps might appear radically different until experienced, through awareness of correspondence, as the myriad forms taken by the spiral patterning of life.

Artists often offer intellect, skill, and imagination to the service of keeping alive awareness of the fundamentals of existence. The seven pieces presented here, made by artists affiliated with Penland, appear to manifest each artist's conscious/unconscious awareness of correspondence as well as demonstrate a preoccupation with spiral forms and patterns of design.

These examples artistically focus our awareness on and contemplation of the spiral; quite importantly so, as the spiral appears to be one of the most, if not the most, fundamental forms taken by life. These pieces are formed from the two most widespread and basic types of spirals, the spiral of Archimedes and the proportional spiral.

THE CIRCLE AND THE SPIRAL

Envision a sailor carefully coiling rope on the deck of a sailing ship. The rope is uniform in thickness and, as a result, the curve beginning at the center coils outward while maintaining an equal thickness/distance with each coiling. The spiral of Archimedes (287–212 BCE) thus mirrors the circular center from which the spiral is formed, as does the coiling of fabric braided into a rug or the coiling of clay rope in handbuilding a pot. The spiral of Archimedes embodies the close form-connection between two archetypal, symbolically rich forms: the circle and the spiral.

The spiral of Archimedes appears, dramatically, as the form of several of the pieces. *Bowl on Stand* (Figure 1) is replete with archaic, primal forms—three coiled spirals functioning as legs reach up to support a disk, a bowl. Or, experienced from the top down, a circle ("unity") extends downward to bring into being a succession ("multiplicity") of spirals. The coils comprising the three spiral legs maintain equal distance throughout movement from/to the center of the spiral. The circular-appearing coils of the three spiral legs, spirals of Archimedes, mirror the circular shape of the bowl and thus dramatize the interrelationship of the circle and the spiral.

Notice that the conical spiral legs of *Bowl on Stand* are counter-opposed; that is, the spirals coil from the center outward in opposing directions. Two types of coiled spirals appear across cultures and, as we will see, within human prehistory: a clockwise spiral beginning at the center and coiling outward to the right, and a counter-clockwise spiral beginning at the center and coiling outward to the left. The clockwise/counter-clockwise pairing of coiled spirals evokes widespread human symbolisms such as the "unity" underlying perceived "duality," the differing though interrelated oscillations of sun and moon, male and female, birth and death, and so forth.

Figure 2 is a photograph of reindeer antlers from the prehistoric site of Isturiz, Basses-Pyrénées, France. Dated to the late Magdalenian Period (circa 10,000 BCE), the pieces of antler are strewn with spirals formed from deep cutting into

the bone; the fragments of bone are dense with both clockwise and counter-clockwise spirals. Whatever their meaning, the appearance in prehistory of spirals so intentionally and carefully rendered is compelling.

On the bone fragment to the left, clockwise and counter-clockwise spirals are paired to interweave opposites. Correspondingly, counter-opposed clockwise and counter-clockwise spirals are interwoven as the foundation of *Bowl on Stand*; in addition, the counter-opposed spirals evoke the tai-chi image in Figure 8. *Penland Poplar* (Figure 3) is a wooden bowl constructed from the counter-clockwise coiled arrangement of segments of poplar bark. Perhaps we expected concentric circles as the center of the bowl, as trees grow outward concentrically leaving familiar "tree rings." But trees grow upward as well as outward, and the upward growth of trees is spiral. As our eye follows the counterclockwise spiral of *Penland Poplar*, coiled like rope on the deck of a sailing ship, we experience a curve of movement to and from the center of the bowl echoing the spiral growth of trees. In its spiral form, *Penland Poplar* makes evident that which is invisible (a spiral) if we only view a cross-sectional slice of tree as the exclusive pattern (concentric tree rings) of the larger spiral pattern of growth of the tree. *Penland Poplar* is a utilitarian object stimulating contemplation of the spiral as the form of organic growth in nature.

Spirals can unfold into three-dimensional space (length; width; depth) as well as into two-dimensional space (length; width), and *Sycamore Spiral* (Figure 4) dramatizes just such a spiral unfolding into three-dimensional space. Howard

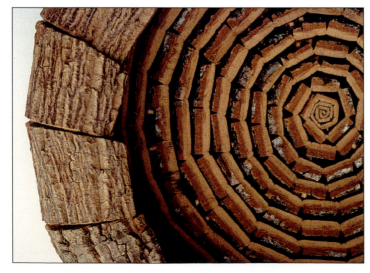

Figure 3: Dorothy Gill Barnes, *Penland Poplar* (detail)

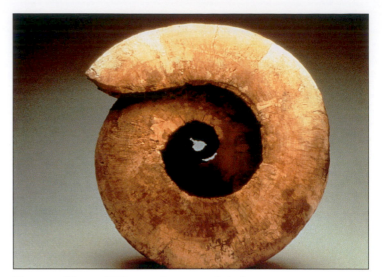

Figure 4: Howard Werner, *Sycamore Spiral*

Werner told me that his nearly twenty-year use of spirals in wood sculptures has been quite conscious. "My spiral sculptures are inspired by nature," he said, "especially by the forms of sea shells." Not unlike peeling an apple in one strip, *Sycamore Spiral* was cut with a chainsaw to overlap the unfolding coils so as to define the three-dimensional depth of the sculpture. Crafts such as *Sycamore Spiral* in their form preserve the spiral process of their creation just as do seashells, the tips of our fingers, and distant galaxies. Many cultures in addition say that Deity is a potter, the first Maker of things. A potter at the wheel throwing a pot, coiling a bowl into being, repeats a process of metaphysical significance within many cultures. When artists craft works of art in spiral forms or patterns of design, the very process of production mimics and repeats the formation of spirals in nature; in the process of crafting spirals, the artist literally is one with nature.

Rainstick Goblet (Figure 5) also evokes the movement of a coiled spiral unfolding into three-dimensional space. Subtly zoomorphic or anthropomorphic in form, *Rainstick Goblet* feels alive. Glass artist Sally Prasch told me that the presence of spirals in her work is unconscious, as "motion and sound were the intent of *Rainstick Goblet*." Prasch placed small marbles in the coil of the glass sculpture so that when the goblet is used for drinking the marbles will tumble about in the coil.

Rainstick Goblet can be experienced as a coiled spiral elongated in evoking vital movement and generative growth. The tip of the bottom spiral is placed slightly in front of the upward coil of the spiral, assigning three-dimensional depth to *Rainstick Goblet* in the same manner in which *Sycamore Spiral* was carved to present a sense of depth.

Photos: left, courtesy Dorothy Gill Barnes; right, courtesy Howard Werner

CROSS-CULTURAL CORRESPONDENCES OF SPIRAL DESIGN

Consider again the fragments of prehistoric antlers in Figure 2. The bone fragment on the right side of the photograph is incised with three distinct spirals, each varying in design. The incised design at the top of the antler approximates a coiled spiral of Archimedes rotating clockwise from the center. The top design corresponds to the clockwise-rotating coiled spirals within the bowls in Figures 3, 7, and 9, as well as to spiral aspects of nature such as sea shells (Figures 11 and 12). The middle design incised on the antler appears to be a rotating spiral (top part) attached to two concentric circles (bottom part). The middle design suggests motion from a circular center into a spiral, corresponding to the design and physical form of *Bowl on Stand* (Figure 1). Notice also the correspondence of the lower design on the antler to the right, *Rainstick Goblet* (Figure 5), and the drawing of a *Rain Dreaming* by the Walbiri of Australia (Figure 6). The antler to the right in Figure 2 can be experienced from the top down as a sequence of designs growing more intricate as one moves from the single spiral at the top, down to

Figure 6

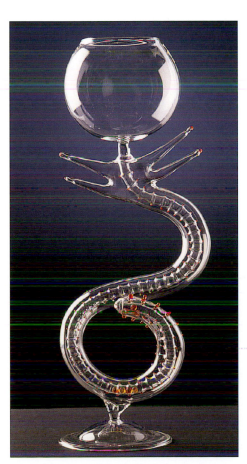

Figure 5
Sally Prasch,
Rainstick Goblet

the differentiating spiral in the middle design, then to the smaller spiral linked to the rectangular set of lines. Similarly, movement accompanied by transformational change in form also is an aspect of the design of *Bowl on Stand, Rainstick Goblet,* and the Walbiri *Rain Dreaming.* The correspondences of spiral design in contemporary crafts, in artifacts from human prehistory, and from disparate cultures are captivating.

People who name themselves Walbiri live in the desert areas north of Alice Springs, north Australia. The Walbiri tell us that ancestor deities, Dreamings (*Djugurba*), created existence and that Walbiri continue to encounter Dreamings during the sleep referred to as Dreamtime. Walbiri believe that Dreamings came up from the earth, then walked about (*wari-wabadja*, the Australian Walkabout) to create myriad forms of life. Walbiri believe ancestor deities were capable of sleep and dream. In *Walbiri Iconography*, Nancy Munn notes that the Dreamings were asleep when they dreamed the world, our world, they created in their dream-travels. As perhaps we at one time or another have felt momentarily, the world may be a dream and, for the Walbiri, the world continues to be dreamed into being by the Dreamings.

Spirals predominate in Walbiri paintings and drawings of Dreamtime which are, by correspondence, paintings and drawings of the generative activity of ancestor Dreamings during their Dreamtime. Figure 6 is a Walbiri drawing (*guruwari*, meaning potent and generative) of the creation of rain through the creative activity of *Rain Dreaming*. The belief is that the *Rain Dreaming* came out of the ground at the central point of the spiral, then walked around. As the *Rain Dreaming* walked, rain came into being and moved outward, from our perspective, in the form of a proportional spiral. In turn, during their Walkabouts, Dreamings from the earth brought into being each and every form of life.

Walbiri attribute depth, three-dimensional space, to their drawings. The center of the spiral in *Rain Dreaming* is envisioned as lower than the progressively-higher outer edges of the spiral. The clockwise-rotating spiral not only moves out horizontally, from the center, but at the same time also moves up, coils up, vertically from the bottom center to expand horizontally across the surface.

Rainstick Goblet and *Rain Dreaming* both associate unfolding coiled spirals with water, rain, and generative movement. Along with the open-ended meandering line incised on the prehistoric antler bones in Figure 2, *Rain Dreaming* and *Rainstick Goblet* both emphasize the open, elongated end of a coiled spiral in association with ongoing creative movement. Consciously or unconsciously, craftspeople often choose spiral designs for their art and in so doing craftspeople consciously or unconsciously give tangible form to ideas and feelings about life itself.

Encircled by the Thread of Spirals

The spiral forms of *Sycamore Spiral* and *Rainstick Goblet* also can be seen to evoke the spiraled genetic basis of life within our bodies. In 1953, Francis Crick and James Watson reported that DNA (nuclear DNA, Deoxyribose Nucleic Acid) molecules coding genetic information spiraled around each other in the now-familiar form of a double helix. Earlier though, in 1890 Richard Altmann found sugar and protein-rich mitochondrial DNA (mtDNA) in the cytoplasm outside the nucleus of cells. MtDNA provides the energy for the intracellular activity of nuclear DNA; if DNA is the genetic blueprint of organic life, then mtDNA fuels that blueprint.

Consider human sperm cells. DNA is carried within the oval-shaped heads, the nucleus, of sperm cells. MtDNA, fueling the frantic oscillating movements of sperm toward and

hopefully into, an egg, is carried outside the heads of sperm cells in the "mitochondria sheath" between the head and the long tail of sperm. Mirroring the spiral form of nuclear DNA, the sheath surrounding the filament of mtDNA genetic material is spiral in form. The double spiral of DNA, and the spiral threads of mtDNA—spirals await us at every turn as we delve ever deeper into the physiology, the form, of life itself.

Crafts and the Curve of the Universe

In addition to the spiral of Archimedes, craftspeople often make art designed around the second basic type of spiral — the proportional spiral. The form of a proportional spiral elaborates upon generative motions of unfolding present in the form of coiled spirals.

The bowls in Figures 7 and 9 re-create spirals corresponding to the form of existence and the ongoing unfolding of life (Figures 6 and 8), as we will see. The green-glazed porcelain bowl in Figure 7 is circular in form, but the outer circular form of the bowl focuses our attention on a double-spiral coiling from/into the center of the bowl. Leah Leitson told me that "spirals have always been a part of my work. I was not as preoccupied with the spirals in the center as with the fluting on the outside of the bowl, stimulated by the forms of plant life and nature." However, the fluting winding around the outer area of the bowl is a concatenation of scallops serving to reinforce the compelling double-spiral design of the inner area of the bowl.

We can experience the circular aspect of the bowl as a round frame, a portal, focusing contemplative attention on the swirling inner area of the bowl even though Leitson told

Figure 7: Leah Leitson, *Bowl*

me that contemplation of spirals was not her intent. One can, though, almost feel the movement of primal energy spiraling toward/away from the center of the bowl. Dark flecks of glaze pepper the light-colored spirals within this beautifully made bowl. As we look deeply, and linger, the bowl visually held between our hands, it is as if a universe flecked with galaxies and stars is swirling into being.

THE SPIRALS OF CREATION

The spirals within the bowls in Figures 7 and 9 correspond with an ancient yet still well-known image of the spiral form and nature of the universe. The familiar yin/yang image originated within the Taoist philosophy of dynastic China (Figure 8). Tai-chi is the spiral manifestation of yin/yang. The tai-chi spiral is the culminating manifestation of a process of creation the beginning of which was imaged as circular. Absolute nothingness, the source and ground of existence, later came to be named the Tao. In Taoism, existence manifests itself as an infinite number of complementary opposites: day, for instance, is primarily yang while night is primarily yin; the sky is primarily yang, while the earth is primarily yin; males are primarily yang, while females are primarily yin, and so forth. The word "primarily" is important. Within the tai-chi image, notice the small dark circle within the larger light-colored spiral and the small light circle within the larger dark-colored spiral: inside yin there is yang and inside yang there is yin. Light exists with dark; dark exists with light, an affecting instance of what Eco, in *Art and Beauty in the Middle Ages*, terms "an aesthetic expression of ontological participation." Complementary-opposition correspondence exists within each aspect of existence, as well as between aspects of existence.

The yin/yang state of interrelationship is not the final Taoist manifestation of the universe, as the beginning of motion is the birth of yang and the end of the motion is the birth of yin. Tai-chi is the spiral motion of complementary opposites, comprising existence. The gradually curving line within tai-chi defines two interrelated spirals, alternating principles in continual motion as the fundamental form and nature of existence.

The interlaced spirals at the heart of the bowls in Figures 7 and 9 correspond to the tai-chi image from early Taoist China. Within the bowl in Figure 7, two comparatively dark spirals are highlighted with faint white lines evoking the perpetual creative motion of the Tao. The process of making the

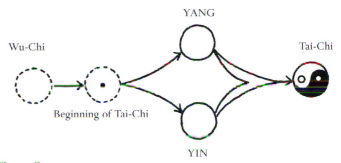

Figure 8

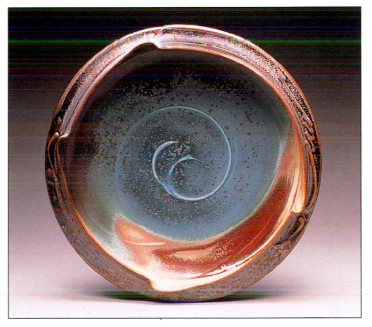

Figure 9: Steven Hill, *Bowl*

bowl thus echoes and repeats what the Taoists long ago named as the creative spiral movements of the universe.

Independently conceived and crafted, the bowl in Figure 9 corresponds to the bowl in Figure 7 in conveying generative motion embodied as a spiral. Here, the compelling contrast in color between the gold of the outer aspect of the bowl and the bluish cast of the inner aspect of the bowl is a beautiful complementary opposition. As in the bowl in Figure 7, the bowl in Figure 9 complementary-opposes the inner spiral area of the bowl and the outer circular area of the bowl. Notice the four spiral-shaped, embellished notches in the rim of the bowl; the notches complement the larger spirals at the center of the bowl, and suggest a quartering of the circle into compass directions. It is as if the bowl itself is rotating clockwise; motion, again, as a primary attribute of a spiral. Mirroring the bowl in Figure 7, the bowl in Figure 9 high-

lights the central spirals within the bowl with faint white lines evoking the generative motion of a primal spiral.

Complementary opposed spirals also are the form of an environmental art installation at Penland (Figure 10). In *Penland Soul*, dark-colored spiral arms (primarily yin) are defined by, and composed of, twigs, pebbles, and leaves. The twigs and leaves generate the organic feeling of the composition, as the spiral arms not only evoke life but in fact are remnants of life intentionally left to decay—"ephemeral art," as the artist, Chris Allen-Wickler, termed it. Interwoven, light-colored spiral arms (primarily yang) are defined by gravel, small pebbles, and flagstones on which the spiraled twigs and leaves are placed. The flagstones are stepping stones inviting people to experience the spiral design directly, intimately, from within. Allen-Wickler said that the spiral motif of *Penland Soul* was quite conscious. "The spiral form of the installation came to mind as I was driving up the mountain to Penland for the first time. From the time you get off the highway, the drive up the mountain is a series of spirals. I think of the soul of Penland as a spiral." Literal movement toward/away from Penland is a spiral, with Penland itself as the center of a spiral.

Artists here thus consciously/unconsciously brought into being spiral-laden crafts resonating as archetypal forms and images. Plato (427–347 BCE) considered archetypes to be divine ideas. The Swedish psychologist Carl G. Jung felt that archetypes were images of the psychic structure of our collective unconscious. Archetypes often manifest themselves as images such as the spiral—primordial images as Jung termed them. In addition, nature also lives in the form of spirals. In making spiral-laden crafts, artists join nature in a synchronicity of song about the fundamentals of existence.

The Craft of Proportion

The spirals comprising the tai-chi image, the spirals in the bowls in Figures 7 and 9, and the earth art in Figure 10 all correspond to the proportional spiral. Proportional spirals possess intriguing natural properties.

Proportional spirals unfold from a center such that the same part-to-part and part-to-whole relationships defined by an unfolding, curving line remain the same *no matter the size of the spiral*. Proportion defines a relationship between different magnitudes, or sizes of things, in which the small part stands in the same proportion to the large part as the large part stands to the whole. Proportion is a constant ratio of

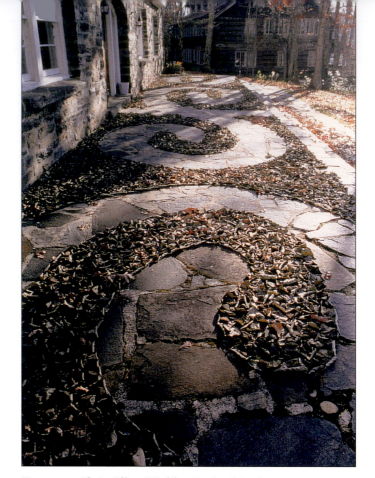

Figure 10: Chris Allen-Wickler, *Penland Soul*

relationship; no matter how large or how small in physical size, the proportional part-to-part and part-to-whole relationships of an unfolding spiral do not change. In *Sacred Geometry*, Robert Lawlor concluded that an unfolding proportional spiral was held to be "so rich in geometric and algebraic harmonies that traditional geometers named it *Spira mirabilis*, the miraculous spiral." Pythagoras of Samos (582–500 BCE) held that proportion was a "divine harmony." It is no wonder that proportional spirals continue to capture the human imagination.

The spirals of nature invariably are proportional spirals and the most widely-noted proportional spiral of nature is the shell of the chambered nautilus (*Nautilus pompillius*) (Figures 11 and 12). The creamy, pearl-white shell of a nautilus is composed of gas-filled chambers that increase in number, up to about thirty-six, as the animal grows to between ten and twelve inches in length. The nautilus lives in the last, the largest, and most recent chamber of the shell.

The shell of the nautilus is not alive, but the form of the shell is linked to the nautilus's pattern of growth. In *The Power of Limits: Proportional Harmonies in Nature, Art, and*

Architecture, György Doczi tells us that as the nautilus grows and secretes ever-larger living chambers as old and new stages of growth continue to share the same proportion. Though the size of the nautilus increases, the overall form of the whole is present in the form of every small part (compare Figures 11 and 12). The naturally proportional spirals in Figures 11 and 12 correspond to the proportional spirals in Figures 7, 9, and 10. Here craft mirrors nature and nature mirrors craft.

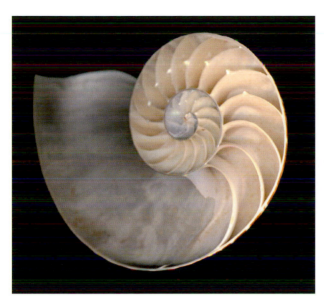

Figure 11

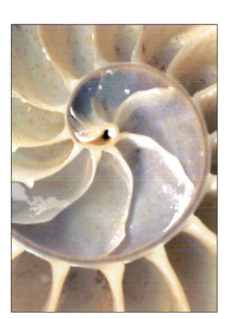

Figure 12

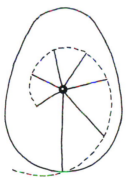

Figure 13

SPIRALS OF EXISTENCE

The proportional curve of spirals in the micro-universe of nature corresponds to the proportional curve of spirals in the macro-universe of the cosmos. Many cultures depict the origin of the cosmos as an unfolding proportional spiral.

The half a million or so people who name themselves Dogon continue to live in villages and towns nested in the Bandiagara cliffs along the upper bend of the Niger river, in Mali, West Africa. In the late 1950s a Dogon priest, Ogotemêlli, gave the French researchers Marcel Griaule and Germain Dieterlen a remarkable account of the Dogon conception of the origin of the universe. According to Ogotemêlli, in *Conversations with Ogotemêlli*, the universe is a primal seed of potentiality within which existence was born through seven primordial vibrations. Figure 13, Ogotemêlli's image of the origin of the universe, shows the seed-shape of a primal yet-to-be-born universe with the seed-of-origin in the center and seven lines of varied but proportional length, creative vibrations, emerging axially from the center seed. Notice the dotted line drawn to link the seven primal vibrations; according to Ogotemêlli, the dotted line defines the unfolding of existence, the curve of which is a proportional spiral. At the seventh vibration, toward the bottom of the sketch, spiraling generativity bursts forth as the universe and the infinite extension of the universe takes the form of a progressively unfolding spiral. For the Dogon, a spiral is the primal form of, the impulse toward, the unfolding creation of, and the on-going life of existence.

The proportional Dogon curve of the spiral of creation corresponds to the curve of the line defining proportional spirals in Figures 7, 9, and 10. Interestingly, as concerns crafts and craftspeople, Ogotemêlli also said that "in his [her] hands a round pot became a sun with eight spirals of copper, and an old basket a universe." In *The Unknown Craftsman*, Soetsu Yanagi in Japan likewise concludes that "every artist knows that he [she] is engaged in an encounter with the infinite, and that work done with heart and hand is ultimately worship of Life itself."

There are intriguing correspondences between the works of craft presented here, cross-cultural accounts of the form of the cosmos, and contemporary astronomical observations of the form of the universe. Galaxies, for instance, are vast clusters of stars and their solar systems. The Sloan Digital Sky Survey intends to map one-quarter of the observable universe and in the process has already catalogued about 200,000 galaxies. It is estimated that there are perhaps 100 billion or

Figure 14

more galaxies in the universe, with each galaxy containing many billions of stars around which circle millions of solar systems and their planets, with some planets perhaps much like our own planet. Spiral-shaped galaxies account for about two-thirds of all known galaxies, reiterating the prominence of spiral formations in nature.

NGC 3310 (Figure 14), for instance, is a comparatively young galaxy (about 100 million years old) 59 million light-years from earth. The galaxy contains billions of stars clumped in several hundred bright clusters. Despite its awesome size, the proportional spiral form of NGC 3310 corresponds to the proportional spiral form of crafts in Figures 7, 9, and 10, the Dogon image of creation and, on an even smaller scale, the sea shells in Figures 11 and 12.

Stars and solar systems and planets continue to be formed as the rotating core of NGC 3310 flings inconceivable amounts of matter and energy into space. Due to rotation, primarily, the matter and energy swirl outward in spiral arms reaching across 80,000 light years of space. The spirals are clouds of fine dust, energy, and gasses from which new stars are born. The kaleidoscopic dots and swirls of color in the spiral arms of the NGC 3310 are new stars; perhaps many stars in time will harbor life, in some form. New life spirals into space from the older dense swirling core, and older dying stars, of the galaxy. From our distant vantage, NGC 3310 is an ever-flowing cornucopia flinging out the potential for life through the delicate fingertips of spirals.

Spring.

Sitting cross-legged on the grass, watching the child playing in the sunlight of a meadow. The laughter of the child brings to life memories of sky and sun and long-ago laughter. Something familiar. Comforting.

The meadow is sparkling with myriad motes of pollen drifting in late-afternoon shafts of light funneling through the tops of maple trees. The child runs up, excitedly: "Show me! Show me! Show me!"

Hand in hand, they walk into and sit in the light. The large hand is a cradle, holding the smaller hand up to the sun in movements half-forgotten but important enough to remember. To pass on. The wrinkled hand guides the smooth hand in ever-increasing swirls within the shaft of light, stirring the pollen motes of life into an ever-larger golden vortex of motion. Joy and laughter explode from the child and they both smile widely at the expanding cone of life between their hands, glinting in the sun. Like angels twirling the spiral dance of eternal possibility, at the still center of a shaft of light.

BIBLIOGRAPHY

Ball, Philip. *The Self-Made Tapestry: Pattern Formation in Nature*. Oxford: Oxford University Press, 1999.

Cook, Theodore Andrea. *The Curves Of Life, Being An Account of Spiral Formations and Their Application to Growth in Nature, To Science, and to Art*. New York: Dover, 1979.

Coomaraswamy, Ananda K. *The Transformation of Nature in Art*. New York: Dover, 1956.

Dewey, John. *Art as Experience*. New York: Perigee Books, G.P. Putnam, 1980, copyright 1934.

Doczi, György. *The Power of Limits: Proportional Harmonies in Nature, Art, and Architecture*. Boston & London: Shambhala, 1994.

Eco, Umberto. *Art and Beauty in the Middle Ages*. New Haven and London: Yale University Press, 1996.

Eglash, Ron. *African Fractals: Modern Computing and Indigenous Design*. New Brunswick: Rutgers University Press, 1999.

Ghyka, Matila. *The Geometry of Art and Life*. New York: Dover, 1977.

Griaule, Marcel, and Germaine Dieterlen. *Conversations with Ogotemêlli: An Introduction to Dogon Religious Ideas*. London: Oxford University Press, 1965.

Johnson, Norris Brock. "A Song of Secret Places." *Pilgrimage* 25(3&4): 4-10, 1999. ———. "Art and the Meaning of Things." *Reviews in Anthropology* 17: 221-234, 1990. ———"Primordial Image and the Archetypal Design of Art." *Journal of Analytical Psychology* 36:371-391, 1989. ———."Image and Archetype: Male and Female as Metaphor in the Thought of Carl G. Jung and Ogotemêlli of the Dogon." *Dialectical Anthropology* 13: 45-62.

Jou, Tsung Hwa. *The Tao of Tai-Chi Chuan*. Piscataway: Tai Chi Foundation, 1979.

Lawlor, Robert. *Sacred Geometry: Philosophy and Practice*. New York: Crossroads, 1982.

Leroi-Gourhan, André. *Treasures of Prehistoric Art*. New York: Harry N. Abrams, 1967.

Lippard, Lucy. *Overlay: Contemporary Art and the Art of Prehistory*. New York: Pantheon Books, 1983.

Munn, Nancy. *Primitive Art and Society*. Edited by Anthony Forge. London: Oxford University Press, 1973.

Purce, Jill. *The Mystic Spiral*. London: Thames and Hudson, 1974.

Thompson, D'Arcy Wentworth. *On Growth and Form*. London: Cambridge University Press, 1968.

Yanagi, Soetsu. *The Unknown Craftsman: A Japanese Insight Into Beauty*. Tokyo and New York: Kodansha, 1978.

Photo: Hubble Telescope

The handmade object does not charm us simply because of its usefulness. It lives in complicity with our senses, and that is why it is so hard to get rid of it—it is like throwing a friend out of the house.

Octavio Paz,
from "Seeing and Using: Art and Craftsmanship"
in *Convergences: Essays on Art and Literature,*
Harcourt, Brace, and Co., 1987

Using your hands as tools to communicate thoughts and ideas; the relationship between hand, mind, thought, and object; the satisfaction of making something that you can use in your life—these are the things I think make craft education important.

Metalsmith **Susan Ganch,** oral history, 2002

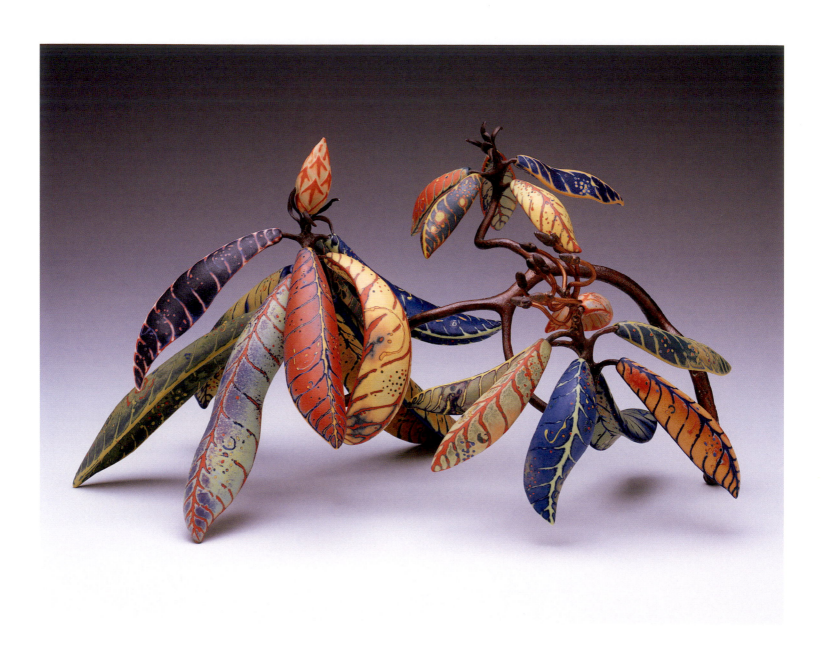

SOURCE: WHERE IDEAS ARE FOUND

Artists have the ability to explain ideas visually. Their inspiration is found everywhere—by looking at natural and built environments, by examining body and spirit, by exploring the past, and by imagining the future. Many insights are discovered by chance, in playful moments or through the process of making. These sources and the ideas they foster are visible in the objects that artists make.

MICHAEL SHERRILL
Shining Rock Rhododendron, 2000
Stoneware
12 x 20 x 12 in.
Collection of Lisa and Dudley Anderson

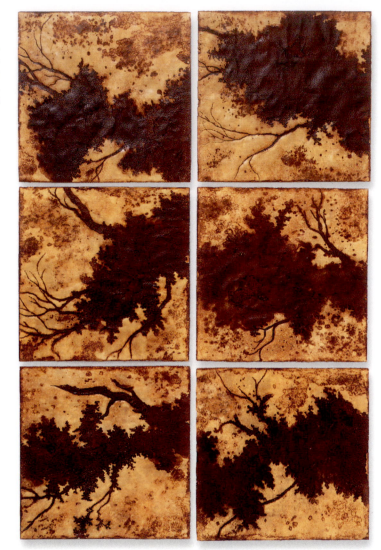

JOE WALTERS
Night Vision Series, 2000
Tea, bleach, shellac, beeswax on paper
6 panels, each 18 x 18 in.
Collection of the artist

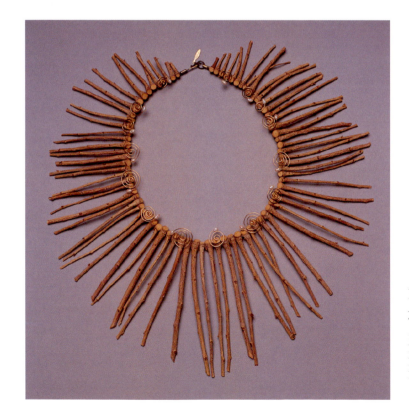

ROBERT EBENDORF
Necklace, 1994
Twigs, pearls, 18K gold
19 x 6 in.
Porter-Price Collection, Gallery of Art & Design,
North Carolina State University, Raleigh, NC
Photo: Doug Van de Zande

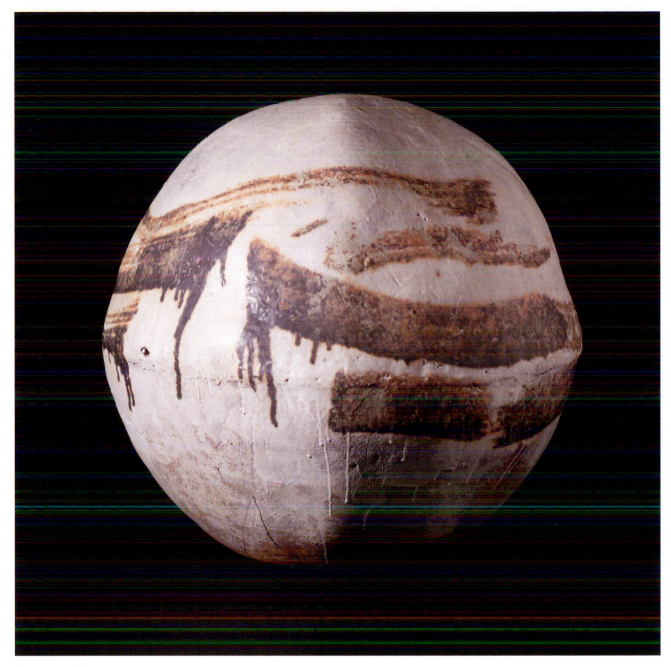

Toshiko Takaezu
Full Moon, 1978
Handbuilt, glazed stoneware with interior pebbles
27 3/4 x 29 1/2 in.
Collection of the Smithsonian American Art Museum,
Washington, DC
Photo: Smithsonian American Art Museum,
Washington, DC/Art Resource, NY

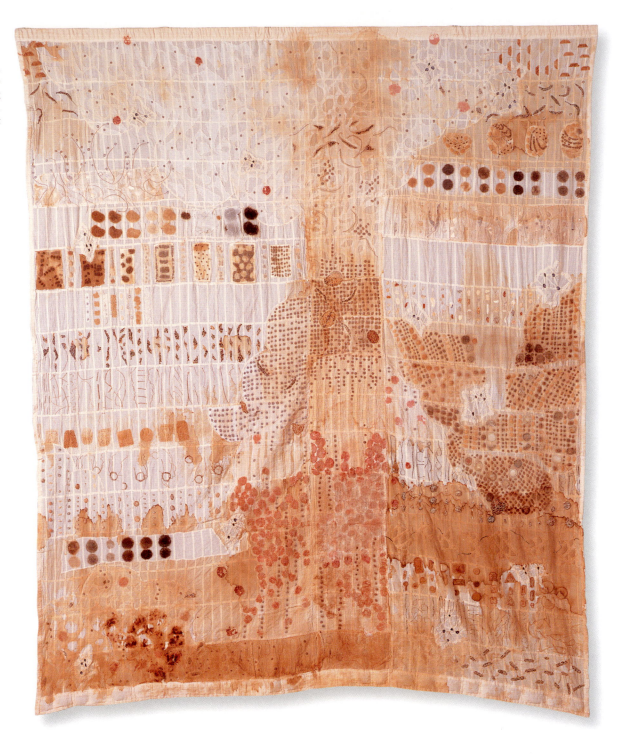

MIYUKI IMAI,
Bibliography, 2000
Cotton, plants, seeds, stitching
100 x 80 in.
Collection of the artist

PENLAND WEAVERS
Wall Hanging: Pine Tree and Snow Ball, circa 1939
Wool and cotton, jacquard double-weave
42 x 29 in.
Collection of Southern Highland Craft Guild,
Asheville, NC

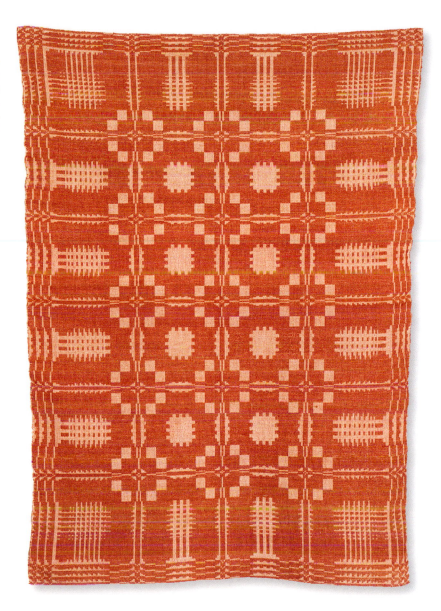

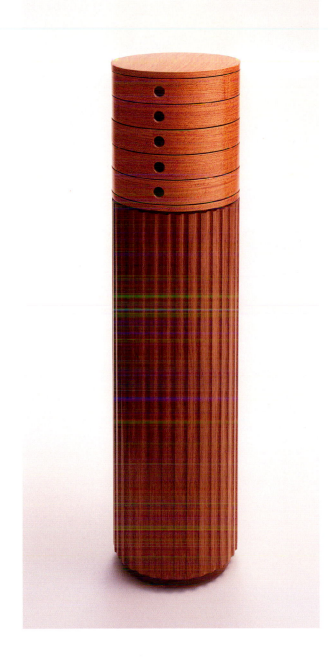

JOHN DODD
Cylindrical Compliment, 2003
Lacewood and mahogany
48 x 12 in.
Collection of the artist

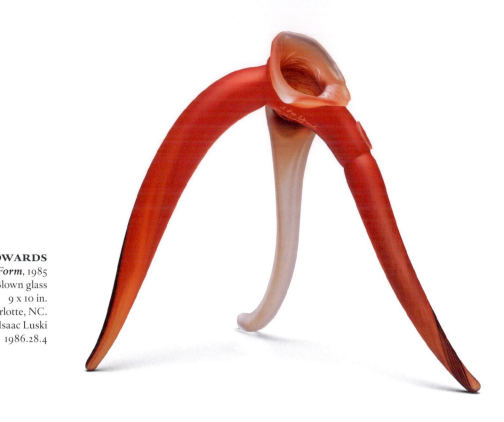

STEPHEN DEE EDWARDS
Tripod Sea Form, 1985
Blown glass
9 x 10 in.
Collection of The Mint Museums, Charlotte, NC.
Gift of Sonia and Isaac Luski
1986.28.4

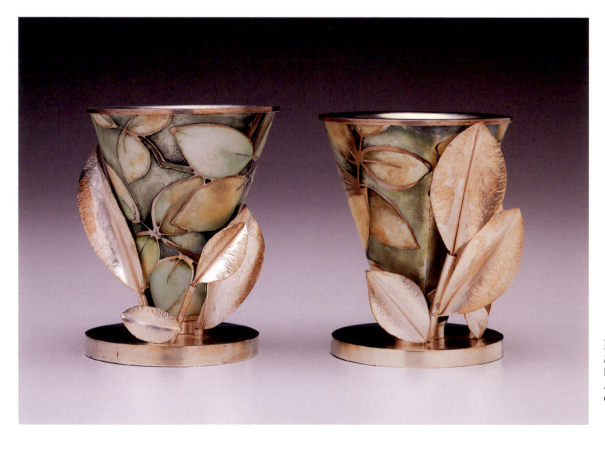

LINDA DARTY
Pair of Candlesticks, 2000
Enameled silver
4 x 3 in. each
Collection of the artist

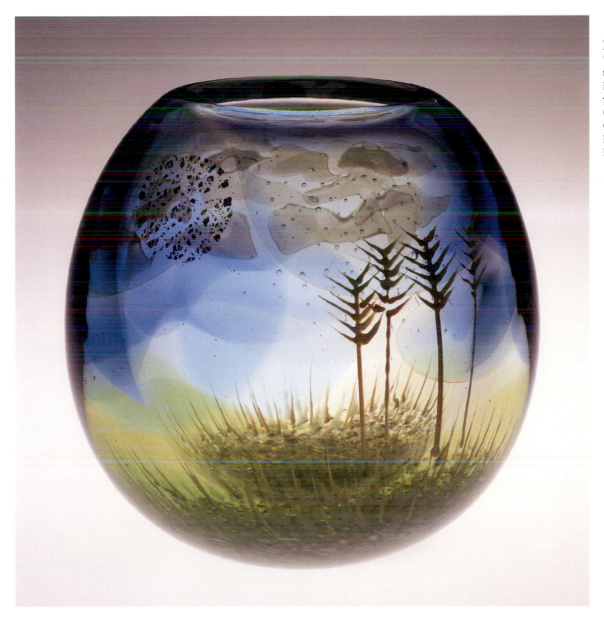

MARK PEISER
The Wheat Piece,
from the *Paperweight Vase series,* 1978
Blown glass
7 x 7 in.
© Mark Peiser
Collection of Indianapolis Museum of Art, Indianapolis, IN
Partial and promised gift of
Marilyn and Eugene Glick

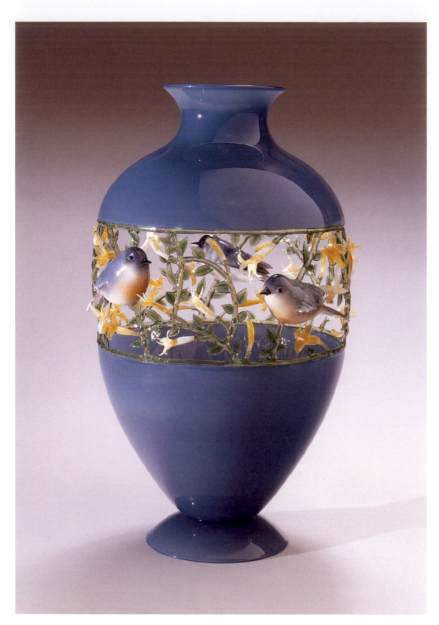

MARC PETROVIC AND KARI RUSSELL-POOL
Banded Vessel series:
Blue Vase with Birds and Honeysuckle, 2003
Blown and lamp-worked glass
16 x 10 in.
Collection of the artists

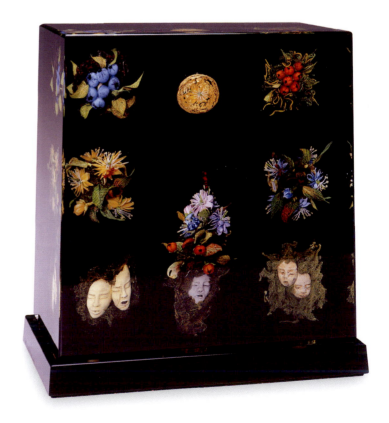

PAUL STANKARD
Penland's Nocturnal Bloom, 2003
Glass assemblage
8 ¼ x 7 ¾ x 4 ¾ in.
Collection of Mike and Annie Belkin

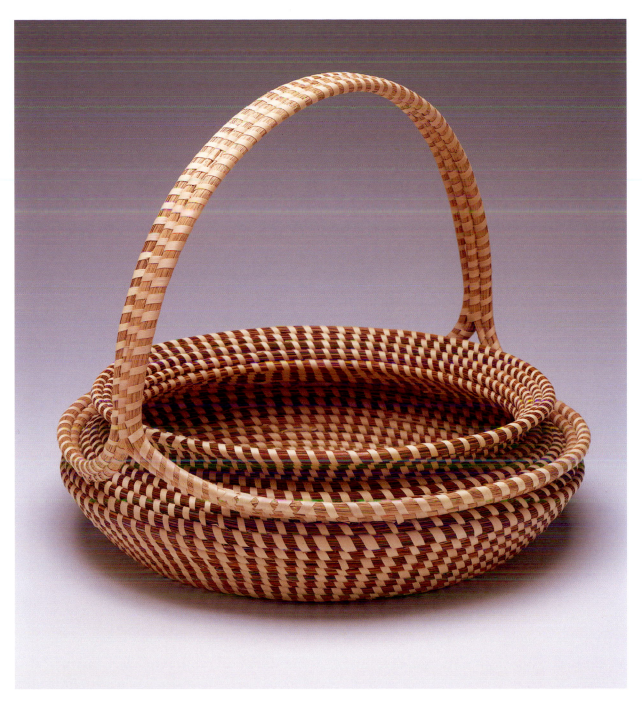

MARY JACKSON
Two Lips, 1984
Bulrush, sweet grass, pine needles, palm
16 x 19 x 19 in.
State Art Collection, South Carolina Arts Commission

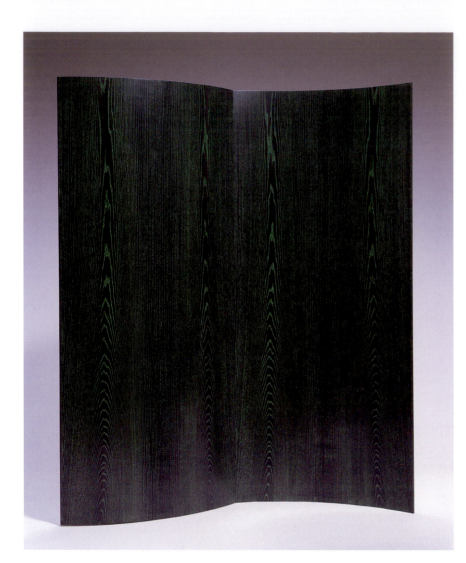

MICHAEL PURYEAR
Screen, 1999
Laminated ash, dyed green
69 x 59 x 4 1/2 in.
Collection of the artist

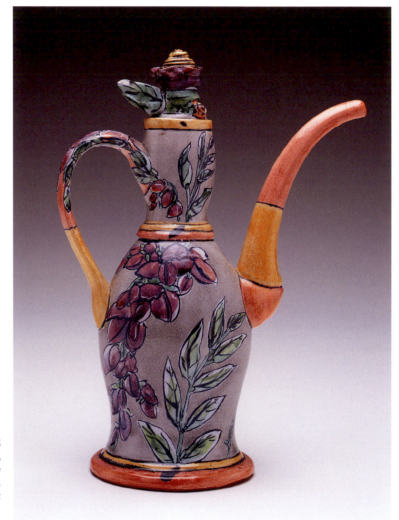

LINDA ARBUCKLE
T-Pot: Her Wisteria, 2003
Earthenware with majolica glaze
12 3/4 x 9 3/4 x 4 in.
Collection of the artist

RICHARD RITTER
Untitled, 1977
Graphite on paper
8 x 11 in.
Collection of the artist

RICHARD RITTER
Floral Core Series #27, 2001
Solid glass with murrine and cane
3 7/8 x 9 x 12 in.
Collection of James and Judith Moore

Ideas sometimes take a while to bear fruit. Richard Ritter kept the above drawing in his studio for twenty-four years before he attempted to make the form he had sketched. The result was his *Floral Core Series*.

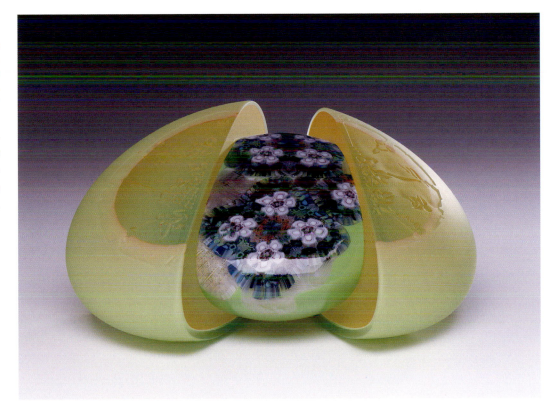

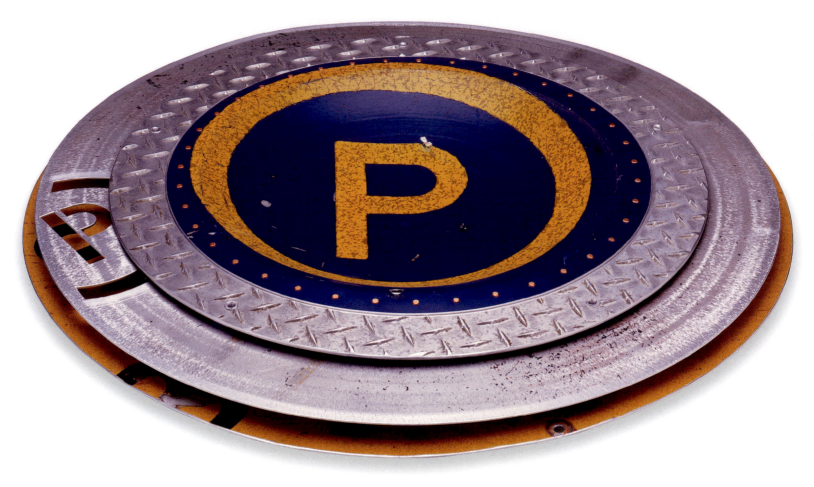

BORIS BALLY
P is for Platter, 2003
Recycled aluminum traffic signs, recycled
deckplate, scrap aluminum, copper rivets
2 ¾ x 30 ⅛ in.
Collection of the artist

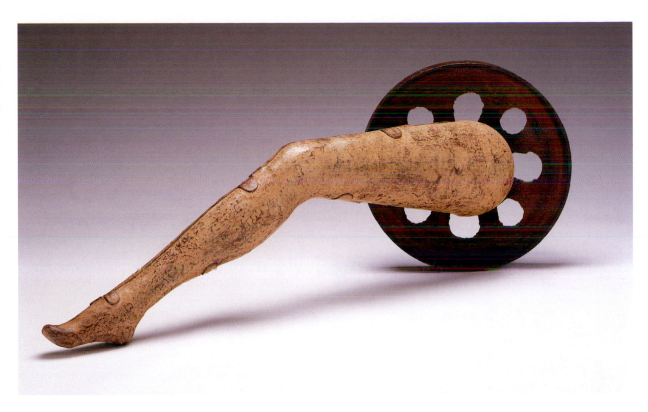

HOSS HALEY
Toy, 1998
Iron, steel, paint
15 x 41 x 10 in.
Collection of Dana Moore

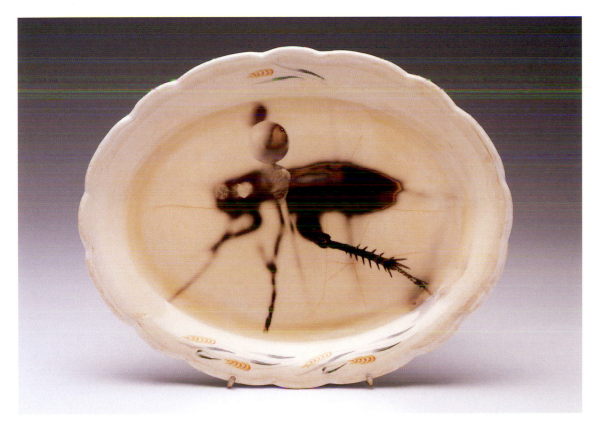

DEBORAH BRACKENBURY
Forbidding Mourning: Camel Cricket, 2002
Ceramic plate with photo emulsion
10 x 13 in.
Collection of Deborah Luster

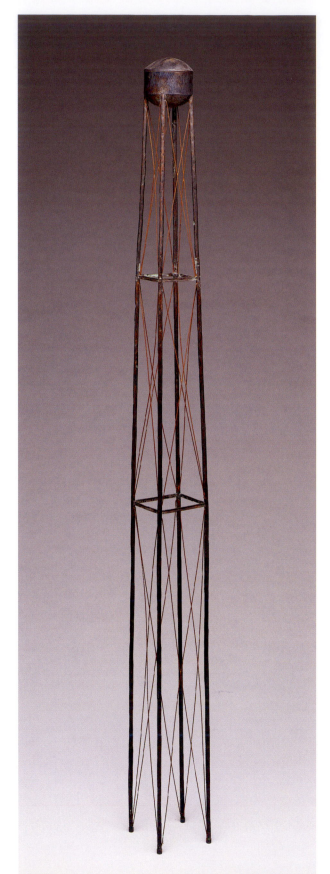

CHRISTINA SHMIGEL
Place & Settlement #4, 1990-91
Brass, copper, steel
67 x 5^1/$_2$ x 5^1/$_2$ in.
Collection of the artist

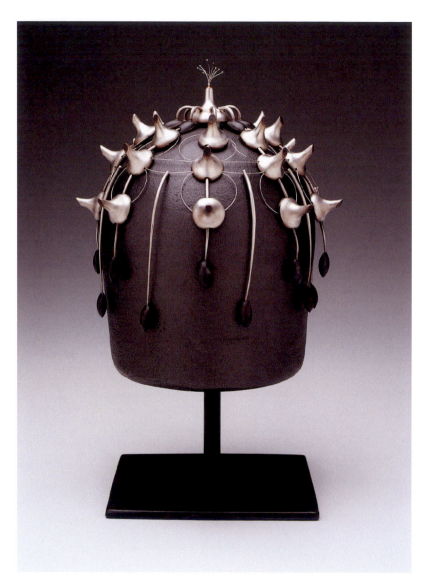

SUSAN GANCH
Thinking Cap #4, 2000
Silver
8 x 7 1/$_2$ x 7 in.
Collection of the artist

PAIGE DAVIS
Bowl on Stand, 1999
Steel, forged
13 ½ x 8 ⅛ in.
Collection of Clyde and Dorothy Collins

DON DRUMM
Mechanical Totem, 1970
Aluminum
20 ¾ x 17 x 4 ⅜ in.
Collection of Don Drumm Studios, Akron, OH

AL VRANA
Fire God, 1968
Steel
14 x 10 x 12 in.
Collection of Jo Vrana

C.R. "SKIP" JOHNSON
Floor Walker, 1988
Cherry
24 x 24 x 24 in.
Collection of the Wood Turning Center

CAROL SHINN
Storm Approaching, 2001
Machine stitched canvas
20 x 15 in.
Collection of the artist

WILLIAM DALEY
Oval Chamber, 1986
Stoneware, press molded
40 3/8 x 23 3/8 x 20 1/2 in.
Collection of Smithsonian American Art Museum,
Washington, DC
Photo: Smithsonian American Art Museum,
Washington, DC/Art Resource, NY

CESARE TOFFOLO
Granelli di Sabbia, 2002
Flameworked glass
14 in. high
Collection of the artist

EMILIO SANTINI
Goblet, 2000
Flameworked glass
15 in. high
Collection of the artist

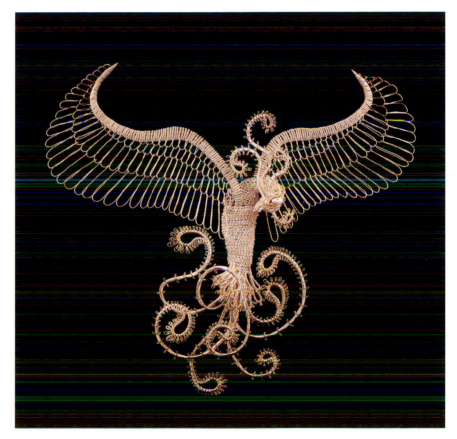

MARY LEE HU
Neckpiece #9, 1973
Silver, gold, pearl
10 x 12 1/4 x 8 3/8 in.
Collection of Museum of Fine Arts, Boston
H.E. Bolles Fund and anonymous gift
1996.1

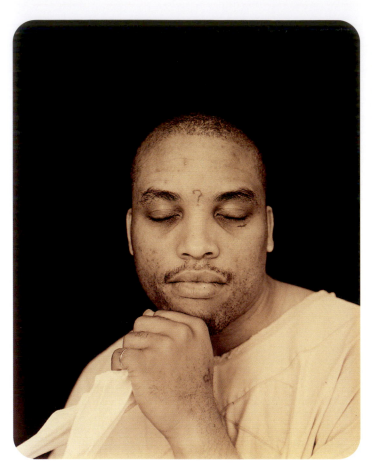

DEBORAH LUSTER
L.S.P. 43 from 9/25,
from *One Big Self, Prisoners of Louisiana*, 1998-2002
Liquid emulsion on metal plate
5 x 4 in.
Collection of the artist

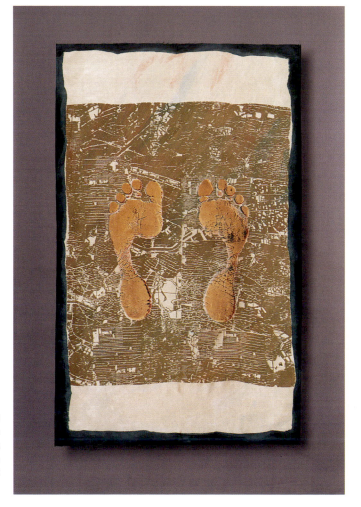

JASON POLLEN
Walking Meditation, 1997
Silk
38 x 27 in.
Collection of the artist

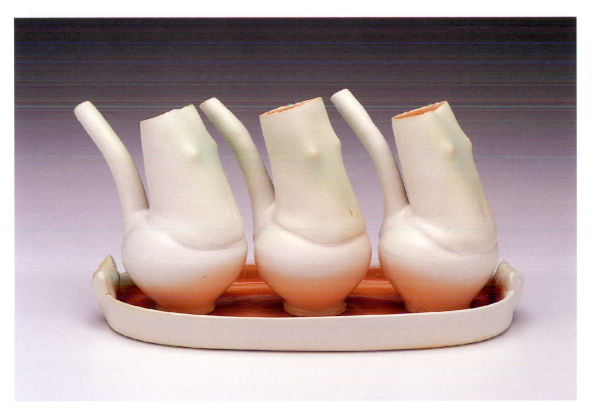

SILVIE GRANATELLI
The Supremes:
Sauce Ewers on Tray, 2003
Porcelain
6 x 11 x 5 1/2 in.
Collection of the artist

JAMES HENKEL
Two Hands, Sun Spots, 1993
Gelatin silver print
20 x 24 in.
Collection of the artist

SALLY PRASCH
Spirit Goblet, 1999
Flameworked glass
8 ¹/₂ x 4 ¹/₂ in.
Collection of the artist

KEN CARDER
Venus and Child, 2001-2002
Glass, assembled inclusions
13 ¹/₂ x 6 x 7 in.
Collection of the artist

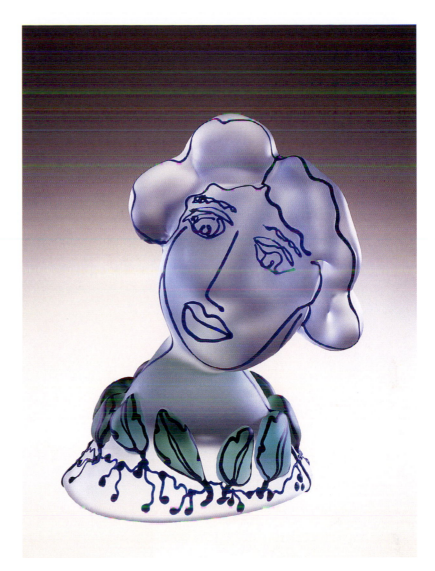

RICHARD JOLLEY
Female Bust with Leaves, 1989
Glass, cast and frosted
13 ¹/₂ x 10 x 7 in.
© Richard Jolley
Collection of Indianapolis Museum of Art
Partial and promised gift of Marilyn and Eugene Glick

SHANE FERO
Yellow/Black Goblet from *Organic series,* 2000
Flameworked glass
9 x 3 in.
Collection of the artist

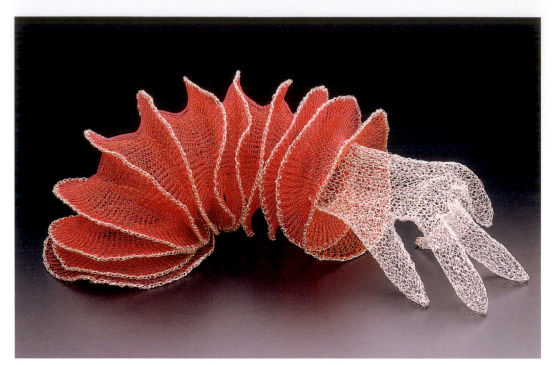

ARLINE FISCH
Bracelet and Glove, 1999
Coated copper, fine silver, machine and hand knit
5 x 20 in.
Collection of the Smithsonian American Art Museum,
Washington, DC
Photo: William Gullette

FREDERICK BIRKHILL, JR.
Blue Skies, 1997
Flameworked glass, wood
20 x 16 x 2 in. (closed)
Collection of the artist

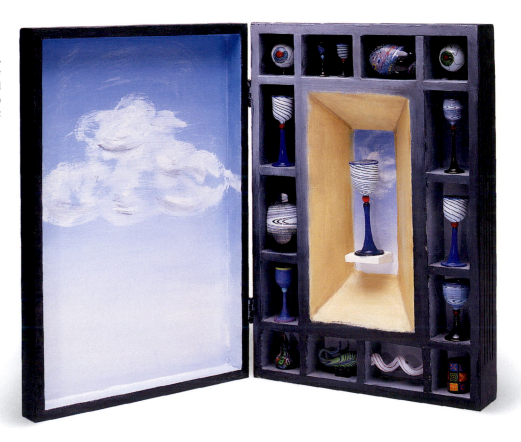

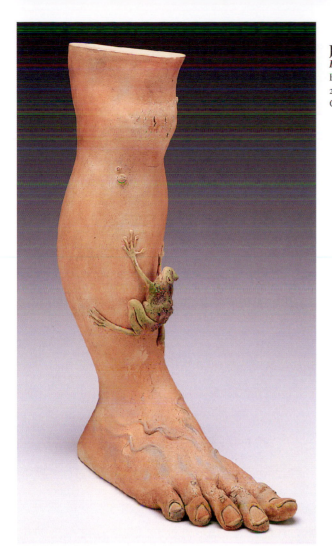

JOE BOVA
Frog's Leg, 1980
Earthenware, overglaze
20 x 9 x 4 $\frac{1}{2}$ in.
Collection of the artist

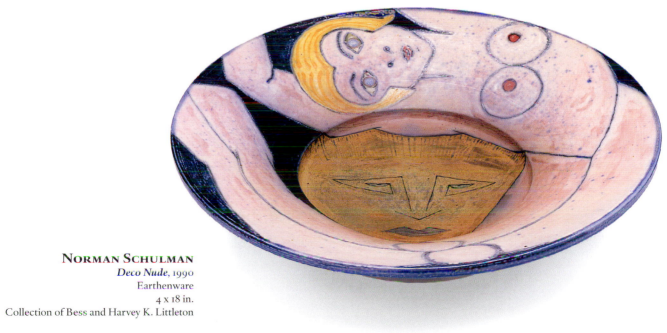

NORMAN SCHULMAN
Deco Nude, 1990
Earthenware
4 x 18 in.
Collection of Bess and Harvey K. Littleton

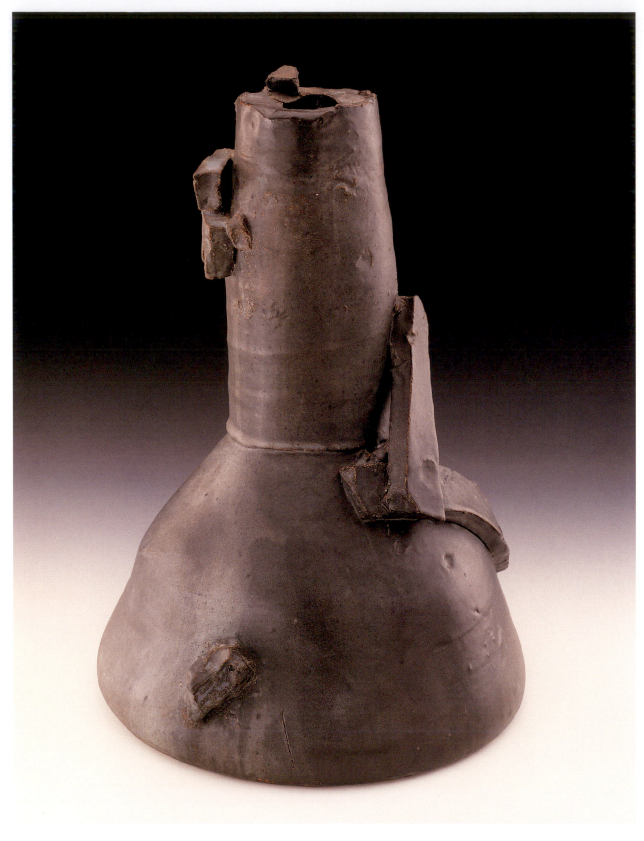

ROBERT TURNER
Akan, 1984
Stoneware
17 3/8 x 12 3/8 x 11 1/4 in.
Collection of Smithsonian
American Art Museum,
Washington, DC.
Photo: Smithsonian
American Art Museum,
Washington, DC/Art Resource, NY

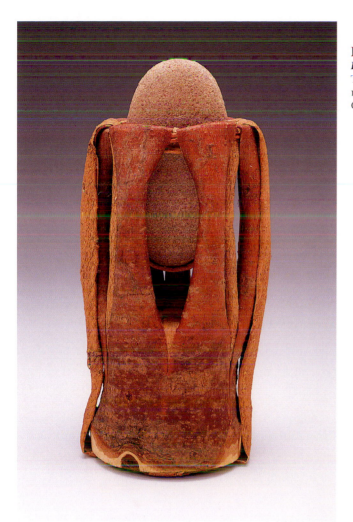

DOROTHY GILL BARNES
Bark Holding Stone, 1997
Tree bark and stone
13 x 6 x 5 in.
Collection of Gordon T. Barnes

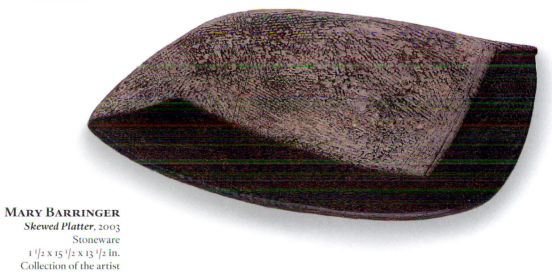

MARY BARRINGER
Skewed Platter, 2003
Stoneware
1 1/2 x 15 1/2 x 13 1/2 in.
Collection of the artist

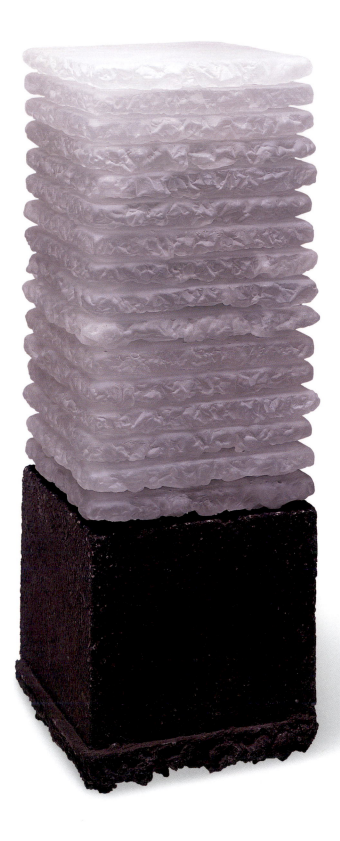

JUNICHIRO BABA
The Memory of Shadows, 2002
Glass, cast and acid etched
24 x 9 x 9 in.
Collection of the artist

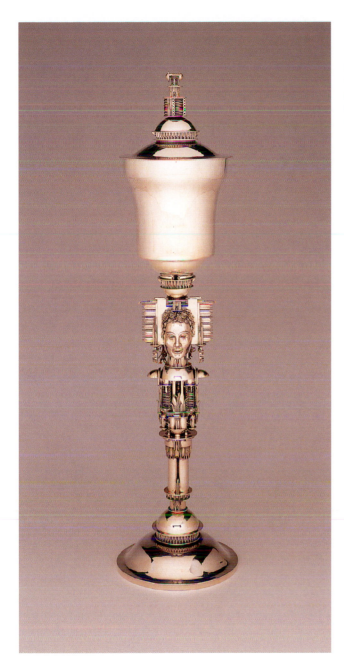

RICHARD MAWDSLEY
Standing Cup with Cover, 1986
Silver, gold
17 1/4 x 5 in.
Collection of Museum of Fine Arts, Boston
Anonymous gift
1988.535 a-b

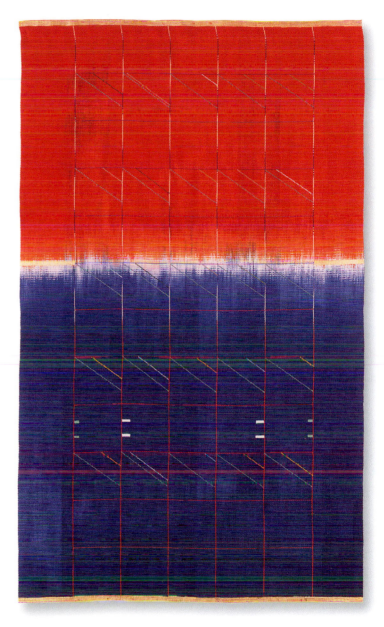

RUDY KOVACS
Cage Letter #2, 1993
Linen, rayon, gold leaf, paint
60 x 36 in.
Collection of Boise Art Museum
Purchase from the Idaho Triennial Exhibition

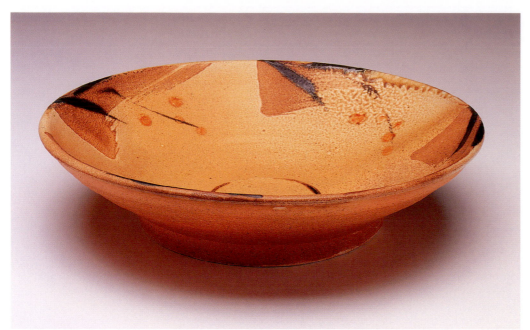

DOUGLASS RANKIN AND WILL RUGGLES
Platter, 2002
Stoneware, wood-fired
3 1/2 x 14 in.
Collection of the artists

CLARA "KITTY" COUCH
Earth series, 2002
Terra cotta
18 x 18 x 15 in.
Collection of the artist's estate

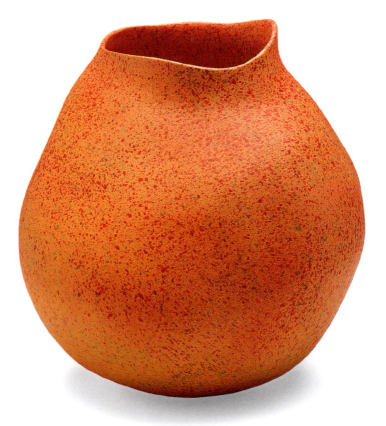

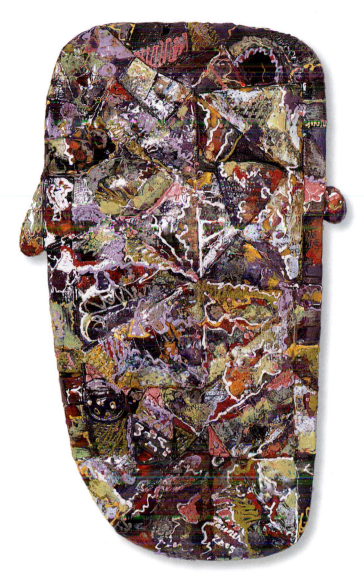

JAMES TANNER
No Know See, 2003
Stoneware
30 x 24 x 3 in.
Collection of the artist

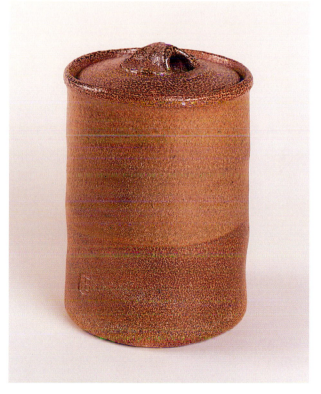

BYRON TEMPLE
Covered Jar, circa 1975
Stoneware
7 1/8 x 4 7/8 in.
Collection of New Jersey State Museum
Gift of Mr. Franz G. Geierhaas
CH 1991.26.a,b

RICHARD MARQUIS
Teapot Goblet, 1991
Blown glass
9 1/4 x 5 in.
Collection of The Mint Museums,
Charlotte, NC
Gift of Rebecca Klemm
1998.99.1

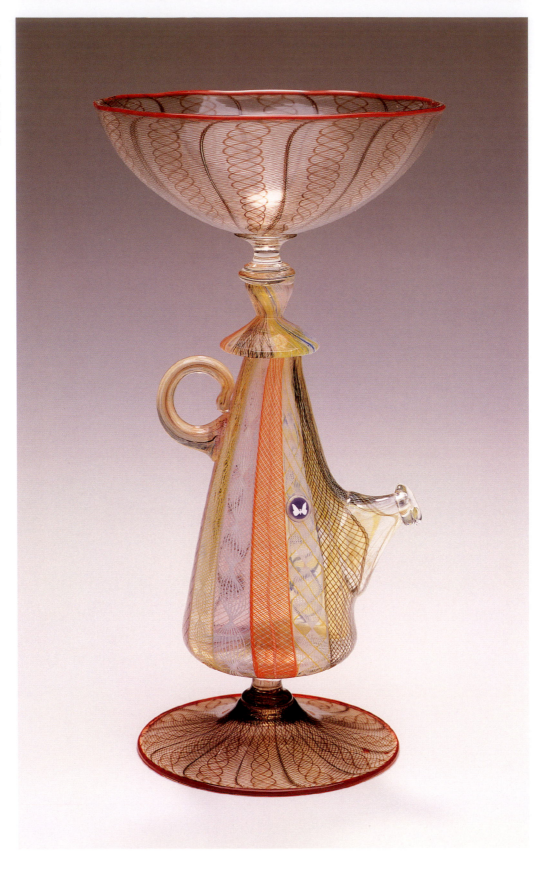

PAUL MARIONI
Grey Jaguar, 1998
Glass
18 ¹/₂ x 10 x 5 in.
Collection of the artist

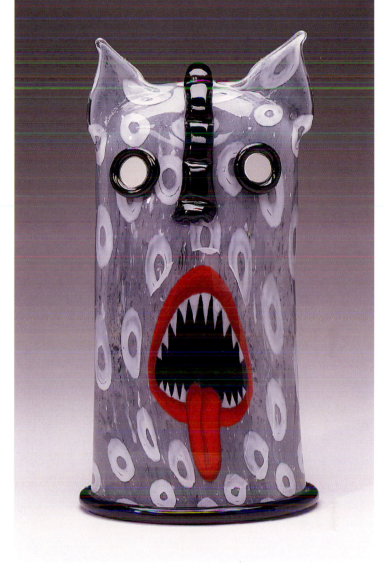

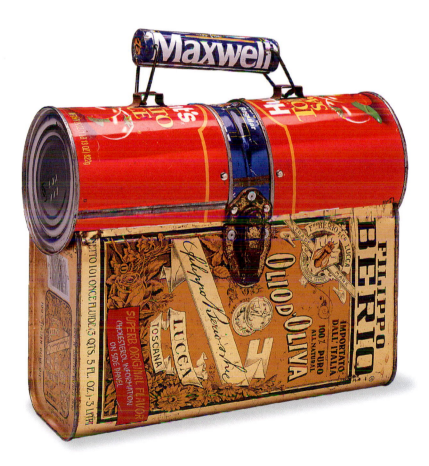

BOBBY HANSSON
Hunt's Briefcase, 1992
Tin cans, altered and joined, recycled latch and hinges
12 x 12 x 6 in.
Collection of the artist

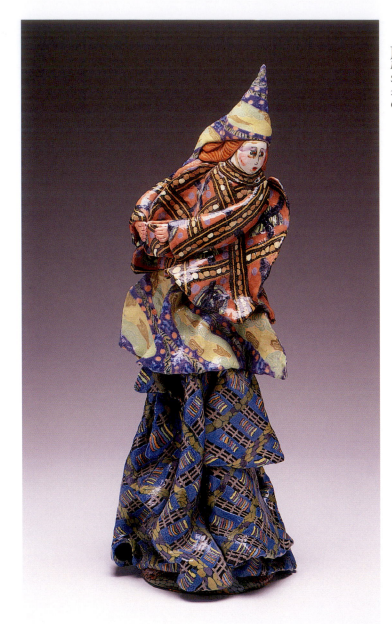

JANE PEISER
Figure, circa 1996
Stoneware, salt glaze
22 x 7 x 4 in.
Collection of the artist

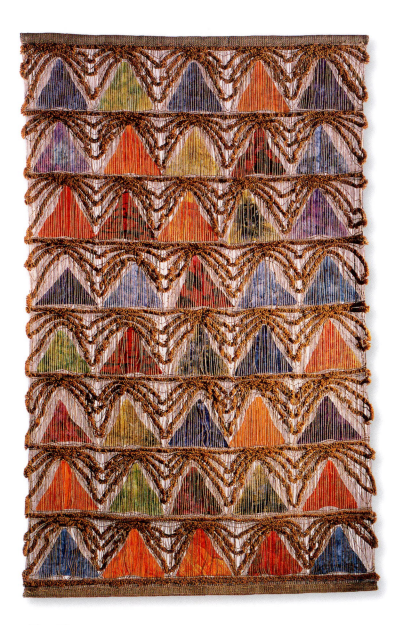

TED HALLMAN
L'Egyptien, 1964
Hand-woven cotton and linen with dyed acrylic inclusions
108 x 60 in.
Collection of Philadelphia Museum of Art
Gift of the artist
1975-3-1

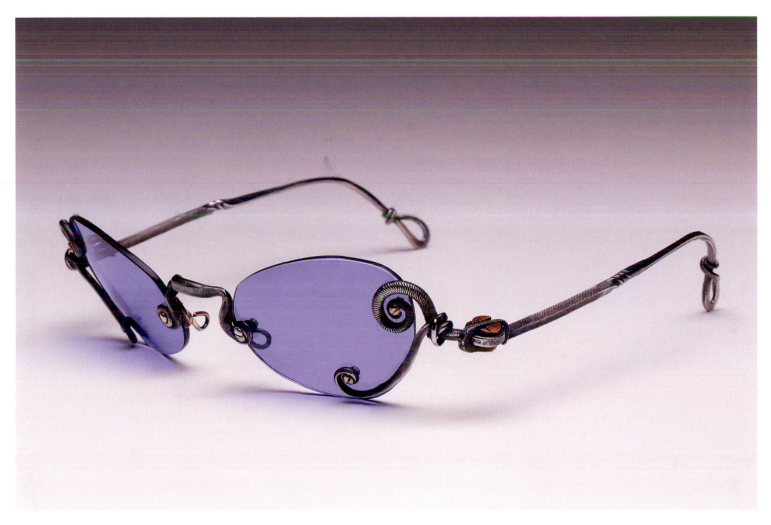

DEB STONER
For/From an Old File, 2002
Recycled jeweler's files, copper, lenses
2 x 5 x 5 in.
Collection of the artist

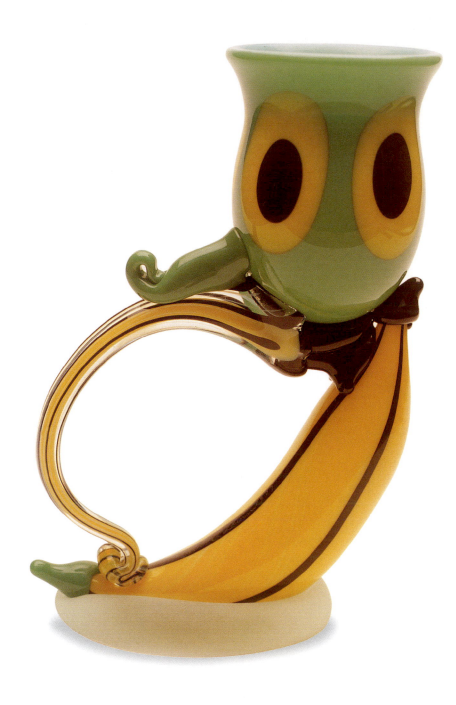

ROB LEVIN
Cup with Appeal #3, 1980
Blown glass
77 $^{1}/_{2}$ x 5 x 2 $^{1}/_{2}$ in.
Collection of the Leigh Yawkey
Woodson Art Museum, Wausau, WI

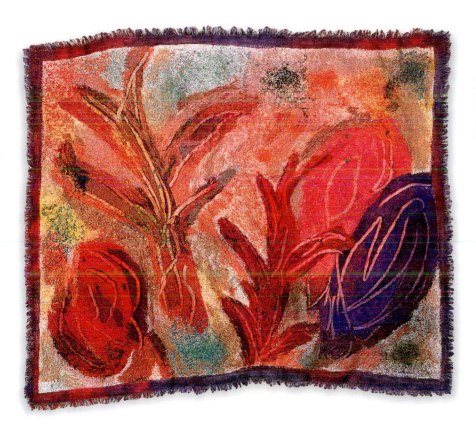

EDWINA BRINGLE
Succulents, 1998
Cotton cloth, textile paints,
free-motion embroidery
27 x 30 in.
Collection of the artist

LENORE DAVIS
Mermaid Parade Float, 1976
Cotton velvetine, wood, paint
23 x 20 in.
Collection of Mobile Museum of Art, AL
Gift of the Art Patrons League

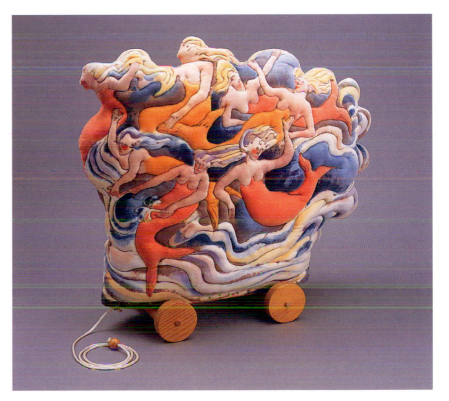

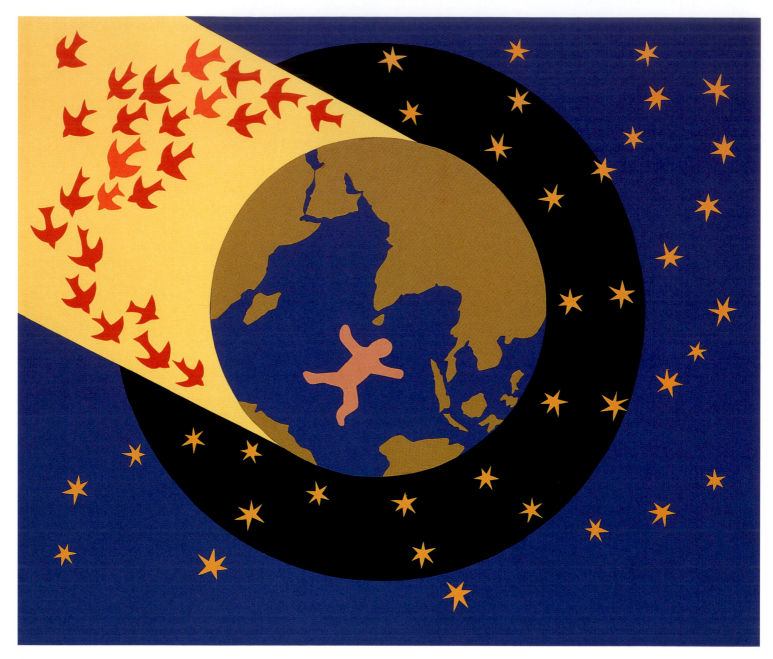

DEBRA FRASIER
On the Day You Were Born, 1989
(back cover art for the book of the same title, published 1991)
Cut paper collage, Canson papers, rubber cement
18 x 24 in.
Collection of the artist

RICK BECK AND VALERIE BECK
Dream Running, 1992
Glass
11 X 12 X 12 in.
Collection of The Mint Museums, Charlotte, NC
Gift of the artists
1994.35

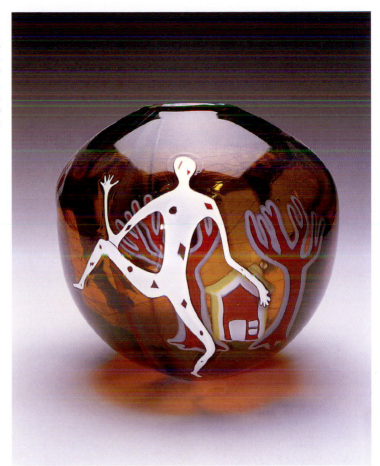

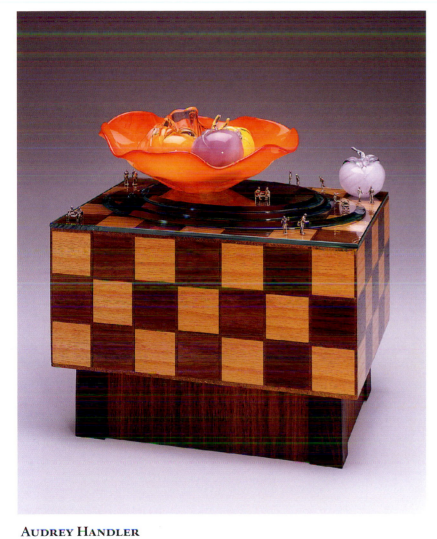

AUDREY HANDLER
Monuments in a Park, 1988
Blown glass, beveled plate glass,
sterling silver, padouk, walnut, ebony
14 X 14 X 10 in.
Collection of the artist

OF FIELD AND FACTORY, HEARTH AND HOME

Art and Aesthetics in Everyday Life

Michael Owen Jones

I grew up in rural Kansas near Wichita. My father and other farmers stood in awe of their neighbor, Gordon. He had an uncanny knack for knowing exactly when to plant, reaping large harvests of wheat and sorghum as his reward. He farmed his land with precision. To the amazement of all, row after row of sprouting plants ran absolutely straight the entire half-mile length of his field. Because his rows were perpendicular to the highway, everyone passing by could witness and marvel at his achievement. Our field lay across the road. My father farmed only part-time. He tried hard but failed to sow or cultivate without a jiggle here, a waggle there, often swearing and shaking his head in despair when he came into the house at night. One year he planted parallel to the road so that anyone driving by could not invidiously compare his crooked rows with Gordon's ruler-straight ones. It cost him dearly. Because my father's rows followed the width rather than length of the field, he had to turn the tractor around twice as often to sow and later to harrow, and he wasted space for plants at every turn.

What he lacked in farming skills, my father made up for at his day job in Wichita. Although he hated working at the aircraft plant, and dreamed of farming full-time, he was a prized worker. Depending on the orders for airplanes, the company shifted him between the tool planning office where he drafted images of the tools needed to make parts, and the factory floor where he operated a drop hammer that flattened welded sheet metal for wings. Welding is an art; so is hammering. My father often waxed ecstatic over a beautifully welded piece. Just as often, he was appalled at what was handed to him; with much effort, however, he managed to turn it into a finely crafted section of a wing.

Nineteenth-century champions of the Arts and Crafts movement might have been surprised to discover that aesthetic appreciation and individual artistry could exist in a modern factory. Few critics and aestheticians of today, still under the spell of the Renaissance concept of *les beaux arts*, would look to farm or factory, much less home, for evidence of human creativity and the appreciation of formal perfec-

tion. Yet, as James West wrote in 1945 in his book *Plainville, U.S.A.* regarding rural Missouri life, "People admire a well-kept house, freshly painted, neat indoors, and well-maintained without. . . . Men who farm admire a straight furrow better than anything else in the world."

My thesis is that art and aesthetics manifest themselves in everyday life, not just in the studio and gallery. Ordinary people seem compelled to transform the quotidian into something extraordinary.[1] The urge to create and the need to express pervade our lives. Understanding how and why aesthetic behaviors abound, and what some of the consequences are, requires attention to the commonplace, which so often is ignored or disregarded when art is treated as the idiom of specialists.

One of my colleagues who is not a folklorist defines my field of study as that of "noticing." Folklorists pay close attention to how people express themselves, to the customs and traditions that evolve in everyday life, to the things that individuals make and do as they interact with one another at work, in the home, and during leisure. In the first class period of a course that I teach on folk art and aesthetics, I give a personal example illustrating both tradition (as continuities and consistencies in behavior) and people's attempts to perfect form in day-to-day existence, namely, the arrangement of

Matching trash cans in triangle with bags of newspapers on top emphasizing the form of the arrangement

trash cans in an area of Los Angeles where I live. Before moving to this neighborhood, my family and I had not made the selection and display of refuse containers a priority in our lives. Perhaps this was because at our previous home the cans were kept in the alley: out of sight, out of mind. In the area where we now live, however, trash collection occurs on the street in front of the houses. Many of our neighbors devote time and energy to positioning their cans and boxes in pleasing ways. Aware of various visual and tactile qualities of both containers and the trash within, they manipulate these materials in rhythmical ways to produce structures constituting forms that, as Franz Boas put it in *Primitive Art*, serve as standards by which their perfection (or beauty) is measured.

My neighbor to the north, for instance, has a matched set of brown plastic containers. He places them in a perfect row along the edge of his yard, lids set to contain the trash neatly, and the handles exactly aligned with the curb. A person across the street usually lines his metal cans with plastic leaf bags, and arranges the four receptacles in the shape of a square. Another homeowner whose driveway is bordered by a low wall, and whose mailbox is near the entrance to the drive, poses his trash cans to either side of the mailbox in a visually balanced organization. One day he solved the problem of what to do with nonconforming items like a stack of newspapers by placing them between the cans and under the mailbox, which filled a gap visually in the display. This is not to say that everyone including me attempts to achieve perfection in the arrangement of trash or its containers, but several people do. Thus some of their behaviors exhibit consistencies in space. There are also continuities through time. My family and I now find ourselves tending to model our behavior after that of our neighbors (to behave "traditionally") to the extent that we have disposed of our disparate and dilapidated containers and replaced them with a matched set of cans that we often arrange in a square, triangle, or other form depending on the number of containers. Think what you will about the Joneses keeping up—about class, status, or fitting in—but the fact that we are dealing with effluvia, which is neither pleasant to observe nor handle, probably has much to do with our activities; garbage represents chaos and pollution whereas containing it and neatly arranging the vessels in a pattern symbolizes order and control while simultaneously transforming the ghastly into the merely disagreeable.

Mentioning the art of trash cans reminds me of Penland School of Crafts: the dining hall, more precisely. Artists in residence, instructors, and visitors alike bus their own tables.

Signs from the Penland dining hall

They discard food scraps in one metal can and liquids in another, and put eating utensils in a tray and dishes in a rack at the pass-through window for kitchen staff to retrieve and wash. Posted on the wall above a waste receptacle are three handmade signs. One announcement constructed of light blue paper with silver stars on each side reads: "Liquid only pleaz!" To the left of it is a collage consisting of a magazine photo showing a woman in sleeveless yellow top, wide brown belt, and blue jeans with hands on hips in an aggressive posture; to one side of this image is a piece of light brown paper cut with jagged edges that proclaims, "Tea bags are NOT a liquid!!" Between the two signs hangs another sheet of paper streaked with the colors of the rainbow. Against this background wash appears the message: "Things that aren't liquid (how ever much you want them to be)" below which appear mention of such items as tomato, lettuce, fingernails.... At the bottom a pen and ink drawing depicts someone whose feet are in the air and head and shoulders are lost in the depths of a sink. The message is signed "the kitchen fairies" (flanked by a heart on the left and a toilet plunger on the right).

To many except the kitchen staff (most of whom are artists on work-study), these colorful signs might seem trivial. Dismissing them, however, would rob us of understanding and appreciating crucial qualities of the school, and perhaps of the nature of craft itself. Brochures and information sheets refer to this retreat as a source of inspiration for the students' personal creative life, and emphasize the "often transformative experience of working with intensity and focus in a supportive community atmosphere." Staff members are cordial. Artists are inclusive, not exclusive or competitive; they share ideas with one another, whether working in the same or in

Photo: Robin Dreyer

different media. The school exhibits a pleasant ambience; for example, the cozy coffee house with homemade pies and pastries, a variety of teas and coffees, handmade objects all around, and small tables that facilitate intimate conversations. In the dining hall are large tables, many of them round, where people dine "family style." Shelves in one corner of the room hold mugs. A hand-lettered sign above them, its borders bearing nearly three dozen versions of a single image of a cup made with a rubber stamp, requests that, "To help conserve please [the 'a' is upside down] use the 'ugly cups' as to go cups and then return them to the dish room. Thank you." Not surprisingly in a school devoted to handmade objects and individual creativity, the "ugly cups" are the ones produced in factories and bearing corporate logos.

Penland's founder, Lucy Morgan, summarized the school's guiding principles as "the joy of creative occupation and a certain togetherness—working with one another in creating the good and the beautiful." Arguably these values are achieved, expressed, and reinforced through the informal traditions that have developed at the school. Joking, eating together, and decorating common areas in uncommon ways convey congeniality, a sense of easy give-and-take with one another, a feeling of community. These feelings are carried back to the studios and instruction areas, influencing people's interactions as well as being strengthened by them, and in circular fashion are once again manifested at breaks and during leisure activities.

Lucy Morgan's reference to the joy of togetherness and "creating the good and the beautiful" invokes spirituality, and reminds me of the aesthetic I've encountered in my study of storefront churches. Although it might not seem evident at first, many storefront churches exemplify her pronouncement as well as illustrate our propensity to find, or create, beauty in the most extenuating circumstances. Occupying boarded-up grocery stores, deserted movie theaters, and other commercial buildings left abandoned, these ministries spring up in the midst of urban blight. Often in need of repair and furnished with cast-offs, they minister to the needs of the most marginalized members of society: the homeless, jobless, abused, depressed, and addicted. Many church leaders come from the same ranks as the congregations they serve. Called by God, they offer hope in the face of despair. With money from their day jobs and the few donors they can find, most manage to spruce up a building over time, salvaging pews, installing secondhand carpet, and locating outdated cans of house paint and old brushes to freshen the walls and limn a

"Ugly cups" from the Penland dining hall

likeness of Christ the Savior or the Tree of Life. In the process of this necessary "sprucing" we can often find evidence of art.

The Church of Humanity and Divine Love, which occupies a former barbershop, is one of many African-American storefront churches dotting the landscape of Los Angeles. Senior Bishop Margaret Johnson is eighty-two years old. Her acolyte of thirty-five years, Dorothy Lambert, is seventy. Together they counsel emotionally troubled residents of the city, particularly women, and provide food, clothing, and shelter as best they can. Everywhere you look in the Church of Humanity and Divine Love you notice displays of objects, whether devotional items, photographs, or children's toys. Some people see only piles of "junk," and they say so. But a moment's reflection on the odd assortment of angels, eagles, the Virgin Mary, a ceramic high-heeled shoe, a crucified Christ, and a rag doll convinces a viewer that there is both order and significance here. All the items and their groupings possess spiritual or personal meanings. Many represent people, incorporating them into the ministry and the lives of congregants: those who are members of the church, those who have moved away, and those who have died. For example, a woman who went to Canada left a black doll in her stead. Jeremiah, a homeless man who has been associated with the church for seven years, storing his few belongings behind a cabinet and sometimes sleeping on the pews, has brought

photographs, found objects, and toy animals to place in arrangements on top of the piano. They stand for him. The tiger *is* him, he contends, and the lion is Christ. Objects convey precepts. A large valentine heart in an arrangement symbolizes love. Bears are spiritual, protective, strong, and powerful. Eagles represent power: Bishop Johnson's ministry is devoted to "spirit and power."

Other items serve as the basis for interaction, discourse, and instruction. For example, on the seat and at the foot of Mother Johnson's chair are stuffed animals: brown bears and white lambs of different sizes. The arrangement occasions comments and questions. Mother Lambert has explained to children that these are God's creatures living in harmony as a family. Although they differ in color, they accept one another; all are equal in spirit. "We're all one, just God's children," says Mother Lambert. "Same spirit!" proclaims Mother Johnson.

To Mothers Johnson and Lambert the objects and their display are "life-saving meat and bread" to "feed the soul." The recurring theme is spirit, which knows no racial, gender, or other distinctions, which never dies, which is the source of divine love and joy, and which unites us as family. Arrangements of everyday objects are not junk but testimonies to spirit, tokens of people's presence even when they are absent, and one of the few means available to create a sense of community and support for those in despair. Collections of found objects, stuffed animals, and a black doll do not obscure the presence of the divine; they prove it.

Rather than consisting of the arts of elegance, the ornamental, the inutile, aesthetic expression in everyday life more closely resembles "craft" as practiced at Penland: the creation of useful things that carry personal meanings while also promoting reflection and appreciation. "If there is such a thing as a "behavior of art," writes Ellen Dissanayake in the *Journal of Aesthetics and Art Criticism* (1980), "we must assume that it developed in human evolution from an ability or proclivity… to recognize or confer 'specialness,' a level or order different from the everyday." In its fundament, art consists of behaviors and products considered "special" (usually because of the skill required and the technical excellence evident) that generate an appreciative, contemplative response in the percipient. Aesthetic forms may consist not only of icon paintings but planted fields, welded metal, a well-kept house, posters in a dining hall, displays of objects in a storefront church, and even neatly arranged trash cans. The maker and others respond to the form aesthetically by perceiving it, being

affected by it, making judgments concerning it, and recognizing it as transforming the ordinary into something extraordinary.

Day-to-day living witnesses many kinds of aesthetic behavior: the way people dress or adorn themselves, decorate their homes and work space, create altars and ornaments or other objects for holidays, prepare and serve food, assemble photographs in albums, and craft such things as quilts, furniture, pottery, rugs, clothing, toys, and gifts for friends. Some people fashion particular things as an occupation or preoccupation, becoming noted as, say, carvers in wood or stone, weavers, needlelace makers, boat builders, chair makers, stonemasons, monument makers, or muralists.

Senior Bishop Margaret Johnson and Bishop Dorothy Lambert next to a chair occupied by the spirit of Bishop Johnson's deceased son, Church of Humanity and Divine Love, Los Angeles, CA

Why make art? Aesthetic forms order things, which is imminently practical in everyday life. For instance, some people organize cans, boxes, and jars on shelves, grouping like objects with one another or employing other principles such as size, height, or color. A few turn their linen closets into showplaces of neatly organized towels, washcloths, sheets, and pillowcases.[2]

Sensory pleasures loom large as motivation or reward. According to Allen H. Eaton in *Handicrafts of the Southern Highlands*, Aunt Sal Creech of Pine Mountain, Kentucky remarked, "Weaving, hit's the purtiest work I ever done. It's a settin' and trampin' the treadles and watchin' the pretty blossoms come out and smile at ye in the kiverlet." Six decades later folklorist Linda Pershing in *Sew to Speak: Mary Milne's*

Fabric Art as Social Commentary, quotes a fabric artist who said, "I really like handling cloth. It's warm, soft, and cozy." It "has such varied tactile qualities that invite the touch... And it's very immediate." The art maker enjoys the sensuous experiences—the weight and feel of the fabric, the vividness and profusion of colors, the smell of freshly ironed cloth, and the rhythmic motions entailed in making something.

The ideational figures significantly in art making: the satisfaction in solving complex problems. Chester Cornett (1913–1981), a craftsman in Southeastern Kentucky, was at once the most traditional chairmaker I've ever known in his use of tools and techniques and the most innovative in his designs. Often his works were exercises in exploring and even challenging the very concept of chair. One consists of many sets of turnings on the arms, posts or legs, and rounds or stretchers, each set differing slightly from the others but all working together aesthetically. Another, which Cornett called a two-in-one rocking chair, has eight legs and four rockers. A third consists of slats and rounds that go completely through and extend beyond the posts. A fourth experiments with alternating pieces of light and dark wood. Yet another explores the relationship between rocking chair components and an undulating snake.

The things that people create evoke ideas, memories, and associations; this includes feelings of connectedness to other people, places, and periods. Some individuals become craft specialists in full knowledge that what they do joins them to the past, and they derive great satisfaction from this. Others consciously seek to preserve a way of life that appears to be rapidly disappearing. Many examples of folk art represent "old timey" ways of doing things, depict scenes recalled from "bygone eras," or require "old fashioned" tools and techniques rather than "modern" ones.[3] Penland School of Crafts purposefully emphasizes the role of oral tradition as the primary means of learning, the age-old method for transferring wisdom from one generation to the next and developing expertise.

Although art making is often solitary, a social dimension may nevertheless surround it that stimulates interaction, community, and links to others. For example, Earl Simmons, an African-American in Bovina, Mississippi, builds wooden jukeboxes, oversized toy vehicles, and even images of chickens out of castoffs. He told Stephen Flinn Young, author of *Building Art with Earl Simmons,* that his art and shop enable him to "meet all kinds of people I ain't never seen. I enjoy all this here [waving to encompass the Art Shop], and I love talking with people.... That's the purpose of building the Art Shop, getting to meet all kinds of people. See, all kinds of people get to come in here. I wanted to meet people. To get their opinions." As Simon J. Bronner writes in an article in *Kentucky Folklore Record* about men who carve wooden chains, "Since chains and similar objects show the carver's skill and creativity, many carvers use chains to relate socially to people, although their actual carving is typically a solitary task. . . . Chains were social tools. They were the ties that bind, the carver's behavioral links to social and personal identity."

I have argued that art making inheres in daily living. It's just something we do. We transform elements of the ordinary into that which is special, whether in the way we organize canned goods on a shelf or linens in a closet, select patterns and colors of clothing to don, furnish, and decorate our homes, design the layout of flowers and shrubs in the yard, or prepare and serve meals to the family. Making things creates order. It immerses us in sensory experiences of sight and touch, sounds and smells. It satisfies emotionally to witness a form emerge from materials shaped with skill. Some people become specialists at crafting things; in creating objects they construct and convey their identity. Craftwork connects us to the past, the present, and the future. It generates associations with people and places and periods in time. A well-made object pleases for its perfection and what it says about human accomplishment. The making of art, the perfecting of a form, occurs regularly in everyday life, even in our most commonplace activities. It is both fundamental to and universal in the behavior of human beings, uniting us as a species.

Bronner's reference to personal identity in regard to men who take up chain carving late in life points to another set of

Utensil holder fabricated from tin cans, Penland kitchen

Photo: Robin Dreyer

motivations for creating things, one with which I close my essay, that of developing and expressing one's sense of self. Some people turn to traditional art forms to understand or symbolically construct who they are, particularly when events challenge their self-concept. A case in point is Radka Donnel, seen in Pat Ferrero's film *Quilts in Women's Lives*. She took up quilting after her career as an easel painter faltered, her children scattered, and her marriage crumbled. "So I was really looking around for something, I don't know what. I came upon quilts. I made one, then I made another. I felt good about it, and anyone who saw them began to tell me, 'Make more. Don't stop. This is your thing.' I was suddenly being taken seriously by all the important persons in my life. And this hadn't happened to me before. So, I felt authentic, and I spoke for myself in a new way, and I was listened to in a new way. So you could actually say, I was getting my voice by ... by staying with the quilts and ... and ... and letting out the issues that they presented." (One of these issues was a prohibition against touching that Donnel sought to overcome.) In addition, "Making quilts helped me to get a sense for my own space, a sense of finding my way, a sense of really working my way out of a labyrinth."

Artists often remark on the role of emotional therapy (and spirituality) as both a motivation for or a consequence of making art. Bronner reports that Floyd Bennington, who took up chain carving in his anxiety over retirement, told him, "I've heard it said lots of times; there's something about carving a piece of wood that you have in your hand—it quiets your nerves—just to keep your mind off something else." Making art has been correlated with such psychological processes as grieving over a loss, coping with stressful situations, and adjusting or adapting to change. Some feelings are difficult to verbalize. Through a literalization of metaphor, one creates in the object a representation of the anxiety-producing phenomenon "When I feel chained, I make chains; when I feel caged, I make cages," one carver explained to Bronner. Many experiences are so complex in their nature and profound in their ramifications that one does not know where to begin talking about them. Assaults on self-esteem occur all too often, and emotional conflicts arise with disturbing frequency. Representing issues in material form redirects inner feelings outward onto an external form. Making things can distract one from the pain, refocusing attention and energy, or even resolve issues and restore a sense of self-worth. The outcome of art's therapy is not just the creation of an object, but the rebuilding of a person.[4]

<div style="transform: rotate(-90deg)">Photo: Dana Moore</div>

These chairs mildewed in storage and had to be washed. Brian McGee, one of the Penland core students assigned to the task, made this arrangement when the job was finished.

Notes

1. A few works that suggest the variety of aesthetic expression in daily life are John Forrest, *Lord I'm Coming Home: Everyday Aesthetics in Tidewater North Carolina* (Ithaca: Cornell University Press, 1988); Michael Owen Jones, "The Aesthetics of Everyday Life," in *Self-Taught Art: The Culture and Aesthetics of American Vernacular Art*, ed. Charles Russell (Jackson: University Press of Mississippi, 2001); Amy Kitchener, *The Holiday Yards of Florencio Morales: "El Hombre de las Banderas"* (Jackson: University Press of Mississippi, 1994); and Leslie Prosterman, *Ordinary Life, Festival Days: Aesthetics in the Midwestern County Fai* (Washington, DC: Smithsonian Institution Press, 1995). In *Folkloristics: An Introduction* (Bloomington: Indiana University Press, 1995), Robert A. Georges and Michael Owen Jones explain the subject matter as well as analytical approaches to folklore studies.

2. For an analysis of a dozen motives and consequences of creating aesthetic forms in everyday life, see Michael Owen Jones, "Why Make (Folk) Art?" *Western Folklore 54* (1995): 253-276. For examples such as arranging jars of home canning in a root cellar, doing the laundry, and using a chain saw to sculpt figures, see, respectively, Katherine Rosser Martin, "Food Preparation and the Folk Aesthetic," *Kentucky Folklore Record 25* (1979): 1-5; Roberta Cantow, *Clotheslines* (VHS, color, 32 min. Buffalo Rose Productions, (1981); and Sharon R. Sherman, *Chainsaw Sculptor: The Art of J. Chester "Skip" Armstrong* (Jackson: University of Mississippi Press, 1995).

3. Such motivations as preserving a way of life, consciously doing things in old fashioned ways, and evoking scenes of past eras are examined in James Culp, *Preserving a Way of Life: People of the Klamath*, Part II (VHS, color, 28 min. New Day Films, 1989), Willard B. Moore, "An Indiana Subsistence Craftsman," in *Material Culture Studies in America*, ed. Thomas J. Schelereth (Nashville: American Association for State and Local History, 1982); and Margaret R. Yocom, "A Past Created for the Present: Selectivity and the Folk Paintings of Jessie Rhoads," *Kentucky Folklore Record 30* (1984): 34-46. In regard to Chester Cornett's preoccupation with the past and yet extraordinary inventiveness in chair design, see Michael Owen Jones, *Craftsman of the Cumberlands: Tradition and Creativity* (Lexington: The University Press of Kentucky, 1989).

4. Several folklorists have addressed the relationship between art and psychological states and processes. See, for example, Simon J. Bronner, *Chain Carvers: Old Men Crafting Meaning* (Lexington: University Press of Kentucky, 1995); Varick A. Chittenden, *Vietnam Remembered: The Folk Art of Marine Veteran Michael D. Cousino* (Jackson: University Press of Mississippi, 1995); Michael Owen Jones, *Craftsman of the Cumberlands*, cited above; and Melissa Ladenheim, *The Carvings of Andrew Zergenyi* (Jackson: University Press of Mississippi 1996).

A New Way of Thinking About Taste

Galen Cranz

In the department of architecture where I teach, aesthetic issues are important criteria for judging buildings and talent. Distinguishing good design from inferior design is part of what a student learns there. This keen sense of discrimination is commonly used to privilege one thing over another and so has some distant relation to power. Because my formal education is in sociology, I think about both the powerful and the powerless, taking pains to include the point of view of the masses, the ordinary, and even the vulnerable. How can anyone with this kind of education be interested in issues of artistic distinction, so associated with taste and connoisseurship? In graduate school an art teacher once asked me how I could be a sociology major since I was good at art. Of course this was flattering at one level, but it also made me frustrated that our culture assumes an either/or choice between clarity of thought (about anything including social life) and sensory beauty. I want both.

I see art as an important part of social life—not just as a way to create distinction, but also as a way to practice personal, social and cultural integration. In our homes we have an ongoing relationship with art. Indeed, for most of us our homes are the site of more everyday art activity than any other place. Accordingly, in this essay I will focus on the ordinary practice of decorating homes to show how artistic activity is a form of personal integration as much as a form of social differentiation. I define interior decoration broadly, not as a business, but rather as a widespread general cultural practice of decorating the interior of a room or house. (Therefore, I will use the term decorator to apply to both professionals and laymen.) While the practice is general, it is more structured than we commonly assume. Almost everyone assembles two different kinds of objects—the practical and symbolic—at home—by means of aesthetics. This view of decoration makes it important by establishing its artistic and social significance.

Many sociologists have recognized the importance of decoration through its connection with taste. (See bibliography.) Since the 18th century, taste has been recognized as a process of discrimination, most recently highlighted by Pierre Bourdieu's seminal study *Distinction: A Social Critique of the Judgment of Taste*. Home decor is one of the major sites for the exercise of taste. Sociologists view taste as a way that people make distinctions between themselves and others and a way that people legitimize class differences. In common speech today the word taste is used much more simply, synonymous with the preference, as in "I have a taste for natural fabrics." The artistic, the everyday, and the sociological views of taste can provisionally find common ground in a definition of taste that refers to the ability to make distinctions, evaluate, and choose aesthetic qualities in all of the arts, including those of daily living.

I am proposing a new framework for thinking about taste that offers an inclusive understanding of artistic assembly in environmental design, including home décor. Graphically and conceptually, it looks something like this:

Taste = (Pragmatics + Symbols)Integrated Aesthetically

People have two classes of objects in their homes—the practical things necessary to live in our culture and the symbolic things that express who we are, from where we have come, and perhaps where we are going. People integrate these two sets of objects into compositions by means of aesthetic principles like symmetry and color coordination. Thus, taste in decorating involves the unification of two fairly discrete categories of objects—the pragmatic and the symbolic—by means of aesthetics.

The pragmatic consists of the objects needed in a culture in order to eat, sleep, dress—toasters, beds, chairs, lamps, ironing boards. The pragmatic basis of taste is important because it differentiates taste from "pure" art, thereby placing taste squarely within the domain of utility.

Symbolic objects represent some part of a person's identity, the sum total of the groups with whom he or she affiliates.[1] They communicate about relatives, activities, achievements, travel, education, and religion. They include photo-

Photo: Dana Moore

graphs, audio equipment, sports trophies, souvenirs, awards, diplomas, and crucifixes, all of which express different aspects of a person's identity. (A few of these objects might be handmade, but most will be industrially manufactured commodities.)

Neither category—the symbolic nor the pragmatic—is fixed. What is defined as pragmatic varies culturally. Tables and chairs are pragmatic requirements for dwelling in western cultures, but became symbols of modernization and westernization in the floor-sitting parts of the world. Moreover, the pragmatic and symbolic can overlap. For example, pragmatic things can be elaborated and overlaid with symbolic meaning. Plastic forks have different meanings than stainless steel forks, which in turn have different meanings than sterling silver forks. The pattern in which they are decorated (or not) gives us additional information about their symbolic significance. Sometimes the bare pragmatic object can be used symbolically. For example, having the "right" colander may be symbolically important to a designer.

Context is important in knowing if something is pragmatic or symbolic. For example, according to architectural historian Greg Castillo, utilitarian stoves and refrigerators installed in model homes in West Berlin became symbols of the benefits of American capitalism in the 1950s Cold War against communism. In other contexts they would be mere commodities, but here the people who displayed them and the audience who viewed them gave them symbolic meaning.[2] Conversely, television, once a symbol of forward-looking people, is now a pragmatic necessity that only the poorest of the poor cannot afford.

These two sets of objects—the pragmatic and the symbolic—are organized in relation to one another functionally and visually, following kinesthetic and aesthetic rules that may or may not be conscious to the homemaker. Empirically, I have observed that people want to make unified tableaux out of their disparate collections of objects. It is as if pragmatic and symbolic objects are added together and then ordered (perhaps multiplied or harmonized) by aesthetic rules. These rules or conventions govern, consciously or unconsciously, the arrangement of parts, details, form, color, etc., so as to produce a complete and visually harmonious unit. These rules vary by culture. For example, rich, deeply carved texture might be more important in one culture or time period than another, depending on sources of wood, climate, shadows, myths—the list is almost endless.

Could we speak of taste in sports, finance, military action, or crime? Yes, possibly, but taste usually refers to the arts and aesthetics. The word *art* has a Latin root meaning to join or fit together and refers to creativeness, the human ability to make things. Our household compositions fit within this definition of art. The word *aesthetics* comes to us from ancient Greek, referring to our capacity to perceive, our sensitivity, hence our sensitivity to art and beauty, our taste. Domestic display also registers our sense of aesthetics. *Kinesthetic* has to do with our awareness of bodily movement, also implicitly involved in domestic compositions because we do not want things to be out of reach, fall on us, or be inconveniently situated. Together, objects along with the artistic and kinesthetic rules used to order them, help us communicate with one another—yes, but also with ourselves.

When we assemble our things and look at them ourselves we are psychologically integrating ourselves, not just showing off to others. I have come to see taste as much as a *process* about selection and assembly as it is a quality of objects, a talent in individuals, or a social status. I would like to explain how I have come to this conclusion.

First, why isn't taste in the object? Why aren't some objects more tasteful than others? In a consumer world what makes us distinctive is not so much the specific qualities of the things we have, but their constellation. We do not make most things by hand; we can buy them fairly readily, so their material significance is not great. Instead, their relationship takes on significance. To change a collection of objects into a composition requires connecting them. Anthropologist Ellen Dissanayake, in studying the practice of craft, has noted the importance of the relationship between things: "I was intrigued with how much depended on two things and their relationship. One rock or one piece of wood is something (*some thing*), but once a second rock or piece of wood, or some other second thing, is placed with it, there is an immediate implicit connection between them that requires consideration." Thus, questions about objects being in good taste or bad taste lose significance. Connoisseurship, a way to distinguish one object from another or one creator from another, is often closely linked to discussions of taste but its significance fades in light of the importance of placement.

Second, is taste a quality in persons? I am not particularly interested in whether or not a person "has taste" or "has no taste." Rather, I am interested in *how* a person assembles the many things in his or her immediate environment. Here taste is the activity and the outcome of assembling objects artistically. It is true that some people have more skill at assem-

bling these secular tableaux than others. This must be acknowledged, but not so much as good, bad, or poor taste. I prefer to see skill differences acknowledged as more or less developed.[3] Not all differences between people are differences in skill, but rather differences in what and how they want to communicate. People differ regarding how much interest they have in communicating in this way; some don't care about communicating about themselves through this medium.

Recently I asked graduate architecture students to make a composition of all the things that they had brought with them into the classroom. There I saw the disservice that comes from using the lens of "good" and "bad" taste. The major distinction between their compositions was in regard to how formal versus how associational they were. Admittedly, I was personally more attracted to some of the compositions than others and I would say that some were more sophisticated than others, but this exercise taught me something else. I was forced to take a more psychoanalytic point of view. The differences related more to what each student was trying to communicate—slice of student life, painterly still life, form for form's sake, mystery—than to my or anyone else's idea of "good" or "bad" taste. And some were more skilled at expressing their intentions than others.

My new framework applies to people at all levels of design skill. The differences are in the number of dimensions that people use to create aesthetic unity (color, texture, shape, size, pattern), the principles of composition (primarily symmetrical versus asymmetrical) and the scale at which they attempt to create such order.[4] In the student exercise there were marked differences in the scale of their compositions; some used a chair seat, some used the whole chair, others used a part of the wall or floor in relation to a chair.

I have learned that domestic compositions follow a developmental sequence. I first realized this after I spent a week studying how residents decorated their apartments in a housing project for the elderly in New Jersey in the 1970s. All of the units were either one-bedroom studios or one-bedroom units. Because they were identical, the only way that they could be individualized was through their decoration. The management made some suggestions as to whom I should interview in the building. The first on the list was Miss Hayworth, whom they called "the best housekeeper" in the building. To me that phrase suggested that I would see a very neat, clean place. Instead, I discovered the best "decorator," or perhaps even the best "interior designer." Today we might

Blue is the theme of this bedroom including paint, bedspreads, alarm clock, and tissue box cover.

say that she was the Martha Stewart of Jersey Manor. Widely acknowledged as the best in the building, she had an influence on her neighbors, especially her immediate neighbor and friend Mrs. Cuff. On the basis of observing, photographing and interviewing these two and another twenty residents I developed a hypothesis which I have since confirmed in many other homes through advertisements, newspapers, movies, decorator magazines, and of course through direct observation.

Generally, we put things together that look alike. And, first, most people use color to make things match or contrast. For example, the bedroom might be all blue—the paint on the walls, the pattern of the bedspreads, the tray on the dresser, even the alarm clock. Now that even bathrooms are decorated (since about 1960) all of the items—towels, shower curtain, the cover of the tissue dispenser, even the plate for the light switch—might be the same shade of fuchsia. One resident used the orange-yellow rug that came with the unit to establish a palette of orange.

In addition to color, the more sophisticated use pattern and texture. Bas-relief metalwork might be paired with a plant having a similar leaf pattern. A paper lampshade with a pattern that includes quarter inch white dots is placed near a small ivory bas-relief representation of the Last Supper because the size of the heads is the same as the dots.

The most sophisticated relate things by shape. Those with training or feeling for sculpture might collect circles, squares, or triangles together into a composition of different colors. A slightly more sophisticated move might be to assemble things of *different* shape and color but of comparable size and definition. A round shape might be composed with a square, triangle, or rectangle of roughly equivalent size.[5]

Regarding scale, some have the psychological or economic capacity to organize the entire wall, not just the dresser top or segment above it, and others can integrate the entire room. Beyond this scale professionals usually take over; relatively few people attempt to create visual order between rooms (the realm of architects), and fewer between inside and outside (architects and landscape architects), and yet fewer between buildings (urban designers), or cities and regions (city and regional planners). Yet the basic impulse to order practical and expressive things artistically remains in professional circles.

Reactions to those who violate the expectation that in our homes practical and symbolic things will be combined artistically help demonstrate how strong this norm is. In the New Jersey housing project of over three hundred units for the elderly, only two people were described negatively by others; one was "not a good housekeeper" and the other was "dirty." They proved to be the exception that proves the rule. In this case, the exception that exposed the workings of this way of thinking about taste. Miss Brevit was a retired nurse who decided to learn about plants and set them up all over her apartment. She went so far as to remove the doors from her clothes closet to create more shelf space for potted plants. She was unusual for several reasons: she had been a professional, she was one of only two people who took a subscription to the *New York Times*, and she had books. But her real eccentricity for the other residents was that she had very few symbolic objects and that she did not organize her things into a visual tableau. She was described as "not a good housekeeper" because her environment was primarily pragmatic.

Mr. Wheeler was not literally "dirty." Rather, he had no conventionally sentimental objects and made no artistic compositions. He was a history buff, interested in local civil engineering. He had boxes full of photographs of tunnels, bridges, and other civic works. He had files full of newspaper clippings and documents. He told me that he had much more when he lived in a house, but had to get rid of a lot of it in order to move in here. He didn't mind living amongst his own files. He violated the unwritten codes about how one should display one's stuff. He was virtually all pragmatic.

These two examples clarified for me how the pragmatic and symbolic have become discrete categories of thought in people's minds. In these two cases the neighbors were not conscious of their mental structures, and so they used other terms like "dirty" and "poor housekeeper" when the symbolic category was ignored or collapsed into one with pragmatic.

Designers, too, sometimes violate this shared cultural process; for some modernist designers, having the right pragmatic objects—the right toaster, the right juicer—may be all the symbolism they allow themselves. Laymen may perceive such strict minimalist environments as "bare" or "cold," but all that has happened is that the two categories have been collapsed into one. Some people have so many sentimental objects in their place that it is hard to move around or make a meal; here the symbolic has dominated the pragmatic. These extreme cases help expose the structure of thought that we routinely bring to bear upon the process of organizing our homes.

Mr. Wheeler lived solely pragmatically so that his entire studio functioned as a giant filing cabinet.

The point of view I am developing here is that everybody decorates and so everyone composes, which is a form of psychological integration. In decorating, people create dioramas in which they actually live. The size of the composition and the way practical things are combined with symbolic ones tell us more about the person than a simple statement that they have good or bad taste. Similarly, there are no objects that are intrinsically in "good" or "bad" taste. For example, toilet lid covers, whether they are hand crocheted or industrially produced, are not "bad taste" despite what my colleagues in architecture might think. The fact that someone chooses to soften the clank of the lid on the tank and at the same time include the pragmatic toilet in an overall decorative scheme means that they are quite serious about the aesthetics of everyday living, and that their taste behavior is highly activated. For all these reason I have concluded that taste is not particularly meaningful as a property of persons or objects.

Advantages of this way of thinking about taste

This set of ideas for thinking about interior decoration can be used to analyze how people decorate in different cultures, different classes, different genders, different age groups, and different ethnic groups and subcultures, even as it allows for and acknowledges individual variations. That is to say, we do not have to use different ideas about how people make things or decorate if we shift focus from the United States to Polynesia, from the rich to the poor, men to women, young to old, from one immigrant group to another. Because each of the elements of this framework is defined generally but analytically, we can locate each of these groups and persons at different points along the same conceptual dimensions.[6] Even though our identities are rooted in group memberships, individuals can and do express themselves visually by assembling their stuff in unique compositions. And as they change, so too do the arrangements of their stuff.

This way of thinking about taste as a special kind of composition is simple enough to apply to all scales of environmental design. It encompasses both the things inside of a room or building, the building itself, and the things outside of it. We could use the same set of ideas to talk about products, interiors, architecture, urban design, and landscape architecture. Differences between an object and a neighborhood would be recognized as different points along a continuum, rather than being used to create separate theories, disciplines, and standards of excellence for each shift in scale.

Another strength of this framework for thinking about taste is that it situates both amateurs and design professionals along a continuum. This means that we don't have to assume a sharp difference between the user and a designer or, in sociologist Herbert Gans's terms, between the audience and the creator. Bluntly, this means that the tastemaker and the most aesthetically undeveloped person share something. If everyone participates in this activity, professionals do not have to feel alienated from their audiences. They can communicate directly with nonprofessionals about this important aspect of living. Conversely, by understanding that what professionals work at for a living is an elaboration of what they themselves are doing when they do something as simple as set the table, the layperson can feel affinity with the artist, craftsperson, and designer.

Practically speaking, this means that citizens might appreciate (and hire) art, craft, and design professionals more than they do now. I do not want laypeople to be intimidated, nor to use professionals as status symbols, but rather to appreciate them for working thoughtfully and full-time to develop and refine this shared impulse to intertwine two categories of objects in a pleasing way. Laymen can learn from these professionals and benefit from their services, even as the most culturally responsive professionals are learning from popular practices. This elemental way of thinking about taste can expand the exchange of ideas about how to develop, enhance, simplify, or elaborate the artistic tableaux in which we live our lives.

Another power of this framework is that it does not require two different sets of considerations for male or female practitioners. In *As Long As Its Pink: Gender Politics of Taste*, Penny Sparke has argued that historically taste referred primarily to women's aesthetic activity within the home, and that male culture claimed the term "design" as a way to differentiate itself from the traditional female concern with "taste" in interior decoration. This perspective recognizes differences in ability and training, but makes much of the observation that the impulse to make order is shared by most people.

This simple but comprehensive (one definition of elegant) view allows us to reconsider a whole series of dichotomies as related qualities. For example, this framework allows us to consider both useful and expressive aspects, in other words both the pragmatic and the symbolic. Further, it allows us to acknowledge both the formal and the associational aspects of these works, that is to consider both form and meaning, sometimes referred to as syntax and semantics. It allows us to consider both structure and surface, both the process and its outcome, both making and display, both activity and result.[7]

This is a general set of ideas for explaining how the values implicit in the term "taste" operate in the world, potentially liberating for the insecure consumer, and especially useful for educators and professionals in planning and environmental design, architecture, art, fashion, sociology, education, and cultural studies. Most writing on taste either debunks it or celebrates it. This is a step toward learning how it works, so that as individuals or as professionals we can use its codes knowingly.

Taste Moves between Material and Nonmaterial Culture

One issue remains: that of rank and class. The sociological contribution to writing about taste sees it as a form of showing off—called conspicuous consumption by Thorstein Veblen and distinction by Bourdieu—a form of rank, legitimizing

class differences. In contrast, I have observed that the basic formula for artistic display is surprisingly similar for all socioeconomic classes. In the United States at least, the working class, middle class, upper middle-class, celebrities, and even artists, designers, craftspersons, and collectors follow similar rules despite differences in money, power, and education.

In discussing aesthetic cultural systems, sociologist Paul DiMaggio has made a distinction between material and nonmaterial culture, and sociologist David Gartman has observed that material culture (for example, cars and washing machines) has become a basis for equalizing social differences, while nonmaterial culture like music has become a basis for sustaining social differences. The qualifications that these sociologists have introduced in order to modify Bourdieu's strict view that all matters of taste are matters of rank can be applied to my way of thinking about taste. Pragmatic things are material and since we all need the same basic things in our Western living rooms we could say that of all the things we possess they provide the most commonality among people; despite cost differences they make us more like one another than anything else. The symbolic things introduce less equality, representing differences in education, travel, religion, etc. The aesthetic principles by which we order our pragmatic and symbolic things are nonmaterial, and they may introduce even more inequality, although design idealists, like me, see this as a way to transcend inequality.[8]

My addition to this evolving set of ideas is to suggest that taste slides back and forth between material and nonmaterial culture. Put another way, taste is a transitional category between the two.[9] Recall that taste is about placement. The mental structures used to place the objects are nonmaterial, but the objects themselves are clearly material. This makes taste, at least in the context of interior decoration, an arena in which social differences are both maintained *and* transcended. Cognitive styles of arranging objects, which the design writer Leonard Koren calls "rhetorics," are the nonmaterial part of culture, but they are inextricably fused with its material base, the objects.

Taste is a slippery concept that can be used either to transcend class differences or to confirm them. A Ming vase and a beer bottle are both material and both signify different social ranks, but in composition they could be related by form—they may have the same silhouette—which would seem to transcend class signification. However, the sculptural sophistication of looking for and seeing common shapes elevates the decorator, bringing back in the vertical element of rank.

A **pragmatic road when lined with a double row of trees can express taste. The same principles of composition apply to landscape as to interiors.**

The active, process-oriented conception of taste that I have described here suggests that we play with the relationship between our changing cognitive distinctions and the universal material plane that unites us all. Thereby, difference and similarity, distinction and wholeness are acknowledged simultaneously. The exercise of taste in the realm of interior decoration is a kind of alchemy.

Let me expand on this particular kind of transformation. The aesthetic operations that unify pragmatic and symbolic objects do not so much fuse the two as much as they temporarily relate them. These operations allow us to reconfigure objects. Very different compositions can be created with identical objects. These secular tableaux remind me of what I have heard about the late 19th century *tableau vivant*. People dressed in costumes copied from famous paintings, often of antiquity, then acted out and held poses of the figures in the paintings. They could be unfrozen, reconfigured, and frozen again. So, too, our things can be reorganized for greater convenience, greater drama, new color schemes, in response to new ideas about what is convenient, and the like. Ah, but how little we take advantage of this ability to change—except when goaded by fashion. We get lazy and let things remain as they have been, but fashion prompts us to reconfigure our

stuff. Psychically, fashion helps keep us flexible. As Tom Wolfe has said, fashion allows us to conform (to group standards) and change by the same token.

Our compositions, as expressions of our wholeness, change as we pass through life. Personally we change and we express those changes through various media including the environments in which we live. The common practice of decorating, arranging our things, may help us integrate our various and multiple identities. Our identities will differ by class, but people in all classes assemble and thereby integrate their identities. Decorating may help us consolidate and integrate who we are as much as it helps us recognize and legitimate social differences.[10] This means that decorating is a *cultural* practice as much as a class-based practice that reflects differences in social structure. This view admits that both our previous and our current selves differ from our fellows. We express interpersonal differences and *at the same time* we express our current sense of wholeness through the choices we make in clothes, jewelry, and home decoration. A composition can be a universe unto itself. For some time during creation or deep appreciation of another person's arrangement, it is not part of a social hierarchy. In this way decoration both expresses and transcends social differences.

NOTES

1. This dimension most closely corresponds to the moral codes by which some elites identify one another according to sociologist Michelle Lamont.

2. In the late 20th century buying commercial stoves for residential kitchens became a symbolic statement more than a pragmatic accommodation to an increase in cooking skill. In fact, those who cook regularly often feel smug that those who have the commercial stoves seldom use them.

3. Accordingly, I am even willing to conceptualize taste "scores," some people scoring higher than others. But they would be scoring higher or lower at an *activity* rather than as human beings.

4. Theoretically, each assembly created by a person could be given a score so that levels of skill could be acknowledged, objectified, measured. Even so, the final score would not be as interesting as the scores in the different parts of the equation. Two people could end up with the same score but have very different profiles in terms of the kinds of pragmatic objects, the kinds of symbols, and how skillfully they were composed.

5. At the scale of landscape an example is architect Benard Tschumi's design for Parc La Villette in Paris.

6. Important questions about this way of thinking about taste, decoration, and craft remain. For example, how early do children learn to manipulate these several components of taste? How are gender differences developed? Where do we get our ideas as adults?

7. For those interested in the debates about mass culture and those interested in society and economy, this perspective also allows us to consider decoration as both production and consumption, important because residents produce interior arrangements even if they buy (and in that sense consume) their component parts.

8. My grandmother, a professional interior designer, told me that it didn't matter how poor one was, if one had to sit on orange crates and shop at the five and dime and thrift stores, one could still put things together well. But her brand of democracy presumes an educated eye—not necessarily formally educated, but an eye raised to think that beauty matters. There may also be innate, not class-based, differences between people in regard to how much information they take in through the senses.

9. Curiously, while this fusion or continuum seems important, we in our culture do not want to blur the distinction between pragmatic and symbolic. That is to say, maintaining the difference between pragmatic and symbolic categories is important even as the two categories are harmonized artistically, and even as doing so creates and expresses a continuum between material and nonmaterial categories.

10. In sociological terms decoration performs an "integrative" function, not just one of "pattern maintenance."

BIBLIOGRAPHY

Bourdieu, Pierre. *Distinction: A Social Critique of the Judgment of Taste.* Cambridge MA: Harvard University Press, 1984.

Castillo, Greg. "A Home for the Cold War: Exhibiting American Domesticity in Postwar Europe." *Journal of the Society of Architectural Historians*, in press.

DiMaggio, Paul. "Classification in Art." *American Sociological Review* 52 (1987): 440–55.

Dissanayake, Ellen. *Two Orphans and a Dog: Art and Transformation.* Haystack Mountain School of Crafts, Deer Isle, Maine, 2000: 4.

Erickson, Bonnie. "Culture, Class and Connections." *American Journal of Sociology* 1021 (July, 1996): 217-251.

Gans, Herbert. *Popular Culture and High Culture.* New York: Basic Books, 1999.

Gartman, David. "Culture as Class Symbolization or Mass Reification? A Critique of Bourdieu's Distinction." *American Journal of Sociology* 972 (Sept., 1991): 421–447.

Koren, Leonard. *Arranging Things: A Rhetoric of Object Placement.* Berkeley, CA: Stone Bridge Press, 2003.

Kron, Joan. "The Semiotics of Home Decor." In *Signs of Life in the USA*, eds., Sonia Maasik and Jack Solomon. Boston: Bedford Books, 1997: 72–82.

Laumann, E. O. and J.S. House. "Living Room Styles and Social Attributes: The Patterning of Material Artifacts in a Modern Urban Community," *Sociol. Soc. Res.* 54 (1971): 321–42.

Lamont, Michele. *Money, Morals, and Manners: The Culture of the French and the American Upper-Middle Class.* Chicago: University of Chicago Press, 1992.

Levine, Lawrence. *Highbrow/Lowbrow: The Emergence of Cultural Hierarchy in America.* Cambridge, MA: Harvard University Press, 1988.

Marcus, Clare Cooper. *House As Mirror of Self.* Berkeley CA.: Conari Press, 1995.

Miller, Daniel. "Consumption and Commodities." *Annual Review of Anthropology*, 24 (1995): 141-161.

Peterson, Richard and Roger Kern. "Changing Highbrow Taste From Snob to Omnivore," *American Sociological Review*, 615 (Oct. 1996): 900-907.

Starke, Penny. *As Long As It's Pink: The Sexual Politics of Taste.* New York: Harper Collins, 1995.

Veblen, Thorstein. *The Theory of the Leisure Class.* New York: Modern Library, 1934.

Wolfe, Tom. "Introduction," in Rene Konig. *A La Mode: on the Social Psychology of Fashion.* New York: Seabury Press, 1973.

He keeps his failures out where
anyone can see them and keeps
his successes in drawers. The
failures could come in handy
someday for parts.

James Galvin,
from *The Meadow,*
Henry Holt and Co., 1993

The secret of life is to have a
task, something you devote
your entire life to, something
you bring everything to, every
minute of the day for your
whole life. And the most impor-
tant thing is—it must be some-
thing you cannot possibly do!

Henry Moore,
talking with Donald Hall in *Life Work,*
Beacon Press, 1993

. . . Beyond this, it's advisable
to have a skill. Learn how to make something:
food, a shoe box, a good day.
Remember, finally, there are few pleasures
that aren't as local as your fingertips.

Stephen Dunn,
from "How to Be Happy: Another Memo to Myself,"
in *New and Selected Poems, 1974 – 1994,*
W. W. Norton and Co., 1994

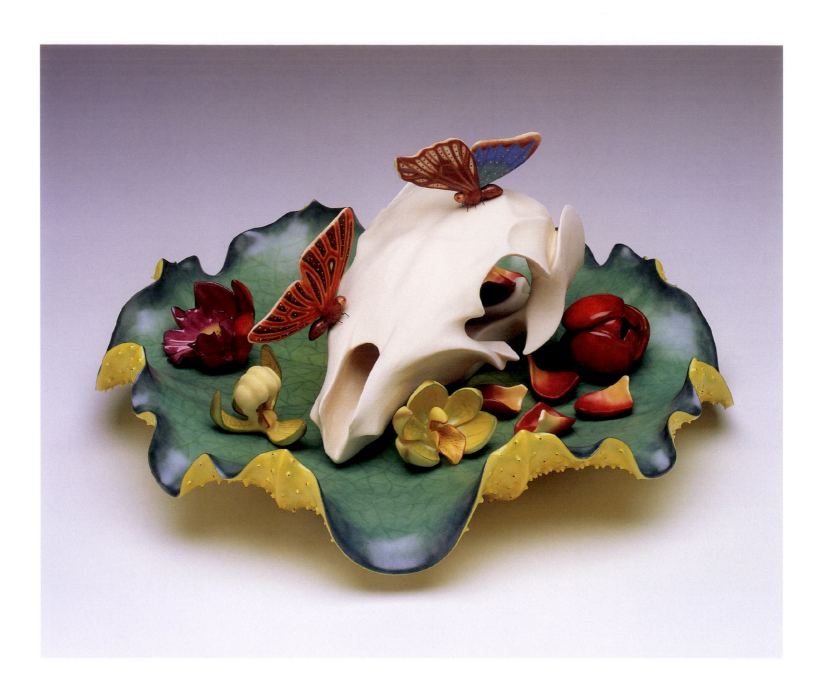

EXPRESSION: NO BOUNDARIES

Craft today has no boundaries as a vehicle for the expression of complex ideas. Gender, ethnicity, age and religion can be expressed through craft, but it is not constrained by them. Craft has no retirement age. Gender does not restrict practice: women weld, men weave. Boundaries disappear when ethnicity is expressed and celebrated through craft, and craft can also be used for potent commentary on political issues and the human condition.

KEISUKE MIZUNO
Squirrel's Skull with Orchids, 2003
Slip-cast and handbuilt porcelain
5 x 12 x 12 in.
Collection of the artist and Frank Lloyd Gallery

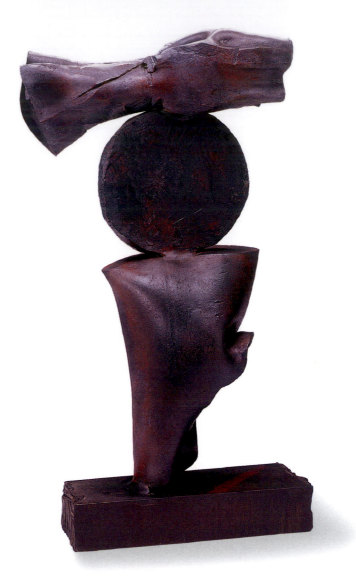

WILLIAM BROWN JR.
Passions in Clay, 2001
Steel with acrylic enamels
28 x 15 x 4 ¹/2 in.
Collection of the artist

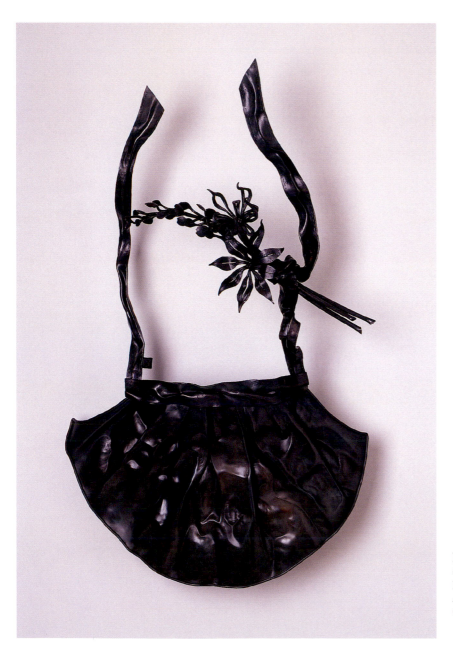

ELIZABETH BRIM
Catch, 2003
Forged and fabricated steel
40 x 15 x 4 in.
Collection of the artist

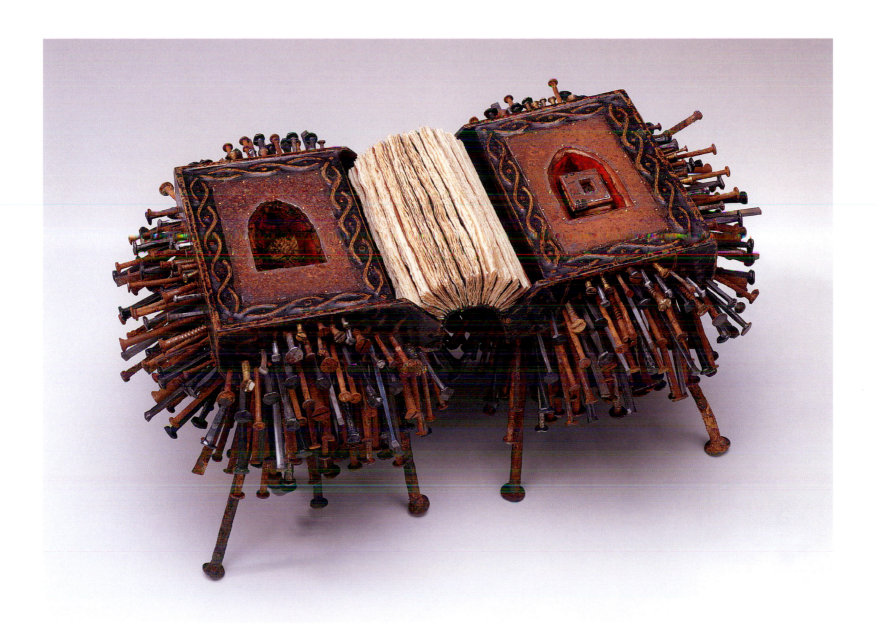

DANIEL ESSIG
Book of Nails, 2002
Mahogany, paint, nails,
mica, trilobite fossils,
handmade paper
4 x 17 x 12 in. (open)
Collection of the artist

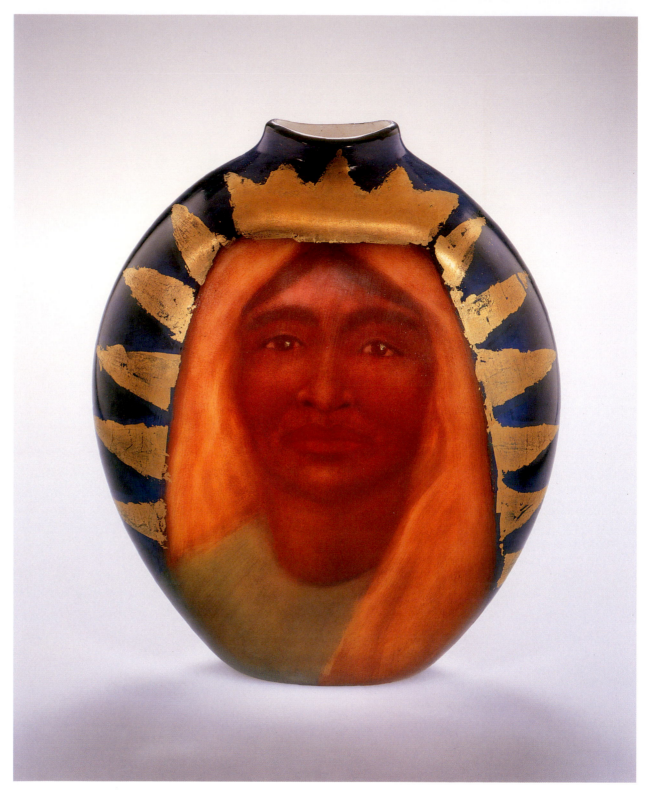

WALTER LIEBERMAN
Nuestra Señora del Cielo
(Our Lady of the Sky), 1994
Blown glass, enamel
14 ½ in. high
Collection of the
Corning Museum of Glass,
Corning, NY
Photo: Corning Museum of Glass,
Corning, NY

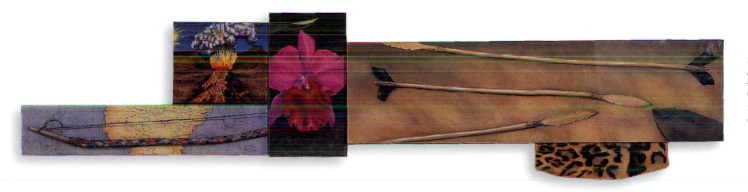

JUDY JENSEN
Indios, 2000
Glass, reverse painted
12 x 49 in.
Collection of the artist

JOHN PFAHL
Roan Mountain Lightning,
Roan Mountain, North Carolina, 1977
Photograph, Ektacolor print
11 x 14 in.
Collection of the artist
Courtesy of Nina Freudenheim Gallery,
Buffalo, NY

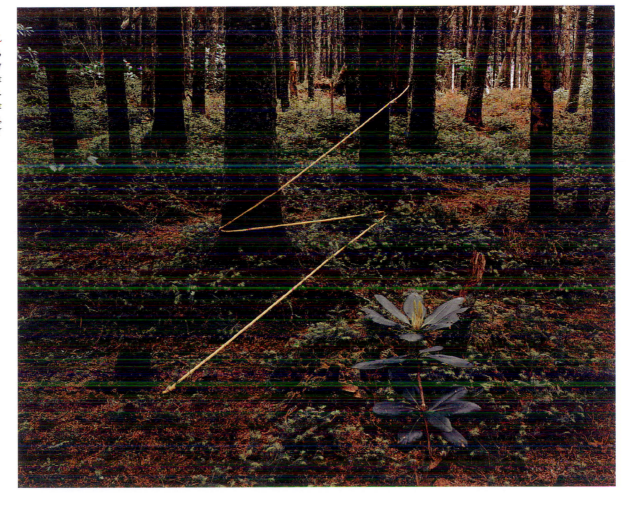

THOMAS SUOMALAINEN
Man with Blinders 1, 1975
Hand-built stoneware, underglaze slips
23 x 8 x 6 ¹/₂ in.
Collection of Cynthia Bringle

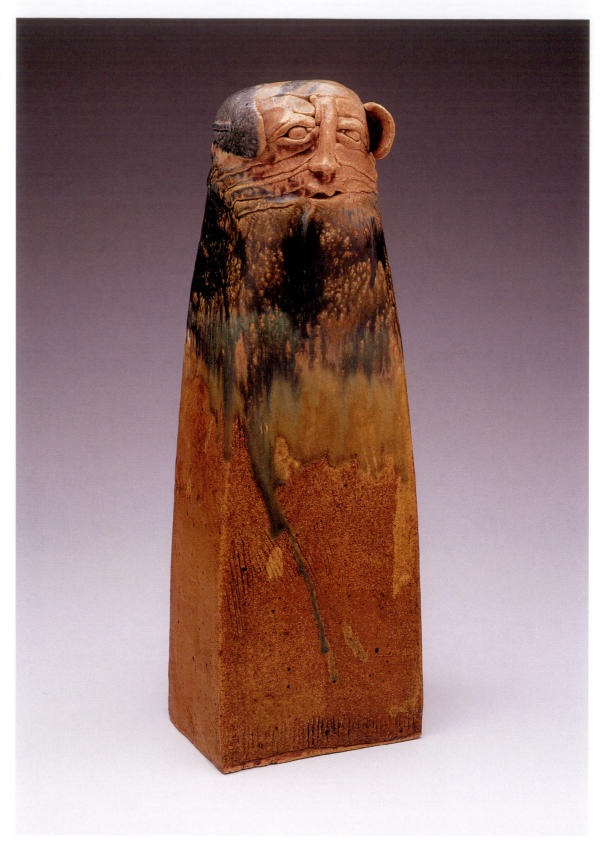

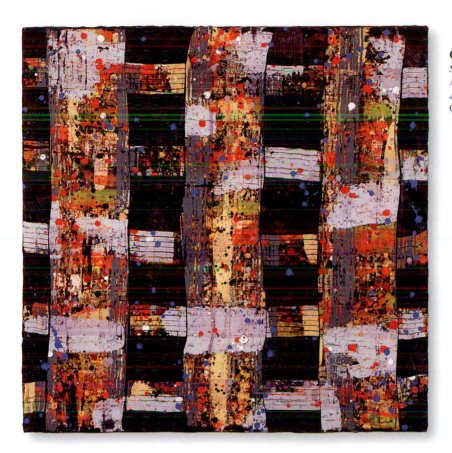

CLARENCE MORGAN
Shift in Focus, 2000
Acrylic on canvas over panel
40 1/2 x 40 1/4 in.
Collection of the artist

EILEEN WALLACE
Three Books and Box,
Japanese Bindings, 2003
Paper, silk
5 x 4 x 1 in.
Collection of the artist

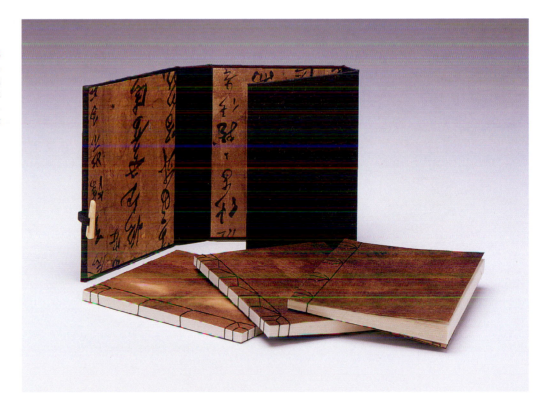

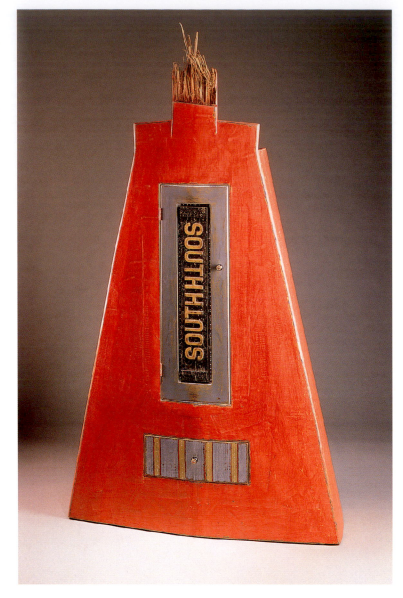

RANDY SHULL,
South Cabinet, 1992
Polychromed wood, mixed media
84 x 50 x 18 in.
Collection of Brooklyn Museum of Art
Gift of Franklin Parrasch
1994.206

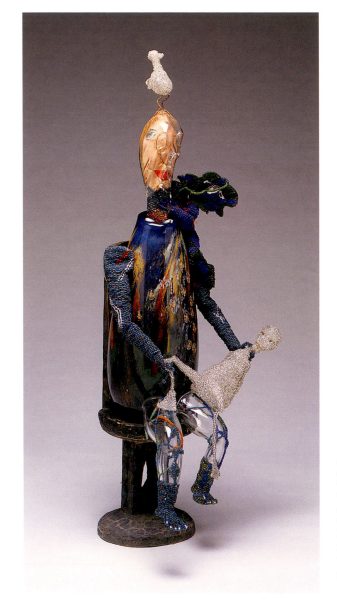

JOYCE J. SCOTT
Spring, 2000
Glass beads, mixed media
45 1/4 x 17 1/2 x 13 1/2 in.
Collection of The Mint Museums, Charlotte, NC
Museum Purchase: Funds provided by Noel Gallery, RDS
Electrical Contracting of Charlotte, Patricia and Richard
VanDyke, Catherine and Herbert Watkins
2001.44

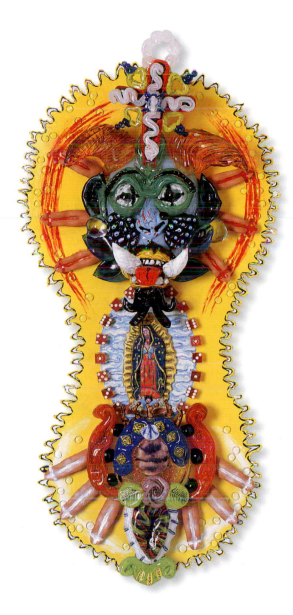

EINAR DE LA TORRE AND JAMEX DE LA TORRE
Christian Devil, 2001
Glass, mixed media
43 x 21 x 9 in.
Collection of Diane and Sandy Besser

TODD WALKER
Sally, Abstract Orange, 1971
Serigraph
9 ¹/2 x 13 in.
Collection of the artist's estate

JANET TAYLOR
Bullseye, 1970
Wool tapestry
96 x 56 x 56 in.
Collection of the artist

BEVERLY McIVER
Dance with Me, 1999
Oil on canvas
40 x 30 in.
Collection of the artist

ALIDA FISH
Walking with Pygmalion #5, 1998
Photograph, altered
11 x 9 in.
Collection of the artist

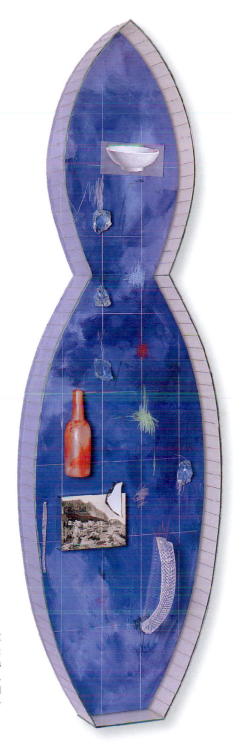

THERMAN STATOM
La Figura Azul, 2001
Painted glass and found objects
80 x 23 ¹/₂ x 5 in.
Collection of the artist and
Maurine Littleton Gallery

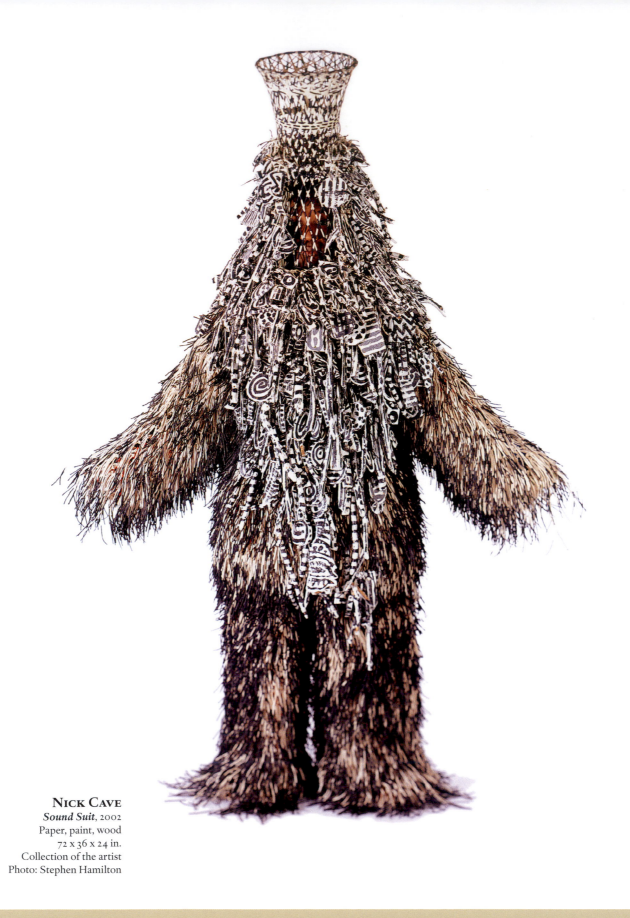

NICK CAVE
Sound Suit, 2002
Paper, paint, wood
72 x 36 x 24 in.
Collection of the artist
Photo: Stephen Hamilton

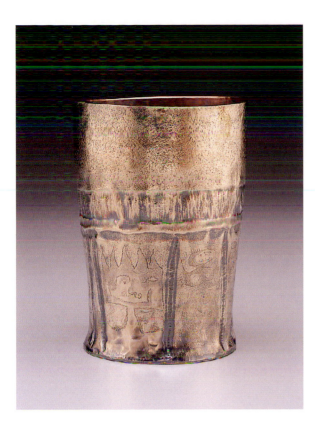

GARY NOFFKE
Goblet, 1968
Silver
5 5/8 x 4 in.
Collection of The Mint Museums, Charlotte, North Carolina
Museum Purchase from the Seventh Annual
Piedmont Craft Exhibition
1970.2

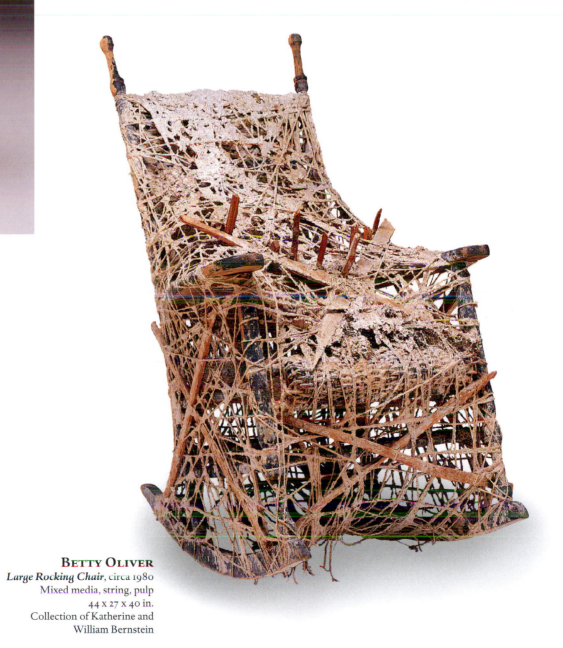

BETTY OLIVER
Large Rocking Chair, circa 1980
Mixed media, string, pulp
44 x 27 x 40 in.
Collection of Katherine and
William Bernstein

SERGEI ISUPOV
To Run Away, 1999
Porcelain, slips
9 x 17 x 7 ¹/2 in.
Collection of The Mint Museums, Charlotte, NC
Gift of Leslie Ferrin and Donald Clark, Ferrin Gallery
2003.14

PETER GOURFAIN
Powerful Days, 1991
Linoleum print
70 x 46 in.
Collection of Elvehjem Museum of Art,
University of Wisconsin-Madison
Art Collections Fund Purchase
2001.53

PETER GOURFAIN
Powerful Days, 1992–1993
Terracotta
96 x 22 x 17 in.
Collection of the artist

KENNETH KERSLAKE
Two Women Talking, 1998
Graphite on paper
32 x 25 in.
Collection of the artist

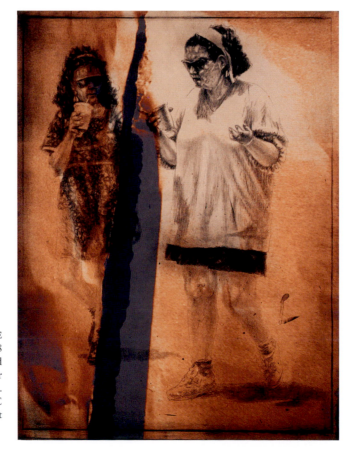

KENNETH KERSLAKE
Gap in Our Conversation, 1998
Waterless lithograph printed from grained
glass plates and digital transfer
24 x 18 in.
Published by Harvey Littleton Studios, Spruce Pine, NC
Collection of the artist

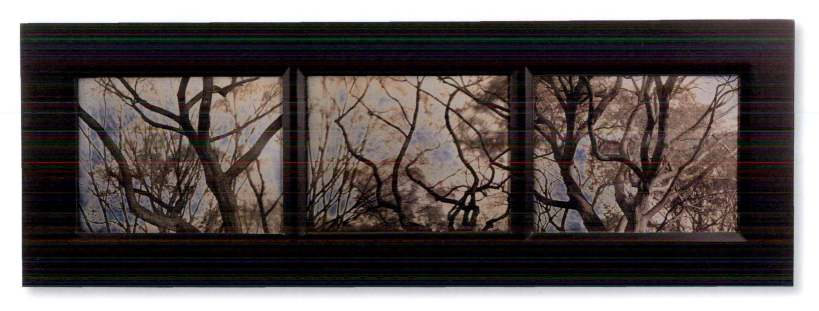

JERRY SPAGNOLI
Untitled, 2002
Daguerreotypes
12 x 26 in.
Collection of the artist

HOLLY ROBERTS
Woman with Big Snake, 2001
Oil on silver print on canvas
27 x 24 in.
Collection of the artist

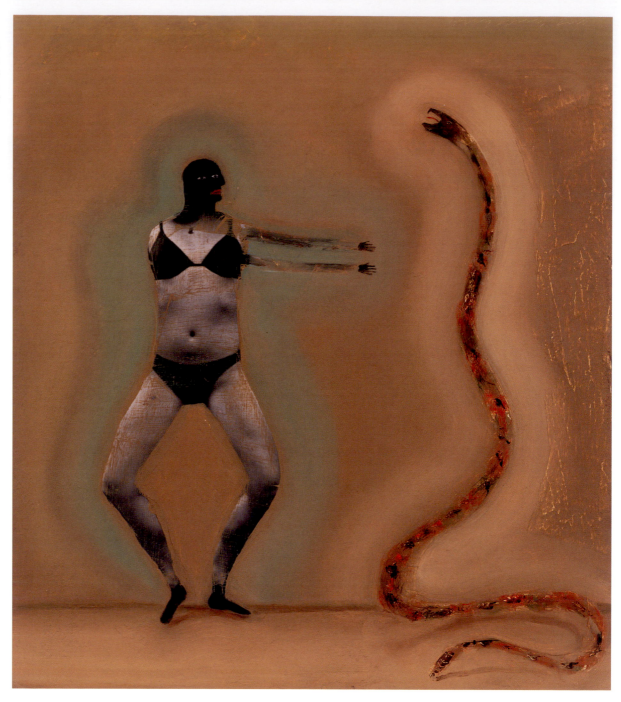

THE NATURE OF CRAFT AND THE PENLAND EXPERIENCE

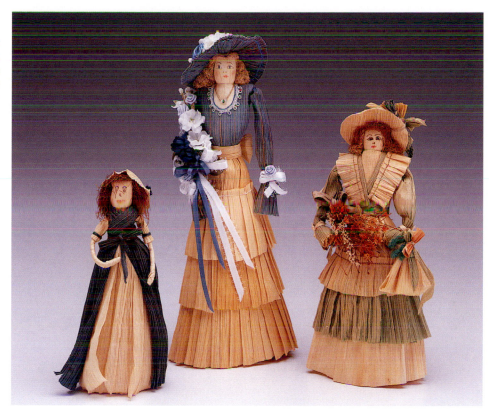

FLOSS PERISHO
Corn-Husk Dolls, 1958–1999
Mixed media
6 to 10 in. high
Collection of Harold Copley

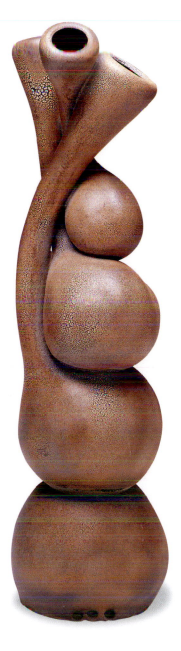

BRIAN RANSOM
Resonator, 2003
Clay, electronics
35 x 11 in.
Collection of the artist

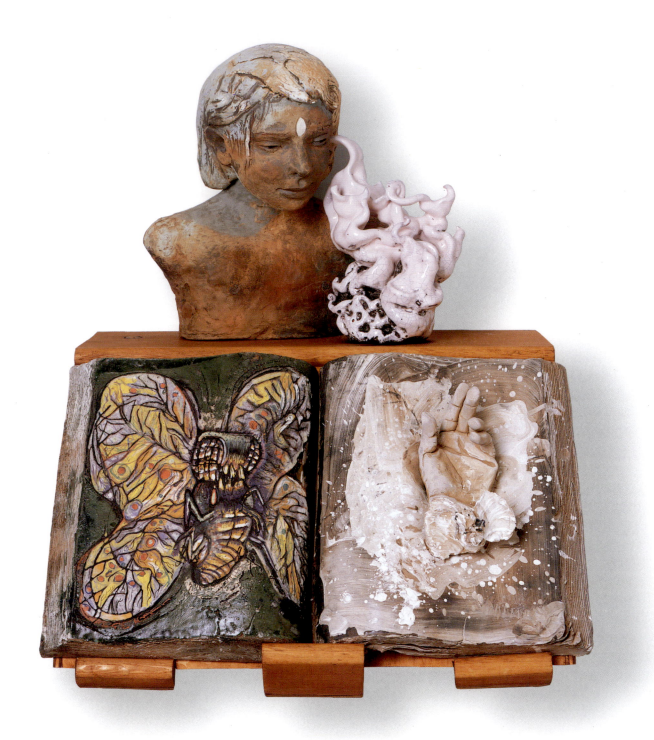

ARTHUR GONZALEZ
Book of Whispers, 2002
Stoneware, underglaze, engobes, oil paint
30 x 27 x 15 in.
Collection of the artist

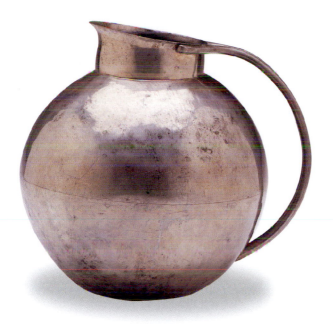

**ATTRIBUTED TO
PENLAND WEAVERS AND POTTERS**
Pitcher, circa 1930–1938
Pewter
8 ¹/₂ in. high
Collection of Southern Highland Craft Guild, Asheville, NC.
Gift of Marian Heard

BOB TROTMAN
Big Hedy, 1998
Limewood, pigments
34 x 43 x 25 in.
Collection of Hedy Fischer and
Randy Shull
Photo: Martin Fox

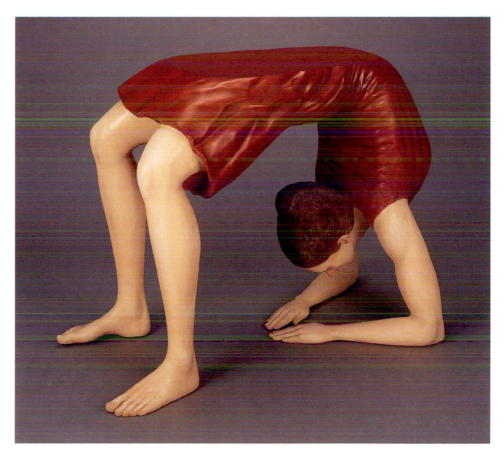

The Time of Craft

Eileen Myles

I came to Penland last summer to do some wondering and searching about craft. Robin Dreyer, editor of Penland's publications, handed me a little article about the potato and the Irish. I'm Irish-American and I've written a lot about my heritage, so Robin thought I might be interested. The article talked about the Irish before the English came around. It said that the Irish were great cattle raisers, and loved riding horses. They were not nomadic people, but they also did not make much about whose cattle were whose. Thus no fences and the cattle roamed and the cattle were led home. I like to think of the route of the cattle and the place they held in the life of the Irish people. I am inclined to call that place an "imaginary." It's a little like the way I think of my own "studio." The place where I do my work. It's no place and everyplace and it's made out of language and goes where it goes. So that maybe rather than thinking about me as a poet, you might think of me as a herder, a shepherd perhaps. Of words. I mean to say they are not my words, it is not my language, but believe me I take care of them. I further the herd, and within it I have pets. A string of relationships with language which is how I move through the world. My attachment to language attaches me to my community and my landscape and my culture and of course I began wondering as I looked at craft—well, how does it happen here?

Lately I've been obsessed with allegory. In Latin it means roughly, "other hand speaking." In Chaucer's time that meant that since each stone and each plant had a meaning assigned, i.e. opals are bad luck and lilacs mean "first emotions of love," then all a poet had to do was cite the details of a landscape and the secret significance of a poem would be obvious as she walked us through. In a way, the world was the poet's hand. And she borrowed it to write.

I was speaking in a bookstore in Chapel Hill. Writing a novel, I told the people in the room, is in essence no different from editing a film, or even making a quilt. Do you really mean that, asked Sherri Wood. She was a youngish brunette with very bright eyes. Mean what? I was feeling defensive. The workshop was over and I had given a lot. About quilts, she gleamed. Well, yeah. Yeah, I think cutting up and arranging text, making a pattern seems similar to quilt making to me. I loved it, she assured enthusiastically. I'm a quilt maker! There's a school in North Carolina where I'm going to teach quilt making. Maybe you would like to know about it.

The next fall, very shortly after September 11th, I was riding past that woodsy sign that says Penland. I was falling asleep as the road went round and round. Robin was driving. Does this get easier I asked him, grateful that he was behind the wheel. Oh, yeah, he said. Because you go faster, I asked? No, because you don't slow down so much.

Dye samples

In the morning, after standing with my coffee over a green, foggy valley that looked like a bowl of smoke, I was the guest in Sherri Wood's class called improvisational quilt making. She opened the class with a song by punk band, Le Tigre. Everyone danced between the piles of cloth and tables and chairs and then we sat down and began. We were now energized and focused. So how did *you* get into this, I asked Sherri. She told me that she had been in divinity school and was intending to become a minister. She was having a hard time writing her thesis but when she proposed she make a quilt instead of writing, her thesis committee agreed. Which was the turning point for her, and she didn't think about becoming a minister anymore. The deeper connection was made. Sherri's class was composed of people of all ages, mostly female, mostly under forty, but not all. Steven, a DC policy-maker, was spending his vacation making quilts and his bad-geometry, bright green and soft blue quilt hummed and thumped like jazz, and filled me with a maddening desire to own it. I think he enjoyed my appreciation. He quickly explained that he was making *this* quilt—and he tugged another of his projects closer—as a gift for a nephew who had been born while Steven was at Penland. This one (the one I wanted) I will hang on my wall, he smiled. It will remind me of the time I spent here. *And it will relax me.* The quilt itself was a mantra. Steven's eyes took on a glow as he mentally catapulted to another time in which he would be needing the attributes of this time. One associates quilting with rural, female, communal, and probably economically disadvantaged citizens, white and black. What kind of time is that?

I was waiting for my *latte* in Starbucks yesterday wondering who would give a friend a gift certificate for twenty-five dollars from here. I was impatiently reading the menu, reading the walls, reading everything. Or a one hundred dollar certificate from Music Warehouse. What's the significance of giving that? Too bad you can't give someone an actual month. Not a month we anticipate or know, but an extra month that could be directly attached to their year. Or how about three years? Or even a week. A day, just an extra day. Steven clearly had bought himself some time. A poorer time? A female time? Or was it a priceless time? A time he wanted. And apart from whether he paid for the time or someone got him a gift certificate, the nature of the time one dwells "in" is pretty much determined by the materials one chooses. One arrives there by accident, or through someone they know. I'm thinking about the medium of teaching, by which a person infuses another with a love of material. There's something

Sketches

impossible about it, it's the fulcrum of all communities, and continually it works.

My favorite metaphor for teaching is the occasion when my dad put me on the seat of my first two-wheeler and with one hand on the handlebar and one on the seat, he ran. I had the feeling of flying down the driveway of my home. And then he let go, and I continued, gloriously riding on my own. He gave me the escalating feeling and it caught. You *can* teach love. What I mostly discovered on my first trip to "craft time," was the primacy of love—the necessary attraction to materials. I was teaching a workshop to a group of students from a variety of media at Penland. I did my thing. I told them how I came to my practice and what I thought it was, and I asked them then to explain who they were and what brought them *here*. Their answers were direct: I'm metal, I'm wood, I'm glass. Everyone, I think, was aware of how funny these self-descriptions were, they delivered them with a grin: I'm clay, and still the descriptions held. The glee was about abandonment to materials and the time the materials demanded. Taking a road and finding out about it.

I returned to Penland nine months later. It was a little harder, like a second date. I had spent months now telling everyone I knew about this amazing place in North Carolina where many people smoked cigarettes (a giant ashtray sits outside of the glass dining hall that faces that same bowl of morning and, sometimes, afternoon smoke in the valley) and look like they're in rock bands or work in natural food stores but in fact they are making metal chairs and funky bowls and blowing glass. Turns out everyone knows Penland, it's many people's dream. A woman I know who is having her second kid gets all dewy-eyed and assures me she will get there and

has been religiously receiving their catalogue for years. Hey, is there a scholarship for Kate? One that includes child care?

The sound of metal was leading me up the path. And heavy metal music. The iron studio stood with its corrugated roof and a pirate's flag perched on top. Elizabeth greeted me—a tall woman with her hair swept up, a string of pearls around her neck and hiking boots planting her firmly in the ground. I will show you our gate. The gate will tell you a lot about who we are in the iron studio. The whole studio moved up here a few years ago. And just because of our new location there was maybe a different feeling about the appearance of our scrap pile. I'll show you. Elizabeth opened the big brown gate and walked me along the side of the building to a commanding and surreal and black heap of scraps, bent fencing, candelabra, warped bells, signs, and doors. Our scrap pile is more than just a pile of junk. It's a teaching tool—it's ideas, it's material. She picks up an odd-shaped clump, like a little shoe. Things too cool to throw away. Some of our neighbors wanted to know if we could move this incredible pile somewhere where their people wouldn't see it. We wanted to keep it close. Well, we like games at Penland. We have fun. Back in the 70s we organized a croquet game whose sole purpose was to demonstrate the amount of interest there was in forging here. Enough to start up a blacksmithing program. You could easily make a croquet wicket out of iron and from there we challenged the other studios to make their own wickets. My first wicket looked like a ribbon. She picked up a wiggly piece of metal, grinning and threw it back on the pile, clang. So, in dealing with our pile, we decided to make it our own people's project to make this big gate. Something really fancy and crazy and cool that would hide the scrap pile *and* give us an opportunity to come together as a group. Sort of like a benefit for ourselves. Elizabeth opened the mammoth gate, and we stepped outside as she spoke. We wrote to all our people and everyone brought pieces. They drove up here with great stuff in their trucks. We still haven't used it all. Plus there was all this stuff hanging on the walls of the old studio and we just used all that stuff for our gate.

Now I can see that the gate's incredible. I mean her story did it, too. It's tall stripes of metal, a big G-clef, wreathy twists of cold, black, shining bands of stuff. Elizabeth leans on the gate. The thing is about working in metal—she pauses, almost politically. I mean, you can make an artistic statement and it will last three weeks. She shrugs. Here we make stuff that lasts. This gate is part of our history. And we have tools. Look at this fifty-ton hydraulic press. You don't have to

sit around with a little spoon going tink tink tink. She smiled at me. Weight is time.

I decided to continue with light. My friend Marco Breuer was teaching a photography workshop without cameras. Which was perfect. If I had to pick something instead of language to be "mine" I felt sure it would be light. Marco gets his students to crumple photographic paper up and stick it in the bushes during a lightning storm and see how that turns out. He shows slides of someone who turned a washing machine into a camera, another who turned a package into a camera and sent the package through the U.S. mail photo-

Blacksmith's workspace

Flameworker's workspace

graphing its journey. I nearly wept at the pictures that can be taken "without" a camera. Camera means room in Italian. No, stanza does. Maybe it's Spanish. Anyhow, I feel like that camera which is not. I'm excited that Marco's work is craft. I'm tremendously excited and I start describing my own process. Which is poetry—but also, I'm *beginning* my project (which is to write an article about craft—which is easy, because I love it). I begin:

This is a great notebook
First I unpack my bags
putting underwear into drawers
hanging shirts
Placing dirty socks in a plastic
bag and throwing them
in the corner

I close the notebook. See I had planned to become a part of Marco's workshop, I wanted to, but then Steve Miller invited me to come to his book craft workshop and talk to his students who were making books out of handmade paper. Their first assignment had been to write a poem—so would I come and give them a few pointers? So I missed Marco's class that second day, and I never went back. Steve's class met on a porch. The chainsaw down below in wood was incredibly loud and making everyone crazy, but some people thought it was good. Steve's people were sitting in a circle, each holding his project-in-progress. Someone would be in the middle of her explanation and the chainsaw would begin and everyone would sit there looking at each other while the talking stopped. The chainsaw grew silent and the speaker would begin again, and the chainsaw would start up. It was different for each speaker—some people plowed right through uninterrupted, others bravely tried to talk over the chainsaw, some refused, making us all wait, and they were most frequently interrupted. Some people just had luck. You could see it. Steve was passing things around—pictures, books that he thought would move everyone ahead, or let them know what was possible. There was a book by a master printer who had died, I think. And all the people who had known his work for years had collaborated on a beautiful book. Steve made admiring but almost scandalized faces at the lengths to which these people had gone. This is just to show you—I mean this is really; he chuckled, kind of maniacal. It was a beautiful book. Green with the master printer's name on the cover and his face in an oval. Maybe the guy

Ideas on the wall

who died had invented a font. And lots of things were still done in his way, in his ancient, revered method. This is almost scary, Steve said. You watch him quake with cringing joy. It's perfect. Perfect is a problem in a way. He held the book up, shaking its heft. So...

While we looked at the students' projects-in-progress, Steve explained the concept of the resting page. You need to give the reader a break. You don't want to overwhelm them. You want to lure them in. You want to keep them going. So you want to occasionally have a page where very little happens. He drops his fingers through the air like a conductor. So they can have a sense of space, once in a while. It's nice, he explained. Not too much, he said, turning the page of someone's book. Steve was masterful at keeping materials in a kind of momentum. Once in a while as we were looking at things, he would say: Switch. And we'd reluctantly pass what we had to someone else and we'd see something new.

I told the guy in wood that maybe I could come down after dinner and see what the racket was all about. I think maybe the yoga people were the only ones who really complained and I've done yoga, they like it silent. The wood guy was a good guy. He and his wife lived in upstate New York. I did go to his studio one night when the light inside and outside the wood studio was incredibly bright on the newly opened wood. It was yellow like paper. Everyone was proud, and freshly opened logs with only a few significant nicks were lying outside on the lawn. It was just kind of a visit. All of it was: it was letting the story unfold.

I was always sitting outside with the instructors after meals and everyone was talking about moving, which everyone hated, and everyone was buying, or looking for a house. Usually there was a perfect one they had just missed. Somebody else got it. I was in the middle of buying a house that summer and I was always running to the office to see if some fax had come, or else borrowing Dana's car to go to the Bank of America in Spruce Pine to be sure I could send the escrow money electronically. Then I'd seep back into the time of craft, thank God.

When I first got to Penland I heard about a man named Norm who'd had his studio burned down. I figured I'd go and talk to him. I did. It seemed like a good story. He's some great ceramist so in the fall he was in Chicago getting an award and some local kids decided to go look at his stuff. His ceramics studio was a desanctified chapel up in the woods around Penland. The kids had heard that the people with the chapel were devil worshippers. Anyway, they set Norm's studio on fire so while he was receiving this award for his life's work it was all getting melted to the ground. Norm seemed amazingly philosophical about it. They just wanted to burn something, he explained. And the kids got caught. They returned to the scene of the crime and someone saw them. Arsonists like to come back and see their work, he explained. Making art and a crime are not so different.

Tell me about your work, I asked. Cause he still had his house and his old studio, and he was building a new kiln in the woods, which he showed me. It was a Japanese kiln and each little step had a meaning, and the stones were laid perfect, each with a goal in terms of controlling and maintaining the temperature. I asked him about clay. He looked at me clearly. He said it was mud's mouth. He had studied philosophy as a young man, but clay really spoke to him. I like mud, he explained. And then he went on to explain the earth's magnetism, and why clay *does stick* together and it's about ions and stuff. And there are specific muds, or clays. For instance, this: red. Deep, deep beautiful red. Albany slip. I stand there in awe, slipping around in worlds of specialization. The endless details, but the earth is a big wad of it, mud. And that would be a huge start, to know that you liked it. There it is.

Potter's workspace

Evon Streetman and some other photographers were conducting a forum at Penland. A student asked how they felt about taking a photograph similar to one done by someone already. Evon replied, "It is no sin to walk through the same gate as someone else, the sin is to just keep standing there."

Weaver **Ruth Kelly Gaynes,** oral history, 2002

A person's hand and feet and larynx and eyes and mind express differently the person within. Our listening is as creative as our speaking. One way to come to know this is to spend time doing it consciously. A dancer may find that movement in space is a bridge to the art of the potter and sculptor. A poet may find that breath and sound are bridges to dance and music and biology. A biochemist may find that metabolism is a bridge to an understanding of meditation.

Potter and poet **M.C. Richards,**
in a 1966 letter to the Rockefeller Foundation requesting funds for an interdisciplinary workshop at Penland

THE SENSES OF PENLAND

Lewis Hyde

From State Route 19 at Estatoe, North Carolina, the Penland Road climbs about a thousand feet into the hills, the Pisgah National Forest lying to the east and west. Small houses, pottery shops, old barns with rusty corrugated metal roofs. Forsythia in bloom. The road twists back and forth and there are regular yellow signs with snaky arrows announcing triple curves ahead. The gravel roads to left and right are black; they look as if they are bedded with coal, though they say that the local mining is for other minerals, feldspar and mica especially. A distant mountain has the white scar of a feldspar mine.

I'm here because of Paulus Berensohn and Hannah Levin. Paulus is a philosophical potter (his 1972 book, *Finding One's Way with Clay*, is about the art of making pinch pots). I met him briefly twenty years ago at the Haystack School of Crafts in Maine (where he'd hired on as a cook). Hannah Levin was a student of mine years later in a class called "Models of Artistic Practice." Hannah's father, the glass artist Rob Levin, lives near Penland, and Hannah interviewed Paulus for my class. At one point in the interview, Paulus said that he'd long felt there were more human senses than the five that we normally name. He said he had a list and that he was up to sixty senses.

When I heard that, I immediately had the fantasy of doing a children's book (*The Golden Book of Human Senses*) with one page per sense. Fantasies come and go, but in this case when Penland School of Crafts called to ask if I might come visit them and write something for their seventy-fifth anniversary, I said, "Yes, if I can spend time with Paulus, and keep a journal about the senses."

The world of craft I take to be one of the places where human contact with the physical world is honored and made into a discipline. We have just left the century that invented conceptual art, a movement started partly with Marcel Duchamp's famous rejection of "retinal painting." In English we say "dumb as a post," but in French they say *bête comme un peintre* (dumb as a painter), a phrase that Duchamp hated

for its implied separation of art and intellect. To counter it, he brought tremendous intelligence to bear on the painted world.

Bully for Duchamp. Still, one must wonder what has happened in the last seventy-five years to the poor retina, that delicate membrane, that wonder of organic response to the fact of photons. The retina, the ear drum, the damp lining of the nose, the pits and folds on the tongue, the great skin that runs from toe to head with its little mountains of nerve endings heaped around the fingers and the lips, the genitals and the anus: what has been the fate of this Gang of Five in the Kingdom of Sense since ideas about ideas took over the art world? And what has been the fate of the forgotten, or never-known Democratic Republic of sense with its scores (if we are to believe Paulus's count) of citizens?

My hunch was that the sensuality of art might have weathered our hyper-heady century by retreating, like some oppressed religious sect, to little mountain villages way south

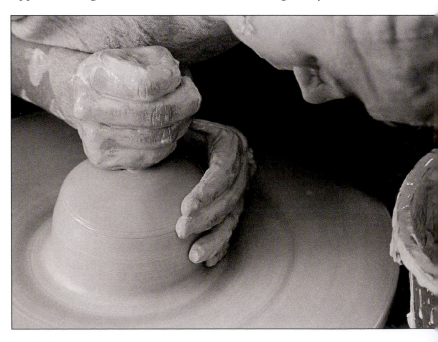

Beginning a pot

Photos: left, Robin Dreyer; right, Ann Hawthorne

of New York where even now the cellphone signals go dead and the TV sets get twelve channels of snow.

So here I am. I flew from Boston to Asheville, and then drove sixty miles into the hills.

Monday, March 17, 2003

Freight trains loaded with coal go along the North Toe River below the house I have been loaned, creaking all night long. A cool, cloudy day. I slept late, then lit a fire in the walk-in fireplace. Went up to the Penland campus—a wide horseshoe of big, old buildings overlooking hilly, green meadows with grazing horses and a few llamas. Got oriented, had lunch, checked my e-mail and the internet headlines. Mr. Bush has advised all the weapons inspectors to leave Iraq. He's going to start a war in three or four days. This news, or low blood sugar, or travel fatigue, or loneliness... made my spirits sink horribly; I wanted to talk to no one, wanted to do nothing. If John Locke was right to derive the mental from the sensual, then which of my senses are in charge today, oh Mr. Berensohn?

Drove down to Spruce Pine, a town of coal trains and lumberyards with squat brick buildings along a few main streets. Wandered through some junk shops; there seemed to be an inordinate number of abandoned mirrors for sale. Came back to the loaned house. The place is full of stoneware—heavy plates, huge useless water jugs, mirrors with brown-glazed frames, squat candlesticks. I hate stoneware.

In the evening, a dinner party where I meet some of the staff and artists. Tom Spleth makes slip-cast porcelain pieces and has just perfected a glaze he is happy with. He showed me a vase about eighteen inches high, shaped like a thin paper bag and almost as weightless. It is translucent and the glaze makes it seem slightly damp. It is beautiful; I wanted to own it. Tom spent much of the evening with it cradled in his lap as if he were carrying a newly-adopted baby on a bus traveling up from the underworld.

Tuesday, March 18, 2003

Now that I'm here I had better take a good look at Paulus's list of senses. He mailed it to me months ago, but I haven't really studied it. The list is handwritten on four large sheets of paper, and divided into categories: the radiation, feeling, chemical, and mental senses. His radiation senses are these:

1) *sense of light and sight—including polarized light*
2) *sense of seeing without eyes, such as heliotropism or the sun sense of plants*
3) *sense of color*
4) *sense of moods and identities attached to colors*
5) *sense of awareness of one's own visibility or invisibility and consequent camouflaging*
6) *sensitivity to radiation other than visible light including radio waves, x-rays, etc.*
7) *sense of temperature and temperature change*
8) *sense of season, including ability to insulate, hibernate, and winter sleep*
9) *electromagnetic sense and polarity, including the ability to generate current as in the nervous system and brain waves*

Heliotropism? Radio waves? What have I gotten myself into? Why is "awareness of . . . visibility" a radiation rather than a mental sense? What is the taxonomy here? We seem in need of what Plato calls "the skills of a good carver."

I am a congenital and willing heir of the empirical tradition. If someone tells me that quartz crystals have healing properties, I want to see the study that proves it. That said, I suppose that Enlightenment empiricism begins with unanswered questions about the senses. Suppose we accept the proposition that we know the world sensually: O.K., but what are the senses? If there are ten or twelve human senses, and we allow only five to attend the meetings of the Royal Society, then the fix is in from the start.

I sat for an hour today watching the glassblowers. The glass artists work in pairs, many of the tasks taking two people, often one at each end of the long rod that holds the molten material. It is very noisy: they play the radio loudly. Later someone told me that is because the work, going back and forth to the ovens and so forth, requires rhythm. A nice idea, though it seems vestigial: the radio I heard offered no rhythm.

Everyone was wearing dark glasses. The room smelled of dry flames. Is there lung knowledge as they blow into the ball of glass?

So how many senses are there? Do we count the complex and subtle, such as a sense of loss, or grief, or a sense of right and wrong? Perhaps. But let us begin close to the body with things equivalent to the retina. What are the organs of sense?

The paleoanthropologist Alan Walker once told me that human beings have accelerometers in their heads, organs that sense changes in speed. (All automobiles now have accelerometers in them: they are the devices that detect when your car is stopping too fast, and set off the airbags.) To prepare for my trip to Penland I wrote to Alan to make sure that I had remembered correctly. I asked him how many human senses he thinks we have. He replied:

> Physiologically speaking, many, and they grade into each other. So a numerical count is difficult. If one were to count the many smells we can sense, then of course the number is huge. If one counts the functions of the two types of smell receptors—one for normal smells and the other for pheromones, then the number is smaller. Probably all of us when born have synesthesia (senses muddled up) and some people keep some of that.

As for accelerometers, Alan explained that we have them in our ears. Actually, all animals have some organ that is sensitive to gravity and all of these organs are built on the same principle. A lump of something heavy—it can be a grain of sand—floats in jelly encased in a sack. The sack is lined with hairs, each connected to a nerve. If the animal moves, the inertial resistance of the grain of sand will press it against one wall of the sack, allowing the nerves to sense both the change in motion and the direction.

Humans don't have grains of sand in their ears; we have otoliths, ear-stones, tiny six-sided crystals of calcium that float on a bed of jelly shot through with little sensory hairs. The whole apparatus is called an otocyst. The otocysts are our accelerometers. They sense changes in linear motion (up-down, left-right, backwards-forwards).

I brought along a book about human perception that has filled me in on all of this and that tells a strange story about the related organ in the crayfish. Crayfish shed their shells to grow, and when they do so they shed their version of the otocyst (called a statocyst). The lumps of something relatively dense in the crayfish statocyst actually are grains of sand, and when the crayfish has shed its old shell it must pick up a few grains of sand with its claws and put them into its new statocysts. As if that weren't strange enough, some mad scientist has of course played with the poor naked crayfish, providing it with iron filings instead of grains of sand so that the beast ends up with statocysts subject to magnetic influence. Pass a magnet over its head and the thing thinks the tide is coming in fast.

In any event, yes, we have accelerometers. And how can it be that in twenty years of schooling I never learned that "I" am partly packets of nerved-up calcium crystals? And if I have otocysts and never knew about them, what else do I have? Heliotropism? Radio waves? I should be patient with Paulus's list.

WEDNESDAY, MARCH 19, 2003

I arranged to meet Paulus for lunch. His house is on the Penland road, behind "a house with a folk-art bear." He greets me on the front path, smoking a pipe, his white hair in a ponytail. The trees around the house are leafless but their leaf buds are fat.

Mr. Bush announced last night that he will be going to war in Iraq. Paulus reports a friend's observation that Baghdad, in the ancient Mesopotamian river valley, is the site of the origin of metallurgy, and that the U.S. military is about to beat it with thousands of pounds of special metals, including depleted uranium, denser than lead.

It turns out Paulus's work on the senses has several antecedents. Joan M. Erikson has a book, *Wisdom and the Senses*. Rudolph Steiner also wrote about the senses—he thought that there were twelve. Then there is Guy Murchie (*The Seven Mysteries of Life*) whose list has thirty-three senses, and one Michael J. Cohen, who got the list up to fifty. Paulus's list is a mixture of these, plus some of his own.

Glass plate printing

He recites a Rumi poem for me: "For millions and millions of years I lived as a mineral, / then I died and became a plant. / For millions and millions of years I lived as a plant, / then I died and became an animal. / For millions and millions of years I lived as an animal, / then I died and became a man. / Now, what have I ever lost by dying?"

We are heirs of the plant and animal senses. This explains Number 2, above, the "sense of seeing without eyes such as heliotropism or the sun sense of plants." For Paulus, our upright posture is a consequence of heliotropism. As he makes this declaration, I look out the window and see, true enough, that all the trees and weeds have upright posture, and they have it because they are sun-seekers. Myself I am of such a plodding scientific mind that I would simply say that heliotropism, if we have it, is a subset of sight—sight lets us follow the light. Now I wonder. Paulus is sitting on an odd backless stool, a black cushion ball, and his posture is erect and elegant. Well, why not say that the erect spine is a version of the cellulose bones of corn and elm, and that we embody, incarnate, and display the heliotropic sense? I would like to have Paulus's posture. I am, after all, suffering from back pain and tension these days, due to a wicked hard winter with serial deaths of familial loved ones. The earth has pulled them down into the ashy ground, and I am the survivor, slumped in a chair.

I confess my addiction to empirical science, and then explain to Paulus about the otoliths. He has not heard of them. Has not had "the sense of acceleration" on his list.

Back at Penland I go to the studio where Julia Leonard is teaching a class on making books by hand. When I come in, the students are looking at samples of handmade books brought by a local artist, Dan Essig. A few have print in them, but mostly the pages are blank; the point is the way the thing is made. Many of Dan's covers are wood and Dan is explaining that he likes mahogany best. Mahogany is "buttery." It is "stable." When you drill it the bit doesn't jump around the way it does with an open-grained wood like oak. But then, some people are allergic to mahogany. I look up at one point and Dan is smelling one of his books. It smells like cigarette smoke, he says.

Do people always talk like this, and I am only noticing because I'm trailing the senses? Then there is talk of nostalgia, and the nostalgia brought on by handmade books, now being compared to reliquaries. Myself, I have always smelled books. I love the physical presence of a book I am reading and sometimes, as I slow down to chew on some passage, I

Adding beads to a quilt

will put the book to my face, bury my nose in the spine, and inhale. Then I am there with the book, as if I have taken my seat. Later, Julia and Dan confess that they too smell papers. Dan likes the smell of an old book taken apart.

Smell is "taste at a distance."

One of Julia's books has a papyrus cover—many sheets glued together cross grained, like plywood. Someone in Iowa has made papyrus from cornhusks. It is a very bumpy kind of paper; I stand around feeling the papyrus.

Later I tell Julia about Paulus's list. She says that Paulus loves numbers. Of course! It's a certain kind of mind. The eight of this; the ten of that; the sixty senses. She says that Paulus used to lead a body-awareness workshop. "'Stand,' he'd say, 'and place a hundred percent of your weight in the soles of your feet. All your weight is there, your whole body is pressing down on the soles of your feet. Now rise in the body. Feel how fifty percent of your weight is in each leg.' He would keep going up, dividing the weight, until soon you were at twelve-and-a-half percent." Julia is laughing, enjoying her parody of Paulus. "'Now your fingers. Half of six-and-a-quarter percent is in each thumb.' You'd keep losing your concentration trying to do the math."

It is daffodil spring here. Crocus spring. Very wet. The sun has not appeared in four days and today it rained hard. It will rain all day tomorrow. The radio asks its listeners to be prepared to go to higher ground. It's like the Pacific Northwest only I gather we aren't really in a rain forest, just

in mud season. When I walk out into the dark after dinner the air is alive with the sound of spring peepers. The volleyball field outside the dining hall is a frog swimming pool.

The potters show slides. Silvie Granatelli is the clay teacher this session. Her show begins with slides of her home, then some images of decorated bodies—tattoos, mud paint, scarification. "A form articulated." Clay like skin. A picture of a student who made a dress of porcelain tiles like fish scales. The shapes of everyday objects like tobacco pipes and oil ewers. Pots that look like bodies giving birth, bodies copulating.

One of Silvie's pots is for tea, but it will make just one cup. People usually put a tea bag in a cup but here they will have to put the bag in the pot, then pour the tea into a cup. It will slow them down. The piece is a slow-down piece, then. It is made to engage time, to mark the temporality of a tea break.

THURSDAY, MARCH 20, 2003

The Bush-Cheney war on Iraq began around 10:15 last night, though it is impossible to get any real news about it. There is a lot of talk about "precision," and the TV stations play films that the government has given them showing the missiles and airplanes in flight.

Rainy with lifting clouds. Mud spring.

I talked with the students who are creating handmade books. They fell into a discussion of the grain of paper, and how you know which way the grain goes, and of papers that have no grain. Julia waves her closed hands up and down to show how she fans a sheet of paper to feel its properties. "I orient myself to them." A sense of direction in the material, and of needing to know its direction.

Things have natures; anciently then there were thousands of natures, not the single Nature we now speak about (that comes with monotheism). Papers have natures. Clay has a nature. Wood has a nature. Pigments have natures. The work begins with a dialogue between the maker and her material, the maker letting the material tell her what it is.

Someone mentions a book by Rupert Sheldrake about how dogs know when their masters are coming home. In another book Sheldrake makes a claim for "morphic resonance," meaning that all natural systems have a kind of memory. Myself, I find such assertions faintly plausible, but wonder why we jump so quickly to the paranormal when we have hardly noticed the normal. I did my otolith lecture for the

students and they seemed astounded; one woman said, "You mean we have crystals in our heads!?" Yes, you really do. But then the conversation drifted to premonitions of death and sensing the moods of your friends half a world away.

The potters say that when you wedge clay you are getting its tiny lozenge-shaped particles to line up. You know when you have succeeded because when you cut the clay it is homogeneous. The thing about the lozenge-shaped particles is lore, passed along from potter to potter. None of the potters I spoke with have actually seen the particles.

After "the radiation senses" on Paulus's list we get "the feeling senses," as follows:

> *10) hearing, including resonance, vibrations, sonar, and ultrasonic frequencies*
> *11) awareness of pressure, particularly underground, underwater, and to wind and air*
> *12) sensitivity to gravity*
> *13) the sense of excretion for waste elimination and protection from enemies*
> *14) feel, particularly touch on the skin*
> *15) sense of weight, gravity, and balance*
> *16) space or proximity sense*
> *17) coriolis sense or awareness of effects of earth's rotation*
> *18) body movement sensations and sense of mobility*

I like Number 13, a sense of excretion. Many animals, toads and birds for example, will excrete when threatened. This is not so much a "sense" as a response to a sense of danger. It both disgusts the attacker (sense of disgust) and lightens the threatened one for flight. That old joke—"I didn't know whether to shit, run, or go blind"—actually lists animal defenses, a beast like the rabbit "going blind," which is to say, freezing as if that could cancel sight. The organs of excretion are full of nerves that tell us of our needs. "Sight, hearing, touch, smell, taste, and the need to take a dump."

Sense of shame.

But why aren't 12 and 15 better integrated? "sensitivity to gravity" does not differ much from "sense of weight, gravity and balance," and actually "balance" is more complicated than "weight" and "gravity." Where is the sense of taxonomy?

Coriolis force. From one Gaspard G. Coriolis, a nineteenth-century French engineer. It is the deflecting force that acts on an airplane, missile, or other body in motion due to the rotation of the earth. Do the ragged lines of migrating geese sense it? Do the whooping cranes take it into account? Hard to feel in the mountains.

<div style="writing-mode: vertical-rl">Photos: Ann Hawthorne</div>

FRIDAY, MARCH 21, 2003

First day of spring. The clouds over Penland lifted in the afternoon. Many craftspeople wearing printed cloth swatches saying "No Attack on Iraq." But the attack goes on. Oil fields burning.

At dinner last night a discussion of learned or schooled senses. With our sense of time especially we get deeply acculturated. In England in the eighteenth century many clocks only had an hour hand. The exact minute of the hour was not something anyone needed to know. But industrial factories need synchronized labor, and they need workers who show up on time, so in the nineteenth century the minute hand descends upon the mind. Cultures without the clock figure time as "task time." If the task is to cut a field of hay, it has a

Filing a knife

Beginning a basket

certain inherent amount of time. Or the time to shoe a horse. The time to make bread. In this culture we drive ourselves nuts cross-graining task time and clock time which simply makes all tasks seem too fast or too slow. One of the bookmakers said yesterday, "This took me all day!" judging herself to be slow. But what exactly does it mean to say "it took all day?" It means the culturally learned sense of time has separated you from the thing you are doing.

The crafts are the work where little temporal anchors drag against the tides of a speeded up world. Factory time is all about efficiency, not about the nature of the materials. The task-time of sewing the signature of a book cannot be altered, nor can the task-time of letting a blown-glass jug cool in the annealing oven. The materials contain their time, and the craftsperson learns it from them. Part of the pleasure may be that in this way we must slow down, get off the clock.

By the same token, the economy of craft will bring a kind of poverty if the dominant economy runs on factory time. So, Penland is in these mountains where it is hard to tell the shacks of the poor folk from the shacks of the potters. Ezra Pound used to complain that Europeans knew how to have dignified poverty, or dignified simplicity, but Americans did not. America has never had good Bohemias, and—in the cities—as soon as one appears the chain stores come in like hermit crabs. These mountains may be the best we can do for Bohemia, the population being too thin to support a Banana Republic.

SATURDAY, MARCH 22, 2003

Yesterday was at last a warm, clear day. It is willow-leaf spring. None of the other trees are in leaf, but the willows on damp ground are a limy green. In the bare woods the poison ivy vines, thick as a man's wrist and furred with hairy roots, climb the trees. Groves of leather-leafed mountain laurel.

Baghdad is in flames, or at least its government buildings are. In Jordan, where the king is described as having a "shaky throne," the TV reporter interviews an engineer, educated in Connecticut, who is so mad at the United States that he can imagine joining an attack against it. The reporter has trouble believing this. "But he spent four years in Connecticut," he keeps saying.

My wife, Patsy, and I went to have tea with Paulus yesterday morning. He was smoking his pipe when we arrived, and playing classical music on the hi-fi. We sat on the porch in the sun at what seemed, under the circumstances, to be an ele-

gantly rotting picnic table. Paulus has several notebooks of work on "touch" as a sense, with drawings of the hand and palm cartography from various traditions. There are ninety thousand sense receptors at the tip of the finger.

We somehow get to his sense Number 5, the "sense of awareness of one's own visibility or invisibility and consequent camouflaging." Actually, it should be camouflage and advertisement—if I don't wish to be eaten, I need camouflage; if I wish to attract a mate, I need to advertise. Or, if I am poisonous to eat, I might show off. Either way, key here for Paulus is Rilke's "Archaic Torso of Apollo," which ends: "Everything / is looking at you. You must change your life." So the demand follows from the sense of being regarded. It must be that this then wakes self-scrutiny, and a concern with matching what you thought you were with what you actually are. The eye of the other calls out camouflage or display.

This is one of my understandings of the function of workshops in the arts. You are given a chance to hear what others think of your work. A community of artists offers the opportunity to acquire a sense of the others' regard.

In Paulus's understanding of shamanism, the shaman stands between the landscape and the inscape and helps them to communicate with each other. "Everything is looking at you," meaning *everything*, including the plants and the animals. So the shaman imitates the gestures of the plant and animal world, letting these inform the human. The fat textbook on the senses I have with me says that honey bees and perhaps pigeons have a sense of the earth's magnetism to help them navigate. There is some indication that humans have this sense too, only if we do it is "fragile." If it is there and fragile, it could be schooled. If someone had fragile hearing, we would go to great lengths to improve the sense; why not improve our sense of the earth's polarities?

As Paulus speaks he keeps gesturing with his left hand. He was once a dancer, and has a dancer's fullness of gesture. He scoops himself out as he talks, ladling from the thorax and then tipping the hand forward.

Paulus makes unfired clay pots and buries them in the earth. He says that a professor somewhere out west has discovered that if you hit a pound of clay with a hammer it will glow with ultraviolet light for a month. Can this light come into your body as you work with the material? He hopes to teach a workshop with this as one of the puzzles. So, it is the same enterprise as the imagined shaman, landscape of clay, its emitted light illuminating the inscape by way of the million receptors in the fingered hands.

At dinner last night someone said he once got to see the structure of clay particles as revealed by an electron microscope. "They looked like gravel," he said. "They didn't have any regular shape." Someone else said, "Oh, Paulus. He gets his facts wrong." And I had meant to pester him a bit about the confused taxonomy of his list, but as I sat there by the rotting picnic table it seemed pedantic and beside the point. Taxonomy has been robust since Linnaeus. The more interesting and difficult task is to bring imagination to bear on the stuff of this world.

Monday, March 24, 2003

Clear, warm day; the horizon line of distant mountains is crisp. There are several llamas in the meadows below the school, and at lunchtime they settle themselves on the dome of one of the hills, as if they know that they are ornamental and that their long necks are meant for hilltop spires.

Mr. Bush is telling us that the war will last longer than people expected (which people?), and at the same time submitting an emergency supplemental military budget to the Congress asking for $75 billion, based on the assumption of a one-month war.

A group of craftspeople meets here occasionally to speak about spirituality and craft, and I was invited to their coffee this afternoon. I explained some of my interests here; Paulus, in describing his inventory of the senses, called it a list of "the senses of the more than human world." I feel like a dope for not seeing that: it isn't a list of our senses, it is a list of

Shoemaking

the senses, which means it can include such things as the honeybee's sense of magnetic forces, or the pit viper's acuity with heat. "The world senses us," says Paulus, and then the issue is reciprocity: can we awaken to the ways in which we are being sensed? Surely the llamas know we see them, and their sense of that contributes to their display.

On the road below the dining hall someone once painted a message: "We Mourn the Death of Penland's Soul." This message has been almost obscured with black paint. Now it is two messages: someone mourning and someone erasing. Paulus said he felt the soul of Penland was not in danger. "I smelled it when I first came here in 1968 and I can smell it still." Someone else said that these arguments (the road painting is not the only example, I gather) derive from someone's having had a precious experience at Penland and then responding to changes in the place as if they were wounds to that experience. I gather that a lot of the tension around "Penland's soul" comes from changes wrought when you need to raise large sums of money to preserve decaying buildings. One woman tells a story of a friend who called to say that she had been accepted for a summer workshop but did not want to come unless she could have the same bedroom she had before, and that an important feature of the bedroom was a dripping faucet. Could they please check to see that the faucet still dripped?

What does the "smell" of Penland's soul consist of, I asked. Good food; good studios; right relationship to the ecosystem; an absence of toxic competition.

Paulus's senses, continued:

The chemical senses.
19) *smell with and beyond the nose*
20) *taste with and beyond the tongue*
21) *appetite and hunger*
22) *hunting, killing, or food-obtaining urges*
23) *humidity sense, including thirst, evaporation control and the acumen to find water*
24) *hormonal sense, as to pheromones and other chemical stimuli*

As Alan Walker suggested, smell can be divided into parts, and one part senses pheromones. Most senses can be thus divided. Touch is not the result of one kind of nerve in the skin. There are nerve-containing capsules called Meissner's corpuscles on the tips of fingers, and there are Pacinian corpuscles which are found near joints and feel pressure, and there are Merkel's disks and Ruffini's endings and heat sen-

sors, and more. (I get this from Diane Ackerman's *A Natural History of the Senses*; that's also where one can find the "true" number of sense receptors on the fingers: "nine thousand per square inch.")

A promotional postcard for Penland shows a group of butterflies and moths, all local, all dead, dried, and lying on a bed of leaves. Included are the three great silk moths of North America: the Cecropia, the Polyphemus, the Luna. These moths have huge feathered antennae for picking up the pheromones of their mates. The Cecropia has no mouth: it never eats, it just follows its feathered nose to its mate. Smelling the soul.

TUESDAY, MARCH 25, 2003

Calvin Tomkins recently wrote an article for *The New Yorker* about teaching art. He says that in 1995 when Harvard University finally decided to get serious about teaching painting and hired Ellen Phelan as their first Professor of the Practice of Studio Arts, Phelan arrived to discover that the department had no budget to buy art materials. In the old days, art students painted with oils and carved in wood or stone. What was taught were the properties of the materials, and the techniques by which to manipulate them. In America in mid-century, several things happened to change that, especially the Duchampian intellectualization of the practice. "In order to become an academic discipline . . . ," Tomkins writes, "craft and technique were subordinated to verbal analysis, problem-solving, and critical theory." Thus might Harvard hire a painter but forget to buy her any paint.

It was seventy degrees or more here today. Tiny-blue-butterfly spring. The ten billion ladybugs have woken up. A sandstorm in Iraq has brought everything to a halt. Preacher on the car radio tells me that America is just and Iraq is evil and, even though America is a land of sinners, God's hand may be at work in this war.

I wandered into the fabric workshop just as a woman from the Golden Paint company was beginning a long demonstration of Golden acrylic paints. Two hours on the properties of the materials, and the techniques by which to manipulate them. For example, the binder (the polymer emulsion) can be loaded with the old mineral pigments like burnt sienna, burnt umber, or cadmium, whereas the binder can carry less of the modern pigments, all the ones with chemical-sounding names like phthalo blue and quinacridone crimson. These therefore look more glossy and transparent.

The zinc white is more transparent than the titanium white. The former thus makes colors lighter while the latter makes them a bit creamy. Golden makes a series of paints that reproduce historic colors, such as sap green (a fugitive green once made from buckhorn berries) or India yellow (which was made by force feeding mango leaves to horses, and then distilling their urine—a process now illegal).

I confess that my eye prefers the old oil colors and the acrylics that imitate them. Why? It may just be habit and a snobby fondness for patina. It may also be that the eye evolved for the colors of nature, for the browns of dirt, the greens of waxy berries, the yellow of piss. Fugitive colors are the colors of time. It is comforting to see time and beauty sharing a single body, whereas an unfading, snappy acrylic like the pyrrole orange makes me feel ashamed to be growing old.

Before dinner I watch the glass teacher Hugh Jenkins and his son make a large glass bowl. The boom box plays a loud rhythmic guitar blues. They move back and forth between the furnace and the working table with a rhythm related to how quickly the glass hardens and softens. At the end, one of them taps the bottom of the glass; it cracks at the stem and falls into the other one's gloved hands; he puts it quickly into the annealing oven, where it will spend a day losing two thousand degrees.

Wednesday, March 26, 2003

We come now to Paulus's list of "the mental senses," and we are off and running for they are numbers 25 through 60. As most people know, in China there are six senses: our five, plus the mind. All week long the mind category has perplexed me because it seems so raggedy big. Is everything we "know" a mental sense? Is intuition a "sense," or is it what the mind does with what the gross senses offer it?

The first ten of Paulus's mental senses:

25) *pain, external and internal*

26) *mental or spiritual distress*

27) *sense of fear, dread of injury, death or attack*

28) *procreative urges, including sex awareness, courting, love, mating, paternity and raising young.*

29) *sense of play, sport, humor, pleasure and laughter*

30) *sense of physical place, navigation senses, including detailed awareness of land and seascapes, of the positions of sun, moon, and stars*

31) *sense of time*

32) *sense of electromagnetic fields*

33) *sense of weather changes*

34) *sense of emotional place, of community, belonging, support, trust, and thankfulness*

If a human sense is that which has a clearly dedicated organ (as the sense of smell has the nose), then it is right to speak of a sense of time, for temporal perception arises from the organs that enable memory, especially the frontal lobes and the hippocampus.

There are many kinds of memory. From Aristotle on, we get memory as we now have it, "recollection," the recovery of what has in fact happened. The other stream of Western memory practice starts with Plato and survives for centuries (you find it in Emerson and Thoreau). Platonic memory is the knowledge of eternal truths, those not in fact available to the more incarnate body senses. Platonic memory is a faculty that can perceive justice, truth, beauty. Aristotelian memory gathers the facts, but it doesn't know what to do with them. "The senses give us representations of things," Emerson once wrote, "but what are the things themselves, they cannot tell." If you want to know *what things are*, you need Platonic memory, or intuition, or imagination.

And then there is smell-memory. There is a part of the brain called the rhinencephelon, the smell-brain. It recognizes and remembers smells. But it is apparently very ancient, and not linked up to the other parts of the brain's memory systems, which is why smells are so evocative, on the one hand, but also so elusive (you cannot call them to mind the way you can call an image to mind). Smell-knowing would be hard to abstract. You can do an art history class with slides, but you couldn't easily design a course based on the smell of art through the ages.

Each studio at Penland has its smell. After they have opened the pottery kilns they clean the shelves by grinding the dripped glazes—smell of ceramic dust. The crafts summon their crafts people, and do so sensually. Someone from the cloth-work class was telling me at dinner that certain textiles simply attract her. I myself work with wood and I have sometimes wondered if the smell of cut wood doesn't get me a little stoned.

That Cecropia moth following the pheromones of its future mate: that is Platonic memory in the moth-world.

Decorating a pot

THURSDAY, MARCH 27, 2003

Periwinkles are blooming all over the Penland campus. Periwinkle-spring. Sunny, cool, some clouds; a flag-lifting breeze. Mr. Bush keeps speaking of being "firm." Why are there no Iraqi dissidents explaining how much they long for the "liberation" of Iraq? If Mr. Bush were going into Cuba, there would be plenty of Cubans on the radio.

Paulus spoke to the pottery students yesterday. His attack is on the idea that clay is inert. Fond thus of any story that points toward clay's liveliness, and links to life. Says NASA has a "life from clay" theory, connecting clay to the evolution of DNA. Tells the students the report that clay can give off ultraviolet light (says the scientist is Leah Coyne at San Jose State). We cannot see this light, but we are imaginative creatures so we nonetheless receive it. Says "porcelain" comes from "vulva": it is the virgin form of clay. "Her brothers float downstream gathering impurities and become stoneware." Advises throwing on the potting wheel while standing up. Tells the story of his first real pinchpot: he had been at week-long sitting meditation and was having trouble quieting the mind; went to the pot shop and sat with a ball of clay while trying to meditate; a half hour later found that he had pinched a pot.

Imagination struggles against inertness. Stimulate it by asking questions that don't have answers. What is clay? What is the hand?

Today, late, I went to the studio of the glass artist Rob Levin, fifteen miles away. The intense fire of the glory hole; the batch of glass itself heated to 2100 degrees. What is heat? What is the light given off? What is a photon? What is the eye to receive it?

I asked Rob about sensual awareness in glassblowing. There is a lot of touch involved as, for example, when he is spinning a bulb of glass in the fire he can tell by the torque on the rod how soft the glass has become. But mostly, he said, "it's a matter of touch," and then he would look at his upraised palms in a slightly puzzled way as if the information was there, in the hands, but hard to make into words. It isn't verbal; the hand and the mind are a single organ, and if one works with glass for years, the understanding is in the hands. It's a matter of touch.

When Paulus taught clay he used to suggest that students put their faces in the slip bucket and then go sit in the sun and feel the slip drying, the sun drawing the moisture from the clay and the clay drawing it from the skin.

Rob helped me make a bit of blown glass. I like the way glassblowing works with gravity. When hot, the material flows toward the center of the earth; you try to engage that flow and shape it, rather than pushing the material. Glassware is made with heat, lung muscle, and gravity.

There was no music in Rob's studio, just the hiss of the gas jets, and an occasional comment from a black and white cat.

The ten senses of the day from Paulus's list:

35) *sense of self, including friendship, companionship and power*
36) *domineering and territorial sense*
37) *colonizing sense, including receptive awareness of one's fellow creatures—sometimes to the degree of being absorbed into a super organism*
38) *horticultural sense and the ability to cultivate crops, as is done by ants who grow fungus, by ants who farm algae, or birds that leave food to attract their prey*
39) *language and articulation sense, used to express feelings and convey information in every medium from the bee's dance to human literature*
40) *sense of humility, appreciation, ethics*
41) *sense of form and design*
42) *reasoning, including memory and the capacity for logic and science*
43) *sense of mind and consciousness*
44) *intuition or subconscious deduction*

Sense of self. My own writing project right now has to do with "cultural commons," that vast, unowned body of art and

ideas inherited from the past (everything from the poems of Keats to the chemistry of aspirin). Included are many questions about the self. How shall we imagine the self that makes a poem? A remark that Goethe made to a friend in 1832 asks this more fully:

> What am I then? . . . My works have been nourished by countless different individuals, by innocent and wise ones, people of intelligence and dunces. Childhood, maturity, and old age all have brought me their thoughts...their perspectives on life. I have often reaped what others have sowed. My work is the work of a collective being that bears the name of Goethe.

In studio classes, the student acquires the technique by watching the teacher and imitating. The touch is acquired by standing side by side. I would not have known that you can cut hot glass with shears, like cutting leather, if I had not watched Hugh and then Rob doing it. If I later have the touch, I may well ask "What am *I* then?" and "What have *I* accomplished?" Where, for that matter, does *touch* come from? What is my body?

FRIDAY, MARCH 28, 2003

Cool and cloudy much of the day with a little rain. Clouds hanging on mountains give the space definition. On the radio Christopher Dickey, in Jordan for *Newsweek,* explains that for the Arabs, "this is an invasion. Nobody in this part of the world uses the word liberation." Mr. Bush is quoted as saying that he finds the media reporting of the war "silly."

I went to Rob Levin's studio in the morning to pick up that bit of glasswork that he helped me make yesterday. I had thought it was a little vase; now it appears to be a paperweight. Thinking about time again, the time that glass takes to cool in the annealing oven. Thirteen hours for thin pieces; days for thick ones. It takes days to go from Basra to Baghdad, even when there are no snipers on the road. A human life is eight decades, give or take. The materials teach their temporality, which is really a kind of fate.

I went down a dead-end road that turned out to lead to the Mitchell County High School. At the gate a sign reads: "No Weapons Allowed Beyond this Point."

Today's senses from Paulus's list:

45) *aesthetic sense, including creativity and appreciation of beauty, music, literature, form, design and drama*
46) *psychic capacity, such as foreknowledge, clairvoyance, clairaudience, psychokinesis, astral projection and possibly certain animal instincts and plant sensitivities*
47) *sense of biological and astral time, awareness of past, present and future events "next" (left brain)*
48) *the capacity to hypnotize other creatures*
49) *relaxation and sleep, including dreaming, meditation, brain wave awareness*
50) *sense of pupation, including cocoon building and metamorphosis*
51) *sense of excessive stress and capitulation*
52) *sense of survival by joining a more established organism*
53) *spiritual sense, including conscience, capacity for sublime love, ecstasy, a sense of sin, profound sorrow and sacrifice*

"Sense of pupation"—the body's task time. In the world of butterflies and moths, the caterpillars get restless before they pupate, and begin to wander. If you see a caterpillar crossing a path, it probably has the pupation itch. The wandering may be protective: if you always pupate near your food plant, predators will learn how to find you. Better to pupate "away."

China painting

Could the shaman bring this over to us humans? Art requires enclosure, some sort of circle drawn around the work, keeping everything else away for a spell. Go to an isolated house. Turn off the phone, the mail, the TV, the Internet; do not speak unless spoken to. Do that for a week. Make the work.

They call the current period at Penland the "Spring Concentration." Exactly. In summer there are two week "sessions," a word derived from the Latin *sedere*, to sit. In the summer at Penland, one can do the two-week iron sitting, or the textile sitting, or the wood sitting. Pupation with a cocoon of matter, matter that takes its own sweet time.

SATURDAY, MARCH 29, 2003

My last day. As I sat drinking my coffee in the loaned house I looked out along the gravel driveway and there was a wild turkey displaying himself for his mate. He is the American peacock, a peacock done in earth tones. The Arts and Crafts peacock. There seemed, at a distance, to be some green about him, and bold brown and white marks on the fanned tail. He was erect. He was flowering. A thin feather bib hung from his chest. Red inflated bulbs goitered his neck. When I tried to approach, he and the hen walked off into the woods. The rest of the morning found me distressed by how empty the driveway seemed.

Flowering-turkey spring.

The newspapers say that Mr. Bush's army is using depleted uranium shells in the war. A United Nations resolution classifies munitions made of depleted uranium as illegal weapons of mass destruction. They are carcinogenic and are listed as a probable cause of the "Gulf War syndrome" that followed the 1991 war.

The final senses on Paulus's list:

54) *sense of awe*
55) *sense of imagination*
56) *sense of tension and release in the body*
57) *sense of chi*
58) ~~*sense of humor*~~ *sense of balance*
59) *sense of story and how it links us up with the cosmic—the universe story*
60) *sense of being known—Bushmen "wherever they went they felt they were known"*

I suppose "sense of humor" is crossed out because it appears in Number 29. Then again, "balance" is in Number

15. In any event, I was thinking about "sense of story" today because I was browsing in *The Twelve Senses* by Albert Soesman, "an introduction to anthroposophy based on Rudolf Steiner's studies of the senses." Steiner's twelve are: touch, life, movement, balance, smell, taste, sight, warmth, hearing, thought, word, and "I." The "I" does not mean being aware of one's self; it means being aware of another human being.

Silvie, the pottery teacher, has an exercise that she does with her class that I had not thought to describe in terms of "the sensuality of craft," but now I see that it fits if the senses are opened up in this fashion. Silvie is a bit of a gourmand; her slides showed pottery *with food on it*. In the class, she asks each student to describe a food that he or she likes to eat, and to describe the ideal circumstances of this eating. I might like an afternoon snack of thinly sliced, crisp apple with equally thin slices of aged Asiago cheese. I might like to be eating it below the wall of an Italian hill town, near the place where the stonework indicates there was an ancient laundry.

Each student does a short description and then puts it into a hat for a random drawing. Each anonymous culinary fantasy is thus in someone else's hands, and that person must now design and make a serving vessel appropriate to the thing described. This session (this sitting) Silvie herself had drawn one from a person who likes to watch TV late at night in a big stuffed chair, eating popcorn. The writer wants a popcorn vessel that could be tucked between the thigh and the arm of the easy chair.

Sense 1 in Steiner: "Touch: determining one's boundaries." Sense 12: "'I' sense: breaking through another's boundaries." In Silvie's assignment the whole thing is much more invitational. "Imagine me eating strawberries." "Imagine the solace of popcorn." Silvie likes a bit of whiskey late in the day, and a fat pretzel lightly touched with Dijon mustard.

The latest use of depleted uranium in the current conflict came yesterday when an American A10 tankbuster plane fired a depleted uranium shell, killing one British soldier and injuring three others in a "friendly fire" incident.

I had a final coffee with Paulus in the afternoon. I had given a lecture earlier in the week that included an explication of the Indo-European *ar* root from which we get "art." I usually take the root to be a noun "joint," and Paulus wanted to know if it could be a verb, "to join." Actually, that's probably what it is. His point, though, was that art is activity, something we do. It isn't an object. We have too many objects. At

Penland, every mantlepiece has an abandoned cup gathering dust, and a bit of blown glass, and something that looks like a goat's head made of unknown material. At the end of any session, there are tables of the stuff. But the stuff isn't the point; the point is the activity, and this is why the stuff is sort of depressing. Don't fix the work, therefore; don't harden it. Paint with sand on the belly of the earth. Paint with rice flour on the street outside your door.

Now I see better why Paulus has given up firing pots. He makes a pinch pot, lets it dry, then "tithes" it back to the earth, sometimes with seeds in it. "Not end-gaining, but living in the means whereby" (a line from Alexander technique body work). The senses as verbs (to touch, to see, to tell a story), and being alive as an activity. I kept thinking of that Tom turkey, shaking his feathers. The feathers had an iridescence that could not possibly be reproduced in paint or photograph or film. The show needed sunlight and the shaking body. The turkey hen and I were allowed "to see."

SUNDAY, MARCH 30, 2003

Snow as I drove down the mountain. Three inches in Asheville. Blossoms-bent-by-snow spring.

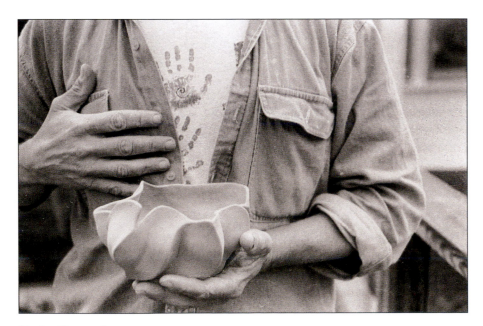

Paulus Berensohn

Wet clay, hot glass, cold steel, a found object, friendship, personal journeys, whimsy, technology, birth and death, light and dark: in short, whatever stimulates the mind or emotions to a high level of feeling will inform the work of the hand.

Penland Interim Director **Donna Jean Dreyer**, in the 1998 summer catalog

I've never known a place where one experiences such a feeling of liberation, of a taking for granted that mistakes are a normal part of the learning process; of tolerant acceptance of people as they are, yet faith in their desire and ability to grow.

A Penland student quoted in the 1944 brochure

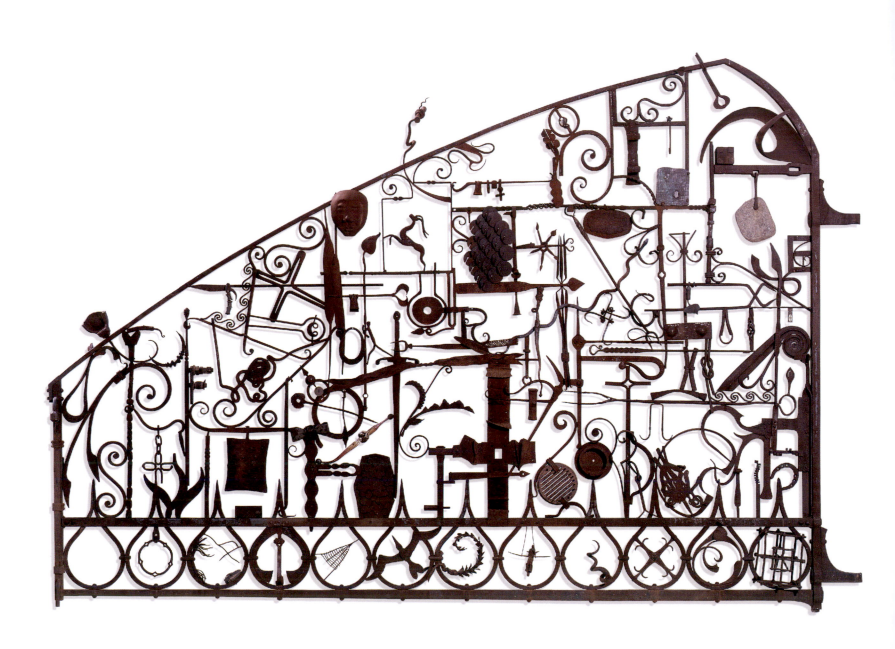

THE NATURE OF CRAFT AND THE PENLAND EXPERIENCE

PENLAND SCHOOL OF CRAFTS: A COMMUNITY OF MAKING

During its seventy-five year history, Penland School of Crafts has developed its own culture, expressed in unique objects and rituals. Teachers, students, staff members, and artists living in the area are bound together in a community of craft characterized by sharing skills, resources, and ideas.

IRON CLASS PROJECT
INSTRUCTORS: JAPHETH HOWARD AND ALICE JAMES
Iron Studio Gate, 2000
Iron, steel
115 x 142 in.
Collection of Penland School of Crafts

This gate, which is attached to the Penland iron studio, incorporates memorabilia, demonstration pieces, and other detritus from the school's first iron studio, as well as objects donated by Penland instructors and small pieces made for the gate by each member of the class.

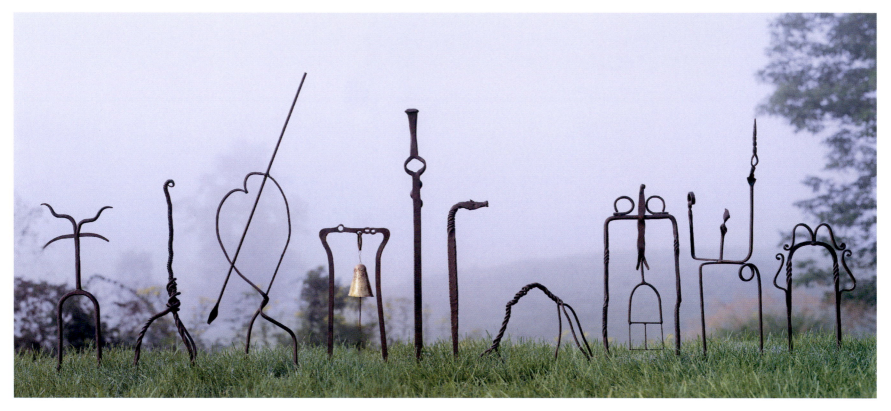

VARIOUS ARTISTS
Wickets from Blacksmiths Croquet Game, 1979
Forged steel
10 to 30 in. high
Collection of Penland School of Crafts

In 1979, blacksmiths Bill Brown Jr., and Jim Wallace were looking for a way to create enthusiasm for blacksmithing, which was not a regular part of the Penland program. Using a makeshift outdoor forge, they invited anyone who was interested to come and forge a croquet wicket. A weekend of forging was topped off by a croquet game played with decorated sledge hammers and cast iron balls.

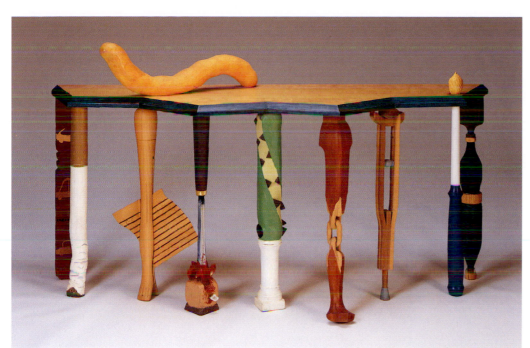

WOOD CLASS PROJECT
INSTRUCTOR: CRAIG NUTT
C Table, 1998
Wood, paint
38 x 67 x 21 in.
Collection of Penland School of Crafts

Each carved element in this table was made by a different student and depicts something which begins with the letter C.

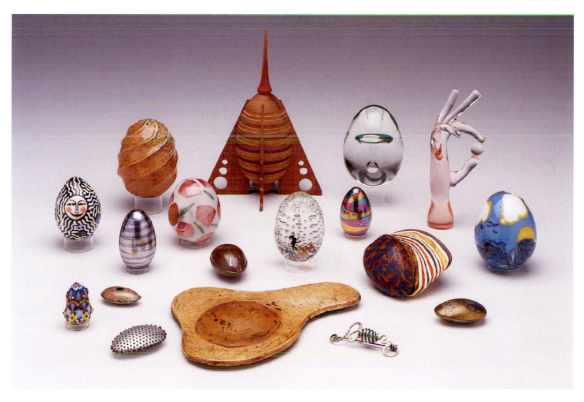

VARIOUS ARTISTS
Craft Easter Eggs
Artists include Stanley Andersen, Andy Buck, Patrick Dougherty, Daniel Essig, Hoss Haley, Dinah Hulet, Marvin Jensen, Kenny Pieper, Sherri Sims, and others unidentified. From collections in and around Penland.

Every Easter, Penland students, instructors, staff, and neighbors are invited to contribute to an Easter egg hunt; the eggs go home with the finders.

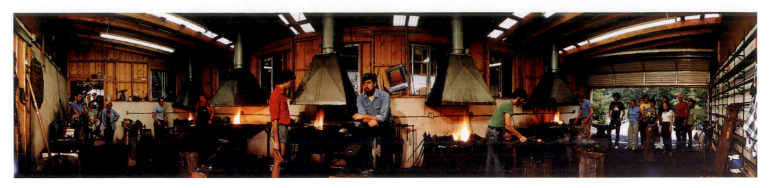

OSCAR BAILEY
Penland Iron Studio, 1982
Photograph
10 x 36 in.
Collection of the artist

OSCAR BAILEY
Panorama of Penland, 1979
Photograph
8 x 39 3/4 in.
Collection of the artist

OSCAR BAILEY
Panorama of Penland, 1971
Photograph
8 1/2 x 45 1/4 in.
Collection of the artist

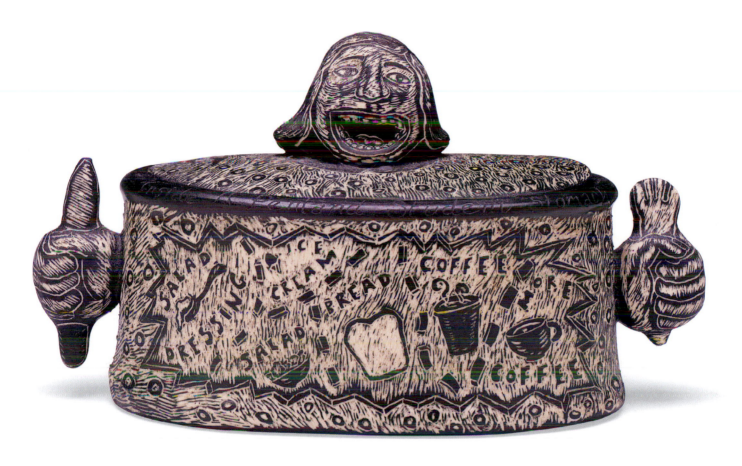

KATHY KING,
Inside a Penland Student's Stomach, 1998
Stoneware
5 1/2 x 10 x 4 1/4 in.
Collection of Mignon Durham

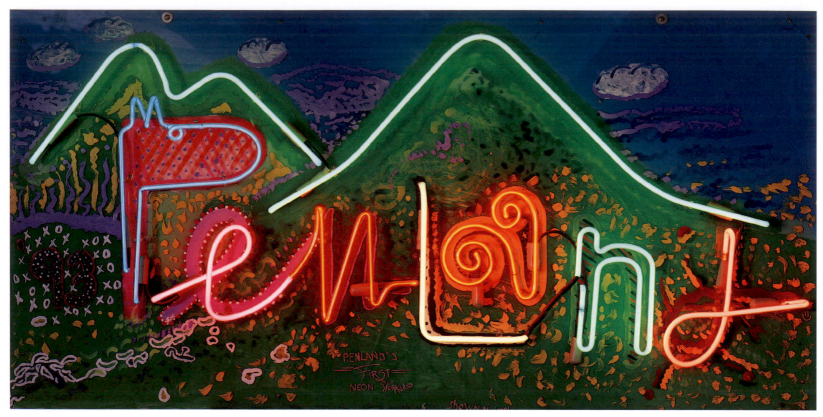

GLASS CLASS PROJECT
INSTRUCTOR: JACOB FISHMAN
Penland, 1993
Neon, painted acrylic
30 x 60 in.
Collection of Penland School of Crafts

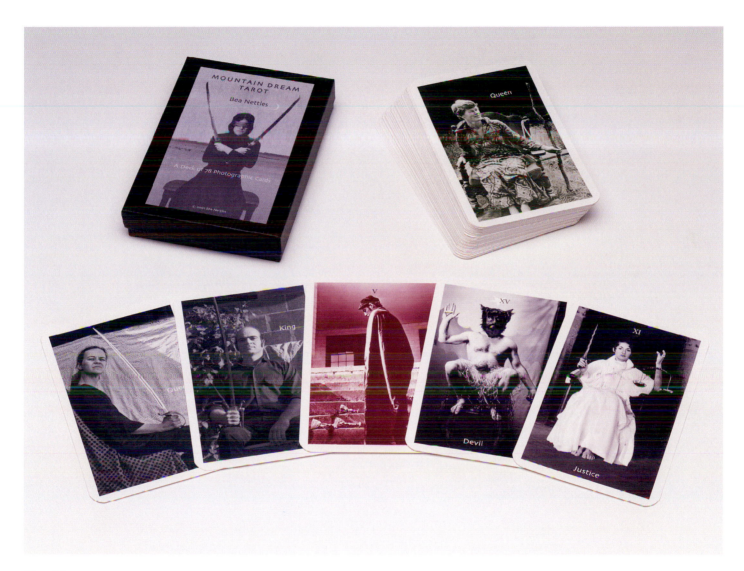

BEA NETTLES
Mountain Dream Tarot, 1970–1975
(2001 edition)
Photographic cards
Cards 5 3/16 x 3 3/8; box 5 3/8 x 3 7/8 x 1 in.
Collection of Penland School of Crafts

Bea Nettles created this Tarot deck at Penland over a
five year period, photographing many artists who were
affiliated with the school during that time. The idea for
the project came to the artist in a dream.

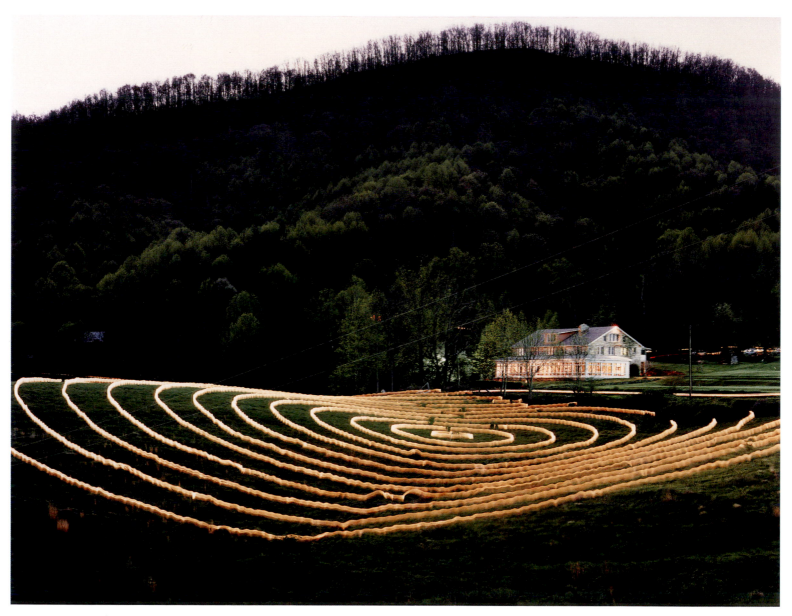

Dan Bailey
Penland Target, 1983
Photograph (time lapse)
32 x 40 in.
Collection of the artist

RICHARD MARGOLIS
Swing Bridge, 1994
Photograph
30 x 24 in.
Collection of the artist

PAULUS BERENSOHN
Pinch Pot, 2003
8 x 12 in.
Unfired earthenware
Collection of the artist

Paulus Berensohn has lived near Penland School off-and-on
since the late 1970s. His influential book, *Finding One's Way
With Clay,* was written during a Penland residency in 1970-1971.

Dear Bobby,

I was in a supermarket in Blacksburg, Virginia, thinking about your book, and what I might say about tin cans, when I saw a little boy carrying a big can of tomatoes for his father, who had just rounded the corner into the next section. Finding himself alone, the boy set the can on its side and used his foot to roll it the rest of the way down the aisle. When he reached the end of the aisle, he picked up the can and disappeared around the corner.

How could I express our nearly worldwide impulse to create any better than this little boy's spontaneous gesture of invention? From his hand to the floor, from the floor to his foot—in those instants, a can became a wheel.

Betty Oliver, from a letter to Bobby Hansson,
in Hansson's book, *The Fine Art of the Tin Can,*
Lark Books, 1996

A World of Things in Between

Patricia C. Phillips

Attention alters what is attended.

Allan Kaprow, "The Meaning of Life" from *Essays on the Blurring of Art and Life: Allan Kaprow*

To live together in the world means essentially that a world of things is between those who have it in common, as a table is located between those who sit around it; the world, like every in-between, relates and separates [people] at the same time. . . . The weirdness of this situation resembles a spiritualistic seance where a number of people gathered around a table might suddenly, through some magic trick, see the table vanish from this midst, so that the two persons sitting opposite each other were no longer separated but also would be entirely unrelated to each other by anything tangible..

Hannah Arendt, *The Human Condition*

ISSUES AND OPPORTUNITIES

It is unlikely that Allan Kaprow was thinking about craft when he offered his blunt aphorism on the effects of paying attention. More reliably, we can imagine that Hannah Arendt was thinking, if indirectly, about craft as she speculated about the "world of things." In this case, a common object—the table—is an animating agent representing the significance and complexity of artifacts in our lives. Whatever the "thing" may be, it insistently occupies spaces in between people, creating situations of engagement and articulation, as well as moments of awkwardness and estrangement. How objects help us to navigate and relate in a world of people and phenomena is a central question that connects the different speculative passages of this essay. Arguably, even apparently functionless objects of art and craft function as relational resources. It is an inquiry in which craft has a significant "in-between" position that may offer particular insights and opportunities for integrative critical perspectives.

As curator Nicolas Bourriaud suggests in his challenging book *Postproduction: Culture as Screenplay*, many contemporary artists respond to the riotous proliferation of global cultures in the information age. Not only is there an exploding volume of works, but the art world commonly embraces existing things that were once overlooked or ignored. Although Arendt made clear distinctions between the character and conditions of constructed objects (artifice) and consumer products (expendables), it appears that our "world of things" has become a mania of materialism. In this high-pitched, spinning cycle of production and consumption, do things still matter? Are they less or more important? If they invariably complicate life (as we require more and improved things), without them does life fall apart? If we accept that things have the capacity to enlist and engage us with each other, these moments of cooperation, companionship, or mutual experience must be understood as entirely transitional and provisional.

Photo: top, Robin Dreyer; bottom, Jan Silberstein

Arendt was preoccupied with the private/public dialectic—how the human condition is an active arrangement and orchestration of singular and shared experiences. In particular, she was interested in how things—artifacts—articulate and assist in this ongoing process of discrimination and negotiation. If we accept the "world of things" as something indispensable to the human condition, of particular interest is how cultural concepts of art and craft influence this process. How do art and craft materialize, objectify, and represent subjective and shared experiences? How does craft relate and separate us?

By examining some of the most puzzling dialectics of art and life, private and public, production and consumption, expectation and use, we may envision a distinctive mediating and critical role for contemporary craft. Without defending why we need craft, it may be useful to explore its conceptual and connective potential. In different contexts, it shares selective characteristics with art, design, architecture, and public art. Unquestionably, there has been an active blurring of the lines between art and craft and an acceptance of their common characteristics. If not singularly, craft (both the constructive activity and the material evidence) invariably exists in the realm between art and the everyday.

Paradoxically, although craft is frequently praised or lamented for its traditional, virtuous, and "pure" qualities, craft always has had a vibrant, optimistic hybridity. If unarticulated and often unexamined, the idea of craft (as both noun and verb) has mixed and appropriated ideas and conventions from a number of fields. If generally not anticipatory (is there an avant-garde crafts tradition?), arguably craft has been characteristically interdisciplinary. It is craft's mixed messages, its tension of formal and functional features and in-between status that continue to make it a compelling critical area. Rather than slouching towards insignificance or obsolescence, craft offers a multiplicity of ideas that inform other cultural queries and developments. Rather than exalt its traditional, even nostalgic role, craft can be an anticipatory agent in contemporary discourse on art and culture. But clearly, critical strategies need to be reconstituted.

ART AND LIFE

Michel de Certeau's theories on everyday life have been profoundly influential. In his essay, "The Practices of Space," (found in *On Signs* edited by Marshall Blonsky) de Certeau considers how meaning is produced in cities and communi-

ties. Predating its apocalyptic demise, he writes about the sweeping view of New York from the 107th-story observation deck of the World Trade Center. Capturing the paradoxical ideas of overlook (a commanding view, as well as a tendency to disregard or neglect), this totalizing, panoramic view of the city seems endless and seamless. Manhattan is a gorgeous, vast, and immobilized sea. The world of details, textures, contrasts, and extremes disappears under a viewer's commanding gaze. Alternatively, de Certeau considers pedestrians' perspectives of the city. Animated, active, changing, and partial, he describes a multiple, faceted choreography of walkers "whose bodies follow the cursives and strokes of an urban 'text' they write without reading." The city acquires meaning, albeit transitive and contingent, through human use and movement. Rather than the great scopic range from the skyscraper's observation floor, views of the city are limited and provisional, intimate and immediate. Basically, de Certeau argues that we more reliably witness the public realm through the everyday, commonplace pieces and activities of many individual urban inhabitants. In other words, the operations and transactions in the city (indeed the "practices of space") enrich and enhance rather than diminish or distract from meaning.

In the following passage, titled "Passers-By," he captures the embodied discourse of daily life:

> Like words, places are articulated by a thousand usages. They are thus transformed into 'variations'—not verbal or musical, but spatial—of a question that is the mute motif of the interweavings of places and gestures. . . . These dances of bodies haunted by the desire to live somewhere tell the interminable stories of the Utopia we construct in the sites through which we pass. They form a rhetoric of space. They are 'steps' (dance figures), glances (composing mobile geographies), intervals (practices of distinction), criss-crossings of solitary itineraries, insular embraces. These gesturations are our everyday legends.

De Certeau's theory of daily practices traces the lineaments of individual sightings to propose a more dimensional and proliferous idea of public. By paying attention, the captivating, sometimes disquieting familiarity in the commonplace emerges. If not directly influenced by his work, many artists come to mind who share similar preoccupations with the meaning of the quotidian. Unquestionably, Allan Kaprow has been an influential theorist and practitioner in this area. In

his essay, "Performing Life," Kaprow writes:

> When you do life consciously, however, life becomes pretty strange—paying attention changes the thing attended to . . .
>
> A new/life genre therefore came about, reflecting equally the artificial aspects of everyday life and the lifelike qualities of created art . . .
>
> Today, in 1979, I'm paying attention to breathing. I've held my breath for years—held it for dear life. And I might have suffocated if (in spite of myself) I hadn't had to let go of it periodically . . .
>
> I've spoken of breathing. Yet I could have mentioned the human circulatory system, or the effects of bodies touching, or the feeling of time passing. Universals (shareables) are plentiful. From this point on, as far as the artist is concerned, it is a question of allowing those features of breathing (or whatever) to join into a performable plan that may reach acutely into a participant's own sense of it and resonate its implications.

Kaprow suggests that rather than art bestowing significance to life, life gives art meaning. Whether entirely accepted, this is a resonant and relevant conceptual position for the eminently "shareable" field of craft.

Scholar Barbara Kirshenblatt-Gimblett offers an intellectual and affective, inquiring and embodied perspective on the aesthetics of the everyday. In a conversation with Suzi Gablik, recorded in Gablik's *Conversations Before the End of Time*, she describes the "arts of living" which means "giving value meaningful form." She says, "The arts of everyday life are highly utilitarian: they give form to value." The "arts of living" involve gardens, parades, domestic interiors, the table, food, as well as conversation, sociability, and etiquette. Arguably, even functionless objects satisfy the "utilitarian" activity of materializing and demonstrating value. For both Kaprow and Kirshenblatt-Gimblett there is an unmistakable aesthetic dimension in functional enactments, repetitious performances, and common rituals. Whether a repetitive activity (Kaprow's suggestion to view a normal routine as performance and carefully chart how one greets someone each day for an entire month) or a devoted resourcefulness (the spontaneous urban gardens that fascinate Kirshenblatt-Gimblett), there is a notion that activity and use have value in an art-life continuum. How does craft articulate this dailiness? How does a craft object perform and perpetuate this "blurring of art and life?" Because of its in-between position, craft has affinities with life-like art and artful living.

A sculpture created by Patrick Dougherty in front of the Penland dining hall, 1994

SINGULAR AND SHARED: PRIVATE AND PUBLIC

There often is an indifference to the in-between. It may seem imprecise and vague. Is it somewhere or nowhere? I suggest that this interstitial space is a germane intellectual idea when considering craft. In-between is a fruitful—not marginal—concept. How does craft enter and mediate the drifting dimensions of public and private, art and life? How do objects represent (rather than settle) the perpetual unrest of transparency (public) and intimacy (private)? How does craft engage social values and self-expression, use and style?

Craft and public art share some common ground that may offer useful critical insights and connections. While they may have an explicit function, often they do not. But they are part of the "highly utilitarian" nature of the "arts of living" that Kirshenblatt-Gimblett describes. The shifting borders of the public realm present significant challenges in defining contemporary public art. Public art has become an errant idea. Increasingly, new technologies and changing civic patterns have rendered both private and public ambiguous, sometimes volatile concepts. There remains a physicality to public space (it is here and not there), but there is a growing recognition of its other quixotic, inchoate, and placeless qualities. Public space has become systemic and molecular, dynamic and granular. Paradoxically, it often seems shockingly vulnerable and

Photo: Ann Hawthorne

infinitely replicable. An uneasy companion of the dramatic excess of information is an alarming uniformity.

In the past two decades, public art has raised salient questions about art and access. Public art is frequently praised, practiced, and defended as a way to bring art into cities and communities. Its democratic, if often unrealized, potential is to introduce art, aesthetics, and ideas into the daily lives of ordinary citizens. People choose to visit museums and galleries with an expectation to encounter some kind of art. They rarely end up in museums by accident. Presumably, public art accommodates both deliberate, as well as fortuitous, encounters. Some people go out of their way to see public art (just as they might go to an exhibition in a museum), but often public art is witnessed as an inadvertent consequence of transit in the city, during a routine errand, commute, or perhaps a new route that brings people into art's proximity.

Access and expectations are widely variable, but generally, people experience public art while they are doing something else. This state of distraction—aesthetic experiences in conjunction with daily activities—may present new critical opportunities for both public art and craft. Both fields occupy in-between positions that require particular maps of the passages of expectation, consciousness, activity, and use.

PRODUCTION AND CONSUMPTION

Squarely facing the contemporary proliferation of things, Nicolas Bourriaud presents a thesis or, rather, identifies aesthetic practices that accept and exploit the increasing velocity and volatility of production and consumption. Bourriaud observes that this chaos of aesthetic activity frequently uses forms and spaces generally ignored or overlooked. Rather than making things from natural, synthetic, or found materials, artists now work with pre-existing things and objects that are often widely circulated. Appropriately taking the term "postproduction" from television, film, and video, Bourriaud cites a common set of processes applied to already recorded material, including montage, voice-overs, and special effects. Bourriaud observes that the artist is like a programmer or DJ who selects, places, and mixes existing works in new contexts.

Citing Claude Levi-Strauss (via Dan Cameron), Bourriaud presents the illuminating dichotomy of "the raw and the cooked." He suggests that the postproduction artist uses things that are "raw," unaltered, and as close to the market form as possible, whereas traditional artists who "cook"

often dramatically transform an existing material, frequently rendering it unrecognizable. Interestingly, the "raw," if not "cooked," is unquestionably pre-prepared.

In this new cultural landscape, the increasingly effaced boundaries between creation and copy, original work and readymade, and most notably production and consumption are disturbed and reconfigured. While Bourriaud's *Postproduction* focuses on new forms of knowledge that have emerged from the information age, his earlier treatise on "relational aesthetics" examines the interaction, exchange, conviviality, and sociality of an encounter with contemporary art. Regardless of its focus or query, this new work embraces a riotous eclecticism that challenges the patrimony and, in fact, possibility of a unified theory of art and the autonomy of disciplines.

I suspect that some people may find Bourriaud's ideas cynical, alarming, and threatening to art and craft. It is coincidental that both "market" and "craft" are nouns and verbs. He cites many artists' fascination with flea markets, as well as the machinations of marketing. It may seem that his embrace of the market (both the place and the activity) is a complete dismissal of making—of craft. Instead, Bourriaud may be a critical realist. As artists, critics, and citizens it is tempting to reject and withdraw from the vulgarities and vagaries of consumer culture. Entering this increasingly globalized and homogenized arena, Bourriaud is neither blindly enthusiastic nor benignly acquiescent. He makes a compelling appeal:

> . . . can't this eclecticism, this banalizing and consuming eclecticism that preaches cynical indifference toward history and erases the political implications of the avant-gardes, be contrasted with something other than [Clement] Greenberg's Darwinian vision, or a purely historicizing vision of art? The key to the dilemma is in establishing processes and practices that allow us to pass from a consumer culture to a culture of activity, from a passiveness toward available signs to practices of accountability. Every individual, and particularly every artist . . . must take responsibility for forms and their social functioning: the emergence of a civic consumption. . . .

EXPECTATION AND USE

Rather than isolate and defend craft's distinctive or unique features, it may be constructive to identify and define what it shares, philosophically and pragmatically, with art, design,

and other objects or activities. For instance, how does time alter, amend, confirm, or extricate a work of art or craft? How do people's expectations and responses transform or stabilize objects of desire over the years? If some thing is first produced, acknowledged, accepted, circulated, and criticized as craft or art, does it always remain so? Is art steadfast? Is craft steadfast? And if something begins as craft (or art), can it also be (or become) something else?

How do these transformations occur? If something comes into existence that was not produced or intended to be art or craft, can it become this or that? Embracing these dynamic, contextual, and circumstantial forces, what are the implications of these improvisational transactions in the perception—and reception—of things? Accepting the inevitable puzzlement, what opportunities do fluidity, instability, impurity, and discontinuity present as critical agents?

We encounter in many situations that boundaries are dependably provisional. People honor, ignore, or respond with indifference or irritation to them. Some people assiduously respect and defend them. Others only begrudgingly acknowledge them. And like Kaprow, some people poise and play at them. The borders of public art are increasingly pliable. And so it seems are the edges of craft. Whether situated in a public space or domestic interior, public art and craft generally are encountered by people involved in a routine activity of daily life. People generally experience craft (and public art) when they are doing something else. Rather than a distraction or dilution of an aesthetic experience, this coupling of craft with daily life can disarm an idealized and increasingly unrealized expectation of focused aesthetic contemplation.

Like Arendt's metaphor of the table, public art and craft give the space between us meaning—or as Kirschenblatt-Gimblett suggests, they "give form to value." Or like the infinitesimal space between hinges or joints that allows movement, the intimacies of craft both separate and relate us to each other and the world. If this diminutive space diminishes and disappears, the joint becomes inflexible and immovable. These "arts of living" serve as spaces and edges that, if unsettled or occasionally disputed, sustain a level of exchange and discourse.

Bourriaud and others have helped to advance and articulate the relational dimensions of aesthetics. Rather than situated within the formal conditions of an object or alternatively with the viewer/participant's experience, relational aesthetics considers the transactional dynamics that occur between an object, event, and perception. Aesthetics move within the liminal space located between moments and things, response and use. This notion of aesthetics as an active phenomenon, inclusive process, and continuous activity does not ignore, but readily accommodates, ideas of both use and style.

This critical proposition has particular resonance for craft. Craft is infinitely more interesting when critically engaged through the rich vagaries of a relational analysis (an open system) than through the virtuosities of a new formal breakthrough (a closed system). This is not to say that constitutive changes, formal innovations, or technological developments cannot be critically examined, but they can be apprehended and examined within the more open, discursive realm of the relational. The relational accepts both our attraction (desire and expectation) and distraction (use and activity) as one of the most insistent dialectics of daily life. Kaprow's appeal for attentiveness acknowledges a chronic (human) condition of inattention.

Bourriaud underscores the prospects of a relational view of art or craft:

> It is up to us as beholders of art to bring these relations to light. It is up to us to judge artworks in terms of the relations they produce in the specific contexts they inhabit. Because art is an activity that produces relationships to the world and in one form or another makes its relationships to space and time material.

Arendt's application of the table to describe the tricky relationship of the private and public realms does, in fact, have more than an incidental relevance for craft. She offers fascinating distinctions:

> . . . the term 'public' signifies the world itself, in so far as it is common to all of us. . . . This world, however, is not identical with the earth or with nature, as the limited space for the movement of men and the general condition of organic life. It is related, rather, to the human artifact, the fabrication of human hands. . . .

Making distinctions between labor and work (which can produce works of art or craft), consumption and use, consumer products and use objects, she describes how things create a public realm. From Arendt's perspective in the mid-twentieth century, there was a clear boundary between consumables—stuff that spontaneously appears and disappears—and the objects of work that are durable, repeatedly used, and give the world a sense of stability and permanence. She pro-

poses that the tangibility of things is central to the activities of remembrance and reification that shape reality. Even action, speech, and thought must achieve some objectification. She suggests that these are materialized through the same processes that build the other things in our world.

Arendt distinguishes things that are more enduring than the activity required to produce them, from short-lived things whose consumption rarely lasts beyond the actual act of production. Of course, fifty years ago it was easier to imagine and justify this world of consumable, ephemeral things as "naturally" constituted. Things were used, consumed, disappeared, and returned to a natural process of absorption or decay. I wonder how Arendt's "world of things" might look in Bourriaud's "postproduction" culture. Could she have imagined the riot of production and consumption in which we are participants, witnesses, and objectors? Could she have anticipated a growing ambiguity and hybridity of consumer goods and common objects?

In spite of these significant changes in the world of artifacts, Arendt's concept that work creates a shared public realm—a "worldliness"—still has resonance. Historically, craft has played a significant role in the dailiness and worldliness of life. Often defended for its virtuous and genuine characteristics, craft is, in fact, thrillingly artificial and interdisciplinary. It is a default of both history and the future to segregate, idealize, or naturalize craft. Craft is a particular kind of attentive production that should be neither trivialized nor valorized. Attentive production and postproduction do—and must—coexist. For this has become our world of things.

Design historian Adrian Forty challenges the art historical tradition of great works and artist/designer-centric accounts. In *Objects of Desire*, he suggests that design is neither timeless nor purely the consequence of the virtuosity of individual practitioners. He suggests that design is the way that ideas about the world and social relations become embodied in actual objects. His observations connect insistently with Arendt, as well as Kirshenblatt-Gimblett's idea of giving "form to value—giving value meaningful form." Craft is an enduring, but ever-changing cultural phenomenon that requires ambitious contextual and critical analysis of its germane, if not central, role in an aesthetics of human exchange.

Arendt's wise aphorism offers an optimistic conclusion. "What I propose . . . is very simple: it is nothing more than to think what we are doing." Craft offers critical insight on the increasingly ambiguous interludes of time and space between making and experience, practice and reception, attraction and inattention. To think is to do. To make is to think.

BIBLIOGRAPHY

Arendt, Hannah. *The Human Condition*. Chicago: University of Chicago Press, 1958.

Blonsky, Marshall, ed. *On Signs*. Baltimore: The Johns Hopkins Press, 1985.

Bourriaud, Nicolas. *Relational Aesthetics*. Paris: Les Presses du Réel, 1997.

———. *Postproduction: Culture as Screenplay: How Art Reprograms the World*. New York: Lukas & Sternberg, 2002.

Forty, Adrian. *Objects of Desire*. New York: Pantheon Books, 1986.

Gablik, Suzi. *Conversations Before the End of Time*. London: Thames & Hudson, 1997.

Kelley, Jeff, ed. *Essays on the Blurring of Art and Life: Allan Kaprow*. Berkeley: University of California Press, 1993.

Biographies

Writers and Curators

Galen Cranz
Oakland, CA
b. 1944
Galen Cranz, Ph.D., is professor of architecture at University of CA/Berkeley, specializing in the sociology of architecture. She is the author of *The Chair: Rethinking Culture, Body, and Design* (W. W. Norton & Co., 2000) and *The Politics of Park Design* (MIT Press, 1989). She is a Kellogg fellow and a certified teacher of the Alexander Technique.

Ellen Paul Denker
Wilmington, DE
b. 1947
Ellen Denker is a museum consultant and writer. She has developed exhibitions for New-York Historical Society, New York Transit Museum, Ellis Island Museum, and Milwaukee Art Museum. She is co-author, with Bert Denker, of *The Rocking Chair* (Mayflower Books, 1979) and *The Warner Collector's Guide to North American Pottery and Porcelain* (Warner Books, 1986).

Ellen Dissanayake
Seattle, WA
b. 1936
Ellen Dissanayake is an interdisciplinary scholar and writer on the arts. Her work provides evidence from several disciplines that art making and experience are inherent in human nature. After living for more than fifteen years in non-western countries (Sri Lanka, Papua New Guinea, Nigeria, India, and Madagascar), she now lives in Seattle. She is the author of *What is Art For?* (University of WA Press, 1990) and *Art and Intimacy: How the Arts Began* (University of WA Press, 2000).

Robin Dreyer
Burnsville, NC
b. 1956
Robin Dreyer is communications director at Penland School of Crafts. His articles and photographs have been published in *American Craft, Time-Life Books, Pinhole Journal, Photovision,* and many Penland publications.

Roald Hoffmann
Ithaca, NY
b. 1937
Roald Hoffmann, Ph.D., the Frank H.T. Rhodes Professor of Humane Letters at Cornell University, is a chemist and a writer of poetry, essays, nonfiction, and plays. In chemistry he has taught his colleagues how to think about the shapes and reactions of molecules, and has won most of the awards of his profession, including the 1981 Nobel Prize. He has a lifelong interest in craft.

Lewis Hyde
Cambridge, MA and Garnier, OH
b. 1945
Lewis Hyde is a writer best known for his works of cultural criticism, *The Gift* (Vintage, 1983) and *Trickster Makes This World* (Farrar, Straus, and Giroux, 1998). A MacArthur Fellow, he is the Richard L. Thomas Professor of Creative Writing at Kenyon College.

Norris Brock Johnson
Chapel Hill, NC
b. 1942
Norris Brock Johnson, Ph.D., is a professor of anthropology at University of NC/Chapel Hill, where he is a specialist on comparative art and aesthetics and the study of religious landscapes. He has been a Fulbright fellow and faculty member at the University of Tokyo and Waseda University, Tokyo and has lectured and published widely on his firsthand study of Japanese Zen Buddhist art and landscape gardening in Kyoto and Kamakura.

Michael Owen Jones
Los Angeles, CA
b. 1942
Folklorist Michael Owen Jones, Ph.D., teaches in the World Arts and Cultures Department at University of CA/Los Angeles. He researches and writes about folk medicine, food customs and symbolism, organizational culture, vernacular religion, and art in everyday life. He is author of *Craftsman of the Cumberlands: Tradition and Creativity* (University Press of KY, 1989), *Putting Folklore to Use* (American Folklore Society, University Press of KY, 1994) and co-author, with Robert A. Georges, of *Folkloristics* (IN University Press, 1995).

Dana Moore
Penland, NC
b. 1954
Dana Moore is program director at Penland School of Crafts. She has an MFA in photography from University of FL. She received an NEA fellowship, and her work has been exhibited at Catherine Edelman Gallery (Chicago), 1708 Gallery (VA), Lisa Sette Gallery (AZ) and is in the collection of the Southeast Museum of Photography (FL).

Eileen Myles
San Diego, CA and New York, NY
b. 1949
Eileen Myles is a poet who ran a female campaign for President of the United States in 1992. Currently she is at University of CA/San Diego creating an MFA program and writing a novel. She is the author of many volumes of poetry including *Skies* (2001) and *Not Me* (1991), a book of stories, *Chelsea Girls* (1994), and the novel *Cool for You* (Soft Skull Press, 2000).

Patricia C. Phillips
New Paltz, NY
b. 1952
Patricia C. Phillips is an independent critic and professor of art at SUNY New Paltz. In July 2002, she was appointed executive editor of the *Art Journal,* a quarterly on modern and contemporary art published by the College Art Association. Her writing has been published in *Sculpture, Public Art Review, Artforum, Art in America,* and *Flash Art.*

ARTISTS

The following abbreviations are used in these biographies:

EXHIBITING INSTITUTIONS

Brooklyn Museum—Brooklyn Museum of Art, Brooklyn, NY

Cooper-Hewitt—Cooper-Hewitt National Design Museum, New York, NY

Corning Museum—Corning Museum of Glass, Corning, NY

Folk Arts Center—The Folk Arts Center of the Southern Highland Craft Guild, Asheville, NC

George Eastman House—The George Eastman House International Museum of Photography and Film, Rochester, NY

High Museum—High Museum of Art, Atlanta, GA

Kohler Arts Center—John Michael Kohler Arts Center, Sheboygan, WI

Metropolitan Museum—Metropolitan Museum of Art, New York, NY

MAD—Museum of Arts and Design, New York, NY (formerly American Craft Museum)

MFA Boston—Museum of Fine Arts, Boston, Boston, MA

MMA—Mint Museum of Art, Charlotte, NC

MMCD—Mint Museum Craft + Design, Charlotte, NC

MOMA—Museum of Modern Art, New York, NY

Philadelphia Museum—Philadelphia Museum of Art, Philadelphia, PA

Renwick Gallery—The Renwick Gallery, Smithsonian American Art Museum, Washington, DC

Smithsonian—Smithsonian Institution, Washington, DC

SOFA—Sculpture, Objects, and Functional Art Expositions, Chicago, IL; New York, NY; Miami, FL

SECCA—Southeastern Center for Contemporary Art, Winston-Salem, NC

The White House Craft Collection—The White House Collection of American Craft, Smithsonian American Art Museum, Washington, DC

Wustum Museum—Charles A. Wustum Museum of Fine Arts, Racine, WI

Victoria and Albert—Victoria and Albert Museum, London, U.K.

EDUCATIONAL INSTITUTIONS

92nd St. Y—92nd Street Young Mens Hebrew Association Art Program, New York, NY

Arrowmont—Arrowmont School of Arts and Crafts, Gatlinburg, TN

Anderson Ranch—Anderson Ranch Arts Center, Snowmass Village, CO

Brookfield—Brookfield Craft Center, Brookfield, CT

Campbell Folk School—John C. Campbell Folk School, Brasstown, NC

CCA—California College of the Arts, Oakland and San Francisco, CA (formerly CA College of Arts and Crafts)

Corning Studio—The Studio of the Corning Museum of Glass, Corning, NY

Cranbrook—Cranbrook Academy of Art, Bloomfield Hills, MI

Haystack—Haystack Mountain School of Crafts, Deer Isle, ME

OCAC—Oregon College of Art and Craft, Portland, OR

Parsons—Parsons School of Design, New York, NY

Peters Valley—Peters Valley Craft Education Center, Layton, NJ

Pilchuck—Pilchuck Glass School, Stanwood, WA

Pratt—Pratt Institute, Brooklyn, NY

RISD—Rhode Island School of Design, Providence, RI

RIT—Rochester Institute of Technology, Rochester, NY

SUNY—State University of New York (individual campuses indicated)

ART AND CRAFT ORGANIZATIONS

ABANA—Artist-Blacksmith's Association of North America

ACC—American Craft Council

Convergence—the biennial conference of the Handweavers Guild of America

GAS—Glass Art Society

NCECA—National Council on Education in the Ceramic Arts

NEA—National Endowment for the Arts

SAF—Southern Arts Federation

SNAG—Society of North American Goldsmiths

SHCG—Southern Highland Craft Guild, Asheville, NC

SPE—Society for Photographic Education

LINDA ARBUCKLE, clay
Gainesville, Florida
b. 1950
Linda Arbuckle, professor at University of FL, makes functional ware using terra cotta clay and the majolica glaze technique which allows her to decorate the work with bright colors and expressive brushwork. She works primarily with botanical imagery. She has an MFA from RISD. She has taught at LA State University, Penland, Arrowmont, Anderson Ranch, and Cleveland Institute of Arts. Arbuckle received an NEA grant and her work is in the collections of Archie Bray Foundation, Frederick R. Weisman Art Museum at University of Minnesota, AK Art Center, Museum of Decorative Arts, and is included in *The Contemporary Potter* (Rockport Publisher, 2002) and *500 Teapots* (Lark Books, 2002). Arbuckle is also one of the featured artists in *The Penland Book of Ceramics: Master Classes in Ceramic Techniques* edited by Deborah Morgenthal and Suzanne Tourtilott (Lark Books, 2003).

JUNICHIRO BABA, glass
Tokyo, Japan and Penland, NC
b. 1964
A former Penland resident artist, Junichiro Baba was born and raised in Japan. He received an MFA from RIT. Baba's cast glass sculptures are meant to represent the forces of nature. He says that his upbringing in the urban environment of Tokyo enhanced his awareness of the manifestation of these forces. He began exhibiting in 1990 and has had solo exhibitions at Chigusa Gallery in Tokyo and Gallery W.D.O. (NC), and

has had work at Blue Spiral I (NC), SOFA, Tucson Museum of Art (AZ), and The Heller Gallery (NYC). His work has been published in *American Craft*.

DAN BAILEY, photography
Glyndon, Maryland
b. 1952
The director of the Imaging Research Center at University of MD/Baltimore, Dan Bailey has taught at University of MD, Parsons, Haystack, Arrowmont, and Penland, where he was also a resident artist from 1980–1983. Although he now works primarily in film and digital media, Bailey's work at Penland was as a photographer. His films have been shown and given awards in festivals throughout the U.S. He has received fellowship grants from the DE Arts Council and the Maryland Arts Council and has films in the collections of MOMA and the Pompidou Center (Paris). He has served on the boards of Penland and Haystack.

OSCAR BAILEY, photography
Penland, NC
b. 1925
Oscar Bailey earned an MFA in photography at OH University in Athens. He taught photography at SUNY/Buffalo, University of South FL, Penland, and was a founding member of SPE. In 1967, Bailey acquired a CIRKUT spring-driven, revolving camera, which takes panoramic photographs up to sixty inches wide. His innovative, serious use of this antique instrument constitutes an important part of his work. He has had numerous solo exhibitions and his work is included in the collections of George Eastman House, National Museum of Art, MOMA, Smithsonian, MFA Boston, and The Library of Congress. Bailey and his wife, Sarah, are lifelong members of the American Kite Flyers Association and have taught kite-making workshops at Penland.

BORIS BALLY, metals
Providence, RI
b. 1961
Influenced by his parents, Boris Bally began working in crafts as a teenager. His training included a one-year goldsmithing apprenticeship in Switzerland and a BFA from Carnegie-Mellon University (Pittsburgh). He has taught at University of Akron (OH), Pittsburgh Center for the Arts, Carnegie-Mellon University (Pittsburgh), Haystack, Penland, and 92nd Street Y. His frequently whimsical pieces use materials ranging from precious metals to recycled highway signs, reflecting not only his passion for recycling but also his interest in challenging ideas about the intrinsic value of different materials. His work has been exhibited internationally, including Cooper-Hewitt, SOFA, Joanne Rapp Gallery (AZ), William Traver Gallery (Seattle), and the traveling exhibit, *Trashformation: Recycled Materials In American Art and Design.*

DOROTHY GILL BARNES, gathered natural materials
Worthington, OH
b. 1927
Dorothy Gill Barnes has an MA from University of IA and taught for many years at Capital University (OH). She has conducted workshops in Australia, Denmark, UK, Canada, Hawaii, New Zealand and at Arrowmont, Haystack, and Penland. She is a fellow of the ACC and received a lifetime achievement award from National Museum of Women in the Arts in Washington, DC. Her vessels and other sculptural objects use gathered natural materials and techniques derived from traditional basketmaking as well as techniques of her own devising. Her work is in the collections of Renwick Gallery and MAD.

MARY BARRINGER, clay
Shelburne Falls, MA
b. 1950
Mary Barringer studied sculpture at Pratt and received a BA from Bennington College (VT). She has taught at Haystack, Greenwich House Pottery (NYC), 92nd Street Y, Peters Valley, Penland, and Arrowmont. Barringer's work, which is both functional and sculptural, is characterized by elegant forms combined with heavily textured surfaces. It has been exhibited in numerous one- and two-person shows including Snyderman Gallery (Philadelphia), The Clay Studio (Philadelphia), Baltimore Clayworks, and Pewabic Pottery (Detroit). A recipient of a New England Foundation for the Arts grant, her work is in *The Spirit of Clay* by Robert Piepenburg (Pebble Press, 1995) and *Ceramics: Mastering the Craft,* by Richard Zakin (Chilton, 1990). She is also one of the featured artists in *The Penland Book of Ceramics: Master Classes in Ceramic Techniques* edited by Deborah Morgenthal and Suzanne Tourtillott (Lark Books, 2003).

RICK BECK AND VALERIE BECK, glass
Spruce Pine, NC
b. 1960 (both)
Former Penland resident artists, Valerie and Rick Beck work collaboratively creating blown glass vessels and sculptures, combining glass forms with expressive use of paint. Rick also works independently creating cast glass sculptures which are distinct from their collaborations. Both received BA degrees from Hastings College (NE). Valerie did graduate work in educational psychology and Rick earned an MFA from Southern IL University/Carbondale. They have taught at Penland and Appalachian Center for Crafts. Their collaborative work has been exhibited at Snyderman Gallery (Philadelphia) and Montgomery Museum of Fine Art (AL).

JAMIE BENNETT, metals
Stone Ridge, NY
b. 1948
A professor at SUNY/New Paltz, Jamie Bennett has an MFA from SUNY. He has served on the board of SNAG, was an honorary board member of the Renwick Gallery Alliance and has taught at Penland. Bennett's jewelry and wall reliefs showcase his mastery of enameling, which he uses in a delicate and painterly fashion. He has exhibited his work worldwide and it is in the collections of MAD, MMA, Musée des Arts Decoratifs (Paris), Philadelphia Museum, and Victoria and Albert. He received three NEA grants and grants from the New York Foundation for the Arts and the Massachusetts Artists Foundation.

PAULUS BERENSOHN, clay
Penland, NC
b. 1933
Paulus Berensohn studied dance at Julliard School (NYC) and Bennington College (VT) before spending ten years with modern dance companies, in Broadway musicals, and early TV. An honorary fellow of the ACC, Berensohn is the author of *Finding One's Way with Clay* (Simon and Schuster, 1972). He has developed workshops and lectures on the interface of craft arts, deep ecology, and social justice, which he has presented all over the U.S. as well as in Europe and Australia. He has also taught workshops in clay and in making and using journals, which he describes as "portable studios." A pioneer in hand-built ceramics, Berensohn was Penland's program director for several years in addition to being an instructor, a visiting artist, and a long-time neighbor.

FREDERICK BIRKHILL JR., glass
Pinckney, MI
b. 1951
An independent studio artist, Frederick Birkhill Jr., is known primarily for his flameworked glass and mixed-media constructions, as well as his teaching and research on the history of his craft. His educational background includes a BS from Eastern Michigan University in Ypsilanti and a BFA from University of Michigan. He has studied with other artists in the United States and Europe, including Patrick Reyntiens, William Gudenrath, and the late Kurt Wallstab. He has taught frequently at Penland with co-teacher Shane Fero. His work is included in the collections of Corning Museum, Detroit Institute of Arts, MMA, and Smithsonian.

JOE BOVA, clay
Guysville, OH
b. 1941
After nineteen years on the faculty of LA State University, Joe Bova moved to OH University where he was a professor until his retirement in 2001. For seven years he also served as director of the School of Art. He has an MFA from University of NM. Animals familiar from his Texas childhood, such as rabbits and alligators, are favorites subjects for his work, which uses human imagery as well. He is a fellow of NCECA and a recipient of grants from SAF/NEA, the LA Arts Council, and SECCA. Bova has taught frequently at Penland, and is a past president of the Penland Board of Trustees. He is one of the featured artists in *The Penland Book of Ceramics: Master Classes in Ceramic Techniques* edited by Deborah Morgenthal and Suzanne Tourtilott (Lark Books, 2003).

DEBORAH BRACKENBURY, photography
Norman, OK
b. 1952
Deborah Brackenbury earned an MFA from University of FL. She was assistant professor of photography at University of OK from 1998–2001 and has taught at Ball State University (IN), Haverford College (PA), University of FL, and at Penland. In 2003 she was part of group exhibitions in Beijing and Shanghai, China, and had a solo show and installation at TX Women's University. She was a featured Indiana artist at Indianapolis Museum of Art in 1996. She has worked with a number of unusual photographic processes including toy cameras, underwater photography, liquid emulsions, and printing on found objects.

ELIZABETH BRIM, iron
Penland, NC
b. 1951
Elizabeth Brim has an MFA from University of GA. A former core student, she studied extensively at Penland in ceramics, metals, blacksmithing, bronze casting, and sculpture. She has taught at Penland, Haystack, Peters Valley, and Campbell Folk School, and demonstrated at ABANA conferences and in Germany and Canada. She coordinated two Penland iron symposia, was the iron studio coordinator at Penland for six years, and was on the advisory committee for the new iron studio. Brim has created a body of sculptural work which uses forged and fabricated steel to interpret traditionally feminine imagery such as hats, dresses, aprons, and pillows. This work has been shown at at Blue Spiral I (NC) and included in the traveling exhibitions *Earth, Fire and Water, Contemporary Forged Metal* and *Women in Iron*.

CYNTHIA BRINGLE, clay
Penland, NC
b. 1939
Cynthia Bringle has an MFA from Alfred University. She established a home and studio at Penland in 1970, holds an open house for students every session and has been on the Penland board. She teaches workshops frequently and has a large following as a teacher. She was a Penland resident artist and was a part of Penland's Nifty Fifty in 1971. Her work is wheel-oriented with some altering, and fired in various kilns. A fellow of the ACC, Bringle's work was the subject of a retrospective exhibition in 1999 at Folk Arts Center. Her work is included in collections of MMCD, Wustum Museum, and High Museum. In 2002 Bringle was a recipient of the North Carolina Award, and she is one of the artists featured in *The Penland Book of Ceramics: Master Classes in Ceramic Techniques* edited by Deborah Morgenthal and Suzanne Tourtilott (Lark Books, 2003).

EDWINA BRINGLE, fiber
Penland, NC
b. 1939
A professor of art emerita from UNC/Charlotte, Edwina Bringle is now a full-time studio artist. She was a Penland resident artist and was a part of Penland's Nifty Fifty in 1971. Her woven textiles and free-motion embroidered textiles emphasize color and design. She has taught at Penland, Arrowmont, and Campbell Folk School. Her work is in the collections of NC Museum of History, Greenville Museum of Art (SC), and the Smithsonian International Traveling Exhibition.

WILLIAM BROWN JR., iron
Linville Falls, NC
b. 1955
William Brown Jr., grew up at Penland where his father was the director for 21 years. Brown was instrumental in the establishment of the iron program and was the instigator of the iron croquet set included in this book. He apprenticed to Ivan Bailey of Savannah, GA. In 1978, he was selected to participate in an NEA research exchange project at Southern IL University/Carbondale. Brown has exhibited in museums and galleries throughout the southeast including Hickory Museum of Art (NC), William King Art Center (VA), Grounds for Sculpture (NJ), Fayetteville Museum of Art (NC), National Ornamental Metal Museum (TN), and was part of the *Penland Overlook* traveling exhibit in 1992.

KEN CARDER, glass
Bakersville, NC
b. 1955
Ken Carder studied at Bowling Green State University (OH), and was a Penland resident artist from 1984–1988, after which he had a studio in Collinsville, CT, before moving back to the Penland area and setting up a studio in 1997. He has taught at Penland and is a part of the Ariel cooperative gallery (NC). He has had solo exhibitions in Heller Gallery (NYC), Grohe Gallery (Boston), Marx Gallery (Chicago) and Habatat Galleries (MI and FL). A recipient of a SAF/NEA grant, his work is in the collections of MMA, Detroit Institute of Art, and Glasmuseum Ebeltoft (Denmark).

WENDELL CASTLE, wood
Scottsville, NY
b. 1932
Sculptor/furniture maker Wendell Castle has an MFA from University of KS/Lawrence. He headed the Wendell Castle School (NY) from 1980–88, has taught at SUNY/Brockport, RIT, University of KS, and has been an artist-in-residence at RIT since 1984. He holds honorary doctorates from SUNY/Brockport, St. John Fisher College (NY), and Maryland

Institute of Art. A recipient of four NEA grants and a Louis Comfort Tiffany grant, he is a fellow of the ACC and received its gold medal in 1997. His work is in the collections of MAD, MOMA, Philadelphia Museum, Art Institute of Chicago, Detroit Institute of Arts, Metropolitan Museum, MFA Boston, and Smithsonian Institution. He first taught at Penland in 1969 and since then has been a visiting scholar and taught classes in furniture making, design, and drawing.

NICK CAVE, fiber
Chicago, IL
b. 1959
Visual and performance artist and designer Nick Cave received an MFA from Cranbrook. He has taught at Art Institute of Chicago, Penland, University of WI/Madison, Art Academy of Cincinnati, Pratt, OCAC, and IN University. His work, which addresses social and political issues, and functions both as sculpture and as garments for performance, has been exhibited in museums and galleries throughout the U.S. including MAD and Kohler Arts Center. He has also designed and marketed a line of clothing for men and women. The *Sound Suits* project, which combined the design for a garment to cover the entire body with a performance in the finished suit, allowed Cave to show his work in theaters and happenings on the street. He received an NEA grant.

JOHN COGSWELL, metals
Clintondale, NY
b. 1948
John Cogswell has an MFA from SUNY/New Paltz, has taught at Hofstra University in NYC, Pratt, Parsons, and is currently on the faculty of SUNY/New Paltz. He has also offered workshops at Penland, Arrowmont, Brookfield, Haystack, and 92nd Street Y. He is the owner of John Cogswell/Contemporary Metalsmith studio, making functional work in precious metals which demonstrates the highest level of craft and design. His exhibition list includes SOFA and Kohler Arts Center. His work is featured in *Jewelry: Fundamentals of Metalsmithing,* by Tim McCreight (Brynmorgen Press, 1997).

CLARA "KITTY" COUCH, clay
Burnsville, NC
b. 1921–2004
A graduate of Agnes Scott College, Clara "Kitty" Couch returned to school after raising a family, and received a BA from Sacred Heart College (NC) and then taught at Central Piedmont Community College for five years. She received an Arts International Lila B. Wallace/Reader's Digest Award for study in Ecuador, a NC Arts Council Fellowship for the Headlands Center for the Arts (CA), and the International Invitational to the Resen Ceramic Colony in Macedonia. She had solo exhibitions at Headlands Center, SECCA, and Green Hill Center for North Carolina Art, and had work in group exhibitions at MMA and National Museum of Women in the Arts (DC). Her low-fired, unglazed vessel sculptures suggest the curves of the human form, and, as she sometimes said, "the music of the spheres."

FRANK CUMMINGS III, wood
Long Beach, CA
b. 1938
Frank Cummings has a BA from CA State University and a BA from CA State University/Fullerton. He has taught in the U.S., Africa, and Madagascar, and has served as a consultant for the NEA and the State Department. His work was the subject of a traveling exhibit in Africa and has been included in exhibitions at Afro-American Museum (OH), Los Angeles County Museum of Art, Pasadena Museum of Art, National History Museum (DC), and is in the White House Craft

Collection. He is featured in *Artistic Woodturning* by Dale Nish (Brigham Young Press, 1980) and *Woodworking: The New Wave* by Dona Meilach (Crown Publishers, 1981). The philosophy for his work is drawn from a reverence for nature and is influenced by the Shaker beliefs in honesty, truth, and that doing a thing well is an act of prayer.

WILLIAM DALEY, clay
Philadelphia, PA
b. 1925
William Daley joined the Army Air Corps after his high school graduation in 1943. He was shot down on his first mission and spent the rest of the war as a German prisoner. After the war, he completed his MFA at Columbia University Teachers College. He taught at SUNY/New Paltz, SUNY/Fredonia, and Philadelphia College of Art from which he retired in 1990. His work reflects his background in painting and his interest in architectonic ceramics. Daley was a consultant on the development of the Penland community education program. His work is in the collections of Los Angeles County Museum of Art, Metropolitan Museum, MMA, Smithsonian, Wustum Museum, Victoria and Albert, and National Museum of Korea. He is a fellow of the ACC and received its gold medal.

LINDA DARTY, metals
Greenville, NC
b. 1952
Linda Darty has an MFA in metal design from East Carolina University (NC), where she is now a professor and head of the metal design program. Her work in jewelry and small-scale sculpture uses a variety of metals, frequently incorporating enamels and botanical imagery. She was honored with a lifetime achievement award from The Enamelist Society and her work is included in *Color on Metal* by Tim McCreight (Guild Publishing, 2000). A former Penland trustee, Darty was administrative assistant to the director of Penland from 1976–1981. She has taught at Penland several times and was instrumental in establishing and preserving the Penland archive.

RANDALL DARWALL, fiber
Bass River, MA
b. 1948
Randall Darwall's background includes a strong interest in painting and scenic design. He received his MAE from RISD. He taught secondary school art for eight years at the Cambridge School (MA) while concurrently establishing a weaving studio. He has also taught at Penland, Haystack, and Arrowmont. His handwoven wearables are a vehicle for his superb sense of color and design. Darwall has had a number of solo gallery shows and his work has been included in group exhibitions in the Textile Museum (DC), Wustum Museum, MAD, and a U.S. State Department *Art to Wear* exhibit which toured Southeast Asia.

LENORE DAVIS, fiber
1936–1995
Lenore Davis was a self-employed fabric artist and workshop teacher from 1969 until her death in 1995. She had an MFA in ceramics from Cranbrook. She studied ceramics in Portugal with a Fulbright-Hays Fellowship and received a Louis Comfort Tiffany grant. Her workshops were presented in universities, craft centers, and conferences nationally. Her work was exhibited in galleries and museums including Hand and Spirit Gallery (AZ) and Contemporary Crafts Gallery (OR). She developed a distinctive form of figurative fabric sculptures, which were painted as if for the stage. Davis left a legacy of video workshops in color and dyeing; she helped establish textile surface design as an important area of study at Penland.

PAIGE DAVIS, iron
Bakersville, NC
b. 1953
Paige Davis has been working as an artist/metalsmith for thirty years, making both functional and sculptural metal art. She was the first woman to practice blacksmithing at Penland, which she began while studying metals in the 1970s. At Penland, she has been a student, core student, services coordinator, and instructor. She has taught at Penland, Haystack, and Peters Valley. Her recent commissions include a steel railing for Ridgeway Hall at Penland. Her work is published in *The Metal Craft Book* by Janice Kilby and Deborah Morgenthal (Lark Books, 2002) and *The Contemporary Blacksmith* by Dona Meilach (Schiffer Books, 2000). She exhibits her work regularly at Penland Gallery, Blue Spiral 1 (NC), and Folk Arts Center.

EINAR DE LA TORRE AND JAMEX DE LA TORRE, glass
San Diego, CA
Einar: b. 1963; Jamex: b. 1960
Brothers and artistic collaborators Jamex and Einar de la Torre were born in Guadalajara, Mexico. They both attended California State University/Long Beach, where Jamex earned a BFA in sculpture. They have taught at Penland, Haystack, UrbanGlass (NYC), RISD, Pratt Fine Arts Center (Seattle), and Pilchuck. Their work, both collaborative and individual, incorporates glass with a variety of media, frequently addressing political and social issues, and derives inspiration from the Catholic and folk art of Mexico. It has been exhibited in many West Coast and Mexican venues and at the Snyderman Gallery (Philadelphia), SOFA, Los Angeles County Museum of Art, and William Traver Gallery (Seattle). It is included in *Contemporary Glass: Color, Light and Form* (Guild Publishing, 2001).

JOHN DODD, wood
Canandaigua, NY
b. 1954
John Dodd has a BFA in woodworking and furniture design from RIT. Principally a studio artist, he has been an instructor for summer sessions and the part-time studies department at RIT and has taught at Penland and Conover School of Woodworking. His work, which is primarily commissions, has been shown at MAD, MMA, Philadelphia Museum Craft Show, Smithsonian Craft Show, and SOFA. He is profiled in *Profitable Woodworking; Turning Your Hobby Into a Profession* by Martin Edic (Taunton Press, 1996), and his work has been featured in *Fine Woodworking, Metropolis,* and *American Craft.*

FRITZ DREISBACH, glass
Seattle, WA
b. 1941
A former Penland resident artist, Fritz Dreisbach received an MA from University of IA and an MFA from University of WI/Madison. He has taught and lectured at over one hundred institutions including Pilchuck, Penland, and RISD. Dreisbach played a leading role in the founding of GAS. His fanciful and innovative goblet designs are often inspired by Venetian glass. His work is in the collections of MAD, Cooper-Hewitt, and Hsinchu Culture Center (Japan). He is a fellow of the ACC and was a part of Penland's Nifty Fifty in 1971.

DON DRUMM, metals
Akron, OH
b. 1934
Don Drumm has an MA from Kent State University (OH) and was artist-in-residence at Bowling Green State University (OH) for six years. He pioneered the use of cast aluminum as an art medium, creating everything from large sculpture and wall reliefs to functional craft objects. He also works in all-weathering steel, stainless steel, cement, and pewter. His work is represented on every continent of the world. He has completed major commissions for the United States Embassy in Tegucigalpa, Honduras; the Richard T. Gosser Memorial of Toledo, OH; the Art Center in Sarasota, FL; and Bowling Green State University (OH).

ROBERT EBENDORF, metals
Greenville, NC
b. 1938
After receiving an MFA from University of KS/Lawrence, Robert Ebendorf studied at the State School for Applied Art and Craft in Oslo, Norway with a Fulbright grant. A studio artist specializing in the use of found objects in jewelry, he is the Carol Grotnes Belk Distinguished Professor of Art at East Carolina University (NC). Ebendorf received a Louis Comfort Tiffany grant, an NEA grant, and is a fellow of the ACC. His work is featured in *Color on Metal* by Tim McCreight (Guild Publishing, 2001), *The Encyclopedia of Jewelry Making Techniques*, by Jinks McGrath (Running Press Book Publishers, 1995), and *The Penland School of Crafts Book of Jewelry Making*, edited by John Coyne (Bobbs-Merrill, 1975), and is in the collections of MAD, Wustum Museum, Brooklyn Museum, Cooper-Hewitt, and Metropolitan Museum.

STEPHEN DEE EDWARDS, glass
Alfred Station, NY
b. 1954
A professor of glass art at Alfred University in New York, Stephen Dee Edwards has an MFA from Illinois State University/Normal. Edwards's work grows out of his ongoing fascination with the forms, textures, and colors of the natural world. It is included in the collections of Renwick Gallery, Corning Museum, MMA, Musée des Arts Decoratifs (Switzerland), and Niijima Contemporary Glass Art Museum (Japan). He received two NEA grants, and has been president of the board of GAS.

CATHARINE ELLIS, fiber
Waynesville, NC
b. 1951
Catharine Ellis received a BA from Marymount College in Tarrytown, NY, and continued her education at Penland and Haystack. She teaches in the Professional Craft Program at Haywood Community College (NC). She also teaches at Penland, offers workshops at Convergence, and has been on the boards of Penland and HandMade in America. Her work has been exhibited in Canada, Korea, Chile, and the U.S. including Blue Spiral I (NC), Kansas City Art Institute, and SECCA. Ellis's work uses complex dyeing and weaving techniques to create woven imagery. She is the author of *Woven Shibori* (Bamboo Creek Press, 2001).

DANIEL ESSIG, books
Asheville, NC
b. 1967
A full-time studio artist making books which incorporate wood and metal as well as sculptures based on book structures using an array of materials and found objects, Daniel Essig has a BA in photography from Southern IL University/Carbondale with additional studies at University of IA Center for the Book and as a core student at Penland. He has taught at Penland, Campbell Folk School, North Country Studio Conference (VT), and Arrowmont. His work has been included in the traveling exhibition of the Woodturning Society and the Furniture Society and at Blue Spiral I (NC), Smithsonian Craft Show (DC), and the Philadelphia Museum Craft Show. He is featured in *Structure of the Visual Book* (Keith Smith Books, 2003) and other books by Keith Smith.

FRED FENSTER, metals
Sun Prairie, WI
b. 1934
Metalsmith Fred Fenster has an MFA from Cranbrook, and has taught at University of WI/Madison since 1961. In 1971 he was a part of Penland's Nifty Fifty. He has offered workshops at numerous colleges and at Penland, Pratt, Peters Valley, Interlochen Arts Camp (MI), Haystack, and Arrowmont. He received an NEA grant, the Hans Christensen Memorial Silversmithing Award, an Award of Excellence from the American Pewter Guild, and is a fellow of the ACC. Fenster is known for his original approach to utilitarian objects and for ceremonial items used in the Jewish tradition. His work is in the collections of Renwick Gallery, Milwaukee Art Institute, Detroit Art Institute, and Korean National Museum of Contemporary Art.

SHANE FERO, glass
Penland, NC
b. 1952
Flameworking glass artist Shane Fero served apprenticeships with Jerry and Lee Coker and Roger Smith and then pursued his craft at Penland and Pilchuck. He teaches regularly at Penland and is a frequent demonstrator for other classes. He has also taught at Corning Studio, UrbanGlass (NYC), Pilchuck, University of Michigan, Niijima Glass Art Center (Japan), and Bild-Werk Frauenau (Germany). His work, which features the vessel and the figure, has been the subject of more than a dozen solo shows and a thirty-year retrospective at University of MI. It is in the collections of Asheville Art Museum (NC), New Orleans Museum of Art, Glasmuseum Ebeltoft (Denmark), and Niijima Contemporary Glass Museum (Japan).

ARLINE FISCH, metals
San Diego, CA
b. 1931
Professor emerita from San Diego State University where she taught from 1961–2000, Arline Fisch has an MA from University of IL/Urbana with additional study at School of Arts and Crafts in Copenhagen. Fisch's work, which is well-known for innovative adaptations of textile techniques in metals, is included in the collections of Musée des Arts Decoratifs (Montreal), Renwick Gallery, MAD, Wustum Museum, Victoria and Albert, MFA Boston, and the Vatican. She is a fellow of the ACC and also received its gold medal. She received four NEA grants, two Fulbright grants for study in Denmark, and was declared a Living Treasure of California. She is the author of *Textile Techniques in Metals: For Jewelers, Textile Artists, and Sculptors* (Van Nostrand, 1975; revised by Lark Books, 1996).

ALIDA FISH, photography
Wilmington, DE
b. 1944
Photographer Alida Fish has an MA and an MFA from RIT. She is a professor of photography and coordinator of the photography program at the University of the Arts (Philadelphia). A former Penland core student, she has been a frequent instructor at Penland and at Haystack, Arrowmont, Peters Valley, and Anderson Ranch. Her recent work blends digital technology with traditional photographic techniques. Her work is included in the collection of Philadelphia Museum, DE Art Museum, and George Eastman House. She received an NEA grant, a DE State Arts Council grant, and an award from the Polaroid Corporation.

DEBRA FRASIER, books
Minneapolis, MN
b. 1953
Debra Frasier has a BA from FL State University and was a Penland resident artist. Frasier began her work as an artist in textiles, making sculptures which won several awards including an NEA Project Grant and the Prix de Paris, American Center, Sculpture Residency at the Cité des Arts (Paris). She is now an author and illustrator of books for children. She incorporates into these books her textile techniques, applying them to paper to create colorful illustrations. Her book *On the Day You Were Born,* (Harcourt Inc., 1991), won the Parent's Choice Gold Award. She served as creative consultant and director of animation for *On the Day You Were Born, The Symphony,* by the Minnesota Orchestra, which won the American Library Association Carnegie Award for Best Video for Children in 1997. Her other books include *Out of the Ocean* (Harcourt Brace & Co., 1998) and *Miss Alaineus, A Vocabulary of Disaster* (Harcourt, Inc., 2000).

TAGE FRID, wood
Middletown, RI
b. 1915
Tage Frid graduated from Copenhagen Technical School in 1934 as a master craftsman with honors in woodworking and furniture design. In 1985 he was named professor emeritus at RISD where he had been professor and department head of woodworking and design for twenty-three years. Before that he was professor and head of furniture and design at RIT. Frid is a fellow of the ACC and received an NEA grant, an honorary doctorate from RISD, the RI Governor's Award, and a Furniture Society award. His work is in the collections of Renwick Gallery and MFA Boston. He was a contributing editor of *Fine Woodworking,* and was the subject of a three-book series *Tage Frid Teaches Woodworking* (Taunton Press 1979, 1981, 1985).

SUSAN GANCH, metals
San Francisco, CA
b. 1970
A former Penland resident artist, Susan Ganch has an MFA from University of WI/Madison. She was an adjunct instructor at University of WI/Madison in 1998 and 1999. She has offered demonstrations and workshops at CCA, Penland, Ox-Bow (MI), San Francisco State College, and The Crucible (CA). Ganch makes sculptural body adornments which stretch the definition of jewelry and often incorporate complex mechanisms. Her work has been exhibited at Kohler Art Center, Gallery W.D.O. (NC), Gallery OXOXO (Baltimore), Steinbaum-Kraus Gallery (NYC), and *Transformations: Contemporary Work in Jewelry and Small Metals,* a traveling exhibit from Society of Contemporary Craft in Pittsburgh.

ARTHUR GONZALEZ, clay
Alameda, CA
b. 1954
Arthur Gonzalez has an MA from California State University at Sacramento and an MFA from University of CA/Davis. He is an associate professor at CCA and has taught at Penland, Haystack, and Mendocino Art Center (CA). He has had four NEA grants and is a recipient of the Virginia Groot Award. Gonzalez makes narrative paintings and figurative ceramic sculptures that include found materials and personal symbolism. His work has been exhibited at MMCD, John Elder Gallery (NYC), William Traver Gallery (Seattle), Kohler Art Center, SOFA, and Works Gallery (Philadelphia). He is the subject of the book *Arthur Gonzalez: At Heart Level* by Katherine Chapin (John Natsoulas Press, 1992) and is included in *American Ceramics: 1876 to the Present* by Garth Clark (Abbeville Press, 1988).

PETER GOURFAIN, clay and printmaking
Brooklyn, NY
b. 1934
Peter Gourfain received a BFA from Art Institute of Chicago. He teaches ceramic sculpture at Greenwich House Pottery (NYC) and has taught at Skowhegan School (ME), Cranbrook, LA State University, and Penland. His work, which is narrative, expressionist, and socially engaged, includes terra cotta reliefs, large scale urns, cast bronzes, woodcarvings, prints, and paintings. It is included in the collections of MAD, Guggenheim Museum (NYC), MOMA, and Brooklyn Museum (NYC). He has created large-scale commissions for NYC Department of Cultural Affairs, National Park Service in Lowell, MA, Cathedral of St. John the Divine (NYC), and Neuberger Museum (NY).

SILVIE GRANATELLI, clay
Floyd, VA
b. 1947
A studio potter, Silvie Granatelli has an MFA from Montana State University in Bozeman. She has taught at VA Tech Institute, Berea College (KY), and the extension programs of IL Institute of Technology (Chicago) and Northwestern University (IL). She has also offered workshops at numerous colleges and at Penland, Arrowmont, and 92nd Street Y. Her work is in the collections of Minneapolis Institute of Art, MMA, and Museum of Ceramic Art at Alfred (NY). As a maker of functional pottery, Granatelli is interested in the relationship between craft and the rituals of hospitality and dining. Her work is included in *The Art of Contemporary American Pottery* by Kevin A. Hluch (Krause Publications, 2001).

HOSS HALEY, iron
Asheville, NC
b. 1961
Former Penland resident artist Hoss Haley learned by doing during ten years of independent study and work experience. From 1984 to 1985, he worked at Iron Heart Forge with Joe Pehoski doing a broad range of architectural ironwork, and from 1985 to 1991 he worked with Tom Joyce Blacksmithing using hot forging techniques to create components for architectural ironwork. He also received an arts/industry residency at Kohler Arts Center. During his time in residence at Penland he was central to the design and planning of a new iron studio. He has taught frequently at Penland and Haystack. His sculpture, which explores the forms of industrial and agricultural structures as well as the human figure, has been exhibited at John Elder Gallery (NYC), Blue Spiral I (NC), Gallery W.D.O. (NC), SECCA, and SOFA.

TED HALLMAN, fiber
Lederach, PA
b. 1933
Ted Hallman has MFAs in textiles and painting from Cranbrook and a Ph.D. in educational psychology from University of CA/Berkeley. He taught at Ontario College of Art and Design in Toronto from 1975–1999 and for ten years of that time was head of textiles. Hallman has been at the vanguard of modern textile interpretation for more than thirty years, using a wide range of traditional and innovative materials and weave structures to comment on contemporary life. He designed textiles for Larsen Design Studios, Thabok Fabrics, and Deering Milliken (all in NY). His work has been exhibited at Brooklyn Museum, Snyderman Gallery (Philadelphia), SOFA, Victoria and Albert, Philadelphia Museum, and the ACC traveling exhibit *Objects USA*. He is a fellow of the ACC and was a part of Penland's Nifty Fifty in 1971.

AUDREY HANDLER, glass
Madison, WI
b. 1934
One of the first women to enter the studio glass field, Audrey Handler has an MS and an MFA from the University of WI/Madison. She first taught at Penland in 1971, and has also taught at Haystack, Archie Bray Foundation (MT), and Madison Area Technical College (MI). Her work has been exhibited at MAD, Renwick Gallery, and Metropolitan Museum, and is in the collections of Lobmeyr Museum (Austria), Corning Museum, and Wustum Museum. She received two NEA Master Craftsmen's Apprenticeship Program grants. She was a board member and a founding member of GAS and received its Honorary Life Membership Award. Handler creates still-life compositions in glass, frequently incorporating glass fruits and vegetables in various scales. She sees the objects in her work as both symbolic and narrative.

BOBBY HANSSON, metals
Rising Sun, MD
b. 1937
Bobby Hansson has been making sculpture, furniture, and musical instruments from found objects since 1955. He was also a photographer of sculpture and crafts for thirty years, during which time he was the principle photographer for catalogs produced by MAD, Metropolitan Museum, and Philadelphia Museum. His work has been shown at MAD, Renwick Gallery, and Oakland Museum (CA) plus many galleries and schools. He has been a teacher at Parsons and School of Visual Art (NYC), and he has taught workshops in tin can art at Penland, Arrowmont, Campbell Folk School, Haystack, Peters Valley, and Touchstone. He is the author of *The Fine Art of the Tin Can* (Lark Books, 1996).

DOUGLAS HARLING, metals
Greensboro, NC
b. 1959
Former Penland core student and resident artist Douglas Harling has an MFA from Southern IL University/Carbondale, and he studied as an exchange student at West Surrey College of Art and Design (U.K.). He teaches regularly at University of NC/Charlotte, and he received an SAF/NEA grant. A master of the technique of granulation, he has taught workshops at 92nd Street Y, Philadelphia College of Art, OCAC, and Appalachian Center for Crafts (TN). His classically styled jewelry has been exhibited at MMCD, Philadelphia Craft Show, and SOFA. It is included in the collection of MMCD and is featured in *Jewelry: Fundamentals of Metalsmithing*, by Tim McCreight (Brynmorgen Press, 1997).

WILLIAM HARPER, metals
New York, NY
b. 1944
William Harper received his MS degree from Case Western Reserve University (OH). He did advanced work in metals and enameling at Cleveland Institute of Art. He has taught at Penland, Kent State University (OH), Cleveland Institute of Art, and Parsons. He was on the faculty of FL State University where he was University Distinguished Research Professor when he left teaching in 1992. Although he is best-known for his enameled jewelry, he has also worked in painting, sculpture, mixed media on paper, and one-of-a-kind books. Harper's work is in the collections of Metropolitan Museum, MFA Boston, Cooper-Hewitt, and Victoria and Albert. His book *Enameling Step By Step,* (Western Publishing Company, Inc., 1973) was translated into four languages. He is the recipient of three NEA grants, a fellow of the ACC, and the recipient of a Master of the Medium Award from the James Renwick Alliance (DC).

JAMES HENKEL, photography
Minneapolis, MN
b. 1947
Studio artist and educator James Henkel has an MFA from FL State University. He has been teaching at University of MN since 1976 and has also taught at Penland. Henkel makes beautifully crafted black and white photographs with imagery he carefully assembles for the camera. His work is in the collections of San Francisco Museum of Modern Art, Whitney Museum (NYC), Walker Art Center (Minneapolis), and Minneapolis Institute of Art. He received an NEA grant, a McKnight Foundation Fellowship, and a Bush Foundation Artist Fellowship.

MARY LEE HU, metals
Seattle, WA
b. 1943
Mary Lee Hu has an MFA from Southern IL University/Carbondale. She is a professor at University of Washington and has lectured and presented workshops for universities, colleges, art schools, guilds, and museums throughout the U.S. and internationally. Using traditional textile techniques of weaving, twining, wrapping, and braiding, she transforms wire into body sculpture. Elected a fellow of the ACC in 1996, she received three NEA grants. Her work is in the collections of MAD, Renwick Gallery, MFA Boston, and Victoria and Albert.

MIYUKI IMAI, fiber
Penland, NC
b. 1968
Former Penland resident artist Miyuki Imai was born and raised in Japan. She has an MFA from AZ University in Tempe. Her exhibitions include Gallery Materia (AZ), Blue Spiral I (NC), Center for Craft, Creativity and Design (NC), a solo exhibition at Green Hill Center for North Carolina Art, and a benefit auction organized by the James Renwick Gallery Alliance (DC). Imai maintains an inventory of collected natural materials which she incorporates into elaborately stitched textile pieces reflecting her experience and observations of her immediate environment. She has had work published in *FiberArts* and *American Craft.*

SERGEI ISUPOV, clay
Louisville, KY
b. 1963
Born in Russia, Sergei Isupov was educated at Ukrainian State Art School in Kiev and Art Institute of Tallinn where he earned an MFA. He creates fantastical porcelain figures which are elaborately painted with narrative imagery. Isupov had solo exhibitions in Finland and Sweden and has exhibited at Wustum Museum, The Clay Studio (Philadelphia) and SOFA. His work was included in *From Dreams to Reality, Northern European Art,* traveling to the Baltics, Sweden, Finland, Norway, and Denmark. He has presented workshops and lectures at Penland, Greenwich House Pottery (NYC), Renwick Gallery, and Tyler School of Arts (Philadelphia). He is one of the featured artists in *The Penland Book of Ceramics: Master Classes in Ceramic Techniques* edited by Deborah Morgenthal and Suzanne Tourtilott (Lark Books, 2003).

MARY JACKSON, fiber
Charleston, SC
b. 1945
Mary Jackson began learning to make coiled sweetgrass baskets when she was four years old; the tradition was passed to her from her mother and grandmother. Today, she uses the technique to make designs and forms that were not previously part of this tradition. She received a Lifetime Achievement in Craft award from the National Museum of Women in the Arts (DC). Her baskets have been widely exhibited including MAD, Renwick Gallery, African American Museum of Fine Arts (San Diego), Museum of African American Life and Culture (Dallas), Gibbes Museum of Art (SC), Columbia Museum of Art (SC), Craft Alliance (St. Louis), Decorative Arts Museum (AK), Flint Institute of Art (MI), and Palazzo Venezia Museum (Rome).

JUDY JENSEN, glass
Austin, TX
b. 1953
Judy Jensen's color-saturated reverse paintings on glass are characterized by precise draftsmanship and trompe l'oeil imagery. A self-taught studio artist, her paintings have been featured in numerous solo exhibitions at Heller Gallery (NYC). International exhibitions include the Eighth New Delhi Triennale (India), Hokkaido Museum of Modern Art (Japan), and museums and galleries in Switzerland, Germany, Asia, and Australia. She has taught at Penland, Corning Studio, and Pilchuck. She received an NEA grant and has work in the collections of The Royal Ontario Museum, The Los Angeles County Museum of Art, Corning Museum and The Racine Art Museum (WI).

MARVIN JENSEN, metals
Penland, NC
b. 1945
A metalsmith specializing in the traditional Japanese layered metal technique called mokume-gane, Marvin Jensen has an MFA from Southern IL University/Carbondale. He has taught at Purdue University (IN) and RIT, and has lectured and given workshops at many universities in hollowware, anodizing, and mokume-gane. He was an assistant to the director of Penland for two years and studio and program coordinator for the metals, iron, and sculpture studios for eight years. He now works as a metalsmith, machinist, and a designer of wood and metal furniture. Jensen has been in more than seventy-five invitational and competitive exhibitions, including NC Museum of Art, SECCA, MMA, and the *Contemporary Aluminum Invitational* at Southern OR University. His work is included in the collections of RISD and MMCD.

C. R. "SKIP" JOHNSON, wood
Stoughton, WI
b. 1928
Professor Emeritus of Art from University of WI/Madison, Skip Johnson has an MFA from RIT. A former Penland resident artist, he has taught at Penland frequently since 1963. He has also given workshops at Haystack, Minneapolis Institute of Art, RIT, and other schools. Johnson's woodwork includes frequently whimsical furniture, musical

instruments, toys, and inventions. His work has been shown in more than 150 exhibitions. It is in many private collections and has been featured in *A Gallery of Turned Objects,* by LeCoff Hanson (Brigham Young Press, 1981), *The Art of the Lathe* (Sterling/Chapelle, 1996), and *Woodturning in North America* (Wood Turning Center, 2001). He received an NEA grant and was part of Penland's Nifty Fifty in 1971.

RICHARD JOLLEY, glass
Knoxville, TN
b. 1952
Glass artist Richard Jolley has a BFA from Peabody College of Vanderbilt University (TN) and continued his study of glass at Penland. He has taught workshops and lectured at Penland, MMA, Hunter Museum of Art (TN), University of Kansas in Lawrence, Tokyo Institute of Art (Japan), Renwick Gallery, and CCA. He has been an artist-in-residence at University of Sydney (Australia), Galeria Angela Hollings (Germany), and was part of a cultural artist exchange in Israel. Jolley says of his figurative and narrative glass sculpture: "There is a classical/modern link in my work just as glass is a modern material with an ancient history." He is represented in the collections of MAD, Glasmuseum Ebeltoft (Denmark), Hokkaido Museum of Modern Art (Japan), Los Angeles County Museum of Modern Art, MMCD, and Renwick Gallery.

KENNETH KERSLAKE, printmaking
Gainesville, FL
b. 1930
Kenneth Kerslake is a Distinguished Service Professor Emeritus of University of FL. He has an MFA from University of IL/Champaign. Kerslake is conversant with many forms of printmaking and digital imaging and frequently combines several processes in a single piece. His work is in the collections of High Museum, MFA Boston, SECCA, Seattle Museum of Art, and Portland Museum of Art (OR). He has served as President of Southern Graphics Council (1990–1992) and received the Joseph Pennell Fund Selection Committee Purchase Award, Library of Congress (DC). He has been an artist-in-residence and lecturer at universities and art centers throughout the country and has taught at Penland, Arrowmont, and in University of GA's summer program in Cortona, Italy.

KATHY KING, clay
Decatur, GA
b. 1968
Kathy King completed her MFA at University of FL. Currently assistant professor at GA State University, she has taught at CT College and the School of MFA Boston. She has given workshops in ceramics at Penland, Cleveland Institute of Art, and MA College of Art. King makes functional, sculptural, and installation work using the sgrafitto decoration technique to incorporate text with personal and political imagery. She has exhibited her work in a solo show at Erie Art Museum (PA) and in group exhibitions at Blue Spiral I (NC), Museum of Contemporary Art of Georgia (Atlanta), and at the World Ceramic Exposition 2001 in Korea. Her work has been published in *Ceramics Monthly* and *The Art of Contemporary American Pottery* by Kevin A. Hluch (Krause Publications, 2001).

BRENT KINGTON, iron
Makanda, IL
b. 1934
Professor emeritus Brent Kington retired from Southern IL University/Carbondale in 1997 after thirty-six years on the faculty and serving as director of the School of Art and Design from 1981 to 1992. There he helped introduce blacksmithing into contemporary metal-

smithing. In 2003 SIU honored him by naming the blacksmithing facility the L. Brent Kington Smithy. He taught the first Penland forging class in 1980 and has taught there many times since. He was also a founding member of SNAG and served as its first official president. He received an MFA from Cranbrook. His steel sculptures incorporate symbolic objects and shapes such as the spire, axis, and crescent. His work is in the collections of Renwick Gallery, MMCD, National Museum of Art (DC), and MAD. He is a fellow of the ACC and received its gold medal. He also received two NEA grants and was one of Penland's Nifty Fifty in 1971.

RUDY KOVACS, fiber
Pocatello, ID
b. 1950
Rudy Kovacs has been a professor of art at ID State University since 1980 and was selected Distinguished Researcher recipient in 1991. He has an MFA from University of KS/Lawrence. He views his work as a visual journey of places, feelings, and spirit. His recent work uses jacquard looms in combination with digitized photographs to create representational woven imagery. Kovacs has exhibited frequently including Pittsburgh Center for the Arts (PA), Wichita Center for the Arts, and OCAC. He taught at Penland for many years and served as the fiber studio director under Bill Brown. He also taught at Peters Valley and Appalachian Center for Crafts (TN). He was awarded two fellowships from the ID Commission on the Arts.

ROB LEVIN, glass
Burnsville, NC
b. 1948
Rob Levin has an MFA from Southern IL University/Carbondale with additional study at Penland. He has taught at RIT and New Zealand's Wanganui College. A Penland resident artist in glass from 1976–1980, Levin is a frequent instructor and visiting artist at Penland and he served on the board and on the glass studio planning committee. Levin works with organic shapes, a strong color vocabulary, and close attention to surface texture to create functional and sculptural work. His work is in the collections of Corning Museum, Glasmuseum Ebeltoft (Denmark), Glasmuseum Frauenau (Germany), MMA, and Wustum Museum. It has been published in *Contemporary Glass,* by Susanne Frantz (Corning Museum of Glass, 1989) and *Contemporary Glass: Color, Light and Form* by Leier, Peters and Wallace (Guild Publishing, 2001).

WALTER LIEBERMAN, glass
Seattle, WA
b. 1954
Studio glass artist Walter Lieberman received a BFA from MA College of Art. He has taught frequently at Penland and Pilchuck. He is known for his classical painting style, which he applies in reverse to flat glass and blown glass objects. Among his solo exhibitions are William Traver Gallery (Seattle) and Heller Gallery (NYC); group exhibitions include Riley Hawk Gallery (Cleveland), Snyderman Gallery (Philadelphia), Metropolitan Museum, and Victoria and Albert. His work is in the collections of Glasmuseum Frauenau (Germany) and Corning Museum and is included in *Contemporary Glass: Color, Light and Form* by Leier, Peters and Wallace (Guild Publishing, 2001) and *Out of the Fire* by Bonnie Miller (Chronicle Books, 1991).

HARVEY K. LITTLETON, glass
Spruce Pine, NC
b. 1922
Harvey K. Littleton is the son of a Corning Glass Works physicist and grew up in the world of glass. He has an MFA from Cranbrook. He began teaching ceramics as the University of WI/Madison in 1951 and was named

Professor Emeritus in 1977. Known as the father of the studio glass movement, he established the hot glass program at Madison in 1962. In 1964, he sent his student Bill Boysen to assist Bill Brown in establishing a hot glass program at Penland. His interest in glass led him to explore using glass plate printing (vitreographs), and he has collaborated with many craft and visual artists to create limited-edition vitreographs. He is a fellow of the ACC and a recipient of its gold medal. He received honorary doctorates from University of the Arts (Philadelphia), RISD, and University of WI/Madison, and he received the North Carolina Award. His works are in the collections of Cooper-Hewitt, MAD, Corning Museum, Metropolitan Museum, Toledo Museum of Art (OH), Renwick Gallery, Victoria and Albert, and Gronigen Museum (Holland). He has been a Penland trustee.

DEBORAH LUSTER, photography
Monroe, LA
b. 1951
Photographer Deborah Luster's education was largely self-directed, including many workshops with instructors whose aesthetics and techniques were important to her. Her work has won many awards including the Anonymous Was a Woman Award, the John Gutman Photography Fellowship, the Bucksbaum Family Award for American Photography, and (with C.D. Wright) the Dorothea Lange-Paul Taylor Prize from the Center for Documentary Studies at Duke University. Her work is in the collections of Museum of Fine Arts, Houston, National Archives (Washington), and MMA. A monograph with text by C.D. Wright entitled *One Big Self; Prisoners of Louisiana* (Twin Palms Press, 2003) documents her work photographing prisoners.

WARREN MACKENZIE, clay
Stillwater, MN
b. 1924
Regents Professor Emeritus Warren MacKenzie was on the faculty of University of Minnesota from 1953 until his retirement in 1990. He was chair of the department of studio arts from 1981–1985. A master of functional, wood-fired stoneware, he graduated from Art Institute of Chicago and then apprenticed to Bernard Leach from 1949–1952. His work is in the collections of Brooklyn Museum, Metropolitan Museum, Victoria and Albert, Smithsonian, and Minneapolis Institute of Arts. He has taught in the U.S., England, Norway, Venezuela, Chile, Canada, Denmark and Japan. He is a fellow of the ACC and was awarded its gold medal. He received an honorary doctorate from Macalester College (MN) and a McKnight Foundation Distinguished Artist Award. MacKenzie is the subject of the book *Warren MacKenzie: An American Potter* by David Lewis (Kodansha Publishing, 1991).

SAM MALOOF, wood
Alta Loma, CA
b. 1916
A self-taught designer and woodworker, Sam Maloof took only one woodworking class, in high school, which he failed because he could not afford the materials. He worked for a time in the office of a Bauhaus-trained industrial designer where he did architectural drafting. Since then he has made everything by commission, producing fifty pieces annually. Most famous for his rocking chairs, he believes that the designer should also be the maker. He was a frequent instructor and visiting scholar at Penland from 1970–1988 and helped build the wood program both by his presence and his counsel. A fellow of the ACC and a recipient of its gold medal, Maloof has won many awards including an honorary doctorate from RISD. His work is in the collections of ACC, The White House Craft Collection, and Metropolitan Museum.

RICHARD MARGOLIS, photography
Rochester, NY
b. 1943
Photographer Richard Margolis has an MFA from RIT. He has a particular interest in bridges and his work includes a series of photographs of bridges in the Penland area. Margolis has taught at Nazareth College (NY), Community College of the Finger Lakes (NY), and SUNY/Brockport. His work is in the collections of High Museum, MOMA, Rochester International Airport, Library of Congress (DC), Polaroid Collection (MA), and Victoria and Albert. He has been featured in *Bridges* by Judith Dupre (Black Dog & Leventhal Press. 1999) and *Contemporary Photographers, 3rd Edition,* edited by Martin M. Evans (St. James Press, 1995).

PAUL MARIONI, glass
Seattle, WA
b. 1941
Studio glass artist Paul Marioni has a BA from University of Cincinnati. He taught at San Francisco State University, CCA, and San Francisco Art Institute. He has taught regularly at Penland and Pilchuck. He received three NEA grants, he is a fellow of the ACC and the recipient of the Lifetime Achievement Award from GAS. His work is exhibited internationally including William Traver Gallery (Seattle), SOFA, and Renwick Gallery. Marioni was a pioneer in the use of cast and blown glass in architectural applications. He specializes in architectural commissions and has work in the collections of Smithsonian, MAD, Oakland Art Museum, and Glasmuseum Frauenau (Germany).

RICHARD MARQUIS, glass
Whitby Island, WA
b. 1945
Richard Marquis has an MFA from University of CA/Berkeley with additional studies in Venice, Italy supported by a Fulbright grant. He was one of the first American glass artists to study traditional Italian techniques which he then shared with studio glassblowers throughout the world. He is admired for his sophisticated understanding of color and form and his original approach to the Italian murrine technique. His work is in the collections of MAD, American Glass Museum (NJ), Renwick Gallery, Corning Museum, and Philadelphia Museum. A fellow of the ACC, he was awarded four NEA grants and two Fulbright-Hays fellowships, and he received an award for outstanding achievement in glass from UrbanGlass (NYC).

RICHARD MAWDSLEY, metals
Carterville, IL
b. 1945
Richard Mawdsley received an MFA from University of Kansas in Lawrence. He is currently on the faculty of Southern IL University. Mawdsley's recent work is a series of ornate vessels inspired by the water towers of the mid-American prairie. Exhibitions include Villa Croce, Museum of Contemporary Art (Genoa, Italy), Kunstgewerbermuseum (Berlin), and DESIGNyard Gallery (Dublin). His work is in the collections of MFA Boston, MAD, Renwick Gallery, and Detroit Institute of Arts. He received two NEA grants and is a fellow of the ACC.

BEVERLY MCIVER, painting
Chandler, AZ and New York, NY
b. 1962
Beverly McIver has an MFA from PA State University. She is an associate professor at AZ State University and has taught at NC Central University, Duke University (NC), and NC State University. She received

a Guggenheim Fellowship, a Creative Capital Grant and the Anonymous Was a Woman Award. In addition to teaching at Penland, she has had residencies at Headlands Center for the Arts (CA), Yaddo (NY), and Djerassi Artist Colony (CA). For years she has painted self-portraits which explore issues of race, class, and identity, and use a bold and expressive color palette. She has had solo exhibitions at Lew Allen Contemporary Gallery (Santa Fe), Scottsdale Museum of Contemporary Art (AZ) and Artemisia Gallery (Chicago) and is currently represented by Kent Gallery (NYC). She is a Penland trustee.

KEISUKE MIZUNO, clay
St. Cloud, MN
b. 1969
Keisuke Mizuno has an MFA from AZ State University in Tempe with additional study at KS City Art Institute (MO). He is an assistant professor of art at St. Cloud State University (MN). Mizuno's porcelain sculptures are small, elaborately detailed studies of plants, flowers, and fruits, frequently in some stage of decay. These tableaux are narrative and contain personal symbolism. He has had several solo exhibitions including Works Gallery (Philadelphia) and Joanne Rapp Gallery (AZ). His work has been included in group exhibitions in Korea, Japan and the U.S., and is in the collections of Renwick Gallery and MMCD.

CLARENCE MORGAN, painting
Minneapolis, MN
b. 1950
Painter Clarence Morgan has an MFA from University of PA. He is a professor of art at University of MN. Before that he was on the faculty of East Carolina University (NC) and has taught at Anderson Ranch and Penland, where he also served on the board of trustees for eight years. Morgan's nonrepresentational paintings explore pattern, rhythm, color, process, gesture, and physicality. He has had more than forty solo exhibitions and his work is in the collections of New York Public Library, Frederick R. Weisman Art Museum at University of MN, and Walker Art Center (Minneapolis). Morgan received a McKnight Fellowship, a Bush Foundation Fellowship, and an SAF/NEA Fellowship.

BEA NETTLES, photography
Urbana, IL
b. 1946
Bea Nettles is an experimental photographic artist. As an educator she has been a tireless promoter of alternative and nonsilver photographic processes. Her work is in the collections of MOMA, Metropolitan Museum, George Eastman House, and Center for Creative Photography (Tucson). She received two NEA Fellowships, and grants from the NY and IL state arts councils. She is the author of the classic textbook, *Breaking the Rules: A Photo Media Cookbook* (Inky Press Productions, 1987). She has also been featured in history texts including *The History of Photography: An Overview,* by Alma Davenport (U.N.M. Press, 1999) and *A History of Women Photographers,* by Naomi Rosenblum (Abbeville Press, 1994).

GARY NOFFKE, metals
Farmington, GA
b. 1943
Gary Noffke has an MFA from Southern IL University/Carbondale. He was chairman of metals at University of GA for twenty years and was named professor emeritus in 1991. For six summers he was on the faculty of the university's summer program in Cortona, Italy. Noffke is a master metalsmith who creates animated functional work using his own specially devised gold and silver alloys. He was the subject of a retrospective exhibit at Kohler Arts Center in 1991, and his work is in the

collections of MMA, National Ornamental Metals Museum (Memphis) and Kohler Arts Center. He received an NEA Fellowship and an arts/industry residency at Kohler Arts Center.

BETTY OLIVER, paper, mixed-media
1939–2000
Betty Oliver was a fiber and paper artist and a poet who lived and worked in New York City. She had a BA in Radio, Television and Motion Pictures from University of NC/Chapel Hill and worked professionally in video production. Oliver was an inspiring and often theatrical teacher who could make art from almost any material that presented itself. She taught workshops in sculptural paper at Penland and Haystack. Her work has been exhibited at Courtyard Gallery (NY), OXOXO Gallery (Baltimore), Duke University (NC), Rockland Center for the Arts (NY), and in the traveling exhibition, *Art in Craft Media: The Haystack Tradition,* and was featured in the book *The Fine Art of the Tin Can,* by Bobby Hansson (Lark Books, 1996). She frequently read her poetry at Penland and at venues in NYC.

JANE PEISER, clay
Penland, NC
b. 1932
Jane Peiser has an MA in art education from IL Institute of Technology in Chicago. She is self-taught in pottery with a little help from her friends. She has taught workshops at Penland, Archie Bray Foundation (MT), OCAC, Parsons, and Hawaii Arts and Crafts (Honolulu). Peiser's adaptation of the traditional glass techniques of murrine and millefiore allow her to create hand-built ceramic pieces which have imagery and pattern incorporated into the clay. She is represented in the public collections of MMA, Smithsonian, Greenville Art Museum (SC) and the private collection of Joan Mondale. She has contributed to *The Penland School of Crafts Book of Pottery,* edited by John Coyne (Bobbs-Merrill, 1975) and *Salt Glazed Ceramics* by Jack Troy (Watson Guptill Publications, Inc., 1977). She received two NEA grants. She lives in the Penland community, has an open house for students each session, and was a Penland trustee.

MARK PEISER, glass
Penland, NC
b. 1938
Trained as an electrical engineer at Purdue University (IN), Mark Peiser received a BS degree in product design from IL Institute of Technology (Chicago) and studied music at DePaul University (Chicago). In 1967, he became the first glass resident at Penland. In 1971, Peiser was instrumental in the first meetings of GAS. A recipient of grants from NEA and the Louis Comfort Tiffany Foundation, he has taught at Pilchuck, Penland, Haystack, RIT and Alfred. For many years Peiser made vessels which used imagery from nature and incorporated torchworked drawing into his vessels. Since 1981, he has produced glass sculpture through casting and coldworking. He is a fellow of the ACC. His work is in collections of Art Institute of Chicago, Cooper-Hewitt, Corning Museum, Detroit Institute of Arts, Glasmuseum Ebeltoft (Denmark), Hokkaido Museum of Modern Art (Japan), MMA, and Toledo Museum of Art (OH).

FLOSS PERISHO, fiber
1909–2001
Floss Perisho was born near Penland School, and worked in the Weaving Cabin for Penland's founder Lucy Morgan. She was part of the life of the school as a teacher, a neighbor and a craft artist making candles and corn shuck dolls. From 1952–1985 she taught such varied classes as non-fired pottery, lampshade-making, graphic design, painting, surface design, and folk arts. She was also a member of SHHG. From 1972 until her death in

2001, she lived in a house by the side of the road in Penland and provided a place and an opportunity for scores of Penland students, residents and instructors to share ideas and laughs around her dining table.

MARC PETROVIC AND KARI RUSSELL-POOL, glass
Centerbrook, CT
b. 1967 (both)
Marc Petrovic and Kari Russell-Pool's collaborative work combines the highest level of craftsmanship in blown and flameworked glass with a love of classical form. They also produce very different work independently. They each earned a BFA from Cleveland Institute of Art (OH). Together they have taught at Penland, RISD, Cleveland Institute of Art, Corning Studio and were visiting artists at Toyama Institute of Glass (Japan). Their collaborative work has been exhibited at Heller Gallery (NYC) and Riley Hawk Gallery (OH), and is in the collections of MMA and Tucson Museum of Art (AZ). Petrovic's work has been published in American Craft. Russell-Pool's work is included in *The Artful Teapot* by Garth Clark (Watson Guptill Publications, Inc., 2001), *Contemporary Glass; Color, Light and Form* by Leir, Peters & Wallace (Guild Publishing, 2001), and *Teapots Transformed* by Leslie Ferrin (Guild Publishing, 2000).

JOHN PFAHL, photography
Buffalo, NY
b. 1939
Photographer John Pfahl received two NEA grants and was awarded an honorary doctorate from Niagara University (NY). He has created a body of work which introduces incongruous elements into the landscape in ways that create surprising compositions which are dependent on the exact placement and perspective of the camera. His work has been published in many monographs and portfolios including *Altered Landscapes: The Photographs of John Pfahl,* a portfolio of forty-eight dye transfer prints in an edition of one hundred (RFG Publishing Inc. 1982). His photographs are in the collections of George Eastman House, Whitney Museum (NYC), National Gallery of Art (DC), Library of Congress (DC), Bibliothéque Nationale (Paris) and Victoria and Albert.

JASON POLLEN, fiber
Kansas City, MO
b. 1941
Jason Pollen has an MFA from City College of NY. He is a professor of art at Kansas City Art Institute (MO) where he has been chair of the fiber department since 1997. He also taught at Parsons, Pratt, Royal College of Art (London), Penland, Mendocino Arts Center (CA), and OCAC. Pollen uses highly evolved applications of surface design techniques to create visual compositions on cloth. His work has been exhibited in Germany, Poland, Japan, and in many U.S. museums and galleries including Snyderman Gallery in Philadelphia and a solo exhibit in Wichita Art Center (Kansas). His work has been featured in *Surface Design Journal, FiberArts, American Craft* and in *Art Textiles of the World* by Matthew Koumis (Telos Art Publishing, 2000).

SALLY PRASCH, glass
Montague, MA
b. 1957
Sally Prasch began her career in glass at an early age, working as an apprentice at University of NE and later as an instructor for the City of Lincoln Recreation Department. She has a BFA from University of KS and an associate degree in applied science and a certificate in scientific glass technology from Salem College (NJ). From 1986–1995, she was a scientific glassblower and glass instructor at University of MA. She has also taught at Niijima Glass Art Center (Japan), Pilchuck, Corning Studio, UrbanGlass (NYC), Snow Farm (MA), Worcester Center for Crafts (MA). Her work is characterized by a combination of the technical skills of scientific flameworking and a strong art aesthetic and often incorporates electrified gases. Her work is in the collection of the Corning Museum and is published in *International Glass Art* by Richard Wilfred Yelle (Shiffer Publishing, 2003).

MICHAEL PURYEAR, wood
New York, NY
b. 1944
Michael Puryear has a BA in anthropology from Howard University (DC) and is a self-taught furniture maker. He began as a carpenter, contractor, and cabinetmaker and now runs his own studio, producing elegantly designed, beautifully crafted, one-of-a-kind furniture pieces. He has taught at Penland, Anderson Ranch, Parsons, and Center for Furniture Craftsmanship (ME). His work has been exhibited at MAD, Philadelphia Furniture Show, SOFA, and Smithsonian Craft Show (DC). He has been featured in *Furniture & Accessories* (The Guild, 1998) and *Fine Woodworking Design Book Seven* (Taunton Press, 1996). His work is in several collections including Cooper-Hewitt and he was featured on HGTV's Modern Masters series.

DOUGLASS RANKIN AND WILL RUGGLES, clay
Bakersville, NC
Douglass: b. 1948, Will: b. 1956
The educations of Douglass Rankin and Will Ruggles converged when they were introduced to folk pots by Warren MacKenzie in 1975, and through apprenticeships with Randy Johnson in 1977–1978. Rankin received a BA in botany from Duke University (NC). Ruggles studied pottery at Grand Valley State College (MI), Chinese art and civilization at Dung Chou University (Taiwan), and Southeast Asian art and civilization through Chiang Mai University (Thailand). They have taught at Haystack, Peters Valley, and Penland. Their pots are in the collections of NC Museum of History, International Museum of Ceramic Art at Alfred (NY), and Gallery of Art & Design at NC State University. Their pottery, kiln designs, and firing techniques have been documented in *Studio Potter, The Logbook, Wood-Fired Stoneware and Porcelain* by Jack Troy (Chilton Books) and *Wood-Fired Ceramics, Contemporary Practices* by Minogue and Sanderson (University of Pennsylvania Press, 2000).

BRIAN RANSOM, clay
St. Petersburg, FL
b. 1954
Musician, ceramist, and anthropologist Brian Ransom has managed to combine all three fields in his work as a studio potter. He has an MFA in ceramics and anthropology from University of Tulsa (OK) and an MFA in sculpture from Claremont Graduate School (CA). Since 1995 he has been an assistant professor of art at Eckerd College (FL). His work is in many collections including Everson Museum of Art (NY), and Alfred University Museum (NY). Using instruments he has made, he performed with Ballet Pacifica in Los Angeles, and at New Music America in Philadelphia, and has made several recordings. He received an NEA grant and a Fulbright/Hays fellowship for research in Peru.

DON REITZ, clay
Clarksdale, AZ
b. 1929
Don Reitz has an MFA from Alfred. He was on the faculty of University of WI at Madison from 1962 to 1988 and was named professor emeritus when he retired. One of the most influential figures in contemporary ceramics, Reitz started a renaissance of the ancient technique of salt-glazing in the 1960s and 1970s. Now known for his wood-firing, he produces large-scale pieces which exhibit a passion for the material.

His work is included in the collections of Renwick Gallery, MMA, and Milwaukee Museum of Art. He is a recipient of an NEA fellowship, he is a fellow of the World Craft Council and a fellow of the ACC which also awarded him its gold medal. During the 1960s and 1970s he was a frequent instructor and visiting scholar at Penland and was a part of the Nifty Fifty in 1971.

RICHARD RITTER, glass
Bakersville, NC
b. 1940
After attending College for Creative Studies (CCS) in Detroit from 1959 to 1962, Richard Ritter worked as an illustrator for five years, then began to teach at CCS where he also took classes in glass and metalworking. In 1971, he enrolled in a Penland glass class taught by Mark Peiser and stayed on to study with Richard Marquis. He was a Penland resident artist from 1973–1977 and subsequently settled in the area and has taught at Penland many times. In 2000, he was honored with thirty-year retrospectives at Christian Brothers University (TN) and University of MI/Dearborn. He received an honorary doctorate from CCS and an NEA grant. Ritter's complex and brightly colored work is characterized by embedded imagery created through extensive use of the murrine technique. It is in the collections of MAD, Corning Museum, High Museum, MMA, Wustum Museum, Los Angeles County Museum of Art, and The White House Craft Collection. Ritter contributed extensively to the design and equipping of Penland's new glass studio in 1995.

HOLLY ROBERTS, photography
Corrales, NM
b. 1951
Holly Roberts has an MFA from Arizona State University. Roberts works with oil paint on the surface of black and white photographs which she refers to as a "canvas with a history." By revealing only fragments of the photograph she creates tension between the photographic and painted imagery. Her work is in the collections of Art Institute of Chicago, CA Museum of Photography, Center for Creative Photography (AZ), Los Angeles County Museum of Contemporary Art, and San Francisco Museum of Modern Art. She received two NEA grants and her work has been published in the monograph *Holly Roberts: Works 1989 to 1999* (Nazraeli Press, 2000).

MARY ROEHM, clay
New Paltz, NY
b. 1951
Studio potter and educator Mary Roehm received an MFA from RIT. She has been a professor of art at SUNY/New Paltz since 1991. She has taught at Penland, worked as a consultant and crafts coordinator at Artpark (NY), and served as artistic director and executive director for Pewabic Pottery (Detroit). Her work appears in the collections of Renwick Gallery, Detroit Institute of Art, and Museum of the Shigaraki Ceramic Cultural Park (Japan). Roehm has been the recipient of fellowships from the NEA and the NY State Council for the Arts, as well as Research and Creative Project Grants from SUNY/New Paltz.

EMILIO SANTINI, glass
Williamsburg, VA
b. 1955
Born into a family with a tradition of glassblowing in Murano, Italy, Emilio Santini studied the techniques of Venetian glass with glass masters Giacinto Cadamuro and Mario Santini (his father), and with the painter Renato Borsato. Santini makes delicate, figurative work in flameworked glass and in cast glass with flameworked inclusions. His work is in the collections of Museo di Arte Contemporanea Ca'Persaro (Venice),

Sheffield Museum (England), and Corning Museum. In addition to teaching frequently at Penland, he has also taught at Corning Studio, Pilchuck, RIT, and Virginia Commonwealth University.

MARY ANN SCHERR, metals
Raleigh, NC
b. 1921
Internationally recognized for her research and development of body monitors, Mary Ann Scherr pioneered the use of exotic metals as media for personal adornment and small-scale objects. She was trained at Cleveland Institute of Art, University of Akron (OH), Kent State University (OH) and The New School (NY). She teaches at Duke University (NC) and Meredith College (NC) and she was formerly the head of product design at Parsons. Scherr has been a major presence in the Penland metals program, having taught at Penland thirty-five times since 1968. She was also part of Penland's Nifty Fifty in 1971. Her work is in the collections of The Vatican, Metropolitan Museum, MAD, Smithsonian, and Renwick Gallery. She was awarded an honorary doctorate from Defiance College (OH), a lifetime achievement award from National Museum of Women in the Arts (DC), and she is a fellow of the ACC.

NORMAN SCHULMAN, clay
Penland, NC
b. 1924
Norman Schulman retired in 1984 from his last teaching position as head of ceramics at OH State University in Columbus. Prior to that he had been on the faculty of Toledo Museum of Art (OH) and was head of ceramics and glass and a professor at RISD from 1965–1977. He has an MFA from Alfred. Schulman's work has ranged from purely functional to purely sculptural, using an array of ceramic materials and techniques. He is a charter member, life member, and past president of NCECA and a fellow of the ACC. His work is in the collections of MAD, MMA, MMCD, J.B. Speed Museum (KY), Butler Museum of American Art (OH), and Renwick Gallery. He has been a Penland resident artist, a trustee, and was part of the Nifty Fifty in 1971.

JOYCE J. SCOTT, fiber, mixed-media
Baltimore, MD
b. 1948
Visual and performance artist Joyce J. Scott is a descendant of African-Americans, Scots, and Native Americans and is part of a long line of artists, potters, blacksmiths, quiltmakers and storytellers. She received an MFA from Instituto Allende (Mexico). Her work is in the collections of MAD, Baltimore Museum of Art, Wustum Museum, Detroit Institute of Arts, MMA, Philadelphia Museum, and Renwick Gallery and toured in a thrity-year retrospective titled *Joyce Scott: Kicking it With the Old Masters,* organized by Baltimore Museum of Art. She is the recipient of an NEA grant, a Louis Comfort Tiffany grant, the Anonymous Was a Woman award, and she is a fellow of the ACC. She has also been the writer and performer of a number of theatrical productions.

HEIKKI SEPPÄ, metals
Bainbridge Island, WA
b. 1927
Born in Finland, Heikki Seppä studied at the Goldsmith School and the Central School of Industrial Arts, both in Helsinki. He describes his education as that of a journeyman, which was furthered by professional training at Georg Jensen Silversmiths in Copenhagen. From 1965 until he retired as professor emeritus in 1992, he was on the faculty of Washington University (St. Louis). He received an NEA grant and is a fellow of the ACC. Seppä's work includes jewelry, hollowware, and sculp-

ture. As a teacher, he brought important European techniques to American metalsmithing. His work is in the collections of Renwick Gallery, Evansville Museum of Science, and Industry (IN) and a number of universities. He is the author of the first silversmithing book in Finnish and *Form Emphasis for Metalsmiths* (Kent State University Press, 1978).

MICHAEL SHERRILL, clay
Hendersonville, NC
b. 1954
Studio artist Michael Sherrill, who is mostly self-taught, says that the craft community associated with Penland, SHCG, and Arrowmont has been the primary influence in his work. He has taught workshops at 92nd Street Y, Pratt, Haywood Technical College (NC), Arrowmont, Penland and a number of universities. Sherrill's current work consists of oversized interpretations of botanical forms which feature complex, abraded surfaces. His work has been the subject of many solo exhibitions including Blue Spiral I (NC) and MMA and in group exhibitions including Los Angeles County Museum of Art, SOFA, MAD, and is included in The White House Craft Collection. Sherrill is a featured artist in *The Penland Book of Ceramics: Master Classes in Ceramic Techniques* edited by Deborah Morgenthal and Suzanne Tourtillott (Lark Books, 2003).

CAROL SHINN, fiber
Tempe, AZ
b. 1948
Best known for her machine embroidery and photo-realistic imagery, Carol Shinn has an MFA from AZ State University. She has taught workshops at Penland, Haystack, Arrowmont, Peters Valley, and weaving classes at Arizona State University. She has exhibited extensively, winning a dozen awards. Selected exhibitions include *Splendid World of Needle Arts,* which toured Japan; and *Creating the Stitch,* which toured the U.S., England and Japan. Her work has also been exhibited at SOFA and featured in *American Craft, Surface Design Journal, FiberArts,* and *Threads.* She is included in *Celebrating the Stitch: Contemporary Embroidery of North America,* by Barbara Smith (Taunton Press, 1991).

CHRISTINA SHMIGEL, iron
St. Louis, MO
b. 1958
Associate professor of sculpture at Webster University in St. Louis, Christina Shmigel has MFAs from Brooklyn College (NYC) and Southern IL University/Carbondale. She has been a Penland teacher, resident artist, visiting artist, and trustee. Shmigel's steel sculptures focus on industrial forms both as individual pieces and complex installations; she also makes works on paper and artist books. She has had solo exhibitions at Gallery W.D.O. (NC), Greenhill Center for North Carolina Art, John Elder Galley (NYC), and St. Louis Art Museum. Her work is featured in *Decorative and Sculptural Ironwork* by Dona Meilach (Schiffer Publishing, 1999), and *The Fine Art of the Tin Can,* by Bobby Hansson (Lark Books, 1996).

RANDY SHULL, wood
Asheville, NC
b. 1962
Former Penland resident artist Randy Shull has a BFA from RIT. He has taught at Anderson Ranch, CCA and Penland. He received an SAF/NEA grant and an NC Arts Council grant. Shull creates functional and sculptural work characterized by animated forms and brightly colored, often abraded surfaces. He has had solo exhibitions at Snyderman Gallery (Philadelphia), Franklin Parrasch Gallery (NYC), MMA, and his work is in the collections of MAD, Asheville Art Museum (NC),

Brooklyn Museum (NYC), MMCD, Renwick Gallery, High Museum, Racine Art Museum (WI), and Mobile Museum of Art (AL).

JERRY SPAGNOLI, photography
New York, NY
b. 1956
The foremost contemporary authority on the daguerreotype process, Jerry Spagnoli has an MFA from Mills College (CA). He has been an instructor at Academy of Art College (San Francisco) and San Francisco Art Institute and he has taught workshops at Penland, CCA, and The Photographers Formulary Workshops (MT). His work is in the collections of MOMA, Art Institute of Chicago, Oakland Museum (CA), Getty Museum (CA), and New-York Historical Society and is included in *Photography's Antiquarian Avant-Garde: The New Wave in Old Processes,* by Lyle Rexer (Harry N. Abrams, Inc., 2002). Spagnoli has used the unique presence and clarity of the daguerreotype in an ongoing series documenting important sites in New York City and a series of detail studies of the human body. He has also been the technician for daguerreotypes by Chuck Close.

PAUL STANKARD, glass
Mantua, NJ
b. 1943
Glass artist Paul Stankard was educated at Salem Technical Institute (NJ). He teaches studio glass art at Salem County Community College (NJ). He was the first instructor of flameworking at Penland and helped set up the studio. A fellow of the ACC, Stankard has received the UrbanGlass Award for Innovation in a Glassworking Technique, two NJ State Council of the Arts awards, and an honorary doctorate from Rowan University (NJ). He makes intricate, organically credible, three-dimensional, floral still-lifes which he encases in crystal to form paperweights and small-scale sculptures. His work is in many collections including MAD, MFA Boston, Corning Museum, Metropolitan Museum, Musée des Arts Decoratifs (Paris), Philadelphia Museum, Renwick Gallery, and Victoria and Albert. He has been the subject of many articles and books including *Paul J. Stankard: Homage to Nature* by Ulysses Grant Dietz (Harry N. Abrams, Inc., 1996).

THERMAN STATOM, glass, mixed-media
Escondido, CA
b. 1953
Therman Statom studied at Pilchuck Glass School and has an MFA from Pratt. He has taught at Bild-Werk Frauenau (Germany), Penland, Pilchuck, Haystack, National University of Australia, RISD and CCA. Statom's constructions incorporate plate glass, blown glass, paint and other media. He has developed a personal iconography that prominently features ladders, chairs and houses. His commissions and installations include Mayo Clinic (MN), Harrah's Casino (Las Vegas), and Los Angeles International Airport. His work is in the collections of High Museum, Los Angeles County Museum of Art, MMCD, Musée des Arts Decoratifs (Paris), and Toledo Museum of Art (OH). He has received two NEA grants and is a fellow of the ACC.

DEB STONER, metals
Portland, OR
b. 1957
A metalsmith and designer specializing in eyewear, Deb Stoner has an MFA from San Diego State University. She was an eyewear designer for Anne Klein for two years and has also designed eyewear for Donna Karen, DKNY, Polaroid, and others. Stoner worked as a bench jeweler for six years before graduate school. After an artist residency at OCAC, she taught school for four years. Since then, she has taught workshops

and lectured throughout the U.S. and in Ireland, Nova Scotia, New Zealand, Portugal, Germany, and Italy. She has exhibited work in museums and galleries internationally. Her work has been featured in *American Craft*, *Metalsmith*, *Metropolis* and the *Los Angeles Times Magazine*. Stoner is on the Haystack board of trustees.

EVON STREETMAN, photography
Suwannee, FL
b. 1932
Photographer Evon Streetman was a professor at the University of FL from 1977 until her retirement in 1999. She earned a BS from FL State University. A former Penland resident artist, she has been a Penland trustee, a frequent instructor, and from 1971–1975 she organized and managed the photography program. She was the photographer for the *Penland School of Crafts Book of Pottery* and the *Penland School of Crafts Book of Jewelry,* edited by John Coyne, and for a number of Penland catalogs. Streetman creates carefully constructed tableaux using natural and other materials and frequently enhances the surface of her Cibachrome prints with acrylic paint. Her work is in the collections of Polaroid Corporation (MA), Ringling Museum of Art (FL) and The White House (DC). Streetman received an NEA grant and was the honored educator at the 2002 SPE conference.

BILLIE RUTH SUDDUTH, fiber
Bakersville, NC
b. 1945
A self-taught basketmaker, Billie Ruth Sudduth has an MSW from University of AL in Tuscaloosa. She began making baskets while working as a school psychologist, and in 1989 decided to work full-time in basketry. She has taught workshops at Arrowmont, Campbell Folk School, and East Carolina University (NC). Sudduth's interpretations of traditional basket forms incorporate patterns based on the Fibonacci number sequence. Her work is included in *American Baskets* by Robert Shaw (Random House, Inc., 2000) and *Baskets, Tradition and Beyond* by Leier, Peters and Wallace (Guild Publishing, 2000). She is the author of *Baskets, a Book for Makers and Collectors* (Hand Books Press, 1999). Her work is in the collections of Renwick Gallery, MAD, and MMCD.

THOMAS SUOMALAINEN, clay
Walnut Cove, NC
b. 1939
Studio potter Tom Suomalainen has an MFA from Tulane University. He has taught at Penland, Arrowmont, RIT, High Point University (NC), Sawtooth Center for Visual Art (NC) and Salem College (NC). He was a Penland resident artist and part of Penland's Nifty Fifty in 1971. Suomalainen says of his work, "The serious and the comic are often presented as figurative forms having plant or animal parts." His work is in the collections of NC Museum of Natural Sciences, MMA and Weatherspoon Art Gallery at University of NC/Greensboro, and is included in *Penland School of Crafts Book of Pottery*, John Coyne, Editor (Bobbs-Merrill, 1975).

TOSHIKO TAKAEZU, clay
Quakertown, NJ
b. 1932
Master potter Toshiko Takaezu studied at University of HI before attending Cranbrook, where she studied clay, sculpture and weaving. From 1955–1964 she was head of the ceramic department at Cleveland Institute of Art. She was a faculty member at Princeton University Creative Art Program from 1967–1992. She was an instructor or a visiting scholar at Penland every year from 1964–1979. Her work is in the collections of Renwick Gallery, MAD, Cleveland Museum of Art, Art Institute of Chicago, MFA Boston, Wustum Museum, and Philadelphia Museum. Her many awards include an NEA grant and honorary degrees from Lewis and Clark College (OR), Moore College of Art (Philadelphia), and University of Hawaii. She is a fellow of the ACC and was awarded its gold medal.

JAMES TANNER, clay
Janesville, MN
b. 1941
James Tanner has been professor of art at Mankato State University (MN) since 1968. He earned MS and MFA degrees from University of WI/Madison. He has taught at Penland, Haystack, Anderson Ranch, IL State University/Normal, and CCA. Tanner's ceramic sculptures use color in a painterly fashion; his seemingly abstract compositions frequently reveal figurative elements. He has been the subject of more than forty solo and two-person shows and is included in collections of Renwick Gallery, MAD, DE Art Museum and MMCD. A recipient of two NEA grants, he has served on the boards of the ACC and NCECA, and he is a fellow of the ACC.

JANET TAYLOR, fiber
Spruce Pine, NC
b. 1941
Janet Taylor has an MFA from Syracuse University. She is professor emerita from AZ State University/Tempe, where she taught from 1977–2000. Taylor has been a Penland instructor, resident artist, instructor, visiting artist, and trustee over a thirty-five-year period and was a part of the Nifty Fifty in 1971. As a studio artist, she concentrated for many years on tapestries before opening Janet Taylor Studio, working with architects and interior designers manufacturing custom-made interior fabrics. A long-time student and teacher of color theory, she brings a subtle and sophisticated use of color to her tapestries and handwoven wearable work. Her commissioned work is in many collections including IBM, Dushoff & Saks law firm in Phoenix, and the Scottsdale, AZ City Hall.

BYRON TEMPLE, clay
1933–2002
Raised on a farm in IN, Byron Temple studied pottery at Ball State University (IN) and attended Brooklyn Museum Art School (NYC) and the School of the Art Institute of Chicago. He apprenticed to Bernard Leach from 1958–1961. Temple established a production pottery in Lambertville, NJ in 1962 where he made functional pottery until 1989. He then moved to the Louisville, KY area, prompted by a shift in focus to more individualistic pots. He influenced generations of potters with classes and workshops at Penland, Haystack, Pratt, and Philadelphia College of Art. He considered his work a combination of Bauhaus and Japanese styles with simple lines and marks left exposed. In describing his approach to his craft, he said, "Old fashioned craftsmanship is not copying forms, but lies in a profound comprehension of the way in which they were created."

CESARE TOFFOLO, glass
Murano, Italy
b. 1961
Born in Murano, Italy into a family of glassmasters, Cesare Toffolo learned flameworking at the studio of his father, Florino Toffolo. After his father died, Toffolo continued perfecting flameworking technique on his own, developing techniques such as filigree, incalmo, and the use of gold leaf. He has been a teacher at Pilchuck, Niijima Glass Art Center (Japan), Corning Studio, Penland, Toyama Glass Art Institute (Japan), and Kanazu Forest of Creation Foundation (Japan). He conceived and founded Centro Studio Vetro, a nonprofit cultural association to promote glass in Italy and abroad. His work is in many collections including Niijima Contemporary Glass Art Museum (Japan) and Corning Museum.

BOB TROTMAN, wood
Casar, NC
b. 1947
Wood sculptor Bob Trotman earned a BA in philosophy from Washington and Lee University (VA), and studied with Jon Brooks and Sam Maloof at Penland, Robert Morris and James Surls at the Atlantic Center for the Arts (FL), and Francisco Rivera at the Sculpture Center (NYC). He has taught at Anderson Ranch, Arrowmont, Haystack, and Penland, and served on the Penland board of trustees. Over the years, the figurative elements in Trotman's furniture became increasingly predominant, culminating in his decision in 1997 to devote himself to figurative sculpture. He received two NEA grants and three NC Arts Council grants. His work is in the collections of North Carolina Museum of Art, VA Museum of Fine Art, Renwick Gallery, and MMA.

ROBERT TURNER, clay
Port Washington, NY
b. 1913
Robert Turner is professor emeritus of ceramic art from Alfred, where he received his MFA and was on the faculty from 1958-1979. He also taught at Black Mountain College, Haystack, and Penland, where he was a part of the Nifty Fifty in 1971. A deeply influential figure in American ceramics, Turner is known for the perfection of his forms. He is a fellow of the ACC and received its gold medal. He also received an honorary doctorate from Swarthmore College (PA). His work is in many collections including MAD, Everson Museum of Art (NY), Los Angeles County Museum of Art, MFA Boston, Philadelphia Museum, Walker Art Center (Minneapolis), and Wustum Museum. He is the subject of *Robert Turner—Shaping Silence: A Life in Clay,* by Marsha Miro and Tony Hepburn (Kodasha International, 2003).

AL VRANA, metals
1921-1994
Al Vrana's early history included a six-year stint with the merchant marines, education as a horticulturist and landscape designer and ten years as the proprietor of a nursery. During a year spent in Florida studying tropical horticulture, he took a sculpture class which began his career specializing in monumental architectural sculpture. He first taught at Penland in 1968. He settled near the school and continued to teach until 1985. He received an apprentice grant from the NEA and a Louis Comfort Tiffany grant. He worked in metals, stone, concrete, and bronze casting. Public sculpture commissions included Miami Beach Public Library, Jacksonville Federal Building (FL), FL International University, Presbyterian Towers (FL), carved limestone for 45 E. 57th St. (NYC), and a fountain for Raleigh's Crabtree Mall (NC).

TODD WALKER, photography
1917–1998
Photographer Todd Walker was educated at Glendale Junior College (CA) and Art Center School in Los Angeles. He was named professor emeritus of University of AZ/Tucson in 1985 after teaching since 1977. He did industrial and editorial photography for a large variety of clients and was a pioneer in the use of nonsilver photographic processes. His work is in the collections of Bibliothéque National in Paris, Brooklyn Museum, Fogg Art Museum at Harvard University (MA), George Eastman House, MMA, New York Public Library, and Philadelphia Museum. He received two NEA grants and self-published twenty-four books or portfolios as Thumbprint Press.

EILEEN WALLACE, books
Chillicothe, OH
b. 1968
Eileen Wallace has an MLS and an MFA from University of AL at Tuscaloosa. Between 1994 and 2000 she was a Penland studio coordinator, publications designer, letterpress printer, instructor, and resident artist. She is co-designer for Dard Hunter Studios (OH) and a co-director of the Paper and Book Intensive. She has taught at Washington University (St. Louis), and in University of Georgia's Cortona, Italy program. Wallace is known for her perfect execution of historical bookbinding techniques and for combining these techniques with non-traditional materials. Her work has been exhibited at Columbia College Chicago Center for Book and Paper Arts, Folk Arts Center (NC), Robert C. Williams American Museum of Papermaking (Atlanta), and Maison de la Culture Mont-Royal (Montreal).

JOE WALTERS, drawing
Charleston, SC
b. 1952
Joe Walters has an MFA from East Carolina University (NC). He has been the subject of numerous solo exhibitions including Solomon Project (Atlanta), Spirit Square (NC), Steinbaum Krauss Gallery (NYC), and Artemisia Gallery (Chicago). He received an SAF/NEA Fellowship and a SC Arts Commission Fellowship. Walters creates imagery using imaginative techniques and non-traditional materials. His work is in the collections of Kemper Museum of Contemporary Art (Kansas City), Emory University (Atlanta), and University of FL.

EDWARD F. WORST, fiber
1866–1946
Edward F. Worst was Penland School's first instructor. His workshops for the Penland Weavers led directly to the beginning of Penland's educational program; he taught at Penland every summer from 1929-1946. A proponent of the educational theories of John Dewey, Worst was the director of manual education in the Chicago public schools. He studied weaving at the Lowell Textile Institute and in Sweden. He was the founder of Lockport Cottage Industries, a craft-based economic development program in IL, and the author of *Foot-Power Loom Weaving* (1918) and *How to Weave Linens* (1926) which were standard references for hand weaving.

INSTRUCTORS, RESIDENT ARTISTS, CORE STUDENTS

Nobody has done more to create Penland School of Crafts than the instructors, resident artists, and core students. As Penland's second director Bill Brown sometimes wrote in his summer brochures,

We are greatly indebted to these fine individuals.

INSTRUCTORS AND VISITING ARTISTS

1929-2004

Jim Abbott
Jackie Abrams
Karen Abromaitis
James Acord
John T. Acorn
B.J. Adams
Peter Adams
Renie Breskin Adams
Sally Adams
Shelby Lee Adams
Aldon Addington
Terry Adkins
Paula Adler
Ann Agee
Deborah Aguado
Sirkka Ahlskog
Joyce Aiken
Adela Akers
Finn Alban
Twila Alber
Nancy Albertson
Heather Allen
Kathy Allen
Terry Allen
Thomas Allen
Vern Allen
Chris Allen-Wickler
Candida Alvarez
Carlos Alves
Philis Alvic
James Amaral
Olga Amaral
Mae Amsler
Stanley Mace Andersen
Adrienne Anderson
Andy Anderson
Bob Anderson
Dan Anderson
Don Anderson
Kristin Anderson
R. Eric Anderson
Willie Anderson
Willy Andersson
Peter Andres
Meade Andrews
Elaine Andrews
Alice Andrews
Mark Angus
David Anhalt
David Appel
Linda Arbuckle
Robert Archambeau
Adrian Arleo
Paul Arnold
Jeff Arvin
Craig Aument

Joan Austin
Ilze Anita Aviks
Herb Babcock
Caleb Bach
Arthur Bacon
Dan Bailey
Ivan Bailey
Oscar Bailey
Sarah Bailey
Anna Reamer Baker
Joe Baker
Russell Baldon
Mark Baldridge
Mrs. Lorenzo Baldwin
Phillip Baldwin
Fred Ball
Boris Bally
Bruce Bangert
Martha Banyas
Julia M. Barello
Lee Barkley
Dorothy Gill Barnes
Nancy Baron
Frances Barr
Dawn Barrett
Mary Barringer
Judith Barrow
Carol Barton
Pinky Bass
Jim Bassler
Jan Baum
Jeffrey Bayer
Carol Beadle
Candace Beardslee
Peter Beasecker
Dick Beasley
Michael Beatty
Gaeten Beaudin
Irene Beaudin
Rick Beck
Valerie Beck
Mike Becotte
Gary Beecham
Malinda Beeman
Harvey A. Begay
Stewart Belk
Astrid Hilger Bennett
Garry Knox Bennett
Jamie Bennett
Paulus Berensohn
Arthur Bergman
Margaret Bergman
Rick Berman
Eddie Bernard
Alex Bernstein
Katherine Bernstein

Ricky Bernstein
William Bernstein
Chris Berti
Lois M. Betteridge
Doug Beube
Anthony Beverly
D'Arcie Beytebiere
John Biggers
Dorothea Bilder
Carolyn Bilderback
Elizabeth Billings
Frederick Birkhill Jr.
Garth Bixler
Mary Black
Lisa Blackburn
Kate Blacklock
Virginia Blakelock
Oliver J. Blanchard
Ruth Blanchard
Wiley Blevins
Karen Blockman
Rebecca Bluestone
Lili Blumenau
Gina Bobrowski
Mac Boggs
Gary Bogue
Mark Bokenkamp
Kener Bond Jr.
Michael Bondi
Neal Bonham
Kenneth Botnick
Bruce Botts
Cindy Boughner
Joy Boutrup
Donavon Boutz
Joe Bova
Ken Bova
Gaza Bowen
George Bowes
Gardner Boyd
Cynthia Boyer
Michael Boylen
Bill Boysen
Deborah Brackenbury
David Brackett
Holly Brackmann
Steve Bradford
Robert Brady
Susan Brandeis
Betty Brastrup
Gertrud Brastrup
Celia Braswell
Augustus Brathwaite
Marna Goldstein Brauner
Vernon Brejcha
Archie Brennan

Ruth Brennan
Marco Breuer
Beth Johnson Brewin
David Brewin
Ray Allen Brigham
Mary Elizabeth Brim
Cynthia Bringle
Edwina Bringle
Edward Brinkman
Byron Bristol
Susan Bristol
John Britt
Steven Brixner
John Eric Broaddus
Caroline Broadhead
Curtiss Brock
Lucinda Brogden
Jan Brooks
Jon Brooks
Lola Brooks
Bill Brouillard
Wendel Broussard
William Brown
William Brown Jr.
Charlie Brown
Charlotte Brown
Jane Brown
Sandra Brownlee-Ramsdale
Dale Brownscombe
Jane Bruce
Inge Bruggeman
J. Robert Bruya
Lucio Bubacco
Curtis Buchanan
Roby Buchanan
Andy Buck
George Bucquet
Jean Buescher
Jim Buonaccorsi
Wanrudee Buranakorn
Ralph Burgard
Klaus Bürgel
Bill Burke
Ellie Burke
Ronald Burke
Arlene Burke-Morgan
Richard Burkett
Mark Burleson
Jay Burnham-Kidwell
Eulalia Burns
Ralph Burns
Fred Burton
Irving Burton
Elizabeth A. Busch
David Butler
Owen Butler

Harlan Butt
Marlene Byer
Jeffery Byrd
Judy Byron
Lou Cabeen
Jean Cacicedo
Sam Caldwell
Ron Callari
Sean Calyer
Graham Campbell
Eileen Canning
Annette Cantor
Ken Carder
Caty Carlin
Bob Carlson
William Carlson
Martha Carothers
Dennis "Bones" Carpenter
Syd Carpenter
Allen D. Carter
Carmen Carter
Carol Ann Carter
Keith Carter
Mrs. L.I. Case
Doug Casebeer
Wendell Castle
Nick Cave
Denyce Celentano
John Chaffee
Martha Chahrudi
Betty Lou Chaika
Paul Chaleff
Gordon Chandler
Bruce Chao
Jerry Chappelle
José Chardiet
Adelaide Chase
E.A. Chase
Harvey Chase
Scott Chaseling
David K. Chatt
Dale Chihuly
Dr. B. G. Childs
Kyoung Ae Cho
Fong Choo
Joyce Chown
Linda Christianson
Elin Christopherson
Y. David Chung
Dorothy Church
Sharon Church
Lisa Clague
Christine Clark
Elizabeth Clark
Jimmy Clark
Joe Clark

John Clark
Kathryn Clark
Lisa Clark
Sonya Clark
William Clark
Sam Clarkson
Daniel Clayman
Maya Clemes
Morgan Clifford
Roy Clifton
Katharine Cobey
Jane Burch Cochran
John Cogswell
Harriet Cohen
Michael Cohen
Akemi Nakano Cohn
Sas Colby
Fern Cole
Jeff Cole
R. Scott Cole
A.D. Coleman
Sarah A.T. Coleman
Warrington Colescott
Frank Colson
Arianne King Comer
Emma Conley
Harriet Conley
Theresa Conley
Julie Connaghan
Julie Connell
Elizabeth Conner
John Cook
Barbara Cooper
Jim Cooper
Steven Cooper
Louise Todd Cope
Lawrence G. Copeland
Harold Copley
Philip Cornelius
Michael Corney
Chris Correia
Charlie Correll
Nancy Megan Corwin
Jim Cotter
Clara "Kitty" Couch
Mary Beth Coulter
Lane Coulter
Liz Covey
Chandra Cox
Tom Cox
Tim Cozzens
Linda Crabill
Ellen Craib-Mitchell
John Craig
Galen Cranz
Rhonda Crenha
KéKé Cribbs
Kim Cridler
Frederic A. Crist
Jim Croft
Michael Croft
Cara Croninger
Nancy Crow
Kevin Crowe
Maegan Crowley
Ronald Cruickshank
Jimmie Crumrine
Walter Cudnohufsky

Frank Cummings III
Willis Cummins
Richard Cunningham
Val Cushing
Jack da Silva
Marilyn da Silva
Ron Dale
William Daley
Stephen Daly
Gina D'Ambrosio
David Damkoehler
Robert Dancik
Susan Daniel
Linda Darty
Chris Darway
Randall Darwall
Edward David
Jacqueline Davidson
Marilyn Davidson
Don Davis
Edward Davis
Lenore Davis
Malcolm Davis
Michael Davis
Paige Davis
Virginia Davis
Stephen Paul Day
Einar de la Torre
Jamex de la Torre
Georgia Deal
Bruce R. Dean
Nick Dean
Valerie Dearing
Margaret Decker
Skip Deegans
Amanda Degener
Shari DeGraw
Ron Dekok
Ira DeKoven
Edward DeLarge
Peter DeLory
Ellen Paul Denker
Christina DePaul
Pauline Deppen
Ed Deren
Virginia Derryberry
Eugene Deutsch
Rita DeWitt
Will Dexter
Dominic di Pasquale
Don Dickenson
Jane Dillon
John Dillon
Leonard DiNardo
Bettina Dittlmann
Dwayne Dixon
John Dodd
Karon Doherty
Louie Doherty
Eddie Dominguez
Laura Donefer
Craig Dongoski
Tess Doran
Sondra L. Dorn
Catherine Dotson
Tracy Dotson
Patrick Dougherty
Patrick T. Dougherty

Betsy Douglas
Arnelle Dow
John L. Doyle
Kathleen Doyle
Leonard Doyle
Catherine Drabkin
Dean Drahos
Patricia Dreher
Fritz Dreisbach
Donna Jean Dreyer
Don Drumm
Liza Drumm
Mindell Dubansky
Emily DuBois
Paulo DuFour
Hadrian Duke
Bandhu Dunham
Martha Dunigan
David Dunlap
Jane Dunnewold
John Dunnigan
Elsie Eagle
Clifford Earl
Henry Easterwood
Rico Eastman
Robert Ebendorf
Edward Eberle
Lilith Eberle
Jean Ebert
Charles Ebner
Barbara Eckhardt
Nicki Hitz Edson
Gilda M. Edwards
Stephen Dee Edwards
Yvonne Edwards-Tucker
Ernst Ehalberstadt
Michael W. Ehlbeck
Eva Eisler
Jon Ellenbogen
Lillian Elliott
Andra Ellis
Catharine Ellis
Hattie Ellis
Gail Ellison
David Ellsworth
Timothy Ely
Daniel Engelke
Johanna Erickson
Sigurd Alf Eriksen
Ashley Jameson Eriksmoen
Eleanor Erskine
Kathey Ervin
Ruben Eshkanian
Daniel Essig
Dan Estabrook
Chuck Evans
Connor Everts
Barbara Ferguson Factor
Joan Fain
Don Falk
Bob Falwell
Lorna Faraldi
Tom Farbanish
Bill Farrell
Tom Farrell
Dikko Faust
Mollie Favour
Jim Fawcett

Tom Feldvebel
Fred Fenster
Lorna Feraldi
Barbara Ferguson
Wayne Ferguson
Shane Fero
George Ferrandi
John E. Ferritto
Bernice Ficek-Swenson
Robert Fichter
Anne Field
Dorothy Field
Lin Fife
Phillip Fike
Susan Filley
Angela Fina
Dan Finnegan
William Fiorini
Arline M. Fisch
Alida Fish
Col. John Fishback
Jacob Fishman
Marguerite Fishman
Steve Fitch
Regina Flanagan
Penelope Fleming
Peter Fleming
Leroy Flint
Pat Flynn
David Fobes
Tina Fong
Bill Ford
Howard "Toni" Ford
Laura Ford
Margaret Ford
Martha Ford
Richard Ford
Neil Forrest
Amy Forsyth
Robert Forsyth
Michael Fortune
Suellen Fowler
Gabrielle Fox
Herbert Fox
Briony Jean Foy
Hans Frabel
Jean Francis
Ke Francis
John Charles Frantz
Debra Frasier
Helen Freas
Gail Fredell
Helen Frederick
Phyllis Freeman
Alvin Frega
Alan Friedman
John French
Tage Frid
Bilge Friedlaender
Lee Friedlander
Don Friedlich
Jan Friedman
Christopher Friedrich
Diane Ericson Frode
Gary Frost
Diann Fuller
José Fumero
Jeffrey Funk

Harry Furches
Hannelore Gabriel
Dennise Gackstetter
Julia Galloway
David Gamble
Susan Ganch
Jesus Melchor Garcia
Glen Gardner
Robert Gardner
John Garrett
Paula Garrett
Henry Gaskett
Carol Gaskin
Hans Gassman
Mitchell Gaudet
Bob Gauvreau
Tony Gaye
Ruth Kelly Gaynes
Tom Gentille
Suzanne Gernandt
James Gervan
Terry Gess
Bruce Gholson
Alexander Giampietro
Dudley Giberson
Christina Gibson-Sears
David Gignac
Peg Gignoux
Albert Gilmore
Glenn Gilmore
Janice Hartwell Girouard
Jo Ann Giordano
John Glick
Martha Glowacki
Robert Godfrey
Sylvia Goh
Vivien Goh
Debra Lynn Gold
Jenna Goldberg
Scott Goldberg
Judith Golden
Rory Golden
Harvey Goldman
Layne Goldsmith
Audrey Goldstein
Jeffrey W. Goll
Arthur Gonzalez
Catherine Good
Michael Good
John Goodheart
Jeff Goodman
Bonnie Gordon
Jeannine Goreski
A.P. Gorny
Karen Gorst
H. Betty Gott
Esther Gotthoffer
Jennifer Gottiener
Peter Gourfain
Paula Gourley
Emmet Gowin
Beth Grabowski
David Graham
Lisa Gralnick
Silvie Granatelli
Henry Graves
Katherine Gray
Myra Mimlitsch Gray

Pat Graybeal
Persis Grayson
Leslie Green
George Greenamyer
Arch Gregory
Kathryn Gremley
Barbara Grenell
Judith Grenell
Carmen Grier
Guadalupe Grimaldi
Mrs. Hoy Grindstaff
Judith Grodowitz
Erik Gronborg
Deborah Groover
Mimi Gross
Randall Gunther
Margaret Gustin
Chad Alice Hagen
Susan Hagen
Betty Hahn
Henry Halem
Hoss Haley
Ted Hallman
Nancy Halpern
John Hamil
Bill Hammersley
Tom Hammond
Audrey Handler
Drewry Hanes
Bobby Hansson
William Happel
Peter Happny
Mary Hark
Ed Harkness
Thomas Harkusen
Douglas Harling
Pamela Harlow
Mike Harms
William Harper
Ruth Harris
Peter Harrison
William W. Harsey
Melissa Harshman
John Hartom
Anthony Haruch
Keith Hatcher
Jane Hatcher
Flo Hatcher
Elizabeth Hatmaker
Ann Hawthorne
Ana Lisa Hedstrom
Steven Heinemann
Denise Heischman
Ralph Helmick
Bill Helwig
Richard Helzer
Helen Henderson
Wayne Henderson
Doug Hendrickson
James Henkel
Robert J. Hennessey
Christoph Hentz
Pinkney Herbert
Steven Herrnstadt
Pat Hickman
Leon N. Hicks
Jean Hicks
Catharine Hiersoux

Wayne Higby
Edith Hill
Judy Hill
Patti Quinn Hill
Steven Hill
Chuck Hindes
Lola Hinson
Will Hinton
Curtis Hoard
Annie Hoffman
William S. Hoffman
Kevin T. Hogan
Holis Holbrook
Michael Holihan
Harry Hollander
Jeffery Holmwood
Bryant Holsenbeck
Cathy Holt
Martha Holt
Warren Holzman
Donna Horie
Jerry Horning
Deborah Horrell
Bernie Hosey
Helen Hosking
Janet Hoskins
Colette Hosmer
Christiane Howard
Japheth Howard
James Howell
Steve Howell
Mary Lee Hu
Tom Hucker
Robert Huff
Woody Hughes
Michael W. Hughey
Ingeborg Hugo
Wendy Huhn
Dinah Hulet
Paula Hultberg
Terry Hunt
Terry K. Hunter
Lissa Hunter
Frederick Hunter
David Hurwith
Michael Hurwitz
Dick Huss
Martha Hybel
Katie Hyde
Clary Illian
Florence Illman
Mr. Imagination
Mike Imes
Rosemary Ingham
Robert Ingram
Lois Inman
Kent Ipsen
Marcia Isaacson
Sergei Isupov
Diane Itter
Susan Iverson
Gregory Ivy
Karen Ivy
Peter Ivy
Daniel Jackson
Rob Jackson
Steven Jackson
Mary Jackson

Ferne Jacobs
Sarah Jaeger
Alice James
Cassandra James
Robert C. James
Peggy Jamieson
Aino Jarvesoo
John Jauquet
Hugh Jenkins
Judy Jensen
Marvin Jensen
Paul Jeremias
Michael Jerry
Kim Jessor
Wayne Jewett
Roland Jhan
Daniel Jocz
Michael Joerling
Nicholas Joerling
C.R. "Skip" Johnson
David Johnson
Gregg Johnson
James Johnson
Joyce Johnson
Lillian Johnson
Lois M. Johnson
Priscilla Johnson
Randy J. Johnston
Robert Johnson
Elsie Johnston
Mickey Johnston
Richard Jolley
David Jones
Geary Jones
Judy Jones
Cary Emile Jordan
Mark Jordan
Mary Anne Jordan
Steve Jordan
Peter Joseph
Tom Joyce
Helen Juhas
Urban Jupena
Peggy Juve
Edwin Kalke
Mary Kanda
Anita Kapaun
Enid Kaplan
Jerry Kaplan
Eva Karczag
Hunter Kariher
Karen Karnes
Pat Kay
David Keator
Tom Kekic
Claire Kelly
True Kelly
Maureen Kelman
Kimberly Kelzer
Steven Kemenyffy
Susan Kemenyffy
Gail Kendall
Tom Kendall
Joe Kenlan
Amos Kennedy
Ann Marie Kennedy
Kevin Kennedy
Brian Kerkvliet

Kenneth Kerslake
Jane Kessler
Lothar Kestenbaum
Bernard Kester
Sally Key
Bill Keyser
Kathy King
Peter King
Ruth King
Susan E. King
Susan Kingsley
Brent Kington
Pat Kinsella
Jim Kirkpatrick
Harold Kitner
Barbara Klaer
Judy Klaer-Kerns
David Klahn
Mark Klett
Michael Kline
Allan Kluber
Esther Knobel
Ellen Kochansky
Masami Koda
James Koehler
George Kokis
Bob Kopf
Silas Kopf
Barbara Korbel
Gloria Kosco
Gene Koss
Ebba Kossick
Jane Kosstrin
Rudy Kovacs
Ron Kovatch
Richard Kraft
Tom Kreager
Lynwood Kreneck
Mary Kretsinger
Shana Kroiz
Daniel Kruger
Deborah Krupenia
Peter Kruty
Paul Kubic
Cappy Kuhn
Carol Kumata
Karen Kunc
Yih-Wen Kuo
Jan Ring Kutz
Eva Kwong
Hedi Kyle
Bruno La Verdiere
Jane Lackey
Curtis LaFollette
Judith Lakin
Gyongy Laky
Michael Lamar
Edward Lambert
Zoe Lancaster
Rosemary Lane
Cay Lang
Rodger Lang
Tom Lang
Ingeborg Langbers
Scott Lankton
Julie Larson
Susan Larson
Tyrone Larson

Judith Ann Larzelere
Rebekah Laskin
Karl Laurell
Mary Law
Preston B. Lawing
Tony Laws
James Lawton
Tim Lazure
Jaymes Leahy
John E. Lear
Albert Le-Coff
Mildred Ledford
Gil Leebrick
Jacquelyn Tait Leebrick
Bill Leete
Leah Leitson
Mary Jane Leland
Max Lenderman
Tony Lent
Ah Leon
Julia Leonard
Yvonne Leonard
K. William LeQuier
Mick LeTourneaux
Marc Leuthold
Susan Leveille
Bob Leverich
David Levi
David Levin
Rob Levin
Cynthia Gano Lewis
David Dodge Lewis
Duncan Lewis
Keith A. Lewis
Linda Lewis
Marcia Lewis
Marsha Lewis
Meta Lewis
Charles Lewton-Brain
Bojana Leznicki
Walter Lieberman
Jenny Lind
Kris Lindahl
Max Linderman
Suze Lindsay
Joan Lintault
Beth Lipman
Marvin Lipofsky
Bobbie Lippman
Tomas Lipps
Harvey Littleton
John Littleton
Keith Lo Bue
Tom Loeser
Peter Loewer
Bill Logan
David Logan
Juan Logan
Kristina Logan
Alicia Lomné
Lloyd Long
Randy Long
Betty Helen Longhi
Pam Longobardi
Kari Lonning
George Lorio
Steven Loucks
Vanni Lowdenslager

George Lowe
Austin Lowery
Joseph Lukens
Robert Luse
Janet Luse
Deborah Luster
Adeline Lyle
Finn Lynggaard
Nathan Lyons
Joan Lyons
Elizabeth Lyons
Andrew Macdonald
David MacDonald
Elizabeth MacDonald
Marcia Macdonald
Clinton MacKenzie
Warren MacKenzie
Cornelia MacSheehy
Susan Martin Maffei
Richard Mafong
Andrew Magdanz
Paul M. Maguire
Barbara Mail
Marc Maiorana
Bernard Maisner
Jim Malenda
Charles Malin
Sam Maloof
Terrie Hancock Mangat
Kirk Mangus
Thomas Mann
Emerson Manzer
Lorna Manzler
Dan Maragni
Stephen Marc
Barney Marchialette
Fred Marcus
Mary Margaret
Richard Margolis
Dante Marioni
Paul Marioni
Thomas Markusen
René Marquez
Richard Marquis
Mrs. Chester Marsh
Tony Marsh
Irene Marshall
Andrew Martin
Donna Martin
Wendy Maruyama
Thomas Mason
Charles Massey, Jr.
Tim Mather
Edward Mathews
Ann Matlock
Helen Matson
Melissa Matson
Glenice Matthews
R.P. Matthews
Alphonse Mattia
Diane Maurer
Barbara Mauriello
Lynn Mauser-Bain
Richard Mawdsley
Clare Maxwell
Bob May
Eric May
B. Michele Maynard

Luberta Mays
Claire Maziarczyk
Craig McArt
Mac McCall
Marianne McCann
Scott McCarney
Tom McCarthy
Rodney McCoubrey
Paul McCoy
Tim McCreight
Randy McDaniel
Lauren McDermott
Mary Elen McDermott
Mary Elizabeth McDonald
Josiah McElheny
Katy McFadden
Linda McFarling
Jim McGargee
Tom McGlaughlin
Dan McGuire
John McIntire
Beverly McIver
Jan McKeachie-Johnston
Byron McKeeby
Kent McLaughlin
Laura Jean McLaughlin
Maggie McMahon
John W. McNaughton
Dr. Franklin McNutt
John McQueen
Cornelia McSheehy
Alleghany Meadows
Lorran Meares
Elizabeth Ryland Mears
John Medwedeff
Daryl Meier
Michael O. Meilahn
James Mellick
John Menapace
Shari Mendelson
Margo Mensing
Michel Merrel
Hugh Merrill
Berry Merritt
Francis Merritt
Nancy Merritt
W.E. Merritt
Roger Mertin
Bruce Metcalf
Matthew Metz
C. James Meyer
Jim Meyer
Judith Meyer
Lois Meyer
Ron Meyers
Dimitri Michaelides
Robert Mickelsen
Clyde P. Miller
Daniel Miller
Edjohnetta Miller
Joseph Miller
Scott Miller
Steve Miller
Robert Milner
Robert Milnes
Janis Miltenberger
Myra Mimlitsch-Gray
Elizabeth Minnich

James Minson
Mary Mintich
LeeAnn Mitchell
Tini Miura
Keisuke Mizuno
James Mongrain
Clifton Monteith
Martha Mood
Moon
Benjamin Moore
Clarence Morgan
Dana Moore
Eudorah Moore
D. D. Moose
Dakin Morehouse
Betty Morgan
Georgia Morgan
John Morgan
Lucy Morgan
Mark W. Morgan
Catherine Morony
Joan Morris
Kelly Morris
William Morris
Nick Mount
Gisela Magdalena Moyer
Robert Mueller
Joe Muench
Tom Muir
Gretchen Muller
Tina Mullen
Tchai Munch
Mary Virginia Munford
Hank Murrow
Sana Musasama
Jay Musler
Frances Myers
Joel Philip Myers
T.J. Nabors
James Nadal
Bob Naess
Judy Natal
Harris Nathan
Tony Natoulas
Pattie Neal
Rusty Neff
David Nelson
Patricia Nelson
Bea Nettles
Kim Newcomb
Karen Newgard
Bill Newman
Don Niblack
Sammie Nicely
Donna Nicholas
Anne Nickolson
Joe Nielander
Lilith Eberle Nielander
Kurt Nielsen
Audrey Niffenegger
Jerry Noe
Gary Noffke
Matt Nolen
Elliott Norquist
Roberta Nosti
Richard Notkin
Walter Nottingham
Craig Nutt

Nance O'Banion
Father Gregory O'Bee
Harold O'Conner
Tom O'Connor
Hiromi Oda
Jeff Oestreich
Komelia Hongja Okim
Daria Okugawa
Betty Oliver
Vincent Olmsted
Patricia Olynyk
Bridget O'Malley
Pavel Opocensky
Edward Oppenheimer
Victoria R. Oppenheimer
Ted Orland
Judith O'Rourke
Ann Orr
Don Osborn
Lyndal Osborne
Jere Osgood
Ganadi Osmerkin
Walter Ostrom
Ben Owen III
Winnie Owens-Hart
Robert Owings
Timo Pajunen
Albert Paley
Beverly Palusky
Elizabeth Pannell
Victor Papanek
Marilyn Pappas
Joan Micheals Paque
Ralph Pardington
Bart Parker
George Parker
Ken Parker
Peter Parkinson
Susan Parks
Roger Parramore
Krishna Patel
Carolanne Patterson
Neil Patterson
Michael Pavlik
Pam Pawl
Jeannie Pearce
Abigale Pearlmutter
Colin Pearson
Ronald Pearson
Joseph Pehoski
Jane Peiser
Mark Peiser
Jaime Pelissier
Noellynn Pepos
Robert E. Peppers
Sibylle Peretti
Floss Perisho
Lester Perisho
Flo Perkins
Sarah Perkins
Alan Perry
Lyn Perry
Gord Peteran
Mark Peters
Rupert Peters
David Petersen
Grethe Petersen
Norman Petersen

David Peterson
Meg Peterson
Elizabeth Petrie
Marc Petrovic
John Pfahl
Connie Noyes Pfiefer
Bill Pfizenmaier
Mary Phelan
Tom Philabaum
Maria Phillips
Margaret Phillips
Mary Walker Phillips
Jay Phyfer
Eric G. Picker
Kenny Pieper
Sandi Pierantozzi
Constance Pierce
Peter Pierobon
Michael Pierschalla
Gene Pijanowski
Hiroko Pijanowski
David Pimentel
Al Pine
Pete Pinnell
Babette Pinsky
Geraldine Plato
Craig Pleasants
Marcia Plevin
John Ploof
Susan Plum
Vita Plume
Rebecca Plummer
Beverly Plummer
Reginald Pointer
Junco Sato Pollack
Jason Pollen
Allen Pollock
Heike Polster
Elsie Dinsmore Popkin
Benjamin Porter
Richard Posner
John Powell
Stewart Powers
Olga Powers
Angelica Pozo
Sally Bowen Prange
Sally Prasch
Margaret Prentice
Douglas Prickett
Richard Prillaman
Doug Printz
Richard Prisco
Stephen Proctor
Ron Propst
IlaSahai Prouty
Elliott Pujol
E. Dane Purdo
Helen Purdum
Frank Purrington
Martin Puryear
Michael Puryear
Nol Putnam
Liz Quackenbush
Lucy Quarrier
Mark Rabinowitz
Max Rada Dada
Louise Radochonski
Dan Radven

Kent Raible
John Rais
Jeanette Rakowski
Humberto Ramirez
Chris Ramsay
Ted Ramsay
Douglass Rankin
Brian Ransom
David Read
Thomas Reardon
Arthur Reed
Brad Reed
Harry Reese
Ireland Regnier
Don Reitz
Eric Renner
Barbara Jo Revelle
Jill Reynolds
Kait Rhoads
Ché Rhodes
Daniel Rhodes
Lyn Riccardo
Leland Rice
M.C. Richards
Pat Richardson
Kathleen Rieder
Jon Riis
Cheryl Riley
Dorothy Riley
Patricia Riley
Jan Ring-Kutz
Murray Riss
John Risseeuw
Richard Ritter
Victoria Rivers
Sang Roberson
William Roberson
Holly Roberts
Patricia Roberts
Sue Roberts
Terence Roberts
Marsha Robertson
William Robertson
Ken Rockwell
Dan Rodriguez
Mary A. Roehm
Sally Rogers
Christine Rolik
Helen Roller
Caroline Romada
Judith Roode
Stephen Rose
Leland Roseboom
Bird Ross
D.X. Ross
Ed Ross
Gertrude Duncan Ross
Ivy Ross
Lynda Ross
Peter M. Ross
James A. Rubley
W. Steve Rucker
Bud Rudesill
Katherine McCanless Ruffin
Ginny Ruffner
Joseph Ruffo
Will Ruggles
Louise Runyon

Tommie Rush
Joy Rushfelt
Kari Russell-Pool
Ervin Rust
Mitch Ryerson
Andrew Saftel
Karen Sairanen
Michiko Sakano
Judith Salomon
Mary Ann Sampson
Jean Sanders
Arturo Alonzo Sandoval
Claire Sanford
Ethel Sanford
Emilio Santini
Jennifer Sargent
Pauline Sargent
Paul Sasso
Sandy Sasso
John Satterfield
Bill Sax
Geraldine Scalone
Tommye McClure Scanlin
John Scarlata
William Schaaf
Anthony Schafermeyer
Gaylord Schanilec
Stu Schechter
Naomi Schedl
Mary Ann Scherr
Sydney Jo Scherr
Joanne Schiavone
Marjorie Schick
Cynthia Schira
Mimi Schleicher
Patti Schleicher
Alice Schlein
Jude Schlotzhauer
Ed Schmid
Jack Schmidt
JoAnn Schnabel
Nana Schowalter
Imre Schrammel
Peter Schreyer
James Schriber
Peter Schroth
Norman Schulman
John Schulz
Michael Schunke
Ivan Schwartz
Joel Schwartz
Brad Schwieger
Pati Scobey
R. Scott Scoe
Jean Scorgie
Virginia Scotchie
John T. Scott
Joyce J. Scott
Elizabeth Caldwell Scott
Thomas Seawell
David Secrest
Kenneth Sedberry
Robert Sedestrom
Larry Seegers
Bill Seeley
Warren Seelig
Barbara Seidenath
Joy Seidler

Niti Seip
Kay Sekimachi
Nancy Selvin
Heikki Seppa
Donna Service
Don Sexauer
Richard Sexton
Mark Sfirri
Mayer Shacter
Mary Shaffer
Dave Shaner
Bradlee Shanks
Lizabeth Shannon
Jeff Shapiro
Mark Shapiro
Susan Joy Share
Palmer M. Sharpless
Kaete Brittin Shaw
Richard Shaw
Judith Shea
Diane Sheehan
Jessie Shefrin
Jane Shellenbarger
Paul Shepard
Piper Shepard
Jenny Lou Sherburne
Sondra Sherman
Michael Sherrill
Susan Shie
Carol Shinn
Keiji Shinohara
Tony Shipp
Helen Shirk
Christina Shmigel
Bill Shoemaker
Oliver Shuchard
Randy Shull
Byron Shurtliff
Doug Sigler
Pino Signoretto
Linda Sikora
Zdzislaw Sikora
Robbin Ami Silverberg
Annie Silverman
Bobby Silverman
Ben Simmons
Sherry Simms
Marjorie Simon
Michael Simon
Sandy Simon
Glen Simpson
Josh Simpson
Clifford Sims
Laura Sims
Ruth Sims
Daniel Singer
J. Paul Sires
Sissi Siska
Brita Sjoman
John L. Skau
Brent Skidmore
Mrs. Carl Slagle
Nancy Slagle
Ron Slagle
Clarissa Sligh
Susan Sloan
Brad Smith
Carlyle Smith

Christina Y. Smith
Dolph Smith
Esther K. Smith
Gertrude Graham Smith
Henry Holmes Smith
J. D. Smith
Keith Smith
McKenzie Smith
Michael Smith
Rick Smith
Terry Smith
Nancy P. Smithner
Susan Smyly
Zerbe Sodervick
Petra Soesemann
Peter Sohngen
Ramona Solberg
Judith Solomon
Mel Someroski
Emmy Sommer
Kimberly Sotelo
Ishmel Soto
Peter Sowiski
Jerry Spagnoli
Rissie Sparks
Liz Spear
Shigeko Spear
Nancy Spencer
Sandy Spieler
Tom Spleth
Bonnie Stahlecker
Chris Staley
Budd Stalnacker
Gary Stam
Jean Stamsta
Verne Stanford
Melissa Stanforth
Mark Stanitz
Paul Stankard
Sandra Stark
Irma Starr
Susan English Starr
Therman Statom
Joel Stearns
Judy Steinhauser
Seth Stem
Hubert Stern
Rob Stern
Mollie Sternberg
Joan Sterrenburg
Bill Stewart
J. Douglas Stewart
Mary Stewart
Dorothy Stiegler
Christopher Stinehour
Susan Stinsmuehler-Amend
Bob Stocksdale
Floride Stoddard
Harris Stoddard
Bob Stoetzer
Jim Stone
Deb Stoner
Mimi Strang
Viet Stratmann
Adam Straus
Janice Strawder
Martha Strawn
Crit Streed

Tal Streeter
Evon Streetman
Loren Stump
Dorothy Sturn
Billie Ruth Sudduth
Boyd Sugiki
Donna Lee Sullivan
Lionel Suntop
Thomas Suomalainen
Lynn Sures
Didi Suydam
Charles Swanson
Marilyn Sward
Chuck Swedlund
Jon Swenson
Bernice Swenson
Hiroko Swosnik
Ian Symons
Felicia Szorad
Martta Taipale
Toshiko Takaezu
Mina Takahashi
Lori Talcott
Richard Tannen
James Tanner
Suzanne Tanner
Taoist Tai Chi Society
 of Florida
Steven Tatar
Tim Taunton
Janet Taylor
Julia Baskin Taylor
Michael Taylor
Turid Teague
Byron Temple
Steven Tengelsen
Phillip Tennant
Barbara Tetenbaum
Max Tharpe
George Thiewes
Rachelle Thiewes
Mary Thomas
Cappy Thompson
Heather Thorpe
Azalea Thorpe
Linda Threadgill
Stephen Thurston
Marcy Tilton
Valeri Timofeev
James Tippett
Rissie Tipton
David Tisdale
Bernie Toale
Jeffrey M. Todd
Yaffa Todd
Cesare Toffolo
Nancy Norton Tomasko
Anna Tomczak
John Torres Jr.
Gianni Toso
Carl Toth
Tim Towner
Naomi Towner
Bob Townsend
Larry Travis
Simone Travisano
Pamina Traylor
Jill Trear

Charles Trent
Gary Trentham
Kathy Triplett
Linda Troeller
Bob Trotman
John Troup
Ann Troutner
Jack Troy
Ruth Truett
James Tucker
Frank Turley
Fritz Turnbull
Robert Turner
Tom Turner
Virginia Tyler
Jerry Uelsmann
Toshi Ueshina
Consuelo Jimenez Underwood
Munya Avigail Upin
Joel Urruty
Dan Valanza
Sybren Valkema
Johan van Aswegen
Mary Van Cline
Madelyn van der Hoogt
George van Duinwyk
Lydia Van Gelder
Michelle Van Parys
Tim Veness
Betty Vera
Pauline Verbeek-Cowart
Clare Verstegen
Sylvia Vigiletti
Sara Vincent
Bernie Vinzani
Triesch Voelker
Kate Vogel
Hede von Nagel
Phil von Raabe
Al Vrana
Yoshika Wada
Kate Wagle
D.R. Wagner
Jon Wahling
Ron Walker
Todd Walker
Barbara Wallace
Eileen Wallace
Jim Wallace
John Wallace
Pamela J. Wallace
William Walmsley
Allan Walter
Joe Walters
Paul Andrew Wandless
Kiwon Wang
Sam Wang
Phillip Ward
Jacqueline Ward
Terri Warpinski
Sara Waters
James C. Watkins
Polly Watkins
Jim Watrel
Simon Watts
Jack Wax
Al Weber
Susan Webster

Walker Weed
Norma Weisner
Jeff Weiss
Charles Wellman
Alice Wells
Carol Wells
David H. Wells
Bob Wenger
Howard Werner
Inga Werther
John Wescott
Virginia Wescott
Huff Wesler
Katarina E. Weslien
Mark Wessinger
Effie Wetherill
Jayne Wexler
David W. Wharton
Francis Whitaker
Heather White
Larry White
John Whitesell
Trent Whitington
Mike Whitley
Douglas Whittle
Dorothy Wiechel
Ellen Wieske
Norma Wiesner
Susan Wilchins
Don Wilcox
Jeanette Wilding
Walter Wilding
Sandy Willcox
Karen Willenbrink
Gerry Williams
Gini Williams
Jan Williams
Katharina Williams
Patricia Williams
David Williamson
Liz Williamson
Roberta Williamson
David Wilson
Doug E. Wilson
George Willson
J. Morrow Wilson
Lana Wilson
Robert Willson
Wallace Wilson
Carlton Wing
Stanley Winkler
Merry Moor Winnett
Paula Winokur
Martha Winston
Michele Wipplinger
Jeff Wise
Susan Wise
Lee Witkin
Fred Woell
Rosalie Wognum
Thomas Wojak
Joan Wolbier
Elizabeth Wolfe
Jeffrey Wolin
Jackie Wollenberg
Kerris Wolsky
Joe Wood
John Wood

Sherri Wood
Jean Woodall
Julia Woodman
Arthur Woody
Charlie Woody
Dessie Woody
Bill Worcester
Sally Worcester
Nancy Worden
Edward F. Worst
Virginia Wright-Frierson
Rufus Wyatt
Phyllis Yacopino
Phillip Yanawine
Christina Yarborough
Nico Yektai
Debra Fine Yohai
Stephen Yusko
Richard Zakin
Theodora Zehner
Steven Zeitlin
Therese Zemlin
Charlotte Zerfoss
Lisa Zerkowitz
Bhakti Ziek
Sandra Zilker
Jen Zitkov
Nell Znameroski
Christine L. Zoller
Mary Ann Zotto
Donn Zver
Emmy Zweybruck
Glen Zweygardt

RESIDENT ARTISTS

1963-2004

Peter Adams
Adela Akers
Vernon Allen
Stanley Mace Andersen
Anne Arick
Junchiro Baba
Dan Bailey
Bruce Bangert
Pat Bangert
Rick Beck
Valerie Beck
William Bernstein
Katherine Bernstein
Cynthia Bringle
Edwina Bringle
Ed Brinkman
Judy Brinkman
Bill Brouillard
William Brown Jr.
George Bucquet
Ron Burke
Geraldine Calone
Kathleen Campbell
Ken Carder
Alice Carroll
John Clark
Don Cohen

Cristina Cordova
David Cornell
Judy Cornell
Ellen Craib-Mitchell
Sondra L. Dorn
J. Doster
Kathleen Doyle
Fritz Dreisbach
Rick Eckerd
Stephen Dee Edwards
Rostislav Eismont
Cynthia Fick
Greg Fidler
Debra Frasier
Steve Gamza
Susan Ganch
Ron Garfinkle
Ruth Kelly Gaynes
Terry Gess
Kathryn Gremley
Carmen Grier
Deborah Groover
Hoss Haley
Douglas Harling
Jane Hatcher
James Henkel
James Herring
Yoko Higuchi
Martha Holt
Paul Hudgins
Miyuki Imai
Shawn Ireland
Skip Johnson
Cary Emile Jordan
Mark Jordan
Steve Jordan
Bart Kasten
David Keator
True Kelly
Ann Marie Kennedy
Alicia Keshishian
Michael Kline
Ebba Kosick-Hance
James Lawton
Julia Leonard
Rob Levin
Suze Lindsay
Marc Maiorana
James McBride
Catherine Morony
Harris Nathan
Jack Neff
Joe Nielander
Harold O'Connor
Hideo Okino
Ed O'Reilly
Marsha Owen
Jill Peek
Jane Peiser
Mark Peiser
Meg Peterson
Ron Propst
IlaSahai Prouty
Louise Radochonski
Richard Ritter
Pamela K. Rockwell-Babcock
Sally Rogers
JoAnn Schnabel

Norman Schulman
Christina Shmigel
Randy Shull
Ben Simmons
Gay Smith
Rick Smith
John Snyder
Mark Stanitz
Cynthia Stone
Evon Streetman
Thomas Suomalainen
Janet Taylor
George Theiwes
Travis Townsend
Jerilyn Virden
Eileen Wallace
Jan Williams
Jonathan Williams
Phyllis Yacopino
Suzanne Yowell
Ed Zucca

CORE STUDENTS

1971-2004

Jim Abbott
L. John Andrew
Brian Barber
Cyndy Barbone
Nancy Barnett
Dorothe Bohringer
Meredith Brickell
Mary Elizabeth Brim
Doreen Brinkerhoff
Belinda Bruns
Andy Buck
Carie Cable
Geoff Calabrese
Critz Campbell
Marion Carter
Rebecca Carter
Frances Castelli
Jake Chamberlain
Jim Charneski
Susie Chin
Janet Coghenaur
Sharon Cohen
Thomas Judd Cook
Georgianine Cowan
Linda Crabill
Natalie Craig
Rick Cronin
Andy Crum
Sharon Dascomb
Jesse Davenport
Bruce Davis
Paige Davis
Terry Davis
Eric Dekker
Chuck DeWolfe
Tom Dorais
Elizabeth Dorbad
Sondra L. Dorn
Day Dotson

Penland School of Crafts Timeline

1920 Lucy Morgan begins teaching at the Appalachian School and serves as acting director.

1923 Lucy Morgan studies weaving at Berea College. She has three looms shipped to Penland, begins teaching local women to weave, and works to market their woven goods.

1925 John C. Campbell Folk School is founded at Brasstown, NC.

1926 The Weaving Cabin is built by the families of the weavers.

1928 Edward Worst, Chicago educator and author of *Foot-Power Loom Weaving,* visits Penland and works with the Penland Weavers. The Southern Highland Handicraft Guild is organized during a planning meeting at Penland's Weaving Cabin.

1929 Nine out-of-state students join local weavers for weaving classes taught by Edward Worst.

1930 Edward Worst is named director of the annual Penland Weaving Institute. The Southern Highland Handicraft Guild is chartered.

1932 More than twenty people from over nine states come to the Weaving Institute. Pottery, leather tooling, wood carving, and basketry are also taught.

1933 Penland Weavers and Potters take wares to the Chicago World's Fair. Black Mountain College is founded near Asheville, NC.

1935 Edward F. Worst Craft House is built.

1938 Penland School of Handicrafts incorporates as a nonprofit educational institution; the program includes weaving, metals, ceramics, shoemaking, basketry, chair caning, cornshuckery, carding, spinning, and other crafts.

1940 Penland hosts the Second National Conference on Handicrafts.

1941 *Craft Horizons,* later *American Craft,* is first published.

1943 American Craft Council is founded.

1945 A new Penland dining hall, called The Pines, is built. The old one was destroyed by fire in December, 1944.

1948 Lily Loom House and new pottery studio are under construction. Fall and winter sessions are open for experimental labs with instructors available.

1949 Edward Worst dies.

1950 Haystack Mountain School of Crafts is founded.

1956 American Craft Museum is founded.

1958 *Gift from the Hills* by Lucy Morgan and LeGette Blythe is published.

1961 East Tennessee State College offers college credit for Penland classes.

1962 Lucy Morgan retires at age seventy-two and Bill Brown becomes the school's second director in the fall. Harvey Littleton and Dominic Labino lead the first studio glass workshop in Toledo, Ohio.

1963 Penland School begins the resident artist program. Principle program offerings are ceramics, metals, fibers, graphics, and wood.

1964 Edward Fortner Metals Studio is completed.

1965 The first sculpture classes are offered, and Penland's first glass studio is built.

1966 Seven buildings and several hundred acres of land are purchased from the Appalachian School. The first formal photography class is offered; glass is added as a regular program.

1967 National Council for Education in the Ceramic Arts is founded. Penland Weavers and Potters stop production.

1968 Penland receives its first grant from the National Endowment for the Arts. Photography becomes a regular program

1969 Society of North American Goldsmiths is founded.

1970 Penland begins to offer eight-week spring and fall sessions, called Concentrations, and begins the core student program.

1971 The first meeting of the Glass Art Society is held at Penland. Pilchuck Glass School is founded. Penland hosts the *Nifty Fifty,* a two-week work session for fifty artists.

1972 The Renwick Gallery, dedicated to craft, opens under the auspices of the Smithsonian Institution.

1973 Artist-Blacksmith's Association of North America is founded.

1976 Bonnie Willis Ford Glass Studio is built. Bonnie Ford, long-time Penland staff member, dies.

1977 Penland's first papermaking class is offered. Surface Design Association is founded.

1979 Penland's fiftieth anniversary is celebrated all summer. Penland School begins receiving general operating support from the North Carolina Arts Council.

1980 Surface design is listed as a separate program.

1981 Lucy Morgan dies. Blacksmithing is added as a regular program.

1983 Bill Brown retires.

1984 Verne Stanford is named director of Penland School.

1985 The clay studio is expanded and a new wood studio is built. Book and paper classes are offered regularly.

1986 First annual benefit auction is held.

1987 A second metals studio is built.

1988 Drawing classes are offered regularly.

1989 Hunter Kariher is named director of Penland School. Penland hosts the first symposium on expressive design in iron.

1991 Northlight building is completed, housing printmaking, drawing, and photography studios. Bill Brown receives the North Carolina Award.

1992 Books and paper studio is added to Northlight. Bill Brown dies.

1993 Ken Botnick is named director of Penland School. The White House Collection of American Craft is formed.

1995 The Bill Brown Glass Studio opens in conjunction with the twenty-fifth conference of the Glass Art Society.

1998 Jean McLaughlin is named director of Penland School.

1999 Penland celebrates its seventieth anniversary with a reunion. The Mint Museum of Craft + Design is founded in Charlotte, NC.

2000 Penland's new iron studio opens.

2004 Penland School celebrates its seventy-fifth anniversary. Activities include the publication of this book, an exhibition of the same name at the Mint Museum of Craft + Design, a historical exhibition at the Penland Gallery, and an artists' work session with one hundred participants.

Acknowledgments

Penland School of Crafts

With this publication, Penland School of Crafts honors more than two thousand artists who have taught at Penland as well as the many artists who have studied and worked at Penland over the past seventy-five years. Throughout its history, Penland School has been a retreat and sanctuary for artists. It has nurtured both the individual's voice and the collective voice of craft. It has encouraged traditions to remain strong and new directions to emerge. Foremost among the values Penland holds firmly is respect for the incredible presence, mystery, and power of the handcrafted object. It is in recognition of the work of all craft artists that Penland School of Crafts celebrates its seventy-fifth anniversary.

In 1998, Penland's board of trustees, led by trustees Linda Darty (artist, instructor and a former staff member under Bill Brown), Laurel Radley (great niece of Lucy Morgan), and Paul Smith (director emeritus of the American Craft Museum) talked of ways to celebrate Penland's seventieth and seventy-fifth anniversaries. The board wanted to link present to past and to capture the memories of people who had been active in the life of the school through oral histories and video documentation. They envisioned and, with the help of many volunteers, achieved a reunion of two hundred people on campus in 1999. At this same time, the board funded the position of archivist to collect, protect, catalogue, and make available the history of the school.

Among other ideas to emerge in 1998 was the desire for the school to collaborate with a major museum to mount an exhibition related to the impact of the school and a publication that could bring the story of the school and the importance of craft to a broad audience. A seventy-fifth anniversary planning committee—Robin Dreyer, Nicholas Joerling, Dana Moore, Erika Sanger, and myself—began a four-year planning process in 1999 to develop an exhibition and publication. Advice was sought from a number of people including Charlotte V. Brown, Lynn J. Ennis, Philip Yenawine, Andrew Glasgow, Kenneth Trapp, and Edward Cooke. Collectively, the planning committee decided to create a publication that would stretch our understanding of craft through an interdisciplinary perspective. The group began referring to the publication as a "gift" to the field.

To create essays for this publication, the committee cast a wide net for recommended writers from different disciplines. A final list yielded eight people invited to be in residence at Penland School to experience a craft community first-hand and to learn directly from artists about their work. We extend our warmest appreciation to these writers and scholars who embraced our vision and provided us with their best thinking in order to stimulate future conversations about craft: Galen Cranz, Ellen Dissanayake, Roald Hoffmann, Lewis Hyde, Norris Brock Johnson, Michael Owen Jones, Eileen Myles, and Patricia C. Phillips.

Penland approached the Mint Museum of Craft + Design to be its collaborator on the exhibition. From the first conversation, the staff members of the Mint Museums enthusiastically supported our concept. Penland gratefully acknowledges the thoughtful contributions of Phil Kline, Mark Leach, Mary Douglas, Melissa Post, Mary Beth Ausman, Kristen Watts, Katherine Stocker, Charles Mo, and Kurt Warnke. We are also thankful to Kenneth Ames and Mint curator Barbara Perry for their recommendation of Ellen Denker, who became the exhibition's co-curator. We deeply appreciate the suggestions and thoughtfulness of other museum professionals as our project evolved—John Coffey and Dan Gottlieb with the North Carolina Museum of Art, Charlotte V. Brown and Lynn J. Ennis with the North Carolina State University Gallery of Art & Design, Ruth Summers at the Southern Highland Craft Guild, and independent curator Lloyd Herman, among others. Many museums and individuals across the country have generously loaned works from their collections to make the exhibition possible. For their trust and support we are most thankful.

This publication and exhibition would not have been possible without the support of Penland's highly creative and dedicated staff. A team of individuals gave innumerable hours and good humor to this project which stretched deeply into their already full lives. Dana Moore served as co-curator with Ellen Denker and as lead researcher for the exhibition, publication,

and artist-related special programs. Robin Dreyer exerted great sensitivity and skill in researching and writing a brief history of Penland's seventy-five years. He and Dana Moore also coordinated the publication's editing, design, and preparation for printing. Barbara Benisch led the development team to raise the funds required for all aspects of Penland's anniversary. Special recognition goes to archivist Michelle Francis for her enthusiastic responses to all historical questions and research requests, Kat Conley for her knowledge of the school's history and her help with photographs and the timeline, Laura Way for her accounting prowess, Stacey Lane for her residency coordination, Sarah Warner for her work on various special assignments, Katherine Boyd for her research assistance, Scott Bunn for his attention to the details of our grants, and Ann Marie Kennedy for her assistance with archival research.

Penland was also fortunate to have the assistance and talent of several individuals. Ronni Lundy worked with the writers on the final edits of their essays. Donna Jean Dreyer researched and composed biographies of the represented artists. Kristi Pfeffer designed the publication and Leslie Noell was responsible for its layout. Nathalie Mornu and Sarah Warner did meticulous and thoughtful proofreading. David Ramsey photographed most of the art which appears in the publication. Caroline Hannah provided curatorial assistance. Kathryn Gremley, Clarence Morgan, Tom Spleth, and Bob Trotman provided thoughtful reviews of the essays.

A most sincere and special thanks goes to co-curators Ellen Denker and Dana Moore. Ellen's understanding of craft in the context of material culture has strengthened and enriched our project. Dana's knowledge of the artists and contemporary craft along with her fine curatorial eye were critical to the content of the exhibition and publication. They both embraced the concept of the project and guided it carefully and tirelessly from start to finish.

Finally, we would like to extend our profound gratitude to the sponsors of this project. We are particularly indebted to the Windgate Charitable Foundation whose early and significant support enabled us to realize our dream. The National Endowment for the Arts provided steady and valuable support for research and publication costs. The American Craft Council provided funding for video editing equipment enabling Emily Ennis, Chelsea LaBate, Tom Spleth and Joe Murphy to move our video documentation efforts forward. The North Carolina Humanities Council provided funding to bring the writers to campus over a two year period. The North Carolina Arts Council and many friends of Penland provided operating support for the staff expenses related to the project. And, most importantly, we thank Rob Pulleyn and Lark Books for believing that this seventy-fifth anniversary experiment in the spirit of Penland was also in the spirit of Lark Books.

Throughout every phase of the project we have enjoyed the support and encouragement of the Penland Board of Trustees and the entire Penland staff. We especially thank trustees Nicholas Joerling, Bill Davis, and Glen Hardymon for their expertise and assistance. This project has benefited from the help of generous people who care deeply about crafts. Together, with our many partners and supporters, we are telling an important story that will encourage the making and thinking about craft to grow in a broader and deeper way.

Jean W. McLaughlin
Director, Penland School of Crafts

This pattern of logs at the end of the Craft House porch is the basis for the logo Penland School has used since 1990.

MINT MUSEUM OF CRAFT + DESIGN

The Nature of Craft and the Penland Experience began with a vision. Five years ago, then curator of the Mint Museum of Craft + Design Mary Douglas and I met with Penland School of Crafts director Jean McLaughlin and John Coffey, chief curator at the North Carolina Museum of Art, to explore the feasibility of developing an exhibition that would celebrate Penland's many contributions. More specifically, the exhibition would commemorate the momentous occasion of Penland's seventy-fifth anniversary and the school's special role in nurturing the development of the crafts sector in the United States. Since then, the Mint Museum of Craft + Design and Penland School of Crafts, along with a number of museums and galleries across the country joined with artists, collectors, art patrons, scholars, and web designers to bring the exhibition, this scholarly publication, and the project's dedicated website to fruition.

The exhibition would not have been realized without the extraordinary and early support of The Windgate Charitable Foundation. Additionally, significant support came from the federal and corporate sectors. We acknowledge the generosity of the Institute for Museum and Library Services, a federal agency that fosters innovation, leadership, and a lifetime of learning. We express our sincere gratitude to Altria Group, Inc. and Philip Morris USA for sponsoring the presentation of the exhibition in Charlotte. For more than four decades Altria Group, Inc., the parent company of Kraft Foods, Philip Morris International, and Philip Morris USA, has been a leading corporate supporter of the visual and performing arts, championing artists and arts organizations that inspire and reflect the qualities that the company values in its business operations—creativity, diversity, excellence and innovation. Through its commitment to the arts, the Altria family of companies have improved and revitalized the quality of life in communities worldwide. The company's association with the Mint Museum of Art spans more than two decades and includes funding for several exhibitions, including *Michael Lucero: Sculpture 1976-1995* and an inaugural grant in 1998 for the opening of the museum's craft and design facility. We are proud that they are partnering with us on this historic project, which will illuminate our state's excellent craft traditions. In addition, we extend profound gratitude to the Mint Museum of Craft + Design's national support group, the Founders' Circle, for their continued generosity and dedicated funds.

The Mint Museum of Craft + Design receives operating support from the Arts and Sciences Council, Charlotte/Mecklenburg, Inc.; the North Carolina Arts Council, an agency funded by the State of North Carolina and the National Endowment for the Arts; and the City of Charlotte.

The Mint Museum of Craft + Design extends its gratitude to all the lenders who selflessly shared their objects with this exhibition. We are inspired by the generosity of those organizations whose loans join with those of the Mint Museum of Craft + Design and Penland School of Crafts. They are: Arkansas Arts Center Decorative Arts Museum, Boise Art Museum, Brooklyn Museum of Art, Corning Museum of Glass, Elvehjem Museum of Art, Gallery of Art & Design at North Carolina State University, High Museum of Art, Illinois State Museum, Indianapolis Museum of Art, Leigh Yawkey Woodson Art Museum, Los Angeles County Museum of Art, Memorial Art Gallery at the University of Rochester, Mobile Museum of Art, Museum of Arts & Design, Museum of Fine Arts, Boston, New Jersey State Museum, Philadelphia Museum of Art, Rhode Island School of Design Museum of Art, St. Louis Art Museum, the Renwick Gallery of the Smithsonian American Art Museum, South Carolina Arts Commission, Southern Highland Craft Guild, The Jewish Museum (New York), The Newark Museum, and the Wood Turning Center. We acknowledge the prominent galleries who responded to inquiries for information and subsequent loan requests. Among them, we appreciate the generosity and participation of the following: Frank Lloyd Gallery, Habatat Galleries, Maurine Littleton Gallery, Nina Freudenheim Gallery, Noel Gallery, and Rosenberg + Kaufman Fine Art.

Individual lenders are critical to the success of an exhibition of this magnitude. We are deeply grateful to the following individuals: Lisa S. and Dudley B. Anderson, Gordon T. Baldwin, Mike and Annie Belkin, Katherine and William Bernstein, Sandy and Diane Besser, Cynthia Bringle, Dorothy and Clyde Collins, Harold Copley, Mignon Durham, Hedy Fischer and Randy Shull, Harvey K. and Bess Littleton, Deborah Luster, Dana Moore, James and Judith Moore, Ron Porter, Martha A. Strawn, Jo Vrana, and Melanie Walker.

Noteworthy pride within the Penland artists' community resonated in their willingness to lend works from their own collections. Among these talented individuals are Linda Arbuckle, Junichiro Baba, Dan Bailey, Oscar Bailey, Boris

Bally, Mary Barringer, Jamie Bennett, Paulus Berensohn, Fred Birkhill Jr., Joe Bova, Elizabeth Brim, Cynthia Bringle, Edwina Bringle, Bill Brown Jr., Ken Carder, Nick Cave, the estate of Kitty Couch, Linda Darty, Randall Darwall, John Dodd, Don Drumm, Catharine Ellis, Daniel Essig, Fred Fenster, Shane Fero, Alida Fish, Debra Frasier, Susie Ganch, Peter Gourfain, Silvie Granatelli, Audrey Handler, Bobby Hansson, Doug Harling, Jim Henkel, Miyuki Imai, Judy Jensen, Kenneth Kerslake, Deborah Luster, Warren MacKenzie, Richard Margolis, Paul Marioni, Beverly McIver, Keisuke Mizuno, Clarence Morgan, Jane Peiser, John Pfahl, Jason Pollen, Sally Prasch, Michael Puryear, Douglass Rankin and Will Ruggles, Brian Ransom, Richard Ritter, Holly Roberts, Mary Roehm, Kari Russell-Pool and Marc Petrovic, Emilio Santini, Mary Ann Scherr, Carol Shinn, Christina Shmigel, Jerry Spagnoli, Deb Stoner, Billie Ruth Sudduth, James Tanner, Janet Taylor, the estate of Todd Walker, Eileen Wallace, and Joe Walters. It is their creativity that is the very soul of this project.

We thank co-curators Ellen Denker and Dana Moore for their thoughtful selection of objects and the orchestration of them into provocative themes. These curators, working with the museum's project manager and curator of craft and design, Melissa Post, produced an exhibition that provides intriguing perspectives on the history of craft.

Together, associate registrar Katherine Stocker and curatorial research associate Kristen Watts coordinated the loans and arranged the oftentimes complex crating and shipping of these incredible objects. Their uncompromising dedication and their unparalleled consistency of endeavors throughout this project facilitated the management of this monumental undertaking.

The education programming that accompanies such an important exhibition is vital to the project's connection to its audiences, both young and old. The museum's education staff, under the leadership of Cheryl Palmer, director of education, is responsible for a plethora of innovative community programs. Chuck Barger and Tim Songer of Charlotte's Interactive Knowledge, and Mary Beth Ausman, education resource coordinator, created a compelling website which captures the essence of the Penland experience and the beauty of the objects selected for the exhibition. We also thank Penland School of Crafts staff members Barbara Benisch, Stacey Lane, and Meg Peterson, who have helped to shape and enrich this project's educational programming.

Phil Kline, executive director of The Mint Museums and the museums' chief curator Charles L. Mo have facilitated informative and inspirational project sessions that have kept all project participants on the path to success. Marketing advisor Fred Dabney and public relations manager Phil Busher immediately embraced this exhibition, thus ensuring its success with exciting marketing and media opportunities. Development officer Rosemary Martin admirably supported grant applications throughout the organization of the project. Through her dedication and tireless efforts, The Mint Museums face a richer future. Special events manager Mark Huffstetler, membership manager Pat Viser, and membership coordinator Elizabeth Sanders have collaborated with Penland's director of development and communications Barbara Benisch to oversee the organization of the exhibition's opening events.

Photographer David Ramsey, along with numerous institutions, provided the stunning images that appear in this publication, the website, and within marketing and media campaigns. Kurt Warnke, head of design and installation for The Mint Museums, along with graphic designer Emily Walker, created memorable designs for the exhibition and the accompanying printed materials. Their commitment to quality is shared with that of chief preparator Mitch Francis and preparators William Lipscomb and Leah Blackburn. Mike Smith, chief financial officer for The Mint Museums, along with his able accountants Lois Schneider and Hannah Pickering provided financial oversight for this complicated project. Property manager Ed Benton and his conscientious security staff oversaw the safety of the exhibition while in the museum's care.

It is with deep professional respect that I acknowledge the special contributions to this project of Jean McLaughlin, director of Penland School of Crafts. Jean's dedication and experience assured the success of this project from the outset. In addition to her professionalism, I appreciate her friendship throughout this project and those of the past.

I thank all of these individuals for their valuable contributions and for their unrelenting commitment to this project. Through their efforts, the Mint Museum of Craft + Design and Penland School of Crafts are able to present *The Nature of Craft and the Penland Experience.*

Mark Richard Leach
Deputy Director, The Mint Museums

Index